AMERICAN VIEWS

AMERICAN VIEWS

Essays on American Art

JOHN WILMERDING

PRINCETON UNIVERSITY PRESS · PRINCETON, NEW JERSEY

Published by Princeton University Press, 41 William Street,
Princeton, New Jersey 08540
In the United Kingdom: Princeton University Press, Oxford

Library of Congress Cataloging-in-Publication Data

Wilmerding, John.
American views : essays on American art / John Wilmerding.
p. cm.
Essays originally published 1968–1990.
Includes index.
ISBN 0–691–04090–7
1. Art, American. I. Title.
N6505.W57 1991 759.3—dc20 91–4479

This book has been composed in Linotron Goudy

Princeton University Press books are printed on acid-free paper, and
meet the guidelines for permanence and durability of the Committee
on Production Guidelines for Book Longevity of the Council on
Library Resources

Printed in the United States of America

10 9 8 7 6 5 4 3 2 1

Designed by Laury A. Egan

Contents

Contents

List of Illustrations

Black and White Illustrations

List of Illustrations

Preface

American Views represents a selection of nineteen essays, culled from a much larger group, published over more than two decades from 1968 to 1990, on various aspects of American art, artists, and culture. Of those assembled here, only a handful are otherwise still in print. Many were originally essays contributed to monographic exhibition catalogues; a few served as forewords. Others appeared in scholarly journals or general art magazines. Some pieces began as lectures or papers delivered at symposia and were subsequently reworked for publication—not usually an easy process given the differences in verbal versus written expression. In several cases, a particular section or even a chapter from a book seemed to have a sufficiently self-contained coherence and interest to stand on its own. And in a couple of instances, essays appeared as separate publications for special occasions or needs. The writings are rearranged here not by their original chronology or purpose, but in two general thematic groupings. These establish the range of focus from ideas and traditions in American art to individual artists and works of art as well as to some of the regions that have been especially appealing to painters over long periods of time.

The book's title first of all asserts an attention to the national character of American art, and one will find here various investigations into the forms of realism and attitudes toward nature so long associated with this country's aspirations and destiny. But in using the word *view* the title is intended to signal equally all its rich meanings as both noun and verb. For instance, the word suggests both what is seen and the act of examining or looking, that is, the scene or prospect along with an implication of a viewpoint or position held by the observer. To *view* something can have the neutrality or objectivity of simple seeing or watching, but it may also take on the more active dimension of scrutiny and careful consideration. Likewise, the noun has a useful variety of applications: a view can be alternatively an inspection, a survey, a range of vision, or even an objective. And in its capacity as a point of view, it assumes an opinion or judgment. Thus the word's powers to analyze and argue are especially appropriate to the shifting forms and intentions of these essays, while its synonymous extension to scene and scenery perfectly suits the American artist's central devotion to landscape and nature.

The subjects of this volume cross not only that familiar terrain of American geography but also issues in portraiture, still life, and genre painting, from the eighteenth to the twentieth centuries. During this time America invented and defined itself, declared its political as well as cultural independence, then fractured and reconstituted the national union, and continued to adjust its place in the world order. How we may view America's artistic achievement as distinctive in its own right, but also in relation to the conduits of history, is the generating question for the several pieces of writing that follow.

Although regrouped in new relationships, these essays will give some idea of the patterns of interest and evolving methodologies of American art historians generally over the last couple of decades. For many colleagues completing dissertations and publishing their first books in the field during the mid- and later 1960s, there were major opportunities to research and document entire careers of rediscovered artists, such as Robert Salmon, Fitz Hugh Lane, Martin Johnson Heade, Frederic Edwin Church, William Bradford, and Sanford Robinson Gifford. A lot of groundbreaking work was done in reconstructing full artistic biographies, and these efforts resulted in the appearance of a number of definitive monographs on now-familiar nineteenth-century figures. A second major preoccupation of that period, in part subliminally reflecting the dominant discourse of the time of formalist criticism in modern art, was the language of

formal analysis as it could define and illuminate both individual artists, like John Singleton Copley, Lane, or John Frederick Kensett, and luminist painting generally. The pieces here written on Bradford and Salmon emerged out of such contexts.

During the 1970s and 1980s, the scholarly interests of Americanists began to broaden further, as younger colleagues along with others from cognate disciplines like literature and history entered the field, provocatively opening up the possibilities of interdisciplinary study. In this context, for example, the thinking about luminism increasingly amplified its stylistic and formalist concerns with issues of iconography and meanings that could be grounded in a particular historical framework. This thrust in turn led to work that saw useful analogies in literary and social studies but which more recently has striven for the more complex sweep of cultural and intellectual history. Characteristic of such directions are the works included here on Rembrandt Peale, George Caleb Bingham, and John Frederick Peto, which respectively address the interrelationship between art and ideas at the beginning, middle, and end of the nineteenth century. So whereas earlier convention might have paid due to Emerson's transcendentalism as complementary to luminist spiritualism, one will find in more recent writing references to the central intellectual forces of Jefferson, Lincoln, and Henry Adams, and the ways in which they can deepen our understanding of American self-expression.

The reader of this volume will also discover a more personal explanation for some of the author's recurring subjects, particularly marine artists and the sea. For one born in Boston and schooled in New England, learning to sail on Fishers Island Sound and then spending summers on the Maine coast, the passions for Salmon, Lane, Winslow Homer, and Mount Desert Island expressed here seem to have been natural imperatives. But no single methodology dominates these views: historical context, literary parallels, broad cultural forces, biographical circumstances, iconographical study, and purely formal or aesthetic concerns respectively claim attention, and contribute, one hopes, as much to the insight as to what's in sight.

J. W.

I

THEMES AND PLACES

1

The Allure of Mount Desert

AMERICAN geography has always seized the collective American imagination. From the time of discovery onward, nature and nation have been mutually dependent in defining one another. The consciousness of a virgin wilderness of great and variable wonders helped create a national identity distinct from that of the Old World of Europe, by definition newer and by conviction better. This was to be a landscape for democracy, where many of the country's great wilderness sites would be designated national parks for the people. Quite appropriately, as discovery and settlement moved westward, Americans could celebrate a multiplicity of natural wonders, some focal like the Natural Bridge in Virginia, others spatial like the Great Plains, some seemingly frozen in time like the Grand Canyon, others endlessly charged in motion like Niagara Falls. Rising in unique configuration from the sea, and containing America's only national park in the northeast, is Mount Desert Island on the Maine coast. Peculiar to its topography are the immemorial conjunctions of sheer cliffs and ocean plane, and of evergreen, pink granite, and northern light.

By virtue of its location off the easterly running coastline, extending south some twenty miles into the open Gulf of Maine, Mount Desert possesses a certain image and actuality of isolation. Because its mountain summits slope off almost directly into the sea (fig. 1), a unique geological junction on the east coast of the North American continent, there is an additional visual drama to the island's silhouette against the horizon (see fig. 3). From almost all approaching vantage points, the intersecting lines of land and water appear clean and sharp, a characteristic that would have continuing appeal for artists recording the island's features over more than a century.

Another factor contributing to the sense of the island's singular presence is its relative inaccessibility. Situated on a rugged part of the northeast coast, Mount Desert lies approximately two-thirds of the way along the Maine shore from the New Hampshire to Canadian borders. Nearly three hundred miles from Boston, it is reached even today only by a long overland trip from New England's largest population centers. During the early centuries of discovery and settlement, the most common approach was by water, and, as Samuel de Champlain was among the first to learn in the seventeenth century, coastwise travel was constantly endangered by sudden fogs, strong seas and tides, and treacherous unmarked ledges. Coming upon a place of such bold beauty after long distance and often arduous effort only heightened the visitor's feeling of reaching a New World island of Cythera.

Certainly in nineteenth-century America the wilderness frontier held a special lure for the national consciousness. As westward expansion moved that frontier ever farther across the continent, adventurers and artists alike sought increasingly distant horizons to find solace and solitude away from the axe of civilization. First steamboat and later rail travel reached to the farther sections of the New England coast. Mount Desert was one of several natural sites at once seemingly pure as wild nature and yet accessible for commerce and enjoyment. It was inevitable that the island should evolve as both a national park and a summer resort.

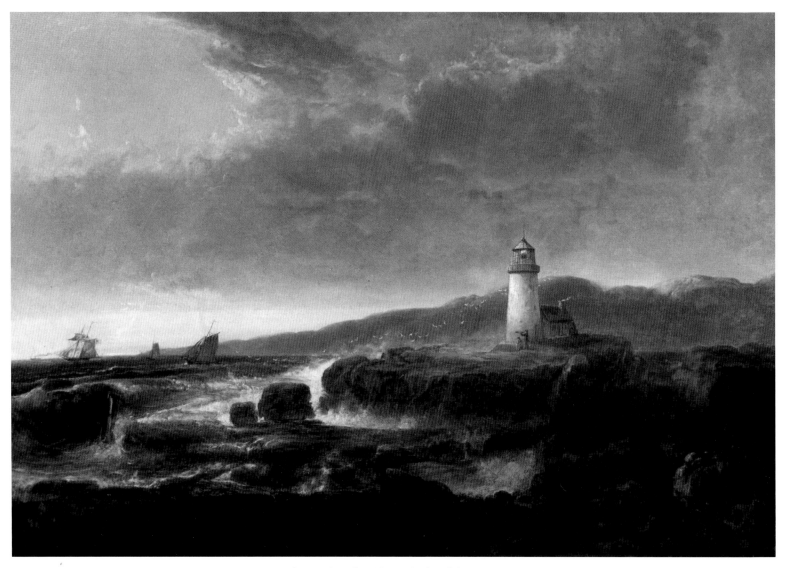

1. Thomas Doughty, *Desert Rock Lighthouse*, 1847

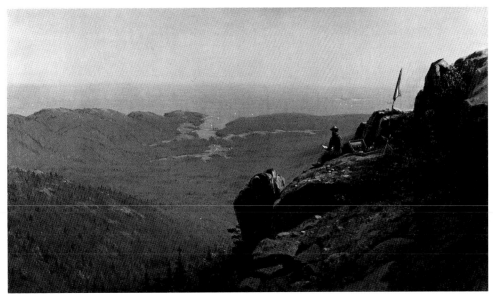

2. Sanford Robinson Gifford, *The Artist Sketching at Mount Desert, Maine*, 1864–1865
(Color Plate 1)

Given Mount Desert's visual prominence on the edge of the coast, it has always afforded superb views of two types, which might be called focal and panoramic. Like the other solitary summits to the island's west, the Camden Hills and Blue Hill, and that of Mount Katahdin in central northern Maine—or for that matter like other singular peaks in New England such as Chocorua, Washington, and Mansfield—the totality of Mount Desert looms up as a single commanding form from a good distance off. Indeed, from the open sea its combined summits are readily visible at twenty miles or more away, making it one of the most distinctive landfalls in North America.

As trails made their way up its hills, and later in the nineteenth century when a carriage road and then a tram railway were built to the top of Green (now Cadillac) Mountain, the island's highest point, viewers were rewarded with unsurpassed vistas in all directions (fig. 2). To the north lie the Gouldsboro hills and Tunk mountains; to the east the islands of Frenchman's Bay and Schoodic

Point; to the south open ocean, then more small islands marking the entrances to Northeast and Southwest Harbors; finally to the west larger islands again at the lower end of Blue Hill Bay and Blue Hill itself. On days of clearest light and air, one can also make out the Camden Hills beyond, and, turning back to sea, a sharp eye can find the lonely rockpile of Mount Desert Rock lighthouse twenty miles offshore due south (fig. 4). When American artists turned their attention to landscape for their primary subjects at the beginning of the nineteenth century, these natural vantage points of and from Mount Desert provided types of views that would remain continually vivid in defining both its physical and its spiritual dimensions.

Perhaps one recurring sense about the island's character is that of fundamental contrasts or opposites, the first and most obvious one being the balance of water and rock. In artistic terms we shall see that this terrain has also naturally served the opposing conventions of the picturesque and the sublime. On the one hand, the island's inner harbors, meadows, and valleys well suited the romantic sensi-

5

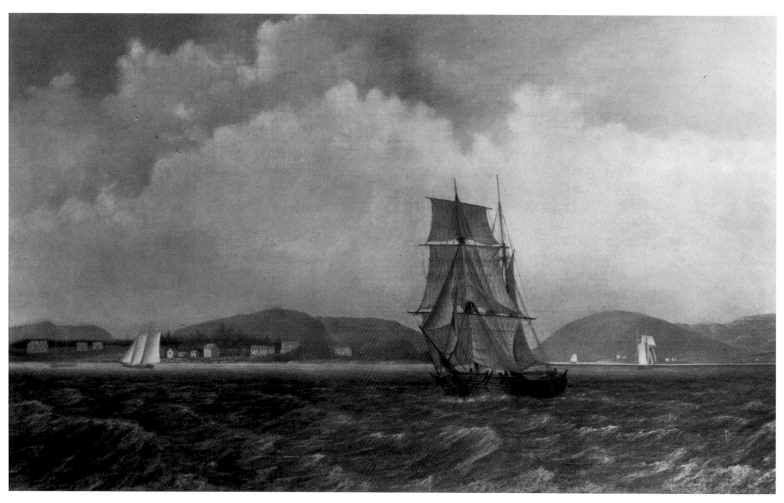

3. Fitz Hugh Lane, *Off Mount Desert Island, Maine,* 1850s

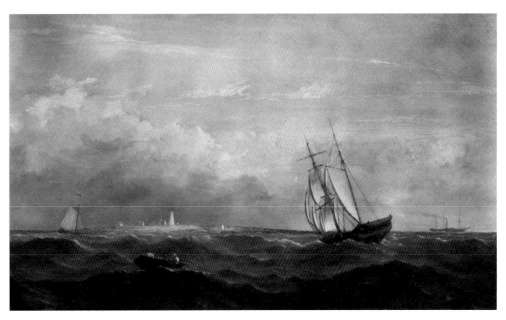

4. Fitz Hugh Lane, *Northwesterly View of Mount Desert Rock*, 1855 (Color Plate 2)

bilities of the picturesque formulas, which stressed modulation and balance, meditative calm in both subdued sound and motion, and overall feelings of gentle accommodation and well-being. By contrast, the precipitous outer shores perfectly embodied the features of the sublime: they were rugged and threatening, and nature's forces were visible, its noises palpable. The human presence here was more precarious and the juxtaposition of forms intimidating. Altogether, the scenery inspired awe, wonder, and exhilaration. Fitz Hugh Lane would undertake almost the full range of this imagery in his drawings and paintings of the Mount Desert region (figs. 3–6).

Arguably, the most indelible contrast is that linking past and present, in which almost every experience of the moment is enhanced by some inevitable consciousness of the area's geological and historical past. There are few places in continental America, especially in the east, where the surface of the earth so directly reveals the face of time. The bare mountain tops of Mount Desert not only evoked the

precise observations of early explorers and later artists, they have also endured as the tangible record of their own creation and evolution. That story of course extends back into scarcely countable periods of time. Even a rudimentary knowledge of geology indicates that these strikingly sloped hills were the result of prehistory's elemental polarities, namely fire and ice, volcano and glacier. Coming to this factual knowledge helps explain why so many feel they have also come to a timeless place.

First there was water, and geologists tell us that most of present New England was covered by sea around 450 million years ago.[1] Ever since, the forces of water and stone have engaged one another in shaping this landscape. In the long settling of the earth's crust, there followed alternating periods of unstable lifting and sinking of the land mass. Underneath the sea, ash and sediment stratified; then, as pressures arose from within the earth, land formations protruded above sea level and in turn were subjected to different patterns of

erosion. One sequence of volcanic eruptions produced the Cranberry islands off the southern coast of Mount Desert, but they were only covered again by the sea during a settlement of crust. Today one can readily see the two basic rock types around the island: the rounded popplestones formed by constant erosion from the movements of the sea, and the cubic blocks of rock walls created by ages of layered deposits.

Toward the end of this process (about sixty million years ago), the combination of volcanic eruption and resistance to erosion by the strongest granite produced a nearly continuous mountain range along this part of the coast. Its crestline was almost even, and the ridge extended in an approximately straight east-west direction.[2] During another period of uplift in the earth's crust, what is now Mount Desert, and the offshore islands as well, were all joined to the mainland. Further upheaval resulted in the promontories and island formations we recognize today. The so-called Mount Desert mountain range was then subjected to a final great phase of geological action, that of the ice age beginning a million years ago.

Scientists believe that at least four major continental glaciers spread southward from the polar icecap. The one that most recently covered New England began about one hundred thousand years ago and reached its maximum extent some eighteen thousand years ago. As it met the hard granite of the Mount Desert range, which extended across its path at right angles, the ice pack gradually ascended the ridges, thus accounting for the slow-curving rises of the island's north slopes today. After reaching the summits, the glacier, at its fullest more than two thousand feet thick, pressed down on the resisting rock beneath. The moving ice gouged deep valleys running north-south through the range.[3] When the glacier finally retreated, it left behind some dozen separate peaks of varying heights. Several of the valleys between them became deep freshwater lakes within the island, while the central one, scoured deeper and longer than the rest, was flooded by the sea. This cut of Somes Sound now reaches up the middle of Mount Desert as a unique coastal fjord (fig. 5). On the island's southern slopes the terminating glacier abruptly broke off granite blocks and deposited random piles of stony debris, prominently visible today in the sharp cliffs and massive seawalls of the present ocean coastline. No less than the average visitor, American artists from the early nineteenth century on have responded to these powerful primal formations.

The modern land formation that resulted after the cooling of the fire and the melting of the ice comprised about one hundred and eight square miles; the island is an irregular circle twelve miles across and fourteen miles long. Perhaps the most appropriate description of its outline comes from its earliest inhabitants, "the Indians, who called Mt. Desert 'Great Crab Island' in allusion to its shape."[4]

Recorded history does not begin until the early sixteenth century. The first documented sighting of the island occurred during the first ambitious explorations of the New World by the Spanish and Portuguese, who were followed by the French and English. The Portuguese reached this part of North America in 1525 and made the first map of the area in 1529, one that served explorers for almost a century following.[5] The most prominent European visitor and observer of this coast was to be Samuel de Champlain, whose extensive and distinguished career in North America began with his first voyage to Canada in 1603. Under the command of his countryman, Pierre du Gua, sieur de Monts, Champlain not only pursued expeditions along the coasts of Nova Scotia and New England but, more importantly, kept written accounts and drew admirably accurate charts of the harbors and islands he passed.

Champlain was given independent authority to undertake explorations along the Bay of Fundy and New Brunswick coastlines to consider sites for possible future settlements. He set forth in June 1604 and made his way to the south and west. Toward summer's end, he left Sainte-Croix and sailed by the high cliffs of Grand Manan Island, now a Canadian possession at the southern end of the Bay of Fundy. The next point of land he made for was Schoodic Point (see fig. 8), where he evidently put in for the night, having sighted even more alluring eminences of land rising from the horizon beyond.

The following day, 6 September 1604, Champlain rounded the point of Schoodic and sailed across Frenchman's Bay for Mount Desert Island. Passing Great Head and Sand Beach on the southeast corner of the island, he came close to Otter Cliff and there struck the offshore ledge usually submerged at high tide. Able to make his way around the headland, he put into the long mudflat inlet of Otter

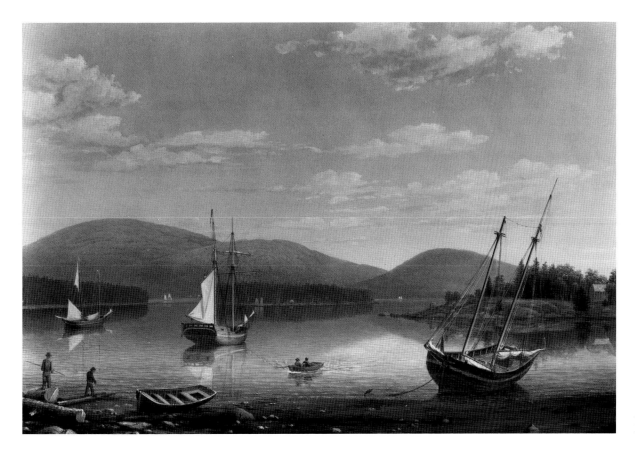

5. Fitz Hugh Lane, *Somes Harbor, Maine,* c. 1850

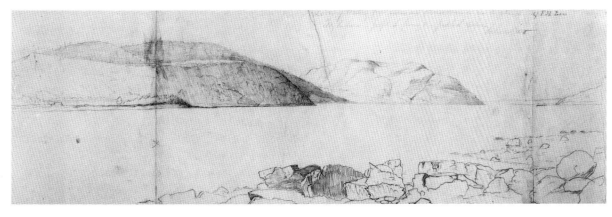

6. Fitz Hugh Lane, *Looking Westerly from the Eastern Side of Somes Sound near the Entrance,* 1855

Creek nearby, where his men could repair their vessel and take on fresh water. Next Champlain sailed along the rest of the island's southern coast, continuing his explorations through Penobscot Bay.[6] The changing panorama of the Mount Desert summits led to his bestowal upon this barren terrain of the name by which it has been known since:

> The land is very high, intersected by passes, appearing from the sea like seven or eight mountains ranged near each other. The summits of the greater part of these are bare of trees, because they are nothing but rocks . . . I named it l'isle des Monts-deserts.[7]

Champlain's observations were noteworthy in other respects as well. He was the first European to record the fact, presumably learned from local Indians, that the island was clearly separated from the mainland. Besides leaving an evocative written account of his travels, he drew what have been called "remarkably accurate maps and harbor charts, the best ever of northern America in that century."[8] His passage here was only a part of his larger continuing explorations: he navigated much of Penobscot Bay again and farther south in the summer of 1605, and by the end of his life had crossed the Atlantic twenty-nine times.[9] But perhaps the most resonant chord he struck for all who have followed him flowed from his observation that "on arriving in summer everything is very pleasant owing to the woods, the fair landscape and the good fishing. . . ."[10]

Over the next century and a half, the French and English struggled intermittently for the possession and settlement of eastern Maine and Canada. The French called this territory Acadia, a name memorialized today in the parklands on the island. Conflicts over its domain reached a climax with General Wolfe's triumph over the French in Quebec in 1758 and the conclusion of the French-Indian wars. Thereafter English interests were in the ascendancy, passing to their own former colonists after the American Revolution two decades later.

Representative of this moment in the eighteenth century is the visit by the English governor of Massachusetts, Francis Bernard, who arrived by boat in 1762 on a surveying expedition. On 1 October, he recalled,

at daybreak entered Penobscot Bay. . . . Between Fox Islands saw Mt Desert [*sic*] hills at near 30 miles distant . . . with a pilot boat proceeded for Mount desert [*sic*]. . . . At first we came into a spacious bay formed by land of the great island on the left and of the Cranberry islands on the right. Toward the end of this bay, which we call the Great Harbour, we turned into a smaller bay called the southwest harbour. This last is about a mile long and three fourths of a mile wide. On the north side of it is a narrow opening to a river or sound which runs into this island eight miles, and is visible in a straight line with uneven shores for nearly the whole length.[11]

After taking an observation of a sunrise a week later, Bernard sailed up Somes Sound, which he described as

a fine channel having several openings and bays of different breadths from a mile to a quarter of a mile in breadth. We passed through several hills covered with wood of different sorts. In some places the rocks were almost perpendicular to a great height.[12]

Bernard's interest was the beginning of increased visits and settlements by the English. After the Revolution the territory of Maine remained part of Massachusetts through the first quarter of the nineteenth century, when it gained separate admission to the Union. Thereafter a new phase of development and visitation began.

With the lingering disputes between the young republic and Great Britain finally settled by the War of 1812, commerce and well-being prospered along the entire Atlantic coast of the Union. In New England the architects Charles Bulfinch and Samuel McIntire built fashionable houses for the new merchant class of sea captains and ship owners. Immigrants from Europe swelled the population of east coast cities, and trade to distant oceans expanded the nation's horizons and pride at once. Now America's wilderness landscape not only called for exploration and settlement; by the second quarter of the nineteenth century it was also perceived to provide the substance of nothing less than national self-definition.

At this very juncture, America's first great native writers and artists began their adventurous travels into the wilder tracts of the

northeast. In 1836 Thomas Doughty, a founding figure of American landscape painting, completed the first major canvas of the Mount Desert area, and a decade later Henry David Thoreau, one of our primary writers and philosophers on American nature, made his first journey into the wild interiors of Maine nearby. Thoreau made three excursions into the northern woods, in 1846, 1853, and 1857, traveling by steamer from Boston to Bangor via Monhegan Island. Although he never visited Mount Desert directly, he would have had distant glimpses of her mountains as he sailed up Penobscot Bay and River to Bangor. "Next I remember that the Camden Hills attracted my eyes, and afterward the hills about Frankfort."[13]

Reaching Bangor, Thoreau expressed sentiments presumably common for travelers in this time and place. He felt that he was on the threshold of the wilderness, and that this northern city was "like a star on the edge of night." Beyond, "the country is virtually unmapped and unexplored, and there still waves the virgin forest of the New World" (p. 108). Others of his generation shared his acute awareness of balancing on the fulcrum between civilization and nature: "though the railroad and the telegraph have been established on the shores of Maine, the Indian still looks out from her interior mountains over all these to the sea" (p. 108).

But Thoreau's journeys also prompted him to higher thoughts. He pondered the American paradox of having both an established identity and a destiny yet to be discovered: "While the republic has already acquired a history world-wide, America is still unsettled and unexplored. . . . Have we even so much discovered and settled the shores?" (p. 107). These sentiments, an extension of the original experience of exploration in the New World by voyagers three centuries before, animated American aspirations through much of the early nineteenth century. Thoreau was the first important writer to articulate the belief that an excursion to the Maine wilderness was more than a physical passage. It led, he exclaimed, to a glimpse of basic matter and of God's first nature.

To the transcendentalist this was no less than "the fresh and natural surface of the planet Earth, as it was made for ever and ever. . . . It was Matter, vast, terrific . . ." (p. 92). Thoreau was particularly impressed with the continuousness of the Maine forest. The farther he traveled inland, the more aware he became of unin-terrupted woods—still, even timeless. By contrast, when he reached the mountains, he felt they were "among the unfinished parts of the globe . . . their tops are sacred and mysterious" (pp. 84–85). On climbing Katahdin, he expressed a reaction equally applicable to the hills of Mount Desert:

> Here not even the surface had been scarred by man, but it was a specimen of what God saw fit to make this world. What is it to be admitted to a museum, to see a myriad of particular things, compared with being shown some star's surface, some hard matter in its home! (p. 93)

Travel along the coast was also arduous and memorable as one proceeded to the east. The first steamer service from Boston to Maine began about 1850. Runs were made to Portland and Rockland; from there the *Ulysses* ran to Southwest Harbor and Bar Harbor on Mount Desert. Subsequently, there was service from Boston to Bucksport and Bangor, in turn the points "of departure for a journey of from thirty to forty miles by stage."[14] One of the first recorded accounts at this time was a trip by Charles Tracy of New York, father of Mrs. J. Pierpont Morgan, Sr., who came for a month in the summer of 1855. He arrived by steamer in Southwest Harbor, accompanied by the family of Reverend Stone of Brookline, the writer Theodore Winthrop, and the painter Frederic Edwin Church, back for his fourth visit to sketch, this time with his sister along.[15]

Getting to this part of the coast on one's own, by chartered or privately owned vessel, would have been even more adventurous and demanding. In the same years as Church's visits, Fitz Hugh Lane reached Mount Desert, sailing with friends from Castine. Robert Carter, the Washington correspondent of the *New York Tribune*, kept an account of another independently undertaken voyage made in the summer of 1858. "Summer Cruise on the Coast of New England" described his trip from Boston to Bar Harbor. His reactions were not unique: "the approach to Mount Desert by sea is magnificent. It is difficult to conceive of any finer combination of land and water."[16]

For those who sailed the coast in modest sloops or schooners, there was always the glory as well as the unpredictability of Maine summer weather. Besides the daily rush of tidal currents, torpid calm

can alternate with forceful storms, dense fog with sparkling sunlight, favoring breezes with unmarked hazards. During the first half of the nineteenth century, there were relatively few navigational aids along the Maine coast, though a number of the major offshore ledges and islands did have lighthouses. The oldest lighthouse in Maine is that at Portland Head, built in 1791 at the direction of George Washington. At least one other, that on Seguin Island marking the mouth of the Kennebec River, was constructed in the eighteenth century. More than two dozen others were built on sites between Portsmouth, New Hampshire, and Isle au Haut before the Civil War.[17]

East of the Mount Desert area, at least half a dozen lights were put up between 1807 and 1856 on points from Narragaugus Bay to West Quoddy Head at the Canadian border. Around Mount Desert itself and the nearby approaches, seven lighthouses are known to have been constructed during the early nineteenth century: those of Bass Harbor Head, 1858; Mount Desert Rock, 1830; Baker Island, 1828 (and rebuilt in 1855); Bear Island, 1839; Winter Harbor, 1856; Prospect Harbor, 1850; and Petit Manan, 1817 (also rebuilt in 1855). In addition, the government erected a stone beacon daymarker on East Bunkers Ledge off Seal Harbor in 1839–1840.[18] These obviously facilitated travel along the many treacherous passages leading down east, and made it possible for artists and others in increasing numbers to sail at their own leisure to Mount Desert by midcentury.

But these starkly simple stone towers served as more than fixed points of reference. For the early generation of adventurous travelers, they also carried implicit symbolic and emotional connotations. They were emblems of safety and security, guidance and direction, and metaphors for spiritual salvation.[19] No wonder artists painting in a period of increasing national strife and anxiety should turn for solace to the imagery of lighthouses. For example, between the 1830s and the 1860s, Doughty (fig. 1), Church, Lane (fig. 4), and Alvan Fisher all painted lighthouse views around Mount Desert. These towers were not mere factual features punctuating the physical landscape. They also were beacons of stability, founded on the literal rocks of ages of bold Maine granite.

Coastwise traffic of all sorts increased during the middle decades of the century. Mount Desert and the larger islands of Penobscot Bay were centers for a growing economy based on forest and sea. Shipping and shipbuilding flourished in the older fishing villages. The timber was cut from the lower slopes of Mount Desert more than once and loaded aboard sturdy schooners for transportation back to Portland and Boston. This rocky landscape also yielded up another element of its "basic matter": Maine's quarries provided much of the granite cut in great blocks for the new Greek revival buildings rising in Boston and elsewhere, and many of the smooth popplestones from its shores were removed for the streets of New England's cities.[20] Broad-bottomed schooners carried these loads of stone back to harbors to the west and south. Finally, the island's waters offered a bounty of seafood, especially herring, crab, and lobster, in a continuity from Indian to modern times.

Visitors to Mount Desert who came to see its splendors or stay for a few summer weeks found simple accommodations in private lodgings or taverns around the island. The painter Church, for example, stayed on his 1855 trip at the tavern in Somesville, while on another occasion he boarded at the Higgins homestead in Bar Harbor.[21] One of the most popular places artists chose to stay was on Schooner Head, an especially dramatic site on the eastern side of the island (see fig. 19) overlooking Frenchman's Bay. This was

> the Lynam Homestead, to which Cole, Gifford, Hart, Parsons, Warren, Bierstadt, and others renowned in American art have from time to time resorted to enrich their studies from the abounding wealth of the neighborhood.[22]

Among other painters making early excursions to the island who stayed at Somes Tavern, besides Church and William Hart, were Thomas Birch and Charles Dix.[23] After the Civil War, accelerating prosperity and better transportation led to replacement of the taverns by larger hotels built in Bar Harbor, Southwest Harbor, and later Northeast Harbor. Correspondingly, during the 1870s and the 1880s new growth occurred in summer cruising and yachting, followed by the first wave in building large summer cottages, which are still familiar today.

Travel on the island itself was fairly primitive well into the middle of the nineteenth century. When the first artists arrived, most roads were rough tracks and the sea was "still the high road for the dwellers

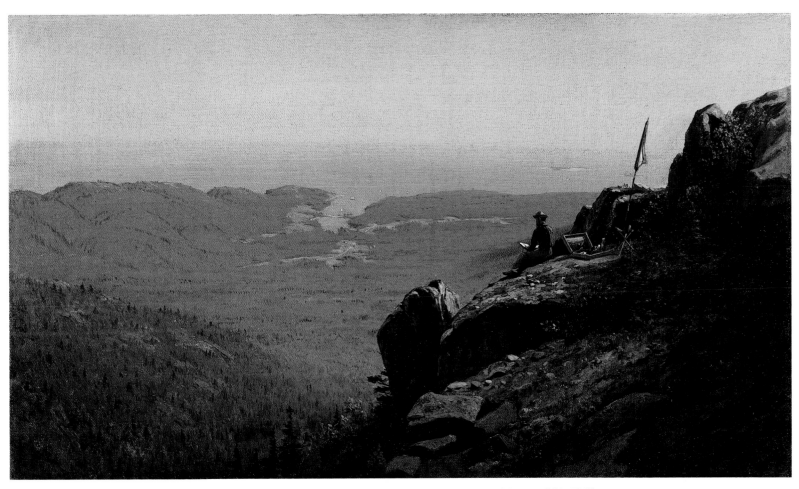

1. Sanford R. Gifford, *The Artist Sketching at Mount Desert, Maine*, 1864–1865

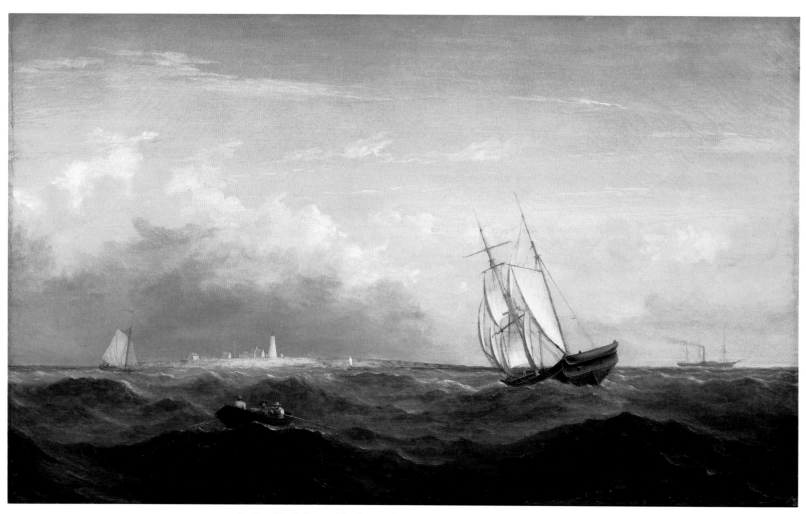

2. Fitz Hugh Lane, *Northwesterly View of Mount Desert Rock*, 1855

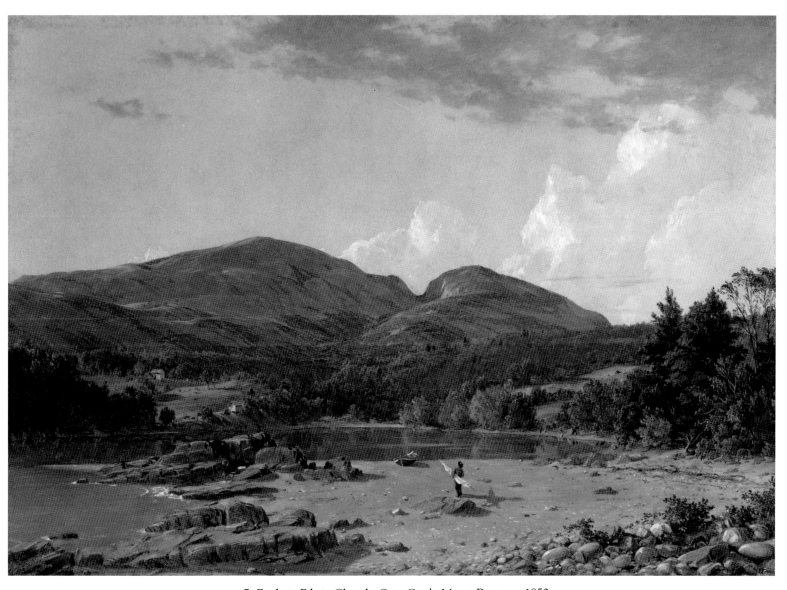

7. Frederic Edwin Church, *Otter Creek, Mount Desert*, c. 1850

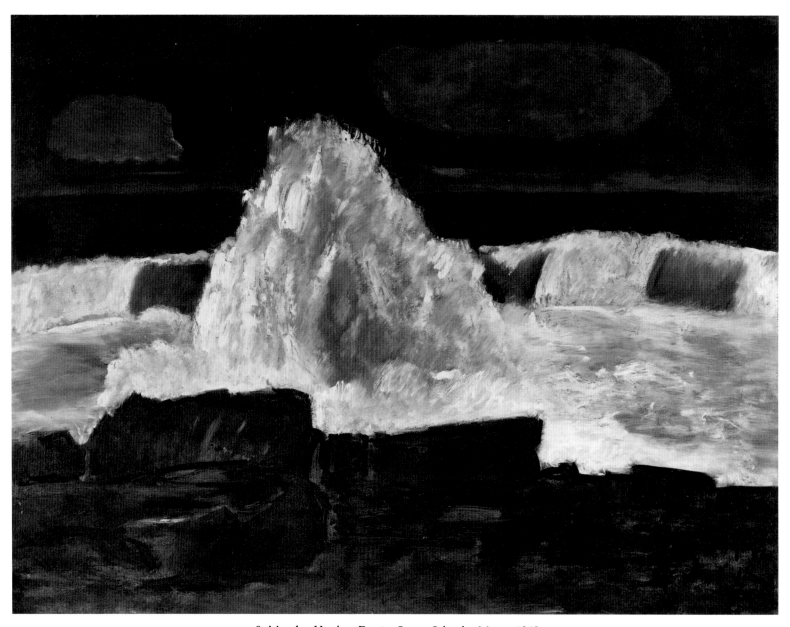

8. Marsden Hartley, *Evening Storm, Schoodic, Maine*, 1942

14

on the island."[24] However, by 1875 surveyors had laid out a carriage road to the summit of Green Mountain, and beginning in the 1880s for a few years a narrow-gauge railway also ascended nearby. Sightseers crossed Eagle Lake, in the center of the island, by steamer, landing on the west slope of Green Mountain, where they could board the tram car for the ride up and back.[25]

Now Mount Desert attracted a host of prominent visitors, including vacationing clerics and academics, like Bishop Doane of Albany and Charles William Eliot, president of Harvard. The one distinguished writer of the nineteenth century who made the trip and recorded his observations was John Greenleaf Whittier. In contrast to the scientific and philosophical cast of Thoreau's journals, Whittier's lines bear the romantic sensibility of the later nineteenth century:

> Beneath the westward turning eye
> A thousand wooded islands lie,—
> Gems of the waters! with each hue
> Of brightness set in the ocean's blue . . .
> There, gloomily against the sky
> The Dark Isles rear their summits high;
> And Desert Rock, abrupt and bare,
> Lifts its gray turrets in the air.[26]

The painters who visited the island over the last century and a half worked in an array of artistic styles and aims. Some, like John James Audubon and Thomas Eakins, intended to paint subjects quite different than the Maine landscape. Audubon came in search of local bird species he might include in his grand pictorial inventory, *The Birds of America*, completed in 1838. Eakins was a guest in Seal Harbor of Henry A. Rowland, a professor of physics at Johns Hopkins University in Baltimore and a summer resident; he worked on Rowland's portrait for several weeks in 1897.[27]

The Maine coast has also attracted other major American painters, in the nineteenth century Winslow Homer and in the twentieth Edward Hopper, both of whom worked in the southern part of the state but were never lured farther east to the Mount Desert region. But those who did venture this far, whether for brief stays and single works or for repeated visits and an extensive output, collectively give us an unusual and striking survey of American art. Indeed, part of the island's continuing allure is that a fixed point of geography can inspire such diverse visual responses and stylistic treatments as the romantic realism of the early Hudson River painters, the crystalline luminism of artists in the mid-nineteenth century (fig. 7), the variants of impressionism practiced at century's end, and the new modes of representation in the twentieth, approaching aspects of abstraction (fig. 8). Each generation of American artists was favored with a glimpse of nature many felt to be God's first creation; with their own creativity they returned the favor by changing that nature into an American art for posterity.

15

2

Thomas Cole in Maine

THE MOST important figure in the early group of artists to come to Mount Desert Island during the mid-1840s was Thomas Cole. The most significant document of his trip is a sketchbook now in the Art Museum at Princeton University. By then he had been acknowledged as not only the leader of the Hudson River School but also the foremost philosopher-artist of the day. He was the first major painter in American art to have been born in the new century, in 1801; a native of Lancashire, England, he emigrated with his family to America in 1818, then traveled briefly in Ohio and Pennsylvania before settling in New York in 1825. Up to then he had been struggling to become an artist, but he gained success after a summer sketching trip up the Hudson Valley, which resulted in the completion and sale of his first ambitious landscape paintings. Purchased by three distinguished colleagues, John Trumbull, Asher B. Durand, and William Dunlap, these pictures were soon shown at the American Academy of the Fine Arts and led directly to subsequent patronage from the collectors Daniel Wadsworth of Hartford and Robert Gilmor, Jr., of Baltimore.

Cole's art matured rapidly. Stimulated by his associations in New York with such nature writers as William Cullen Bryant, Washington Irving, and James Fenimore Cooper, Cole produced an outpouring of canvases depicting Hudson River, Catskills, and White Mountain scenery. At the same time, two excursions to England and Europe immersed him in the landscape of ancient ruins and cultures, the philosophy of late eighteenth-century English aesthetics, and the paintings of his contemporaries John Martin and Joseph Turner. His combined celebration of national geography and romantic ide-

alism resulted in the creation of such great pictorial icons of his day as *Schroon Mountain, Adirondacks* (1838; Cleveland Museum of Art), *The Ox Bow on the Connecticut River* (1836), *Crawford Notch* (*The Notch of the White Mountains*) (1839; National Gallery of Art, Washington) and the two allegorical series, *The Course of Empire* (1836; New-York Historical Society), and *The Voyage of Life* (1840–1842) (figs. 35–38). Through his meditations on American nature, Cole was able to articulate for his generation the physical as well as spiritual power of his country.

During the period that he was conceiving and executing his philosophical narrative, *The Course of Empire*, in five monumental canvases, Cole delivered an equally significant lecture in 1835, which he published as an "Essay on American Scenery" in *The American Monthly Magazine* the following year. He talked fervently about the elevating capacity of nature to instruct and inspire, and then dwelt on the fundamental components of America's scenery so that his fellow citizens might "appreciate the treasures of their own country." In general, he argued, "the most distinctive, and perhaps the most impressive, characteristic of American scenery is its wildness."[1] He then spoke of the specific virtues of mountains, lakes and waterfalls, rivers, forests, and the sky. Not yet thinking about a journey to the Maine coast, or the impact of its elements on his vision, his imagination staked out the full expressive power of water, to him the *sine qua non* of any landscape:

Like the eye in the human countenance, it is a most expressive feature: in the unrippled lake, which mirrors all surrounding

16

objects, we have the expression of tranquility and peace—in the rapid stream, the headlong cataract, that of turbulence and impetuosity.[2]

Whereas still water promoted reflection, in motion it was "the voice of the landscape" and sublime in its vociferous energies. Most of all Cole had found "Niagara! that wonder of the world!—where the sublime and beautiful are bound together in an indissoluble chain." The cataracts possessed "the contents of vast inland seas. In its volume we conceive immensity; in its course, everlasting duration; in its impetuosity, uncontrollable power. These are the elements of its sublimity."[3] If Cole could compare Niagara to vast inland seas, he was soon to paint the coastal waters of Maine with a similar grand sublimity.

The year 1844 was a key one in Cole's mature career: at the intercession of Daniel Wadsworth, the artist agreed to take on the promising young painter Frederic Edwin Church of Hartford as a pupil; Cole also planned and undertook a summer trip to Mount Desert in the company of his fellow artist Henry Cheever Pratt. The inspiration and work resulting from this visit were certainly factors leading Church himself to travel to Maine more than once in the following decade. Toward the end of the summer, Cole first made his way to Hartford to meet with Church and then proceeded on to Maine, where he joined Pratt and sailed by steamer from Penobscot Bay to Mount Desert. While Church was to keep company for Mrs. Cole, the older painter wrote his wife, "I intend to be as spirited as possible, and to get as many fine sketches as I can."[4] He did, if the surviving sketchbook full of drawings is any indication.

The Reverend Louis L. Noble's biography of Cole includes several paragraphs from the artist's diaries describing his visit and reactions to Mount Desert Island. These are worth quoting almost in full for their references to the several sites he saw and recorded:

AUGUST 29.—We are now at a village in which there is no tavern, in the heart of Mount Desert Island. One might imagine himself in the centre of a continent with a lake or two in view. The ride over the island took us through delightful woods of fir and cedar.

AUGUST 30.—The view from Beech Mountain—sheets of

water inland, fresh-water lakes, and mountains, the ocean with vessels sprinkling its bosom—is magnificent.

SEPTEMBER 3.—The ride here to Lynham's [sic] was delightful, affording fine views of Frenchman's Bay on the left, and the lofty peaks of Mount Desert on the right. The mountains rise precipitously—vast bare walls of rock, in some places of basaltic appearance. Those near us, I should suppose, were not far from 2000 feet above the sea. The road was exceedingly bad, stony, and overhung with the beech and spruce, and, for miles, without inhabitant. We lost our road too, and came to a romantic place near a mountain gorge, with a deserted house and a piece of meadow. One might easily have fancied himself in the forests of the Alleghenies but for the dull roar of the ocean breaking on the stillness. The beeches of this region are remarkably fine. Sand Beach Head, the eastern extremity of Mount Desert Island, is a tremendous overhanging precipice, rising from the ocean, with the surf dashing against it in a frightful manner. The whole coast along here is iron bound—threatening crags, and dark caverns in which the sea thunders. The view of Frenchman's bay and islands is truly fine. Some of the islands, called porcupines, are lofty, and belted with crags which glitter in the setting sun. Beyond and across the bay is a range of mountains of beautiful aerial hues.[5]

Cole and Pratt first made their way to the center of the island and the early village of Somesville, situated on a pretty and protected harbor at the very head of Somes Sound (see fig. 12). A few years later, Cole's pupil Church would record his impressions of the town road in the same area, and Fitz Hugh Lane likewise described in sketches and letters his own approach to Somesville by water. The day after their arrival, 30 August, Cole climbed nearby Beech Mountain on the western side of the island, where he found a broad view of the area's several features: the long freshwater lakes in between the hills, the dense forest cover and open granite ledges on adjacent summits, and to the south and west open views to the surrounding bays and ocean. A second major excursion a few days later took Cole across to the eastern coast of Mount Desert, with its much more dramatic shoreline of sheer cliffs, crashing surf, and island

views in Frenchman's Bay. Here he did his most extensive sketching, which resulted in several canvases, in response to the island's principal scenes of sublime landscape. Partially due to Cole's example, this area also became a favored haunt for Church and William Stanley Haseltine in the next two decades.

With the exception of a separate sheet and a couple of drawings from the Princeton sketchbook, Cole's Mount Desert sketches are little known and never reproduced. The sketchbook has an even greater importance for its coverage—Cole worked in it from 1839 to 1844—and its inclusion of studies related to some of his most famous images, for example, *Crawford Notch, Catskill Mountain House* (1843–1844; private collection), *The Voyage of Life,* and *Mount Aetna from Taormina* (1843; Wadsworth Atheneum).[6] Originally, the book contained twenty-six folios, of which three have been removed or lost, and a couple of sheets remained unused. The pages measure 11¼ × 17 inches and contain some forty sketches, several drawn across two facing pages. At least a dozen show Mount Desert views and another handful prospects of nearby scenery around Penobscot Bay. For the most part, these are simple line drawings with little texturing or shading, although many carry extensive notations by Cole as to location, prominent islands or hills, and occasional effects of color. Like Alvan Fisher and Lane, who stopped first at picturesque sites like Camden, Owl's Head, and Castine before proceeding to Mount Desert, so Cole also sketched first around Castine, site of a historic old fort above the town dating from the Revolutionary War. One particularly charming view he titled *Old Bastion, Old Fort at Castine* (fig. 9) and added "Built in 1779 or about." Atop the hillside, which Cole variously marked "quarry," "stones," "hollow," and "daisies and thistles," he looked out to Bagaduce Island and the open waters of Penobscot Bay in the distance. In an upper corner of the sheet, he drew a short line indicating the hilltop and standing on it the small silhouetted figure of "Mr. Pratt" with his sketchpad in hand, presumably recording the same view by Cole's side.

A related drawing focuses on the brick and stone ruins of the circular fort itself with a brick building nearby and across the harbor the wooded hills of Cape Rosier. Out in Penobscot Bay Cole noted an approaching schooner and in increasingly faint outlines islands respectively "10 miles off" and "20 miles off." This drawing is rela-

tively detailed in its delineation of the brickwork in the foreground and of the forestation beyond, and we may regret that more of these studies did not result, so far as we know, in finished paintings. Curiously, Cole's juxtaposition of the crumbling ruins against the wooded hillsides recalls his similar fascination earlier in Italy with the ancient circular *Torre dei Schiavi* (1842; private collection) set on the romantic landscape of the Roman Campagna.[7] Aside from the visual contrasts of color, texture, and structure, the combination of ruins and nature inspired Cole for much of his life as an endless meditation on man's history, the intersection of civilization and the landscape, and the changes wrought by time's passage. Indeed, such counterpoints between architectural remains and real or imagined natural settings served as Cole's focus for a variety of his major works: *A View near Tivoli (Morning)* (1832; Metropolitan Museum of Art, New York), *The Course of Empire, The Past* and *The Present* (1838; Mead Art Museum, Amherst College), *Roman Campagna* (1843; Wadsworth Atheneum), and *Mount Aetna from Taormina.*[8] Cole's drawing of the *Old Fort at Castine* possesses neither the air of melancholy nor the investment of moral allegory that some of these ambitious canvases have, though he must have been attracted to the setting in part for its historical associations. Fort George at Castine and Fort Knox at Bucksport were among the strategic defensive structures built in upper Penobscot Bay during the period of the Wars of Independence and 1812, and survived as bold reminders of the country's early political and economic struggles even along this relatively wild coast.

Cole evidently explored a good bit of the upper Penobscot region, both by vessel and on foot, for another couple of sketches show the shoreline drawn at water level and from a hillside vantage point. One he titled *Inlet of Sea, Penobscot Bay,* and a second *Long Island, Penobscot Bay;* this latter sheet includes three shoreline views with the upper one appearing to focus on the outline of Blue Hill in the far center while the middle one is identified as "The Bluff." Also outlined at the upper left is a sketch of an unidentified stone beacon, which Cole quite likely added after he had gotten to Mount Desert. No other such beacon had been constructed on the coast by this time, and its distinctive pyramidal shape marks it as the first one constructed by the government in 1839–1840 on East Bunker's

Ledge just off the mouth of Seal Harbor.[9] A casual and almost incidental notation here, it was to become a few years later a stark image in one of Frederic Church's most austere sunrise paintings.

From subsequent drawings it appears that Cole's party made its way by overland roads from Castine via Bucksport to Ellsworth and thence southward to Mount Desert Island. En route he sketched *Pond between Ellsworth & Bucksport,* one of the many small inland lakes just in from the coast. Intimate and spontaneous as these wayside views are, Cole instinctively made gestures toward composing what he saw. Here he ruled off the left margin to close in his design and reinforce the large tree trunk on that side, and he centered the small island in the middle ground of the scene. Conscious as always of nature's stages of growth, he contrasted the young pines in the distance with the cracked tree stump to one side and on the other a "dead trunk with hanging green moss." Characteristically careful observations elsewhere indicate the water as "bronze & glittering" and in the foreground a "sandy & pebbly beach."

Approaching the narrows where Frenchman's Bay and Blue Hill Bay come together at the head of Mount Desert, Cole executed two panoramic drawings of the island's full range of hills crossing the horizon before him. *View of Mount Desert from Trenton on the Main Land* (fig. 10) looks toward the westerly range, including Newport, Dry, and Green Mountains (known now as Champlain, Dorr, and Cadillac). Of unusual interest is Cole's notation on the highest summit, "called Big Dry Mt." During the later nineteenth century this was called Green, until it was renamed by the National Park Service as Cadillac in the early twentieth century.[10] The companion drawing, *Mt. Desert Island in the distance seen from the Main Land* (fig. 11), also records what must have been an exhilarating first view of Champlain's several hills. Atypical for Cole was his attention to the elongated format, necessary here to include the island's full silhouette from east to west; to do so he extended his drawing across two pages of his sketchbook, and used his right-hand sheet to indicate the expanse of Blue Hill Bay and Blue Hill itself at the right edge.

Once on the island, Cole paused at Somesville to sketch nearby views both from the village looking toward Sargent Mountain on the east side of Somes Sound and toward the hills on the western side. The former, *View in Somes Sound* (fig. 12), is an anomaly in

this sequence, for its size, paper color, and stained left edge indicate that it was probably taken from a different sketchpad. The use of a light blue paper and white highlighting, along with a much more precise and varied handling of pencil, results in a more finished and sophisticated drawing, as if Cole was thinking of an oil to follow. His vantage point is from the stream and mill pond at the head of Somes harbor, looking out on a view that would equally charm Fitz Hugh Lane a few years later (see fig. 5). Unlike the relatively cursory touch evident in most of the Princeton sketchbook drawings, this has an overall care of execution, seen in the greater range of darks and lights, unobtrusive narrative elements like the foreground rowboats, and the gentle rhythms of shorelines and hillsides surrounding the sailing schooner at the composition's center. The use of colored paper as a tonal midground allowed Cole a greater richness of modeling, texture, and atmospheric ambience, and became a favored method of sketching by the next generation of Hudson River and luminist artists.

Climbing a nearby mountain on the western side of Somes Sound, Cole next drew in his sketchbook a *View from Mt. Desert looking inland Westerly.* This was his first glimpse of the island's varied elements from an elevated position near its center, and in a series of intricate patterns he recorded the alternating contours of sloping hillsides, lakes, inlets, and islands as he looked across to the west to Blue Hill, which he noted to himself he had drawn "not quite high enough." With felicitous effect he instinctively lightened his line as he moved from the firm dark strokes of the foreground to ever more delicate ones in the distance, capturing the sensation of suffusing light and haze in such a broad panorama. Possibly this was "the view from Beech Mountain" toward "the ocean with vessels sprinkling its bosom" that he described in his August 1844 letter to Mrs. Cole.[11] Certainly, this side of the island offered an endless variety of such mixed prospects, combining slopes of forested hillsides and slices of both freshwater and saltwater coves.

Except for saying that "the ride here to Lynham's [sic] was delightful," Cole did not give further details of his explorations around the major inland hills of Mount Desert's eastern side. But presumably in the first couple of days of September 1844 he found much of visual interest as he crossed the island, a supposition confirmed by at least

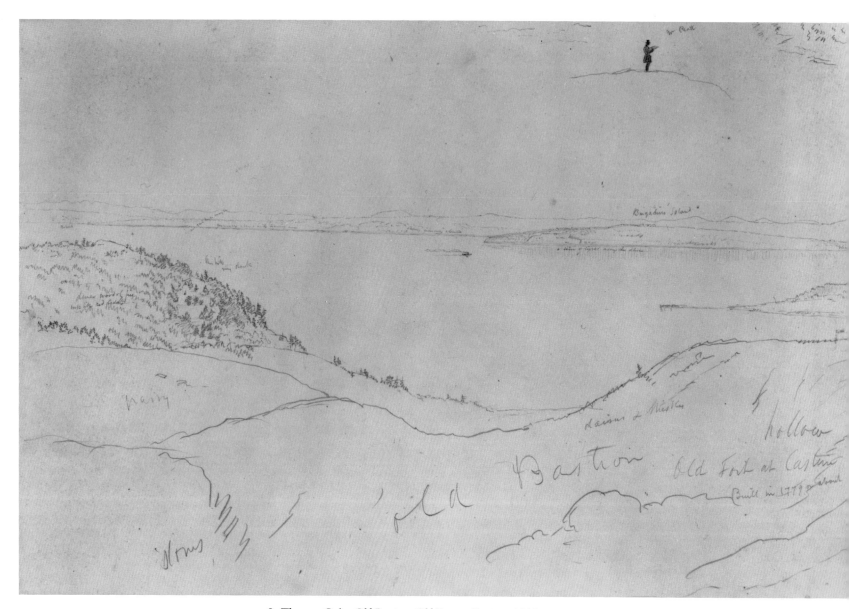

9. Thomas Cole, *Old Bastion, Old Fort at Castine*, 1844

20

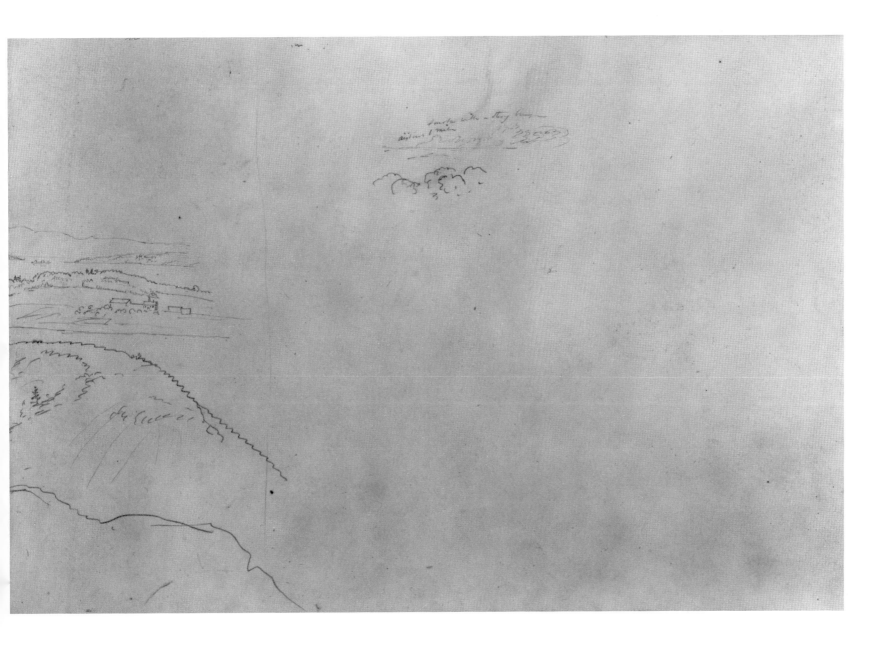

21

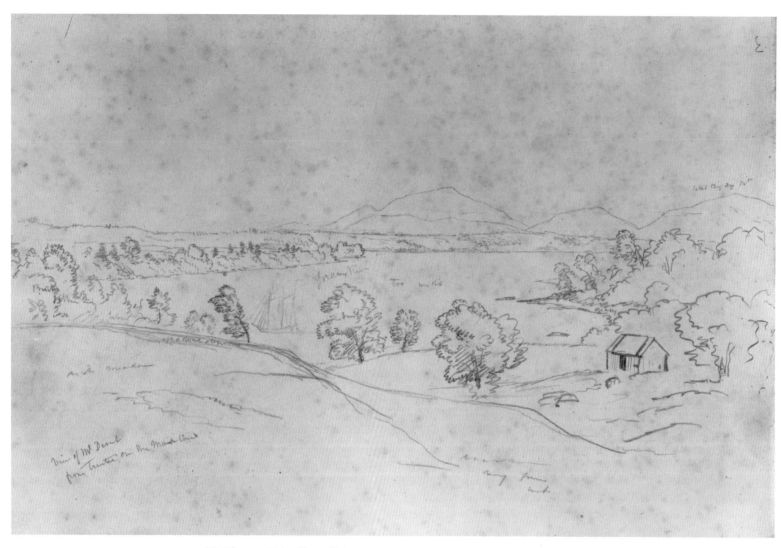

10. Thomas Cole, *View of Mount Desert from Trenton on the Main Land*, 1844

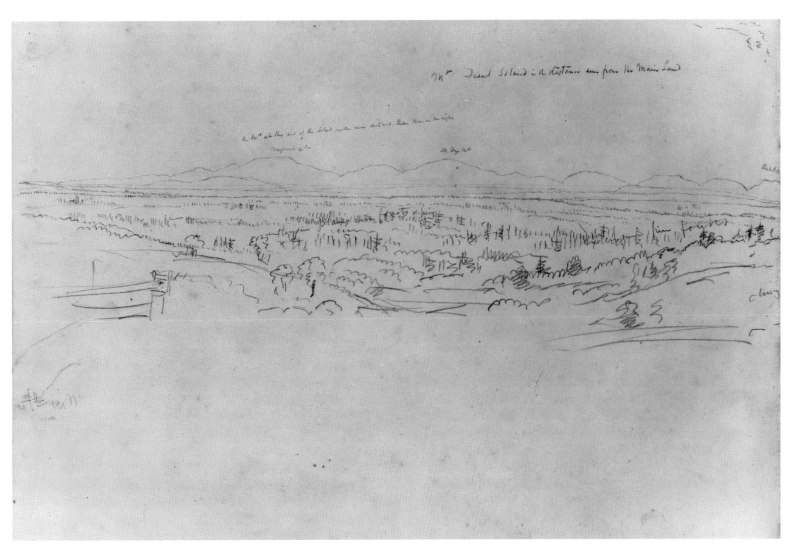

11. Thomas Cole, *Mt. Desert Island in the distance seen from the Main Land*, 1844

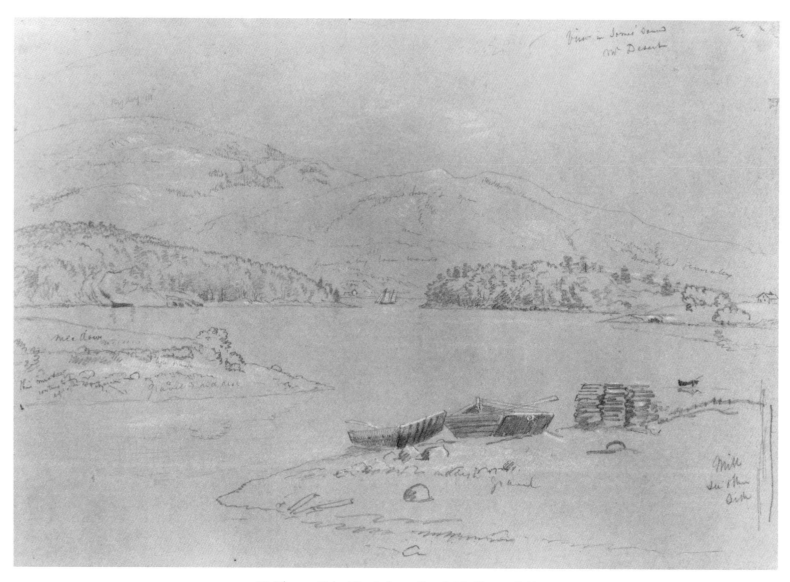

12. Thomas Cole, *View in Somes Sound, Mt. Desert*, 1844

24

three drawings in the sketchbook and one small oil. With the ascent of each mountain slope he saw a new angle on the coastline, and, turning almost like a compass, he dutifully recorded *From Mt. Desert looking South by East* and *Scene in Mt. Desert looking South* (figs. 13 and 14). Both of these look down on either Jordan Pond or Eagle Lake, framed by the slopes of Cadillac, Pemetic, and Sargent. Upon his return to Hartford, Cole must have shown his sketchbook to his pupil Church, for the latter would climb over and draw much of the same area a few years later. From these drawings Cole composed a modest oil showing a log cabin, *House, Mt. Desert, Maine* (c. 1845; Harvard University Art Museums). Like many of his studio paintings, this tended to generalize his experience of a particular scene; so here we are unable to determine exactly where this is set within the island's interior. Cole also introduces details intentionally to comment on man's humble presence in the wilderness, as deer graze near the human dwelling, while the large blasted tree trunk in the foreground reminds us of nature's great cyclical forces. We view the forest in its several stages of growth and decay and in contrast to its transformation by man into the structures of fence and house. In such narrative allusions and its simplified design the picture echoes Cole's major White Mountain canvas of a few years before, *Crawford Notch*. At Mount Desert Cole clearly enjoyed the shifting vignettes from intimate valley enclosures to sweeping mountainside overlooks.

One more drawing in this particular sequence he titled only *Mt. Desert* (fig. 15), though its vantage point and distant island details indicate a similar prospect from possibly the western side of Cadillac or Pemetic looking southerly toward Little Long Pond, Sutton and the Cranberry islands in the middle distance, and Baker's Island and the Ducks beyond. Then, finished with views to the south, Cole began an altogether different sketch on the right-hand sheet of his book, *Sand Beach Mountain* (fig. 16). On 3 September he noted that he had moved to Lynam Farm, just to the north at Schooner Head, where numerous artists coming to the island thereafter, including Church and Haseltine, would stay.[12] It was a convenient location a few miles south of Bar Harbor, nestled off a small cove in a meadow next to Schooner Head, one of the most dramatic promontories on the island's eastern coast. From there it was an interesting walk down to Sand Beach, which as Cole recorded was "the grandest coast scenery we have yet found." Just behind the beach is a tidal marsh and rising above it a small but precipitous cliff, today known as the Beehive.

Squaring off his drawing to emphasize the vertical rock formation, Cole added a lengthy verbal description of his impressions in the right-hand margin:

> This is a very grand scene—The craggy Mountains, the dark pond of dark brown water—The golden sea sand of the beach & the light green sea with its surf altogether with the woods of varied color—make a magnificent effect such as is seldom seen combined in one scene.

Cole made his drawing from partway up the adjacent slope of Great Head, which he called "Sand Beach Head, the eastern extremity of Mount Desert Island . . . a tremendous overhanging precipice, rising from the ocean, with the surf dashing against it in a frightful manner." He did not sketch the headland itself, as Church and Haseltine would later, but he did venture a couple of miles to the west to view the equally bold precipice of Otter Cliffs, a detour which resulted in an oil painted after his return (fig. 7).

There is no preliminary drawing known for this picture, and Cole appears to have relied on his memory of the site in composing his canvas. Indeed, his written description of Sand Beach Head (seen in the far right distance here) almost seems to have served as the basis for his interpretation of Otter Cliffs. In any case, once back in his studio, he took certain liberties with the factual accuracy, introducing exaggerations and narrative details. Typical of the latter are the small sailing vessel off the lee shore and the figure atop the cliffs, dwarfed by the turbulent scene. This is nature sublime, following the pictorial conventions of that term: man stands in awe before the overwhelming scale of the elements, seen as well as heard to be boldly contesting one another. To enhance this wilderness drama, Cole in fact distorted the angle and silhouette of the cliffs. His view looks toward the east, a vantage point that does not expose the cliffs as he has painted them; rather one can view its sheer drop against the open seas only from the other side. Cole has conveyed an essential aspect of the site, but freely modified it for expressive ends.

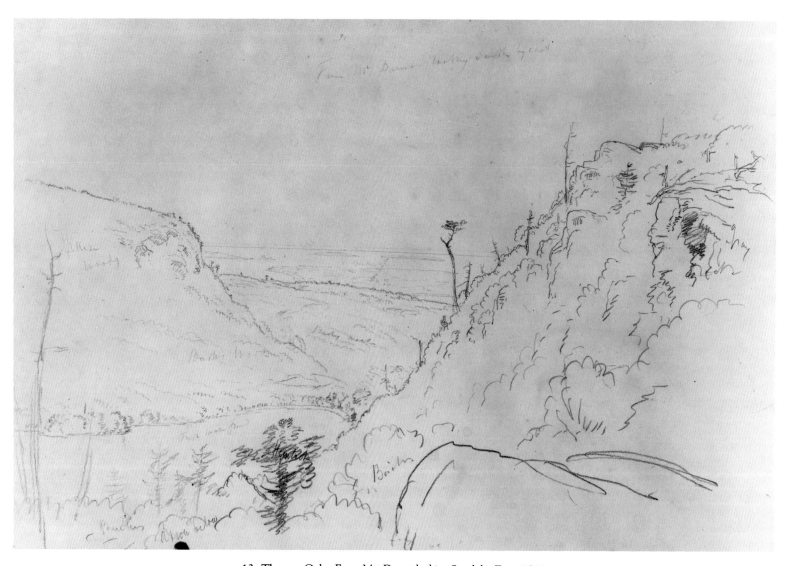

13. Thomas Cole, *From Mt. Desert looking South by East*, 1844

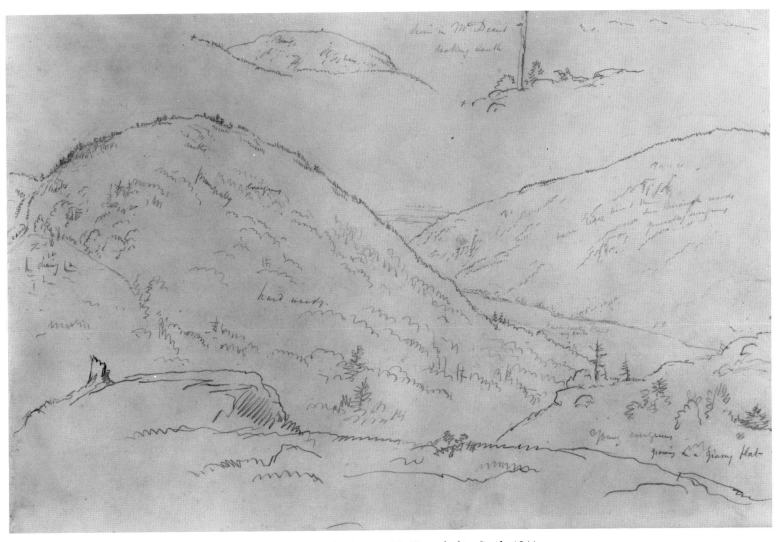

14. Thomas Cole, *Scene in Mt. Desert looking South*, 1844

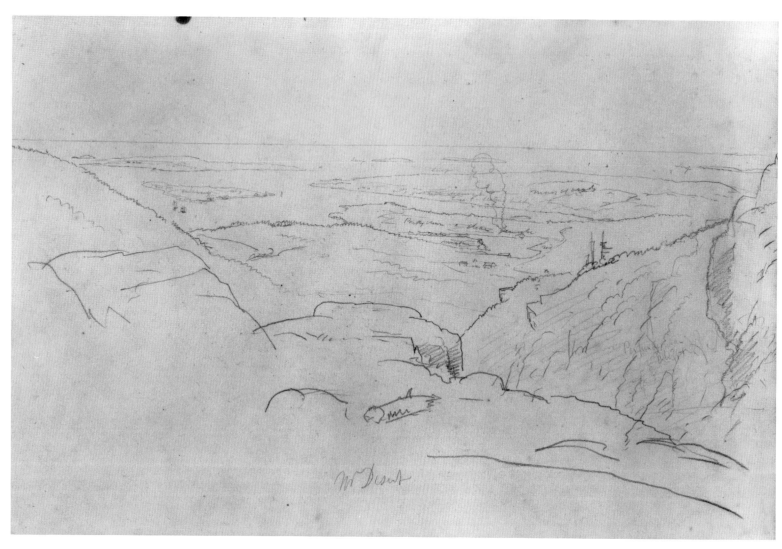

15. Thomas Cole, *Mt. Desert*, 1844

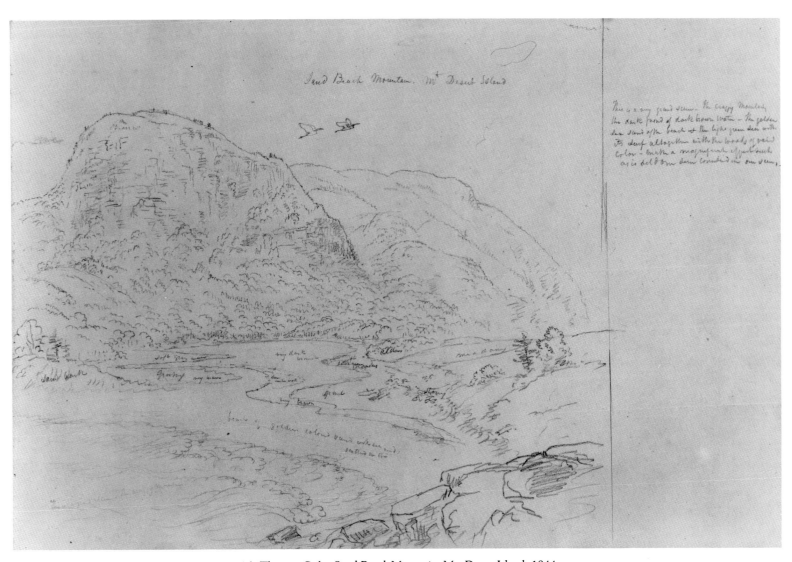

16. Thomas Cole, *Sand Beach Mountain, Mt. Desert Island*, 1844

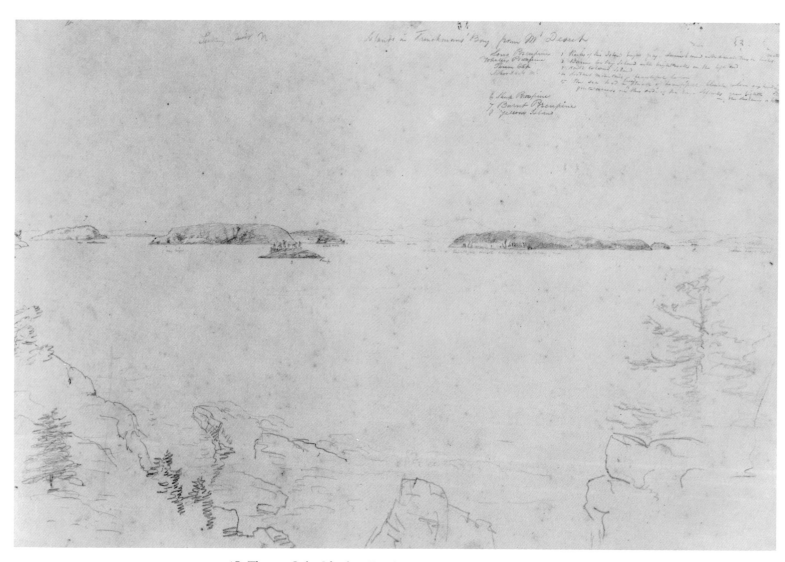

17. Thomas Cole, *Islands in Frenchman's Bay from Mt. Desert*, 1844

30

Similarly, he has overly projected the angle of the cliffs forward—they are actually a straighter vertical drop—to heighten the precarious but exhilarating position of man in this primal setting.

Cole also worked his way north from the Lynam Farm area to Hull's Cove just above Bar Harbor, where he made a simple line drawing from the head of the cove looking out to Bar Island and the Porcupines. One wonders whether the neatly drawn schooner and lone figure in a rowboat nearby are merely a device for focus and scale or if the schooner was possibly a vessel Cole had boarded for daytime travel around these shores. This relatively light and delicate work in turn led to a more expansive and finished sketch from a point just south of Bar Harbor, *Islands in Frenchman's Bay from Mt. Desert* (fig. 17). (To one side turned at right angles is an unrelated sketch of a *Mill, Ellsworth* [fig. 18], which he may well have executed quickly on his way off the island. It is a reminder of early prosperity and the industry of lumbering on and around Mount Desert, an activity Lane, Church, and Haseltine all would observe in the following decades.) His full drawing of the several clumpy Porcupine Islands extending across the bay from Bar Harbor crosses over a page and a half in his sketchbook, and is unique as a preliminary study leading directly to a painting. No doubt with this in mind Cole made extensive notes on the sheet indicating correct titles of islands and mountains along with particular effects of colors and light.

The canvas *View Across Frenchman's Bay from Mt. Desert Island, After a Squall* (1845; fig. 19) is his largest and most ambitious Maine image, a sweeping landscape painted at the height of his maturity that anticipates the shift about to occur in American art toward open horizons and eloquent light effects. Cole had written his wife about the "glitter in the setting sun" and the "beautiful aerial hues," and proceeded once again to paint his embellished recollections. While the view is fundamentally true to life, it actually conflates a panorama of 180°, at once looking north to the islands and southeast to the open end of the bay and Schoodic Point. It is as if Cole were standing on a point as he had at Otter Cliffs, and turned his gaze around a broad arc to capture nature's fullest range of power and variety. Witnessing the purity of Eden and the sense of infinite spaciousness, as he could here, he found fulfilled his beliefs in the promise of American geography: "in looking over the yet uncultivated

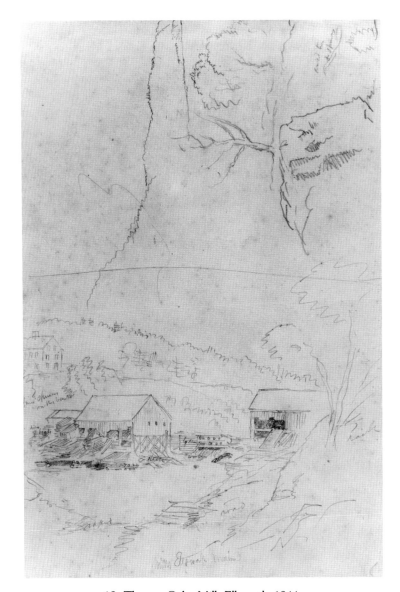

18. Thomas Cole, *Mill, Ellsworth*, 1844

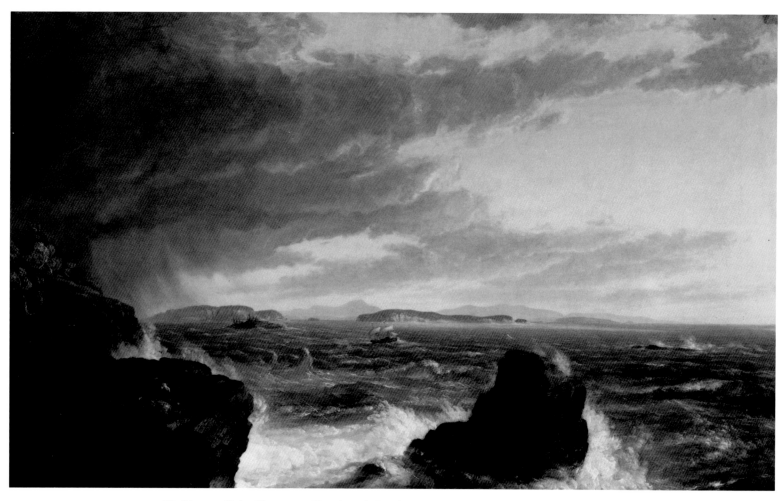

19. Thomas Cole, *View across Frenchman's Bay from Mount Desert Island, After a Squall*, 1845

scene, the mind's eye may see far into futurity . . . mighty deeds shall be done in the now pathless wilderness."[13]

At the time, Cole's compositional liberties were subjected to some criticism. When his painting went on view the next year in New York, a reviewer wrote facetiously in *The Broadway Journal* that "Mr. Cole has gone down to Frenchman's Bay, four or five hundred miles off towards the North Pole, and has come back and painted a pea-green sea with ledges of red rocks." Then, discussing the picture specifically, the critic went on:

88. *View across Frenchman's Bay from Mount Desert Island, after a squall*—T. Cole. This is the only marine picture that we have seen by Mr. Cole. The water is well drawn, but not well colored, and the rocks are of a kind that no geologist would find a name for; the whole coast of Maine is lined with rocks nearly black in color, and tinged with a greenish hue, as all marine rocks are. These in Mr. Cole's picture are red. An artist should be something of a geologist to paint rocky scenes correctly, as he should be a botanist to paint flowers, and an anatomist to paint the human form. The picture is a good deal too large. So wide a surface for so meagre a subject must be filled up chiefly with common places; a few inches of canvas will serve to convey as vivid an idea of the sea, if properly conveyed, as a yard.[14]

In fact, Cole's reddish rocks were an accurate rendering of the pink granite found throughout the Mount Desert region, while his panoramic scale is also both true to the locale and a forward-looking format in midcentury American landscape painting.

In addition, there is another unusual detail in Cole's canvas, the presence of a bald eagle on the left foreground ledge. One biographer has speculated that this may have had symbolic associations with nationalist ideas of destiny and progress, visually reinforced by the seagoing vessel setting forth in the bay.[15] Given Cole's tastes for allegory and moralizing subjects, such a sentiment is entirely likely, and is in any case one quite consciously proclaimed by his pupil Church a decade and a half later, most famously in his *Twilight in the Wilderness* (1860; see fig. 50), in which the American eagle perches atop a tree silhouetted against the fiery sky. A second speculation

connects this image to contemporary interests in ornithology and the natural sciences, a tradition going back to Alexander Wilson and Charles Willson Peale and present in the efforts of John James Audubon, whose *Birds of America* Cole could well have known in New York.[16] But it is equally likely that Cole was recording a first-hand experience, for bald eagles nested around Mount Desert and must have been a common sight sailing on the air currents over the island's hills, even as they are occasionally observed today. Certainly it would not have been beyond the artist's capacity to fuse all of these associations into the meaning of his painting.

Cole considered it the artist's duty to perfect upon nature by rearranging its components on canvas and thus instill the desired qualities of spaciousness and grandeur in his landscape views. By so doing in pictures like those of *Otter Cliffs* and *Frenchman's Bay* (1845; fig. 20) he was revealing nature's higher content and purpose. He summarized this philosophy for his friend and biographer Louis Noble:

The pictures of all great painters are something more than imitations of nature as they found it. . . . If imagination is shackled, and nothing is described but what we see, seldom will anything truly great be produced either in painting or poetry. . . . The most lovely and perfect parts of nature should be brought together and combined in a whole that shall surpass in beauty and effect any picture painted from a single point of view.[17]

Throughout the late 1830s and the 1840s, Cole and his contemporaries initiated an active and productive artistic exploration of the environs of Mount Desert. Cole left for his successors perhaps the most varied and intellectually stimulating record of his visit, and almost all of the views that he sketched or painted would serve as either direct or indirect inspiration for the next generation. Alvan Fisher, who preceded Cole to the island, returned again in 1848. That year also saw Edward Seager at work not far away; meanwhile the young Fitz Hugh Lane was making his first voyage to Maine, which resulted in his first important and influential sunset picture, *Twilight on the Kennebec* (1849; private collection) and the beginning of a critical career painting around Mount Desert. By 1850 Lane's cruising companion could state:

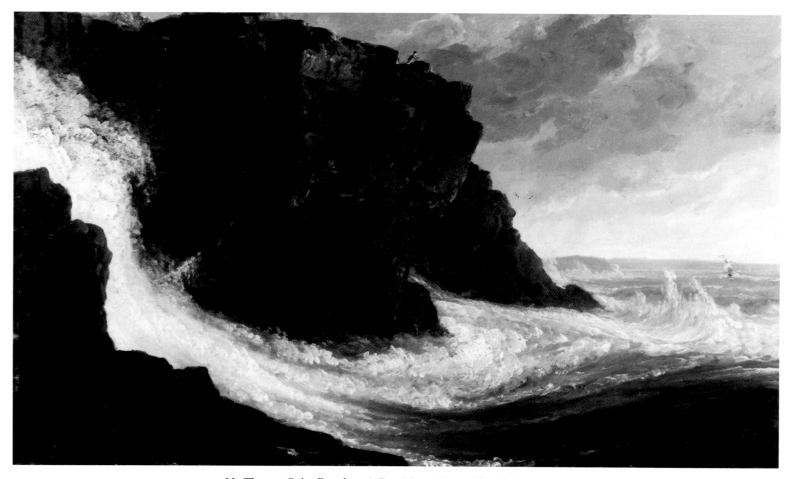

20. Thomas Cole, *Frenchman's Bay, Mount Desert Island, Maine*, 1845

The beauties of this place is [sic] well known and appreciated among artists. We heard of Bonfield and Williams who had reluctantly left but a short time before. Fisher had spent several weeks there. Champney and Kensett were then in another part of the island and we have reason to believe that Church and some others were in the immediate vicinity.[18]

In 1848 Thomas Cole died, having largely defined American landscape painting, and in one summer's observations left an inventory of discoveries and ideas for a golden age of his country's culture.

Winslow Homer's Maine

I T I S possibly the central paradox illuminating Winslow Homer's later career that, in concentrating his vision on but a few acres of Maine rock, he was able to convey a universal sense of nature's forces. From introspection came philosophical breadth, from a finite physical world an expansive cosmos of ideas and feelings. As the last decade of the century, the 1890s was for many Americans redolent of finality and dissolution. Arguably for Homer the decade saw the culmination, even the liberation, of his style. Within his realism at this time, he found a power of abstraction in both form and meaning. At the center of this period and of Homer's vision is *The Artist's Studio in an Afternoon Fog* (1894; fig. 21) for it is in effect emblematic of the history, process, and future of Homer's art. Partially through the subconscious tradition of art history, its suffusive sunlight refers back to Claude Lorrain and Joseph Turner. At the same time, its bold brushwork and contrived design remind one of Homer's present attention to the purely formal elements of his art, while the studio stands literally in the middle of the composition, not just as the principal subject of the painting but as a metaphor for his making of art.

Although Prout's Neck has its high cliffs and views of Cannon Rock and Wood's Island Light, Homer did not come to Maine for such views, as most of his predecessors had. American artists first began to venture down the Maine coast during the late 1830s and 1840s — among them Alvan Fisher, Thomas Birch, Thomas Doughty, and Thomas Cole—primarily in search of sublime wilderness, much as they were discovering it in the Catskills and at Niagara Falls. This was a romantic generation, approaching the new American nature largely through inherited European conventions, yet committed to interpreting that nature as one with the national character. Traveling by boat, the major and almost only means of transportation in this difficult and inaccessible landscape, they reached some of the more dramatic distant outposts like the Camden Hills and Mount Desert Rock. By and large, their depictions were exaggerated and imaginative in the occasional license they took with details, vantage points, and arrangement of elements, as effects of grandeur often took precedence over accuracy of record.

With the next generation of painters, led by the Gloucester artist Fitz Hugh Lane, sailing the coast during most of the 1850s, artistic interest turned more toward capturing with precision actual views and especially the enveloping effects of light and atmosphere. By midcentury, coastal Maine had become increasingly accessible by steamer and thereafter by railroad, yet artists still sought quiet isolated scenery for contemplation of nature's uplifting beauty. Lane was also aware of the growing commerce along the New England coast, and faithfully recorded within his luminous pictures the quotidian details of shipping, quarrying, and lumbering. The Maine wilderness afforded him and his colleagues an imagery of physical serenity and spiritual sustenance, a confirmation of natural bounty and promise believed to express a sense of the nation's high noon in the decade before the Civil War's outbreak. Frederic Church overlapped Lane in his several visits to Mount Desert in the 1850s and early 1860s, but Church found in his language of increasingly intense and explosive sunsets a vision of conflict, anxiety, and change correlating with the physical and emotional turbulence of the war years.

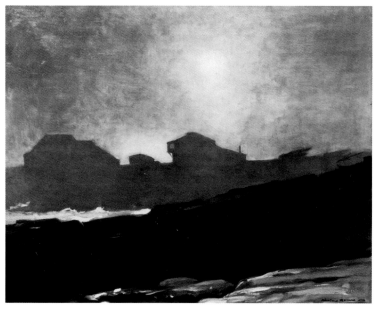

21. Winslow Homer, *The Artist's Studio in an Afternoon Fog*, 1894
(Color Plate 3)

ing summer communities. The building of vacation cottages and resort hotels flourished most famously at Newport, Rhode Island, but occurred up and down the seashore from Toms River, New Jersey, to Bar Harbor, Maine. Painters like Alfred Thompson Bricher, Sanford Robinson Gifford, Aaron Draper Shattuck, and William Trost Richards (those elegant three-part Victorian names!) traveled as far as Mount Desert, and some even farther to Grand Manan in the Bay of Fundy, celebrating this new era of recreation as well as the visual beauty of this still largely pristine landscape.

Just as Homer was settling at Prout's Neck in the mid-1880s, a number of his colleagues were devoting themselves to stylistic variations of impressionism after their French counterparts. Among those who came to paint the islands and bays of the Maine coast in the impressionist vocabulary of sunlight and flowers were Frank Benson, who began to summer at North Haven toward the end of the century; John Singer Sargent, who briefly visited friends on Ironbound Island in Frenchman's Bay; and Childe Hassam, who executed a number of works at both ends of the Maine coast from the Isles of Shoals to Winter Harbor.[1] In part, their bright canvases convey the pleasures of summer vacation life, even as they acknowledge the timeless stimulation of Maine's rugged geology and sharp northern light.

It is all the more remarkable then in this chronology to return to Winslow Homer's art in the same period and region, for by the 1890s his Prout's Neck landscapes were engaged in examining no less than themes of life and death. Which is to say that his canvases were both charged with the energies of life and at the same time deadly serious. During the later nineteenth century, Prout's Neck was also developing as a vacation resort for many Bostonians, and Homer was certainly conscious of the seasonal influx of visitors, contrary to the frequent view of his supposed reclusiveness. Yet in Maine he seldom painted genre pictures; he appeared to reserve his depictions of both lighthearted and more dramatic human activities for his Adirondacks and Caribbean paintings in those cyclical periods of travel away from Maine each year. Once settled at Prout's Neck, moreover, he saw no need to explore or paint the more spectacular or alluring portions of the coast farther east. In contrast to virtually all his predecessors and contemporaries, he was neither adventurer,

Church's technical refinement, his command of draftsmanship in pen, pencil, and brushwork, further reflected the new consciousness in American art of John Ruskin's principles of accuracy and precision in recording nature's aspects. Immediately following Church to Maine was William Stanley Haseltine, another Ruskinian who drew and painted close-up studies of coastal rocks and ledges with the scrutiny of a natural scientist.

Following the Civil War, with America returning to domestic routines, citizens and artists could take up the growing pursuits of leisure. Recently returned from Paris, Homer painted seaside sketches at the resort area of Long Branch, New Jersey, and during the early 1870s along the Gloucester waterfront. At the same moment, other painters still working in the luminist manner of Lane were making excursions to the Maine coast, now, much like many sections of the Rhode Island and Massachusetts shorelines, the setting for burgeon-

tourist, geologist, historian, nor nationalist. A moralist and philosopher perhaps, he required only the circumferences of self, eye, and studio. His nearground was filled with the sloping ledges of the peninsula's cliffs, his horizon with the sun or moonlight on the sea, and in between, the perpetual contest of the elements, symbolized in the breakers often occupying his view. His piece of Maine was sufficient as much for commonplace observation as for the articulation of profound natural truths.

Homer moved to Prout's Neck after his return from Cullercoats in 1882, and it was to be his residence for the rest of his life.[2] He came to live in proximity to his family—both married brothers had houses nearby—and that emotional support provided an ongoing continuity in the rhythms of his life. Those rhythms developed primarily in conjunction with the seasons, and by the 1890s Homer was regularly going in the fall to the Adirondacks on fishing trips with his brother Charles, and in the coldest dead of winter to Florida or the Caribbean. During the decade, his subjects shifted between intimate figural vignettes and bleak landscapes with little or no human presence. One senses that from his midlife onward he continually sought to express the tensions he felt between closeness to and separation from others, between shared experiences and loneliness or isolation. Although most of his major landscapes done at Prout's Neck during the 1890s either are without figures or include them anonymously, he did paint views there at all times of the year.[3] For one, he had become interested in capturing the protean effects of light and moisture; second, he was moving toward compositions of bolder design and formality.

Both impulses explain something of the abstract power we sense in *The Artist's Studio in an Afternoon Fog*. In this regard, two elements of the painting are especially evocative: Homer's isolated studio and the enveloping shroud of glowing fog. In 1890 Charles had built a large painting room onto the old stable that Winslow had earlier remodeled as a residence and studio. Important to him, it was set apart from the main family house, the Ark, occupied by Charles's family. Around two sides of the second floor was a cantilevered balcony affording Homer a panoramic view of the cliffs and ocean.[4] This distinctive feature is visible in the centrally isolated silhouette of his studio building. From its similarity of tone and roofline, we read this structure as part of the family compound; at the same time its placement in the composition and sharper contour emphasize its significant separateness. Thus Homer holds in equilibrium his axial needs for connectedness and independence. In turn, the fog enshrouds the whole, creating privacy and eerie detachment. Anyone who has read a suspense novel set on the Maine coast knows how fog embodies mystery, and anyone who has sailed the coast knows how fog can be surreal and disorienting. As our sight is blurred and confused, the other senses of sound and smell, even touch and taste, are heightened. Indeed, in this painting Homer orchestrates noise and silence in a tone poem of muted colors, themselves amazing in their range of contrast yet internal harmony. On one level the painting is an observation of palpable facts, on another a meditation on the acts of imagination.

We well know that the last three decades of Homer's life are considered his most creative and productive in bringing forth the great masterpieces of his career. What we might argue is that the central decade of this span, the 1890s, saw the greatest concentration and number of such works. By any account, it was an extremely complicated period of achievement and growth. Although we might recognize many of his grand allegorical pictures (*The Life Line, The Fog Warning, Eight Bells*) as belonging to the 1880s, and what might be described as his summary symbolic abstractions (*Kissing the Moon, Right and Left*) coming in the 1900s, the 1890s began with the mysterious *A Summer Night* (1890; fig. 22) and concluded with the iconic *Gulf Stream* (1899; Metropolitan Museum of Art, New York). In almost every year of the period, Homer produced a cluster of memorable and supreme works, a large majority of them having subjects inspired by his Prout's Neck surroundings.

Just as the seasons played off against one another, so too did Homer's images deriving from his sequential trips to the northern woods and southern waters complement the Maine landscapes. Given their chronology, these non-Maine subjects are arguably all of a piece with his Prout's Neck output, but they may equally be seen as foil and backdrop. Among the several developments in Homer's art of the decade of the 1890s, and clearly evident in the Maine work, was his heightened concern with formal means. Both his technical powers and the seriousness of his ideas advanced in this period, together

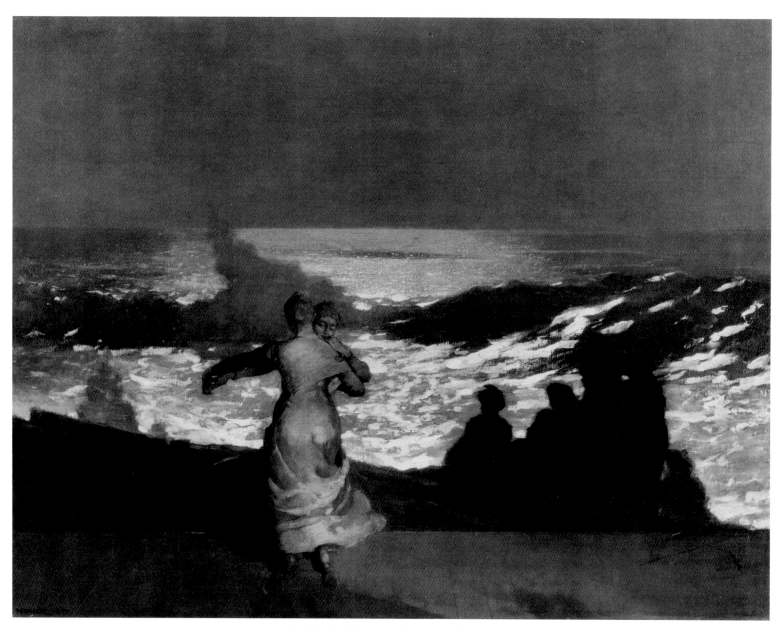

22. Winslow Homer, *A Summer Night*, 1890

38

resulting in works marking the summit of his career. Having begun to paint in watercolor during the early 1870s, Homer thereafter took up related, and in some instances identical, subjects concurrently on paper and on canvas. But during the 1890s he achieved a new sophistication in exploiting the respective expressive possibilities of watercolor and oil, no doubt partially due to the stimulus of his trips to the Adirondacks and the Caribbean, which began at this time. Both of these environments, so different from each other and from Prout's Neck, prompted him to paint some of the most free, lush, intimate, and subtle works of his maturity.[5]

Early in the decade, two major images carried over closely from watercolor to oil: *Guide Carrying Deer* (1891; Portland Museum of Art) and the canvas version, *Huntsman and Dogs (The Hunter)* (1891; Philadelphia Museum of Art), and *Hound and Hunter* (1892), the title for both media. As other historians have observed, in moving from one technique to the other, Homer was able to develop an idea from a particular incident to a general idea, to shift from an expression of spontaneity to one of permanence, from description and definition to allusion and suggestiveness.[6] There are no such direct correlations between his Maine seascapes in watercolor and oil, for a couple of reasons. Some have argued that he was better able to match his livelier brushwork and colors to landward scenes of local gardens and woodland interiors.[7] But Homer in fact had begun his scrutiny and analysis of rolling waves and breakers soon after settling at Prout's Neck a decade earlier. Fluid, transparent watercolors like *Prout's Neck, Rocky Shore* (1883; Worcester Art Museum) and *Prout's Neck, Breaking Wave* (1887; Art Institute of Chicago) led to such solid, corporeal oils as *High Cliff, Coast of Maine* and *Sunlight on the Coast* (1890; Toledo Museum of Art) in the 1890s. In the former he caught the spontaneity and immediacy of the water's action, the refraction and sparkling reflections of light dancing on its surfaces, nature in vibrant motion and pulsing with life. When he subsequently turned to painting on canvas, he seemed more interested in revealing nature's permanence; her physical, even molecular structure; the dynamics of weight, mass, and volume.[8]

Following his literal investigation of the properties of oil and watercolor, Homer also considered their relationship to meaning, as he formulated compositions of opposing forces. Even when nature was calm and gentle, as in *A Summer Night* or *Moonlight—Wood's Island Light* (1894; Metropolitan Museum of Art, New York), one feels an awareness of molecular energy and rhythmic forces, as subtle yet strong as the tides. More frequently Homer favored the struggle and combat of the sea, and the plastic density of oils perfectly suited the collisions of solid and liquid he wished to depict. Some pictures addressed man's contest with nature: in *Winter Coast* (1890; fig. 23) and *The West Wind* (1891; fig. 24) the viewer joins a figure shown facing the oncoming wind and surf. Others like *Cannon Rock* (1895; fig. 25) and *Northeaster* (1895; fig. 26) more reductively distilled the conflict of opposites just by matching water and rock, wind and tide, against one another. Pairs and opposites held in balance or in tension were long a part of Homer's pictorial strategies, and they acquired their boldest form in his art at this time.[9]

Closely related to these reductions was Homer's stress in numerous works of this period on strongly simplified tonal contrasts. Of course, his early training in graphic art thereafter contributed to all his art a fundamental consciousness of line, silhouette, and the play of light and dark. But now in these great dramas of nature's basic elements Homer found a symbolic and fateful language in these tonal extremes. It is not irrelevant that in the same years he also began to make extensive use of photographs and to paint a remarkable series of monochromatic watercolors in grays, blacks, and white gouache.[10] Like other artists approaching their late work—Rembrandt and Goya, for example—Homer discovered the intense emotional resonance of near-black pigments, brooding, mysterious, and universal.

What we are seeing in Homer's art at this time is his increasing use of formal elements for their symbolic more than descriptive capacities. Significantly during the early 1890s he also handled his colors in limited but intense ranges. For example, besides *The Artist's Studio, West Wind, Below Zero* (1894; Yale University Art Gallery), and *The Wreck* (1896; Carnegie Museum of Art, Pittsburgh) are studies in almost Whistlerian tans and browns, whereas grays and blues dominate the ghostly *Sleigh Ride* (c. 1890–1895; fig. 27).[11] Add to this group the striking composition, if disturbing vision, of *The Fox Hunt* of 1893 (fig. 28) and we can understand how more than one observer has pointed to the oriental simplicity of these works.[12]

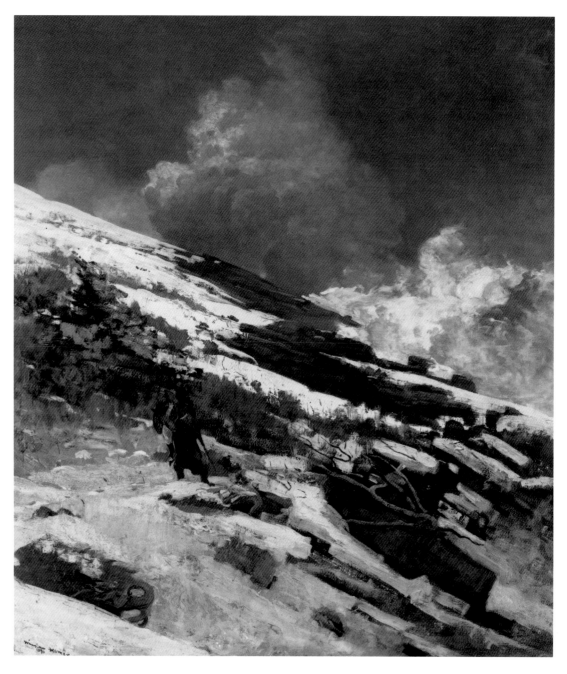

23. Winslow Homer,
Winter Coast, 1890

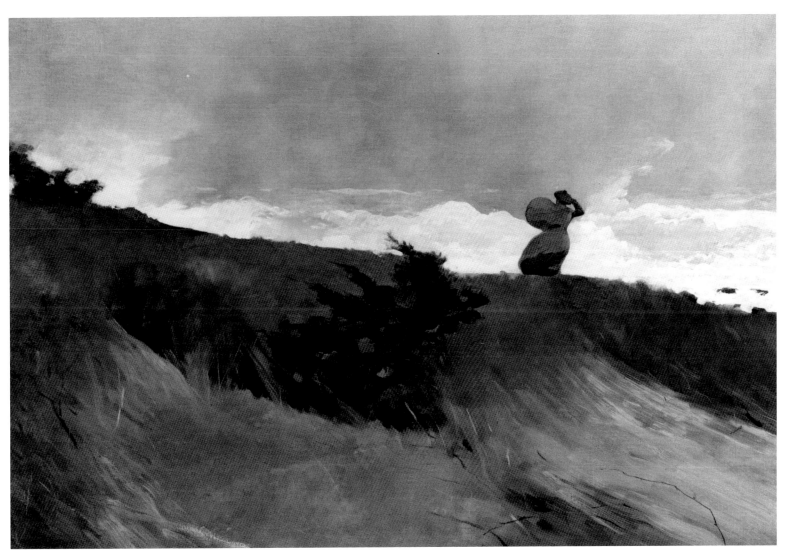

24. Winslow Homer, *The West Wind*, 1891

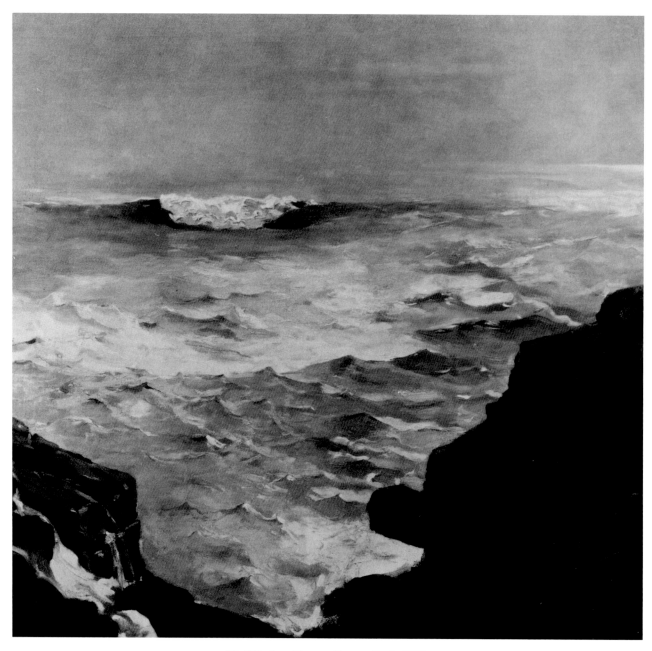

25. Winslow Homer, *Cannon Rock*, 1895

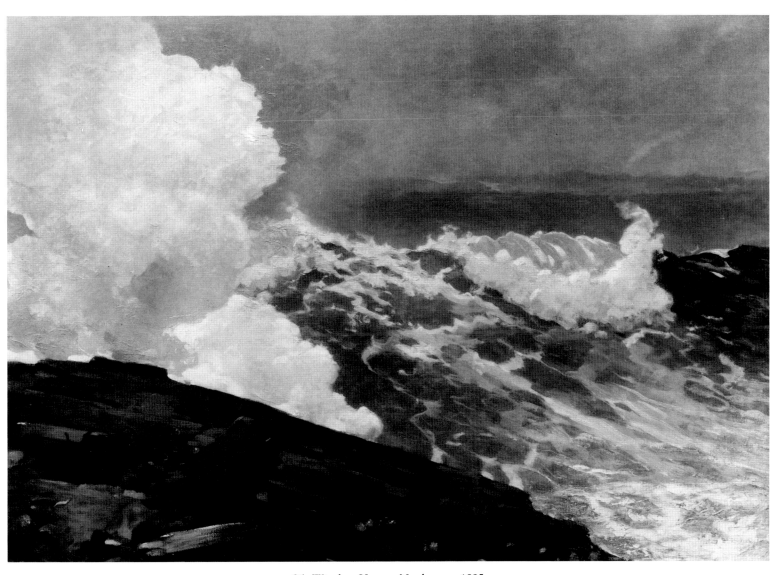

26. Winslow Homer, *Northeaster*, 1895

Aside from being one of Homer's most famous achievements of the decade, this last image dramatizes two further aspects of his late style: in compositions a new emphasis on flatness of surface and compression of space, and in subjects elevated and generalized images of life and death. The process of simplification, whereby an essential piece stood for the whole, is evident in *The Lookout—"All's Well"* (1896; Museum of Fine Arts, Boston), whose title signifies man's more secure place in the universe. By contrast, the threatened mortality of man and animal was a constant in Homer's work—from the beginning to the end of the decade, whether away or at home, in summer as in winter—as witness *Hound and Hunter, The Fox Hunt, The Signal of Distress* (1890, 1892–1896; collection of Baron Thyssen Bornemisza, Lugano, Switzerland), and *The Gulf Stream.*

Two final compositional devices of this period are worth some mention as well. In at least two major oils, *Cannon Rock* and *On a Lee Shore* of 1900 (fig. 29), Homer employed a square format, one artificial for the conventional landscape view and therefore emphatic in its formal purity and attention to composed shapes. Elsewhere, primarily in his virtuoso fishing watercolors done in the Adirondacks and Canada, he began experimenting with startling juxtapositions of foreground and background forms, surprising shifts in scale and vantage points, and almost unnerving asymmetries of design. What began as fish leaping in the distance or at the end of a line, scaled in traditional perspective, gradually shifted to looming forms in the foreground, almost overwhelming and threatening in their domination of the design, but also uneasily placing the viewer in the position of mortal victim.[13] Although more intimate in mood and size than the oils, these works demonstrated a comparable intensity of feeling and metaphor, a comparable transformation of illusion into allusion.

In 1890 Homer was fifty-four years old, and at the end of the decade and the turn of the century, sixty-four. Historians have noted his pictorial response to his mother's earlier death in 1884 with works like *The Life Line* (1884; Philadelphia Museum of Art) and *Undertow* (1885; Sterling and Francine Clark Art Institute, Williamstown, Mass.) and their powerful suggestions of sexual repression.[14] Now, a decade and a half later, his father's death in 1898 appears to have been a factor in Homer's profound consciousness of

impending death and loss, as depicted in the summary work of the period, *The Gulf Stream.*[15] Bearing the date 1899, this last was also an emblem of century's end and subconsciously as much as intentionally an embodiment of the fin-de-siècle mood of anxiety, if not despair, felt by many in America and Europe in these years. Certainly it was an age in transition, as Homer's near contemporary Henry Adams was to articulate in his *Education,* published in 1906, and Albert Einstein was to confirm with his theory of relativity, announced at about the same time. Both art and science, by means of Picasso's cubism, the technology of the X ray, and the practice of psychoanalysis, were about to dissect and penetrate the surface of the visible world. This is not to argue that Homer's mature art was predicting these events, but his sense of abstraction, unease, and anxiety were surely as modern in their expression.

Significantly, Homer painted one of his first reductive visions at the 1893 World's Columbian Exposition in Chicago, an occasion directly marking a major anniversary of American history in the New World but also generally concluding the progress of the nineteenth century. This black-and-white oil depicting *Fountains at Night* (Bowdoin College Museum of Art) at the fair was an almost private meditation on the artificial light and electrical energy of a new age.[16] Equally significant was the photograph taken of Homer in his studio at the end of the decade, standing next to his canvas of *The Gulf Stream.* Although three other works, including the 1892 oil *Hound and Hunter,* are partially visible behind, it is the tragic Caribbean drama with which the artist chose, or allowed, himself to be identified near the end of his own life. We are not sure to what extent Homer empathized with the victimization of blacks in America at the close of the nineteenth century, or more generally to figures isolated by society.[17] But we can see for ourselves that this intense image of the south was both painted and centered in his northern Maine studio. While its nominal subject has nothing to do with his outward observations of Prout's Neck, nonetheless it clarifies for us Homer's overriding confrontation in these years with irony, uncertainty, and fatefulness.

All of which brings us back to *The Artist's Studio,* both the painting and the actual location. Without the topicality of the World's Fair image or the foreboding in *The Gulf Stream,* this introspective

27. Winslow Homer, *Sleigh Ride*, c. 1890–1895

45

28. Winslow Homer, *Fox Hunt*, 1893

view of Prout's Neck nevertheless displays tonal modulation close to the former and a brooding somberness in forecast of the latter. Indeed, most of the formal advances Homer made in the 1890s are present here: the flatness of surface, the reductive palette, the rich and varied textures of brushwork, suggesting mood as much as veiling physical facts. And despite its identifiability, the painting shows evidence of a created design, made clear when compared with photographs of the site.[18] Homer both turned and flattened the buildings, manipulated their silhouettes, and contrived a vantage point that looks at once up and directly at the ghostly structures. He furthermore gave relative clarity to one architectural detail of his house, the overhanging porch, thus signifying the central place from which he could look out to sea. That presumed direction of vision to the left is matched by the incoming narrow wedge of water, as it

46

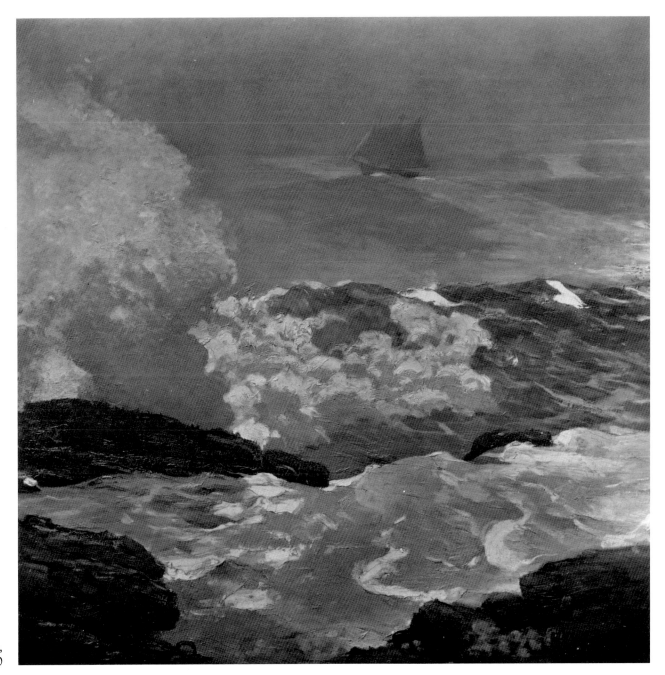

29. Winslow Homer,
On a Lee Shore, 1900

47

were bringing his subject in toward the studio. No such slice of water is visible in the ledges seen from this angle, another reminder that this painting is about more than what the eye sees.

To this end, the fog is an obscurer of the seen world, sometimes shrouding impending peril, as Homer had already depicted in *The Fog Warning* (1885; Museum of Fine Arts, Boston) a decade earlier. Here it transforms all it touches into different densities of liquid, from the wet rocks in the foreground to the radiant particles of light suspended in the moist air. Although Homer recorded on the painting's stretcher that this was an afternoon fog, it has the effect, like an eclipse, of suspending time, or, like the midnight sun in polar latitudes, of inverting day and night. The ultimate inversion of the picture is that Homer in effect turns his studio inside out. On the one hand, he brings the outside observed world inside to his painting room; on the other, he has turned the most private act of imagination into a physical image on his canvas. Of all his Maine landscapes, this one is significant for its double insight, that is, of truly looking inward, first from water's edge inland (instead of the reverse) and second from outside the studio metaphorically to what happens within. More than any other work, this one explains why Homer's Maine was both different and original.

By the end of the 1890s, Homer was moved to undertake some of his greatest pure compositions as well as most somber narratives of our universal condition. In the watercolor *Blown Away*, a lone gale-driven sailboat scuds toward an unknown destiny, a theme more amply realized in the larger oil, *Summer Squall* of 1904 (Sterling and Francine Clark Art Institute, Williamstown, Mass.). Similarly, *Wild Geese* (1897; see fig. 156) would lead to his penultimate masterpiece, *Right and Left* of 1909 (see fig. 147), in which ordinary death is raised to a transcendent level of feeling and understanding.[19] At the decade's turning point, Homer completed three of his most sensuous Maine oils: *On a Lee Shore*, and *Eastern Point* and *West Point, Prout's Neck* (both Sterling and Francine Clark Art Institute). With their exploding plumes of creamy surf, they were unsurpassed expressions of energy, man's no less than nature's. This was the imaginative power of his studio, which happened to stand physically on a granite peninsula in southern Maine.

4

American Waters: The Flow of Imagination

Without water, Thomas Cole asserted, "every landscape is defective."[1] America's premier painter of native scenery was speaking of an essential physical and psychological component of the American experience. Water, the first element, defined the vast space of the early explorers' transatlantic crossings. Subsequently, rivers provided, through their harbors and inland courses, welcoming places of settlement and routes of commerce. Early on, America's waterways were places of fighting and of leisure; they were lines of transportation and forces of energy in the coming of industrialization.

In varying combinations, rivers have always appealed for their scenic beauty and commercial potential, and it is no surprise that many of the world's capital cities are sited on rivers: London, Paris, Moscow, Washington, Rome. In America's development, we are drawn to splendid river settings for cities of all sizes: Seattle, New York, Philadelphia, St. Louis, Chattanooga. Boston harbor marks the confluence of three rivers—the Charles, Mystic, and Neponset. San Francisco sits at the mouth of a great inland bay, while New Orleans oversees the expansive joining of the father of waters with the mother sea.

The original water voyage brought explorers and would-be conquerors and settlers to a new landfall scalloped by river mouths. The mythology of westward travel in empire's course was borne forward by the multiple possibilities of entering this undefined continent. The search for a northwest passage to India was of course the most enduring fixation of early voyagers, and the belief in a westward-flowing river beyond the Appalachians continued for over a century.[2] The first encounter by Columbus with the tides of fresh water must have been an exhilarating, revelatory experience, for here was evidence at once of destination and of future possibility.[3]

Initially, the mouths of rivers provided harbors of refuge in which food might be found and settlements established. The most familiar of the early maps and drawings done of the New World, such as those by Jacques LeMoyne and John White, vividly portray activities along the middle and southern Atlantic coastline. White's maps indicate the location of villages and the configurations of terrain, ever vaguer and more imagined moving inland, while his watercolors give us early mementos of local flora, fauna, and Indian life. LeMoyne's famous image of *René de Laudonnière with Chief Athore* (1564; fig. 30) is a colorful rendering of old and new worlds meeting alongside a decorated column at the mouth of the St. John's River in north Florida. At their feet is an abundant still life of nature's bounty, emblems of the continent's rich produce and prophecy.

Once ashore, visitors soon discovered hostile conditions or unfriendly inhabitants. Travel was impeded by mountain ranges and the growing awareness of an endlessly expanding unknown terrain. Such factors made river travel seem both easy and necessary. Rivers gave America's early settlers mobility, and thus the continent's waterways were to carry the flow of both exploration and development. In the summary phrases of one historian,

The river is a defining agent in the metamorphosis of colonies to republic, serving as entrance or border but always as a symbol

AUDONNIERVS ET REX ATHORE ANTE COLVMNAM A PRÆFECTO PRIMA NAVIGATIONE LOCATAM QVAMQVE VENERANTVR FLORIDENSES
Jacobus Le Moyne dictus de Morgues ad vivum pinxit

30. Jacques LeMoyne, *René de Laudonnière with Chief Athore Standing before a Decorated Column*, 1564

of what might be obtained beyond, whether a more fertile land or a water route to India.[4]

It is important to stress that this movement in time and space was as much mythical as practical. Beyond its functional purpose as a mode of travel, the river also assumed a masculine identity as it penetrated the virgin interior and fathered the conception of a new world.[5]

The great rivers of the middle Atlantic and New England coasts were among the first to draw attention and praise as passageways of notable scenic beauty. As early as 1638 one visitor pronounced, "If you would know the garden of New England, then must you glance your eye upon Hudson's river, a place exceeding all yet named."[6] That river (fig. 33), like its neighboring finger to the east, the Connecticut (fig. 34), was a long artery flowing from the wilderness far to the north. These two lines of geography particularly were to become major forces in both the regional development and artistic interest of the young republic. As the coastline was gradually populated and civilized during the colonial period, travelers were lured to spots of special natural beauty. During the decades following the American Revolution, the country's newfound power and opportunity stimulated new waves of European immigrants, many fleeing the problems of the Industrial Revolution and the Napoleonic Wars at home. In the years around the turn of the century, a significant number of artists came to America, and their attention to the fresh scenic wonders of the continent in effect resulted in our first extensive flourish of landscape painting.

Among the better-known foreign painters of this period were Michèle Félice Cornè, who came from Elba to work in Salem, Massachusetts; the English-born artist Francis Guy, active in Brooklyn, New York; and Thomas Birch and Robert Salmon (figs. 31 and 32), at work respectively around Philadelphia and Boston. Although each of these last two did paint an occasional river view near his city's environs, they remained essentially delineators of coastal activities or historical subjects. Of those émigrés who executed a number of inland river views, the most significant were William Groombridge in Philadelphia; the Robertson brothers, Archibald and Alexander, working north of New York along the upper Hudson valley; and Joshua Shaw, who undertook extensive journeys along the

Atlantic seaboard. In varying ways, this group of artists imported the picturesque conventions of eighteenth-century English painting. For example, Groombridge carefully modulated his feathery trees to punctuate and frame his views of Pennsylvania country estates situated along the Schuylkill River. Their gauzy softness of form and light infused the identifiable sites he painted with an idealizing tone. Shaw only occasionally depicted actual settings, more often preferring to compose imaginary landscape and river scenes. The fine pen and pencil drawings of the Robertsons, based on their voyages along the Hudson, are perhaps the most specific renderings from this period.

In any case, by the first quarter of the nineteenth century, the young nation had developed a sufficient sense of self-awareness that its physical landscape called for full delineation and its spiritual substance for metaphorical articulation. Out of these earlier aspirations now emerged America's first full-scale landscape movement, appropriately named for a key waterway, the Hudson River School. The leading figures of this group, Thomas Doughty, Thomas Cole, and Asher B. Durand, were all to include the river as a key component of their pictorial repertoire. As the oldest, Doughty was actively painting landscape views by the early 1820s, usually according to one of three formulas: from nature, from recollection, or as composition. The first views were ordinarily sketched on the spot and maintained their specificity in the final rendering on canvas. The second category allowed more manipulation and enhancement as the artist modified nature through the filter of imagination, while the last represented fully fanciful invention at the other end of the range. Almost always, the presence of water in a stream or pond was a central ingredient of both design and meaning.

Cole articulated the logic of nature in his 1835 "Essay on American Scenery," in which he asserted that, on the highest level, "wilderness is YET a fitting place to speak of God," and following from that, was "a source of delight and improvement."[7] The contemplation of scenery, in turn, meant that nature's pilgrim needed to appreciate the different expressive functions of each landscape element. For example, the mountains of America were noted for their rugged purity and emphasized a distinguishing aspect of New World nature. Water was one of the next most important features, because,

31. Thomas Birch, *New York Harbor*, c. 1827–1835

tranquil and transparent, it invited meditation and, in motion over cataracts or waterfalls, it became the sublime "voice of the land-scape." Trees and sky completed the basic categories. But it was only water that served as mirror to the sky and to the soul, and it was water that made visible as well as audible the "silent energy of nature."[8]

Cole was as eloquent in practice as he was in theory. Preeminent in his generation, he brought the painting of literal as well as imag-inative landscape to the center stage of American art. Both the Hudson and the Connecticut valleys inspired him to compose views capturing the immediate physical drama of place, along with an ide-alized sense of time's primordial passage. Particularly effective was his device of the elevated point of view, as in *Sunny Morning on the Hudson* (c. 1827; fig. 33) and *The Oxbow on the Connecticut River* (1836; fig. 34), both celebrations of fact and spirit. Indeed, Cole was unrestrained in praising the respective characteristics of each valley:

32. Robert Salmon, *View of Boston Harbor*, 1832

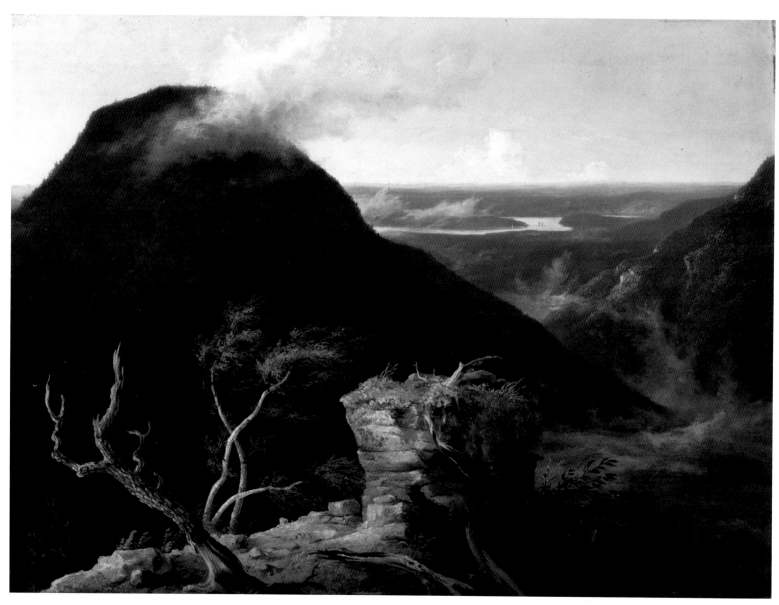

33. Thomas Cole, *Sunny Morning on the Hudson River*, c. 1827

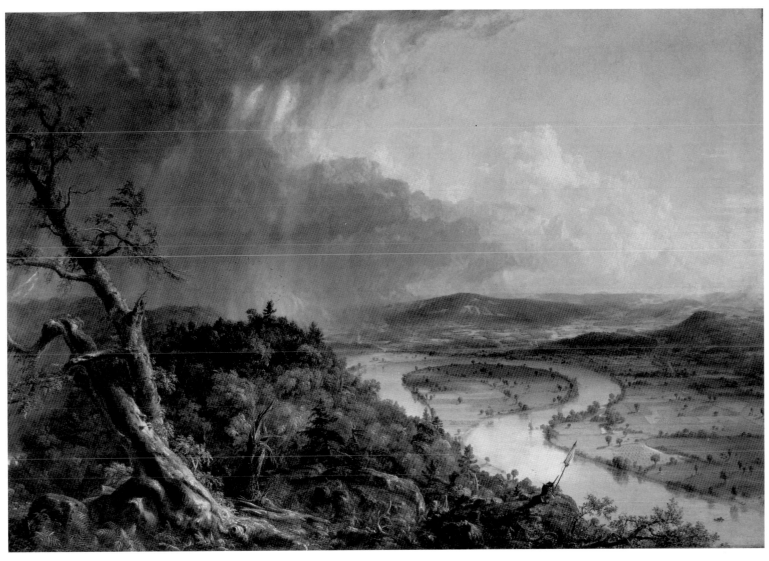

34. Thomas Cole, *Oxbow (The Connecticut River near Northampton)*, 1836

"The Hudson for natural magnificence is unsurpassed. . . . [It] has . . . a natural majesty, and an unbounded capacity for improvement by art."[9] By contrast,

> In the Connecticut we behold a river that differs widely from the Hudson. . . . the imagination can scarcely conceive Arcadian vales more lovely or more peaceful than the valley of the Connecticut.[10]

At the same time that Cole was recording his responses to actual sites, he was also pursuing ambitious imaginative compositions, the most relevant being the two versions of his *Voyage of Life* series of 1840 and 1842. Like the great *Course of Empire* group (New-York Historical Society) that Cole executed in 1836, this was conceived and composed as a coherent series of pictures. In this instance, *The Voyage of Life* was a sequence of four paintings, unified by the river flowing through each. A purely invented subject devoted to the passage of human and natural time, it consisted of four stages: *Childhood, Youth, Manhood,* and *Old Age* (figs. 35–38). Cole not only linked them together with the ideas of flowing water, but also painted them the same size and included the presence of a figure seen respectively in four moments of age. Correspondingly, the growth of nature and the condition of light change from scene to scene, shifting from verdant brightness to increasing drama and contrast. Cole carries us from the symbolic earth cave and clarity of early morning at birth to the open ocean and stormy heavens of the concluding image. Cole accompanied his canvases with an explicit description for his public. In *Childhood,* for example, "the dark cavern is emblematic of our earthly origin, and the mysterious Past," while in *Youth* "the stream now pursues its course through a landscape of wider scope,"[11] the word referring equally to the physically expansive vista and the symbolic aspirations of the figure. "Trouble is characteristic of the period of Manhood," while the final painting depicts "the last shore of the world."[12]

To convey his meaning, Cole cleverly composed his landscapes so that the river made a series of **S** curves within each frame, allowing the eye to follow its course out of the foreground of one and into the background of the next. This served the obvious purpose of visual continuity and embodied the lofty allegory of the inevitable flow of time. In sum, the series was Cole's purest philosophical statement regarding the spiritual content of American nature.

But Cole remained equally the master of the specific landscape, and his views of the Hudson Valley also established formulas that were emulated by younger artists of the next generation. In the middle decades of the nineteenth century, painters sought a wider range of both interpretation and geography, as Cole himself had anticipated:

> Nor ought the Ohio, the Susquehannah [*sic*], the Potomac, with their tributaries, and a thousand others, be omitted in the rich list of the American rivers—they are a glorious brotherhood.[13]

During this early development of the Hudson River School, represented by Cole's maturity and carried on by others traveling more widely, interest concentrated on, we might say, the "prose" of nature. That is, painters sought to describe the accumulated details of a scene in all their density and varied texture. The eye passed through all these natural facts as if experiencing a narrative of actual or implied activity. To this end, the artist alerted his viewer to the changing colors of foliage, the erosion of rocks, the breaking of tree limbs, and especially the movement of water. The waterfall became a favorite subject, seen at its most characteristic in John Frederick Kensett's renderings of Bash Bish Falls, to convey the energies of American nature. Niagara, of course, was the preeminent and enduring pilgrimage site of the nineteenth century, painted early on by John Trumbull and John Vanderlyn, then by Cole and almost all of his associates, and later by such American impressionists as John Twachtman and George Inness. As Cole asserted, and his pupil Frederic Edwin Church made definitive, Niagara was "that wonder of the world!—where the sublime and the beautiful are bound together in an indissoluble chain."[14]

By the late 1840s, there was increasing attention to what we might now describe, by contrast, as the "poetry" of nature, that is to say, its distillation for the eye and mind to contemplate. Less overt action was depicted, landscape elements were often stilled, and visual density yielded more to spacious openness. These were all aspects that would come together to define that next stage of

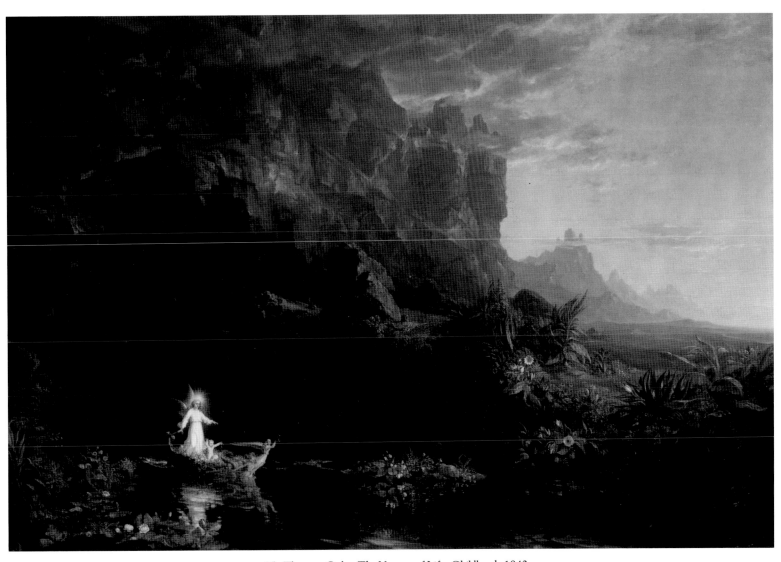

35. Thomas Cole, *The Voyage of Life: Childhood*, 1842

57

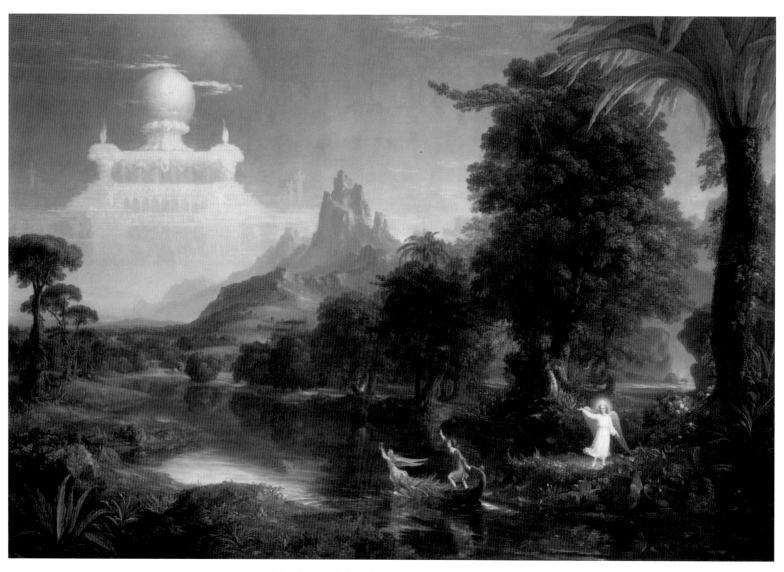

36. Thomas Cole, *The Voyage of Life: Youth*, 1842

58

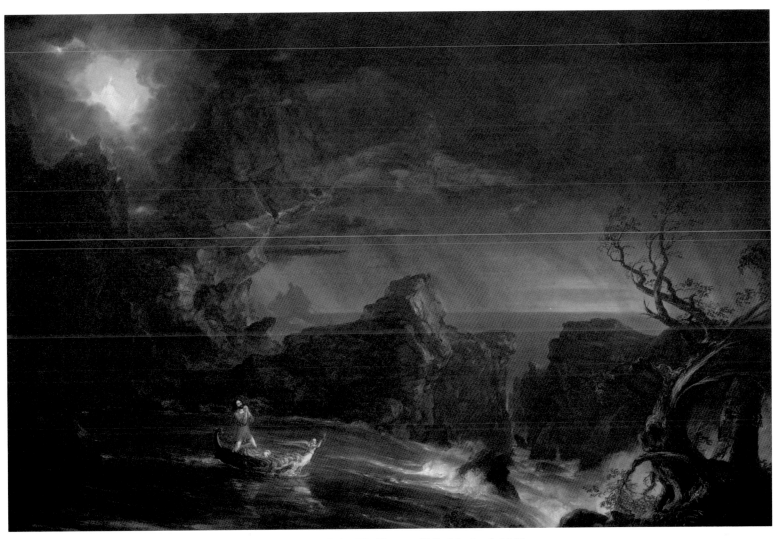

37. Thomas Cole, *The Voyage of Life: Manhood*, 1842

38. Thomas Cole, *The Voyage of Life: Old Age*, 1842

60

American landscape painting now termed luminism. Again, Cole anticipated the spiritual significance of the lake for his colleagues and successors, as "a most expressive feature: in the unrippled lake, which mirrors all surrounding objects, we have the expression of tranquility and peace."[15] The luminist landscape of midcentury would favor the spacious panorama and the clear mirror of open surfaces of water. Painters especially turned now for subjects to lakes and expanses of wide rivers. Typical were Kensett's serene image of *Shrewsbury River* (1859; fig. 39) and the idealized compositions of George Caleb Bingham's Mississippi and Missouri River series.

Bingham's supreme boatman series (fig. 40), painted between 1845 and 1855, is notable for its perfectly calculated compositions, often employing clear geometries of line and plane and building up from solid horizontals into pyramidal figure groups. This sense of orderly design was exactly in keeping with the radiant light that permeates his backgrounds and the calm quiet of his river surfaces, all conveying a wilderness world of tranquility and harmony. Not merely scenes of trade or travel, these expressed man's union with his environment and an implication of productive well-being. Set at midcentury, as well as in the middle of the country, Bingham's imagery captures a culminating period of high noon in the American heartland. It is worth recalling at this point that the same great rivers would similarly inspire some of our greatest imaginative literature in Mark Twain's novels *The Adventures of Huckleberry Finn* and *Life on the Mississippi*. In these, the timeless flow of the river allowed examination of the central themes in American geography and sociology, namely the relationships between north and south and between white and black.

If the serenity of the open river served as one mode for expressing an American vision of optimism and promise, so too did the broad expanses of inland lakes. For example, one thinks of Jasper Cropsey's exuberance in painting the sweep of Greenwood Lake, New Jersey, and of the many artists journeying to Lake George in upstate New York, or Albert Bierstadt's dramatizing the hopeful glory of a rainbow arching over Jenney Lake in the west. In particular, during the middle decades of the nineteenth century Lake George attracted such artists as Kensett, David Johnson, and Martin Johnson Heade, and their visions of its beauty were echoed well into the twentieth

century in the respective images of Georgia O'Keeffe and Alfred Stieglitz. Among the earlier group only Heade gave any hint of anxiety and turbulence. Within the essentially peaceful expanse of his view of *Lake George* (1862; fig. 84), there is a quality of vacuum-like dryness, as if the barometer were unsettled and predicting change as yet unseen. In many ways such as this, American painters were able to infuse their responses to landscape with deep currents of feeling.

Heade is also important to the discussion at this juncture because of his special and virtually individual treatment of the marsh landscapes along the New England and mid-Atlantic coasts (fig. 41). First at Newport, Rhode Island, then at Newburyport, Massachusetts, and later in New Jersey and Florida, Heade painted dozens of views in the saltwater marshes. This was a terrain distinctive for being both land and water, depending on the ever-alternating tides. The usually undulating rivers wound back and forth to the open shore, themselves a mixture of fresh and salt water. Essentially flat expanses, they exemplified the luminist vision of spacious beauty. At the same time, their dual nature and constant flux also spoke to an America in the 1860s and 1870s of increasingly uncertain change and transformation.

The heroic interpretation of American nature culminated in the 1870s as painters discovered the breathtaking panoramas in the mountain valleys of western ranges, especially the Rockies. In gigantic canvases, Thomas Moran sought to capture the scale and grandeur of Yellowstone as Albert Bierstadt did of Yosemite (fig. 42). Like Cole before them, they felt they were entering primeval nature and, by extension, into the presence of the Creator. Never had water in its various manifestations—as ice and snow on the mountain peaks or as glinting liquid in the valley streams—seemed so pure a manifestation of life-giving force. Indeed, Fitz Hugh Ludlow, Bierstadt's companion and narrator of their first journey into Yosemite, later wrote that they felt they were "going to the original site of the Garden of Eden."[16] Once in the valley itself, and with the distant view opening before them, Ludlow described the sensation of

breaking into the sacred closet of Nature's self-examination. . . . Earth below was as motionless as the ancient heavens

39. John Frederick Kensett, *Shrewsbury River, New Jersey*, 1859

40. George Caleb Bingham, *Fur Traders Descending the Missouri*, 1845

above, save for the shining serpent of the Merced, which silently threaded the middle of the grass, and twinkled his burnished back in the sunset wherever for a space he glided out of the shadow of the woods.[17]

This was probably the last generation that saw nature as holding the potency of First Artist.

By contrast, during the last quarter of the nineteenth century the river landscape in America became increasingly a setting of encroaching industrialization. Many painters, whether working in a realist or an impressionist mode, nonetheless retained a poignant sense of the Arcadian past. Thomas Eakins was perhaps the most forthright in addressing contemporary scenes and subjects, including his early series of pictures devoted to rowing on the Schuylkill River in Philadelphia. In these, the river is clearly part of the modern cityscape, even if the latter is only hinted at in the cropped presence of bridges seen in the background or at the sides of several canvases. In showing himself and his friends, most familiarly Max Schmitt or the Biglin brothers, rowing their sculls, Eakins was in part celebrating human discipline and coordination. But through the mathematical

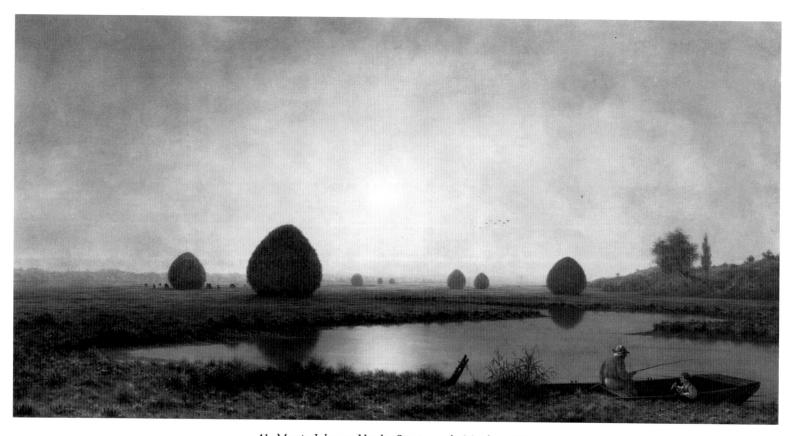

41. Martin Johnson Heade, *Sunrise on the Marshes*, 1863

64

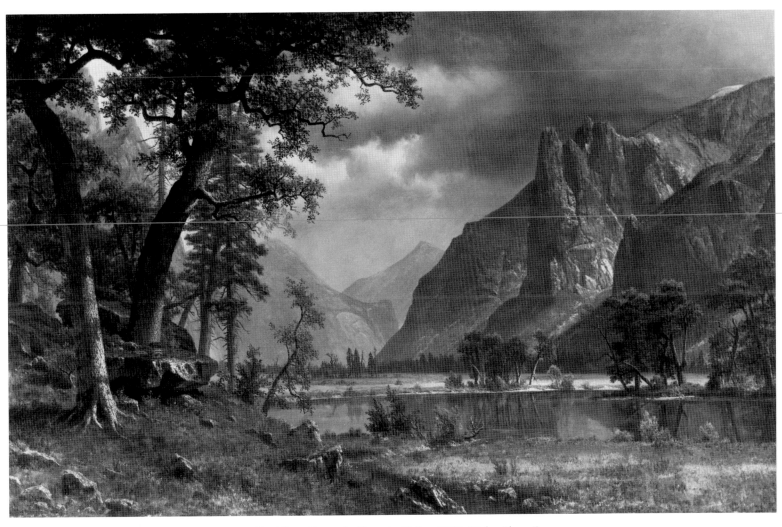

42. Albert Bierstadt, *Yosemite Valley*, 1866 (Color Plate 4)

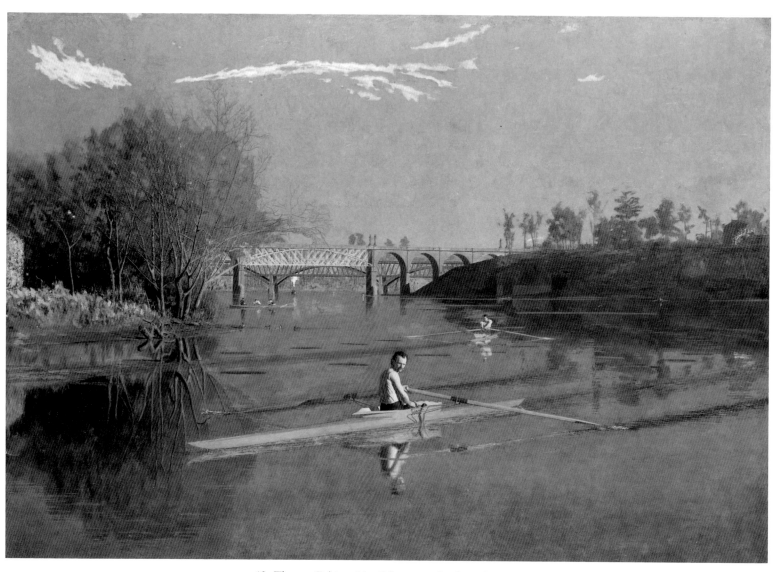

43. Thomas Eakins, *Max Schmitt in a Single Scull*, 1871

66

44. J. Alden Weir, *The Red Bridge*, 1895 (Color Plate 5)

ordering of his architectural designs, he also conveys a belief in the integral relation between man and nature and the parts of a whole all working organically together. Yet he is further conscious in many of these pictures of the actual fact and metaphoric implication of time's passage. The rowers pass through light and shadow. Often a bright haze suffuses the whole. They are caught in transitional moments of action, as if stopped photographically; though, as specific as the time and place seem, we ultimately feel the truth that neither motion nor change can be stopped. *Max Schmitt in a Single Scull* (1871; fig. 43) is particularly relevant, for the golden sunlight and

leafless trees suggest an hour and a season in passage. The steamboat and the iron bridge in the distance are prominent signs of a new era's technology. The river itself is the central element of unseen flux. Thomas Cole's *Voyage of Life* has now been transmuted from allegory to actuality.

The new iron bridges of the last half of the century also figure prominently in the work of the American impressionists. Following the example especially of Monet's numerous views along the Seine in the Parisian suburbs, these painters addressed anew the juncture of nature and civilization. As city populations expanded and the

45. Joseph Stella, *The Voice of the City of New York Interpreted*, 1920–1922

railroad made travel more convenient, the movement of people and things shifted from the rivers themselves to the bridges across them. For a time American painters saw romantic beauty in the power and design of bridges, and, at least in the hands of the impressionists, their delicate tracery provided colorful abstract patterns for their compositions. One thinks of examples by John Twachtman and specifically *The Red Bridge* (1895; fig. 44) by J. Alden Weir.

This tradition continues into the early twentieth century in the work of the Ashcan School. In Ernest Lawson's paintings of the Harlem River bridge and George Bellows's views of the Hudson River palisades, we witness the enthusiasm of a younger generation for what they considered the energies and dynamism of America in a new century. Now it was no longer the pastoral seclusion of the upper Hudson Valley that appealed, but rather the wide and deep mouth of the waterway as it passed the modern landscape of the world's greatest city. The urban spirit, the drama of technology, and the accelerated pulse of contemporary life all fused in the bold abstractions of Joseph Stella's *The Voice of the City of New York Interpreted* (1920–1922; fig. 45). No less in the twentieth century than in the sixteenth, American rivers have served as lines of energy—for self-discovery and self-definition.

Luminism and Literature

THE PULL of American "light," that palpable, spiritual beauty of the American wilderness, was first felt across the western reaches of the Atlantic Ocean as Europe's earliest explorers to the New World glimpsed its indefinite edges. Almost from the beginning were fused the real vastness of space (experienced at sea and soon discovered on land), the sun's golden radiance setting in the west, and the sense of spiritual as well as physical riches in this new continent. Looking to the glowing western horizon, therefore, promised the gold of this world and of the next. That consciousness of salvation and of the divine presence in man's world was stimulated by Puritan theology and revivified by transcendentalism. Indeed, Henry David Thoreau could write:

> Every sunset which I witness inspires me with the desire to go to a West as distant and as fair as that into which the sun goes down. He appears to migrate westward daily, and tempt us to follow him. He is the Great Western Pioneer whom the nations follow. We dream all night of those mountain-ridges in the horizon, though they may be of vapor only, which were last gilded by his rays.[1]

As F. O. Matthiessen has pointed out, the culmination of transcendentalism coincides with a great moment in American cultural expression around the midpoint of the nineteenth century.[2]

Matthiessen's own important book on this period, *American Renaissance*, was first published in 1941, and stands as a broad seminal study of American culture and literature parallel to John Baur's writing at the time on painting. Here are many of the first observations, ones we now take for granted, about social and intellectual developments in mid-nineteenth-century America: the emergence of technology over agriculture, the gold rush of 1849 and its initiation of a truly gilded age of acquisitiveness, the rise of photography concomitant with that of plein-air painting. But perhaps most of all there was what Ralph Waldo Emerson himself called "a new consciousness. . . . Men grew reflective and intellectual."[3] Since Matthiessen's perceptive remarks about Emerson and his contemporaries are frequently directly related to the work of the luminist painters, some of these themes deserve recapitulation here.

For example, speaking of Nathaniel Hawthorne, Matthiessen cites the central role of abstraction, meditation, and symbolism in the writer's work. Whether we look at the novel or essay of the time or at the first classic examples of luminist imagery, we become aware of a spiritual presence abstracted before us. Further, by the sense of order and balance present, we too assume a posture of contemplation. However critics may continue to interpret the meaning of the letter *A* in *The Scarlet Letter*, it clearly reverberates with the symbolic content of art and creativity. As David Huntington has shown us, so too do the eloquent canvases of Frederic Edwin Church speak their own symbolic language of an American Edenic paradise. But the abstraction Matthiessen notes has as much to do with form as with content. He cites the symmetrical design of Hawthorne's novel, the author's use of light and dark contrasts in the ordering of his scenes (both dramatic and landscape), and his keying of events

to specific moments of time or season.[4] Martin Johnson Heade's measured marshes and Fitz Hugh Lane's stilled surfaces (see figs. 41 and 48) possess parallel symmetries, contrasts, and clarities.

One of the most revealing images Hawthorne employs, that of the mirror, is a recurring theme in the work of others as well, from Emerson to Lane:

> Glancing at the looking-glass, we behold—deep within its haunted verge—the smouldering glow of the half-extinguished anthracite, the white moonbeams on the floor, and a repetition of all the gleam and shadow of the picture, with one remove further from the actual, and nearer to the imaginative.[5]

In other words, the mind's eye itself is a form of mirror—observing, imagining, and transforming, such that for writer and painter alike *reflection* truly meant both *what* was perceived and the *act* of perceiving, inextricably fused together. Or, to quote Matthiessen: "perpetually for Hawthorne the shimmer of the now was merely the surface of the deep pool of history."[6] Clearly, the mirror surfaces found so repeatedly in luminist canvases (fig. 50) were equally vehicles for carrying the mind's eye from the specific objectivity of the present moment and place to a transcendent cosmos beyond time.

Of course, it is Emerson the philosopher who has most famously articulated for us the union of man and God through nature. Announcing himself to be a "transparent eyeball," he found it possible for the "currents of the Universal Being" to circulate through him.[7] Not accidentally, Emerson himself had overlapping careers as a minister, natural scientist, and poet. Indeed, he stated, "America is a poem in our eyes; its simple geography dazzles the imagination, and it will not wait long for metres."[8] We need not look beyond the controlled measurements and design of a Heade or Lane composition (fig. 46) from the 1860s to see the American landscape shaped in poetic rhythms. One capacity the artist-poet possessed was to perceive the harmony between the soul and matter, the sublime and the ordinary, the seer and the seen. Emerson often compared this "Oversoul" to water, which, like the currents passing through the transparent eye, brings us back to the layered meanings of reflection.[9]

Emerson's observations, taken here primarily from the landmark essays "Nature" (1836) and "The American Scholar" (1837), seem to fall into three natural groupings—the significance of looking at horizons:

> Our age is ocular.

> But is it the picture of the unbounded sea, or is it the lassitude of the syrian summer, that more and more draws the cords of Will out of my thought and leaves me nothing but perpetual observation, perpetual acquiescence and perpetual thankfulness.

> The health of the eye seems to demand a horizon. We are never tired, so long as we can see far enough.

> There is a property in the horizon which no man has but he whose eye can integrate all the parts, that is, the poet.

> In the tranquil landscape, and especially in the distant line of the horizon, man beholds somewhat as beautiful as his own nature.

the link between mental states and moments in nature:

> Every hour and change corresponds to and authorizes a different state of mind, from breathless noon to grimmest midnight.

> Nature always wears the colors of the spirit.

and, finally, the ordering of nature:

> In view of the significance of nature, we arrive at once at a new fact, that nature is a discipline.

> Nature hastens to render account of herself to the mind. Classification begins.

> Things are so strictly related, that according to the skill of the eye, from any one object the parts and properties of any other may be predicted.[10]

Not merely do horizontal depth and order dominate most pure luminist designs, even as Emerson sees their dominance in nature; but the cogency and compactness of Emerson's style would also seem

46. Fitz Hugh Lane, *Brace's Rock*, 1864

to find counterparts in such intimately wrought works as Lane's *Brace's Rock* series (1863–1864; fig. 46) or Albert Bierstadt's *Wreck of the "Ancon" in Loring Bay, Alaska* (1889; Museum of Fine Arts, Boston). In this regard it is worth noting the penchant of Emerson and most of his contemporaries for such small-scale forms of writing as the essay, short story, and sketch. Even the epigrammatic sentences and notational recordings of Thoreau suggest a parallel with the scrupulous delineations of natural details in luminist pictures. It is a provocative coincidence that the most famous political utterance of the day, Lincoln's Gettysburg Address, dates from exactly the same time as Lane's painting *Brace's Rock*. Both are startlingly compact and poetic; they are self-contained meditations on the moment; they intimate a higher, timeless serenity.

As with Lane and Emerson, we feel with Thoreau too the desire for full immersion in nature. Thoreau seeks to take nature's pulse as much as his own. He records his delight in the sensations of touch, as with water on the skin; of hearing, as with birds on a telegraph wire; or of sight, as in the autumnal tints on a red maple. The total union of artist and subject is a central aspect of pure luminism; with Lane's *Brace's Rock* still in mind, we can see the same aspiration of the transcendentalists to achieve both the spaciousness of the horizon and the immediacy of observed phenomena. There is an essence of fact and feeling, in this small painting of vast scale, that parallel's Thoreau's intention to "cut a broad swath and shave close."[11] This landscape is as much an embodiment of thought as of nature. Its patiently adjusted design seeks to provide, through revealed physical order, a construct for reverie: "In the spaces of thought are the reaches of land and water, where men go and come. The landscape lies far and fair within, and the deepest thinker is the farthest traveled."[12]

Distance, therefore, both measured and mental, is a significant element in the imagery of nature at this time. On one walk Thoreau urged climbing a tree to elevate our vantage point and gain the broader, deeper view. It is noteworthy that quite frequently the luminist painter sought out vistas from unusually high points of view. See, for example, John Frederick Kensett's *View Near Cozzens Hotel, West Point* (1863; fig. 47), Church's *The Andes of Ecuador* (1855; Reynolda House, Winston-Salem, N.C.), Sanford Robinson Gifford's *Mt. Mansfield* (1858; Manoogian Collection, Detroit), Wor-

thington Whittredge's *Home by the Sea* (1872; Addison Gallery, Andover, Mass.), or Eadweard Muybridge's *Valley of the Yosemite from Glacier Point* (1872; University Research Library, UCLA).

Stillness and silence are two other elements that we have already noted in the classic luminist style, and these too form a theme that Thoreau celebrates. Consider how closely his word images match paintings like Lane's *Entrance of Somes Sound from Southwest Harbor* (1852; private collection), Gifford's *Hook Mountain near Nyack, on the Hudson* (1866; Yale University Art Gallery); drawings like David Johnson's *Tongue Mountain, Lake George* (1872; private collection), Aaron Draper Shattuck's *Lake George* (1858; private collection); and photographs like Seneca Ray Stoddard's views of *Upper Saranac Lake* (1889; Library of Congress), Carleton Watkins's *Mirror Lake, Yosemite* (1866; Library of Congress), and Timothy O'Sullivan's *Summits of the Uinta Mountains, Utah Territory* (c. 1868–1869; National Archives):

> To be calm, to be serene! There is the calmness of the lake when there is not a breath of wind. . . . So it is with us. Sometimes we are clarified and calmed healthily, as we never were before in our lives, not by an opiate, but by some unconscious obedience to the all-just laws, so that we become like a still lake of purest crystal and without an effort our depths are revealed to ourselves. All the world goes by and is reflected in our deeps. Such clarity![13]

Reflection took on an especially reverent air at evening. Twilight was a poignant period of time's passage (figs. 48 and 49), and by the 1860s it seemed to assume association with loss of more than day. Thoreau wondered,

> What shall we name this season?—this very late afternoon, or very early evening, this severe and placid season of the day, most favorable for reflection, after the insufferable heats and the bustle of the day are over and before the dampness and twilight of evening! The serene hour, the Muses' hour, the season of reflection![14]

Sunset pictures by later Hudson River School and luminist painters appeared from the 1840s on, as may be seen in examples by Thomas Cole, John S. Blunt, Asher B. Durand, Lane, Heade, Kensett, Bier-

47. John Frederick Kensett, *View of Cozzens Hotel near West Point*, 1863

stadt, Gifford, Jasper E. Cropsey, and, above all, Church. The latter's series of some half-dozen major canvases throughout the 1850s culminates with the spectacular *Twilight in the Wilderness* of 1860 (fig. 50). Virtually burning with the intensity of stained-glass windows, these paintings inspire equally intense responses.

Although Emerson and Thoreau come most readily to mind as intellectual and literary parallels to luminism, there are striking re-

lationships also in the early work of other major writers. Herman Melville was at this time a youthful friend of Hawthorne's, and several of his themes follow directly from the older writer's work. An opening paragraph of *Moby-Dick* contains the familiar phrase, "meditation and water are wedded for ever."[15] Like Hawthorne, too, Melville often constructed his word pictures around oppositions of light and dark, calm and storm, good and evil. And reminiscent of the

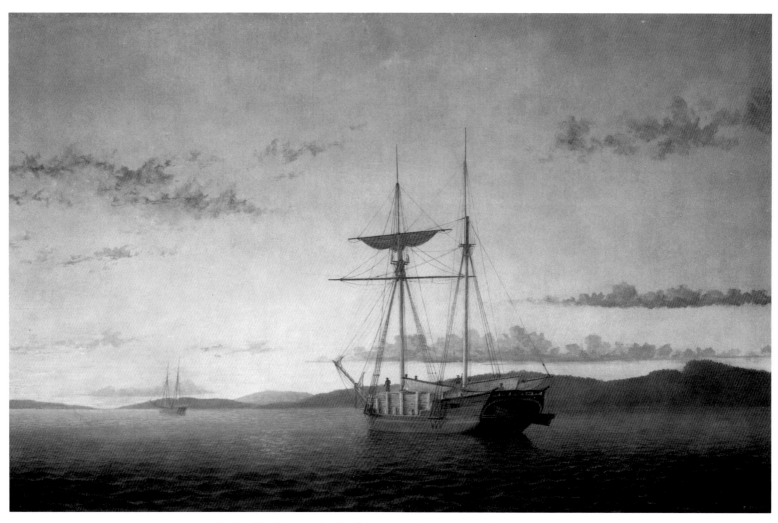

48. Fitz Hugh Lane, *Lumber Schooners at Evening on Penobscot Bay*, 1860

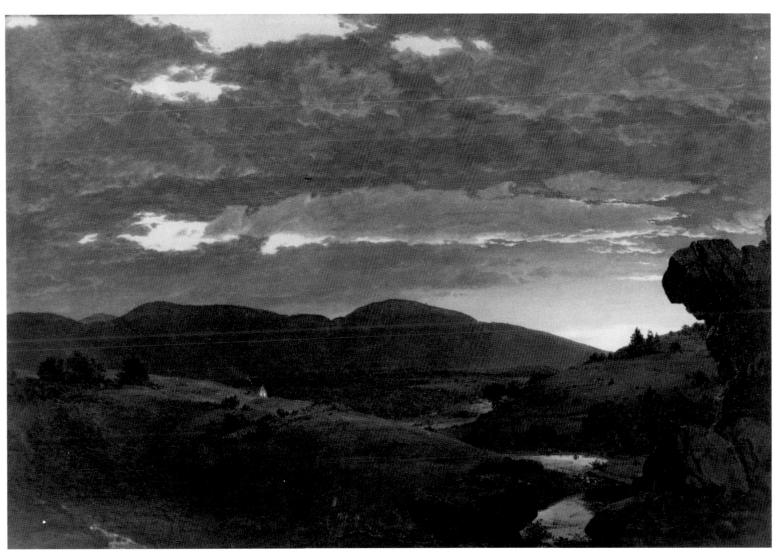

49. Frederic Edwin Church, *Twilight, "Short Arbiter 'Twixt Day and Night,"* 1850

75

50. Frederic Edwin Church, *Twilight in the Wilderness*, 1860

51. Albert Bierstadt, *Valley of the Yosemite*, 1864

writing of Emerson and Thoreau is his synthesis of general and specific, or philosophical and reportorial. Just as Thoreau sought to tie his own existence to the larger rhythms of nature, Melville modulated his prose to match the changing environment of the sea as he experienced its flux. The chapter entitled "Sunset" is a perfect, and particularly appropriate, example here. In it Melville's sense of self, subject, and artifact as comparable organisms emerges: "Yonder, by the ever-brimming goblet's rim, the warm waves blush like wine. The gold brow plumbs the blue. The diver sun—slow dived from noon—goes down; my soul mounts up!"[16]

By contrast, Walt Whitman's poetry can be less directly linked to the spare meditations of much luminist art, yet his exultant and celebratory songs of self and America do bear comparison with the large-scale pyrotechnics of Church and Bierstadt (fig. 51). In setting out to catalogue his cosmos in *Leaves of Grass*, first published in 1855, just four years after *Moby-Dick*, Whitman in his all-encompassing lines set down the variety and vastness of America with Church's naturalist sweep. Whitman joined his colleagues by calling out, "Give me the splendid silent sun with all his beams full-dazzling."[17] In fact, the colors of sky and earth are recurring motifs, as exemplified in the short poem "A Prairie Sunset":

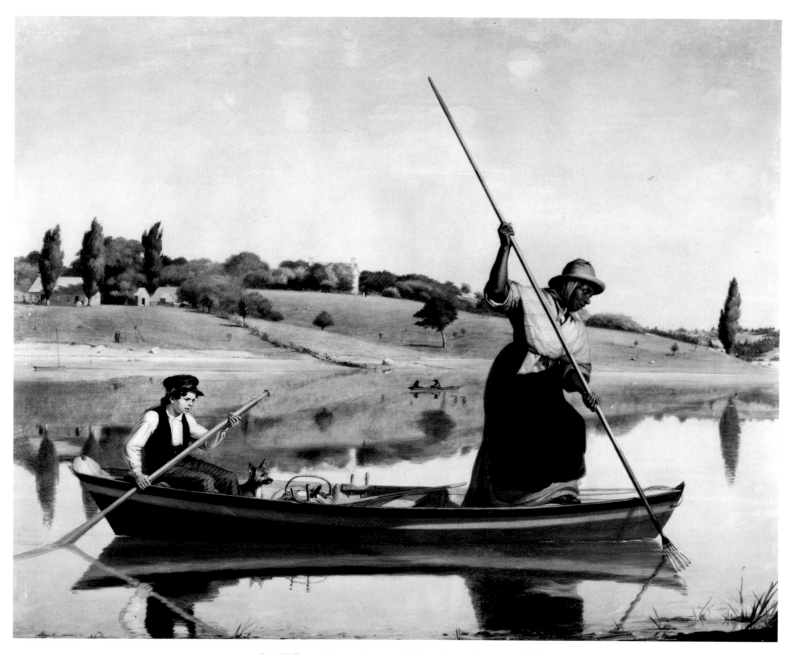

52. William Sidney Mount, *Eel Spearing at Setauket*, 1845

78

Shot gold, maroon and violet, dazzling silver, emerald, fawn,
The earth's whole amplitude and Nature's multiform power
 consign'd for once to colors;
The light, the general air possess'd by them—colors till now
 unknown,
No limit, confine—not the Western sky alone—the high
 meridian—North, South, all,
Pure luminous color fighting the silent shadows to the last.[18]

Matthiessen contrasts this language of nature's harmonies to the plein-air paintings of William Sidney Mount.[19] For example, in

Farmers Nooning (1836; Museum of Stony Brook, N.Y.) and especially *Eel Spearing at Setauket* (1845; fig. 52), we enter a rarified world of optimism and self-contentment.

Finally, we can note the perhaps surprising correlation between luminist imagery and the early writing of Henry James. Baur first called attention to an apt passage in a story called "A Landscape Painter," which James published in *The Atlantic Monthly* in 1866:

I shall never forget the wondrous stillness which brooded over earth and water. . . . The deep, translucent water reposed at the base of the warm sunlit cliff like a great basin of glass, which

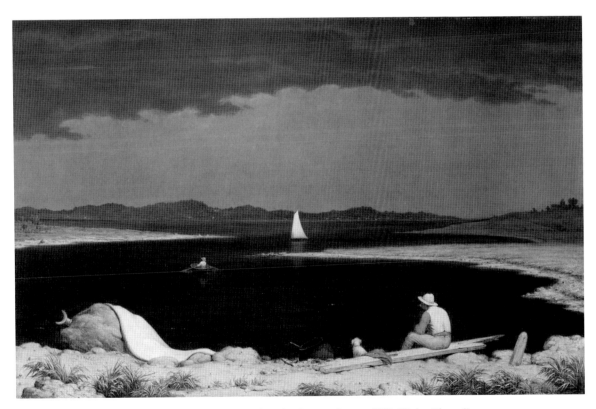

53. Martin Johnson Heade, *The Coming Storm*, 1859 (Color Plate 6)

79

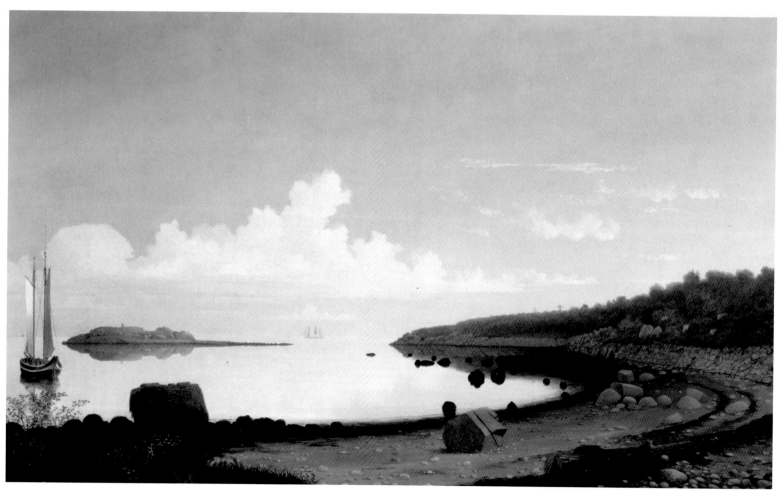

54. Fitz Hugh Lane, *The Western Shore with Norman's Woe*, 1862

I half expected to hear shiver and crack as our keel ploughed through it. And how color and sound stood out in the transparent air! . . . The Mossy rocks doubled themselves without a flaw in the clear, dark water. . . . There is a certain purity in this Cragthorpe air which I have never seen approached—a lightness, a brilliancy, a *crudity*, which allows perfect liberty of self-assertion to each individual object in the landscape. The prospect is ever more or less like a picture which lacks its final process, its reduction to unity.[20]

Although we ordinarily associate James's writing with a more cosmopolitan culture and style of writing fashionable later in the nineteenth century, paradoxically this piece captures the quintessential features of luminist art. The repose, the wonder, the glassy mirror are obvious keynotes. At the same time the brooding and threatened cracking suggest a hidden tension also seen in the darker side of luminism, in such works as Heade's thunderstorm series at Newport (fig. 53) or Lane's *Ships and an Approaching Storm Off Owl's Head, Maine* (1860; collection of Senator and Mrs. John D. Rockefeller IV, Washington, D.C.). The image of mossy rocks doubled in dark water finds corollaries in the latter's *Brace's Rock* and *Norman's Woe* series (1862; fig. 54), Kensett's *Shrewsbury River* (1856; see fig. 39), and Jack Hiller's views of Yosemite Valley. James's reference to "crudity" is another reminder of luminism's conceptual strain. The individuality of all objects perfectly describes the self-effacing precision of the luminist touch, and "reduction to unity," its process.

6

Under Chastened Light:
The Landscape of Rhode Island

THROUGHOUT the history of this small state, the arts have been writ large. For more than two centuries, for example, Rhode Island has been the setting for some of the finest achievements of America's best architects. Beginning in the middle of the eighteenth century, one of the first professionals with a substantial oeuvre, Peter Harrison, built in Newport several major monuments in the Georgian manner, among them the Touro Synagogue, the Redwood Library, and the Brick Market. A little earlier, another identifiable builder-craftsman, Richard Munday, left his elegant mark on Newport's Trinity Church and Old Colony House. Just before the Revolution, Joseph Brown designed such important structures in Providence as University Hall at Brown University, the Old Market House, and the First Baptist Meeting House. During the Federal period, Providence saw the rise of its imposing merchant houses, exemplified by that built for John Brown in 1786.

The major revival movements of the first half of the nineteenth century are equally well represented in Rhode Island's architecture with William Strickland's neoclassical Providence Athenaeum of 1838 and Richard Upjohn's gothic Kingscote of 1841 in Newport. But not only was the state coming to be known for its great residences, it was also the setting, primarily along its inland borders with Massachusetts and Connecticut, for an energetic industrial landscape. Rigorously designed mills in stone and brick still stand in West Warwick, Westerly, and Georgiaville, their clarity of mass and rhythmic articulation at once embodying the function and conveying the spirit of the forces of manufacturing.

Yet another great period of architecture occurred during the last quarter of the nineteenth century with the construction of mansions for empire builders within a narrow strip of Newport's coastline. These include Henry Hobson Richardson's Watts Sherman House of 1874 and McKim, Mead and White's Goelet, Isaac Bell, and William Low houses in the 1880s, as well as the latter firm's Casino, all perfections of the shingle style. In stone, Richard Morris Hunt evoked the Renaissance with Chateau-sur-Mer (1872) and The Breakers twenty years later. McKim, Mead and White carried this tradition of monumental architecture into the twentieth century in the State Capitol of 1900.

No less in literature, Rhode Island in fact and in imagination has been a vivid subject for major American writers, particularly novelists over the last century. Henry James was perhaps the most quotable and comprehensively observant. His chapter "The Sense of Newport" in *The American Scene* describes a visit during his return to America in 1904–1905. First published in 1907, it still glistens with all the master's elegant locutions of style and memorable observations of place.[1] Like others before and after, James saw the area as both unusual geography—"under a chastened light and in a purple

82

sea, the dainty isle of Aquidneck"—and a place of impressive domestic architecture—"it now bristles with the villas and palaces into which the cottages have all turned."[2]

In his travels James was also aware of history and time: on one level Rhode Island's beauty was timeless, a "small silver whistle of the past"; on another it bore evidence of the layerings of civilization, for "there was always, to begin with, the Old Town."[3] This palimpsest of human and natural history served as the organizing structure of *Theophilus North*, the last major novel by Thornton Wilder, which is set mainly in Newport. Wilder perceived a chronology of successive cities, the first being the seventeenth-century village of the earliest settlers. The second was the eighteenth-century town of beautiful public edifices, such as those already noted by Peter Harrison. Subsequent incarnations saw Newport as a prosperous seaport; a locus for the military with its forts defending Narragansett Bay; the home of intellectual families on sabbatical from Harvard and then of the rich empire builders who commissioned castles by Hunt and McKim, Mead and White; and finally a setting for other economic groups—servants, fortune hunters, and the middle class.[4]

More recently, another of America's foremost novelists, John Updike, has linked Rhode Island's present to its past in his tale of eighteenth-century witches made modern, *The Witches of Eastwick*. As important as that juxtaposition is, he focuses for us other contrasts central to the state's character:

> Rhode Island, though famously the smallest of the fifty states, yet contains odd American vastness, tracts scarcely explored amid industrial sprawl, abandoned homesteads and forsaken mansions, vacant hinterlands hastily traversed by straight black roads, heathlike marshes and desolate shores on either side of the Bay, that great wedge of water driven like a stake clean to the state's heart, its trustfully named capital . . . this land holds manifold warps and wrinkles. Its favorite road sign is a pair of arrows pointing either way. Swampy poor in spots, elsewhere it became a playground for the exceedingly rich.[5]

Indeed, in several areas—economy, occupations, geology, and scale—the nature of Rhode Island seems best described in opposites, not necessarily polarities in mutual exclusion but a continuing play of strong contrasts. We have already noted the strong presence of industrial architecture along the state's upper borders with Connecticut and Massachusetts, in contrast to the imposing domestic architecture standing in Newport and along the southern promontories, each form associated respectively with the labor and the wealthy classes. Extending this contrast, Rhode Island presents itself as a state of work and play. As visible as are its mills and factories, it is equally known as a playground of beaches and a setting for leisure activities. Most obvious is Newport's long association with tennis, yachting, and jazz festivals.

But Updike further reminds us that the territory of Rhode Island is as much water as it is land, traversed as much by bridges as by roads. Once across the state line, we are conscious equally of open ocean and solid rock. Ultimately, this awareness defines the most essential experience of all, the paradox of size and scale. Within its narrow confines are constant views of expansive horizons. Repeatedly, the visitor to Rhode Island has the sense of "the small virtual promontory, of which, superficially, nothing could be predicted but its sky and its sea and its sunsets. . . . One views it as placed there, by some refinement, in the scheme of nature, just as a touchstone of taste."[6]

This seemingly perfect balancing of opposites derives originally from the accidents of glacial geology. The southern coastline of the state follows the horizontal lines of the Connecticut, Long Island, and Cape Cod shores, those terminal moraines marking the extent of prehistoric glaciers as they descended over the northern hemisphere and then receded. The ragged indentations of Rhode Island appear as a final crunch of the Ice Age, a hinge in the planes of the continent where the mid-Atlantic coast turns northeast into New England. In this regard Rhode Island sits in the middle ground between northern and southern New England, combining characteristics of both, the rugged cliffs of one and the flat beaches of the other. Yet it does not possess the extremes of either—for example, neither the dramatic bold headlands of Maine and the Bay of Fundy to the north nor the unrelieved linearity of the New Jersey shore and the capes to the south. The special moderation of opposites is, as

55. John Smibert, *The Bermuda Group*, 1729

84

James observed, "a quiet, mild waterside sense, not that of the bold, bluff outer sea, but one in which shores and strands and small coast things played the greater part."[7]

When we turn to the long tradition of the visual arts in Rhode Island, we find these same elements fixed in the artist's eye. As elsewhere in the colonies during the eighteenth century, the principal modes of artistic expression were in the decorative arts, such as silver and furniture, that foremost served functional needs. Here, too, Rhode Island's reputation was disproportionate to its size: many would argue that the Townsend-Goddard family of cabinetmakers in Newport were unsurpassed in the originality and quality of their craftsmanship. Surviving from the colonial period, of course, are a few decorative overmantel views as well as portraits, for the most part straightforwardly recording likenesses for posterity. The major artistic work associated with Newport in the early eighteenth century is John Smibert's ambitious group portrait of *Dean George Berkeley and His Family (The Bermuda Group)* (1729; fig. 55). Not least important as the first professionally painted group portrait in America, it celebrates that moment of Berkeley's arrival in the New World with grand, though unrealized, intentions to establish a "Universal College of science and arts in the Bermudas."[8] Though believed to have been started in London and finished in Boston, the painting marks a significant threshold of stature and accomplishment for the arts in young America. Berkeley's name has ever since been linked to the Newport-Middletown geography, with his name given to the most prominent rock outcropping above Second Beach.

American painters and printmakers did not turn their full attention to landscape as a subject until the first quarter of the nineteenth century. By then the young republic had begun to assert its self-confidence. New states and territories were being steadily added to the Union. Immigration contributed to dramatic increases in population. Growth in shipping and commerce along the entire eastern seaboard extended America's reach to the farthest oceans. The coming of steam forecast new industrial energies for the entire country. Like other cities on the east coast, Providence shared in the rising tides of prosperity and expansion. From this early period onward for more than a century, many of America's greatest artists spent time at work in Rhode Island, recording the various facets of its terrain and character.

Typical of the earliest views are those of Providence in 1818 by Alvan Fisher, and of Clayville, Pawtucket, and Tockwotton done closer to midcentury by other painters. Together, these give an index of thriving mill, river, and port activity. Sturdy brick factories and closely built frame houses surround central unifying passages of water, harmonious images of productivity and enterprise. One of New England's most prominent painters of the period, Fitz Hugh Lane, visited from Gloucester to draw his lithographed *View of Providence* in 1848 (fig. 56). With its density of myriad details, it draws a similar picture of human and industrial vigor. Close by, several modes of transportation contrast with one another: a man on foot, a horse and carriage, and sailing and steam vessels. Though Lane is not known to have painted any specific Rhode Island views, he did return to nearby waters in the 1850s to paint *The New York Yacht Club Regatta* (c. 1856; fig. 57) off New Bedford and to do a color lithograph of Fairhaven. Thus, Lane's dual interests in life ashore and afloat encompass the essential Rhode Island scene.

By the middle of the nineteenth century, attention had more fully turned to the pure scenic beauty of the state's ocean shoreline. Partially this was a consequence of greater accessibility by expanded modes of transportation, as railroads and steamboats regularly traveled the New England coast; but the growing number of leisure hours was also stimulating interest in vacation periods and the idea of summer resorts. From earliest times, the state's latitude and seaside environment had been described as invigorating. For example, a 1789 survey of the United States found the climate of Rhode Island to be

as healthful a country as any part of North America. The winters, in the maritime parts of the State, are milder than in the inland country; the air being softened by a sea vapour, which also enriches the soil. The summers are delightful, especially on Rhode Island (Aquidneck), where the extreme heats, which prevail in other parts of America, are allayed by cool and refreshing breezes from the sea.[9]

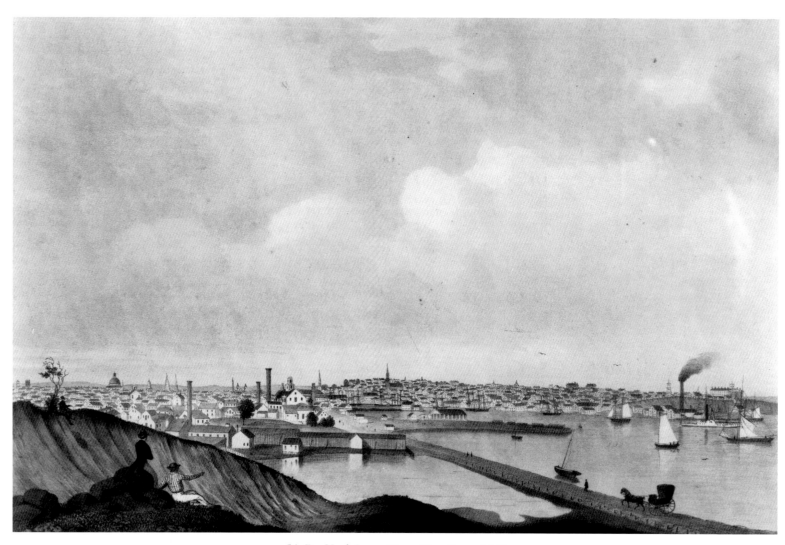

56. Fitz Hugh Lane, *View of Providence*, 1848

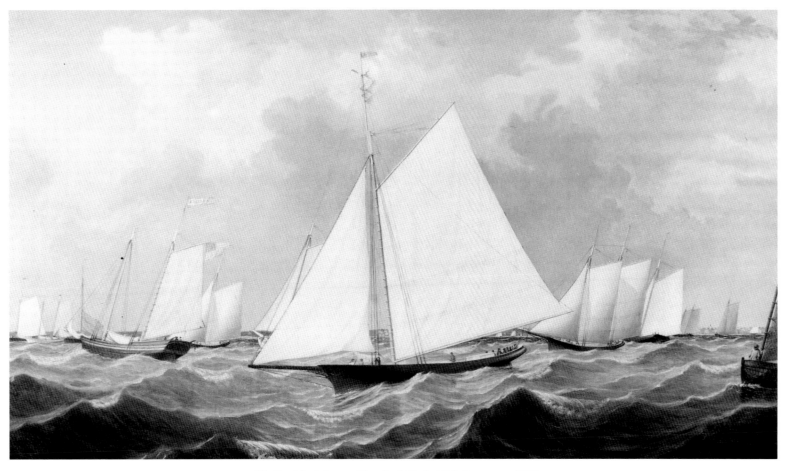

57. Fitz Hugh Lane, *New York Yacht Club Regatta*, c. 1856

This sense of the therapeutic virtues of nature continued with subsequent visitors, and gained reinforcement under the waves of nineteenth-century transcendentalist thinking, which saw nature as morally uplifting. Where an earlier generation of view painters focused on recording cities and towns as places of physical well-being, now artists contemplated the open landscape for its spiritual sustenance. In employing the spacious formats of the horizontal composition and stressing the substance of the still inner voice of God's presence, painters evolved a style now called luminist, one perfectly realized along the shores of Rhode Island. The first major artist to explore the luminist vision extensively in this area was John Frederick Kensett.

Trained as an engraver, Kensett brought to his art a precision of detail and clarity of form well suited to the rocky outlines of the shore (fig. 58). Having traveled extensively in upstate New York as well as abroad in earlier years, he brought a keen traveler's eye to his

58. John Frederick Kensett, *Forty Steps, Newport, Rhode Island*, 1860 (Color Plate 7)

observations of the Newport area. He appears to have moved with great deliberation around the promontories of the inner harbor, selecting his waterline views there and near the beaches of adjacent Middletown. In contrast to his previous work, which tended to be much denser with textures and movement, Kensett's Newport work is more obviously static and open. Occasionally figures mark off a foreground, emblematic of this as a sociable landscape, but increasingly he and his colleagues found quiet unpopulated nature sufficient to contemplate nature's higher order and harmony. His classic pictures from the 1850s and 1860s rely on gracious balances, horizontally between rock and sea and vertically between water and sky. Thus, his horizons serve to lead the eye outward at once to the side and to the distance. All that the eye sees, and by extension does not see but senses, exists as a coherent, orderly whole.

These manifold outstretched headlands, often joined by small curving beaches, match James's metaphor of "a little bare, white open hand, with slightly parted fingers."[10] This is also an appropriate image of organic unity and human scale in the natural world. With Kensett's views of Beacon Rock or Second Beach, like James, we

> come back, for its essence, to that figure of the little white hand, with the gracefully-spread fingers and the fine grain of skin, even the dimples at the joints and the shell-like delicacy of the pink nails—all the charms in short that a little white hand may have.[11]

Taking the broader view, we can read the full map of Rhode Island, for that matter, as an outspread hand reaching down around Narragansett Bay to the open ocean.

If Kensett was the foremost delineator of the Newport rocks in this period, William Stanley Haseltine was equally busy across the Bay drawing and painting the Narragansett shore. With training under the German portrait painter Paul Weber behind him, Haseltine

also brought to his work a sure sense of describing form. In his pencil sketches especially he was able to capture the cubic structure of rocks and the sharp modeling of light and shadow on a sunny day. Often he, too, would include figures picnicking or promenading along the shore, in contrast to sailboats in the distance, complementary notes of sociable leisure. At this high-water mark of self-confidence in the American republic, the landscape was always recorded by artists in the fullness of midday sunlight.

Rarely did the turbulence or drama of storms disturb this artistic picture of serenity, that is, until the critical period of the 1860s. Threatening weather and violent storms are of course a regular fact of life on the coast, though during most of the first half of the nineteenth century artists had no interest in such subjects, so distant from the mood of the nation. But with the coming and outbreak of civil strife, many painters saw an expressive relevance in an imagery of explosive sunsets and breaking storms. Perhaps the key painter who articulated most vividly on canvas the metaphoric power of nature's volatile weather was Martin Johnson Heade, and the central stage where he was to depict this meteorological drama was the Rhode Island landscape. (Only one other setting, the area of Mount Desert Island, Maine, was to provide a comparable arena of expression for American artists. There, most notably Lane and Frederic Edwin Church explored ever more intense scenes of sunset and twilight as visual manifestations of poignant or apocalyptic change.)

Heade's first mature landscapes of the 1850s, painted in the marshes of Newburyport, Massachusetts, and along the inlets of the Newport shore, possess the tranquility and optimism familiar in much painting up to that time. He tended to indulge in a light, airy palette of pale greens, yellows, and blues, well suited to the transparency of light and gentle pastoral tone of his scenes. By the early 1860s, however, he seemed fascinated by more intensified atmospheric conditions, as if sensing pending change in the barometric pressure. In some works he records a dry, strangely still air (*Lake George* [1862; fig. 84] being the best example); in others he envelops his scene with a sense of humidity, often indicating the approach of coming showers. Similarly, at this time Heade takes up subjects of almost surreal moonlight effects, as in *Point Judith* (fig. 59), *Moonlit Calm* (c. 1861–1865; Cleveland Museum of Art), and the wreck of

a vessel offshore (for example, *Coastal Scene with Sinking Ship* [1863; fig. 60]).

As the nation reached a crescendo of physical and psychic crisis in the mid-1860s, Heade's imagery attained a parallel starkness and tension in a series (confined just to this moment) of extraordinary thunderstorm canvases. Now his greens turned acid and his tonal range polarized between dark and light. Indeed, black is the predominant color in this group, dominated by three unsurpassed paintings of the period: *The Coming Storm* (1859; fig. 53), *Approaching Storm: Beach near Newport* (c. 1865–1870; Museum of Fine Arts, Boston),[12] and *Thunderstorm over Narragansett Bay* (1868; fig. 61). The bold aspect of these works is their depiction of storms about to break, creating an anxiety of anticipation and a terror in silence. This inverts, and thereby heightens, we might argue, the traditional definition of sublimity as characterized by noise and action. Here the calm threatens, a *horror vacui* of impending doom and destruction. Relatively few American artists did history paintings of the Civil War, apparently finding a more eloquent link between nature and nation, articulated best through the voice of landscape.

After the war period, Heade returned to his golden marsh scenes, while other painters coming to Rhode Island once again favored depictions of the human presence comfortable within nature's benign panorama. Traditions established earlier by Kensett and Haseltine now continued in the work of Alfred Thompson Bricher, Jervis McEntee, and George Champlin Mason. Characteristically, Bricher composed in gentle contrasts of water and rock, figures and landscape, sea and sky. In one tour de force, *Indian Rock, Narragansett Bay* (1871; private collection), he selected an unusually elevated viewpoint well above the shoreline, fusing under an "irradiating, vague silver" light the domestic pleasures of the foreground with the spatial panoply of Rhode Island's "odd American vastness" beyond.[13]

If certain conventions continued through the later decades of the century, they were also modified and specialized by artists of different temperaments. Like Haseltine, William Trost Richards also received his training from Weber, and he traveled extensively in Europe, mastering a style of draftsmanship noted for its great clarity of detail and texture. Of particular impact in the late 1860s were the theoretical ideas of John Ruskin, who encouraged recording the

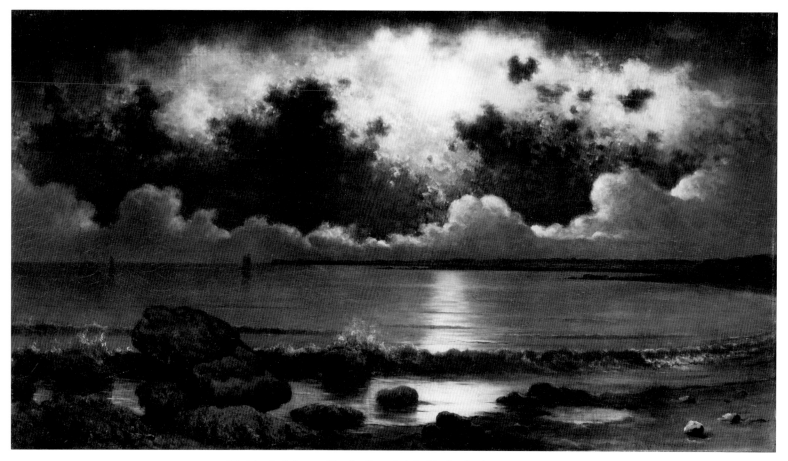

59. Martin Johnson Heade, *Point Judith, Rhode Island*, c. 1867–1868

specificity of all nature's elements with scientific precision. After further travel to Europe and along much of the Atlantic coast, in 1874 Richards settled in Newport for his summers. With almost equal facility and jewel-like rendering, he sketched the endless configurations of rocky ledges in pencil drawings, intimate watercolor series, impressive large gouaches, and glowing oils on canvas (fig. 62). Over more than three decades, giving little evidence of any loss in command in his later years, Richards lovingly walked the Middletown, Newport, and Jamestown shorelines:

a thousand delicate places, dear to the disinterested rambler, small mild "points" and promontories, far away little lonely, sandy coves, rock-set, lily-sheeted ponds, almost hidden, and shallow Arcadian summer-haunted valleys, with the sea just over some stony shoulder: a whole world with its scale so measured and intended and happy, its detail so finished and pencilled and stippled (certainly for American detail!) that there comes back to me, across many years, no better analogy for it than that of some fine foreground in an old "line" engraving.[14]

By contrast, Worthington Whittredge developed a looser touch in his paintings of the same area (fig. 63). His work of the early 1870s is indebted to the luminist sense of panorama and atmosphere: "that unmistakable silvery shimmer, a particular property of the local air."[15] But by the later 1870s and 1880s, his brushwork became freer and more suggestive: figures promenade on the beaches, caught in a mood and technique more associated with impressionism. (One measure of the changes in artists' responses to a site may be seen in comparing Whittredge's 1875 view of Bishop's Rock at Second Beach [fig. 64] with that by James Suydam a decade before [fig. 65]. Where solid geology anchors the earlier landscape, a festive airiness permeates the later.)

Painting in the same area but with yet another mood altogether was John LaFarge. Joining William Morris Hunt in Newport, he shared a growing interest in the French Barbizon manner, acquired during an early trip to France. The broadly defined landscape forms,

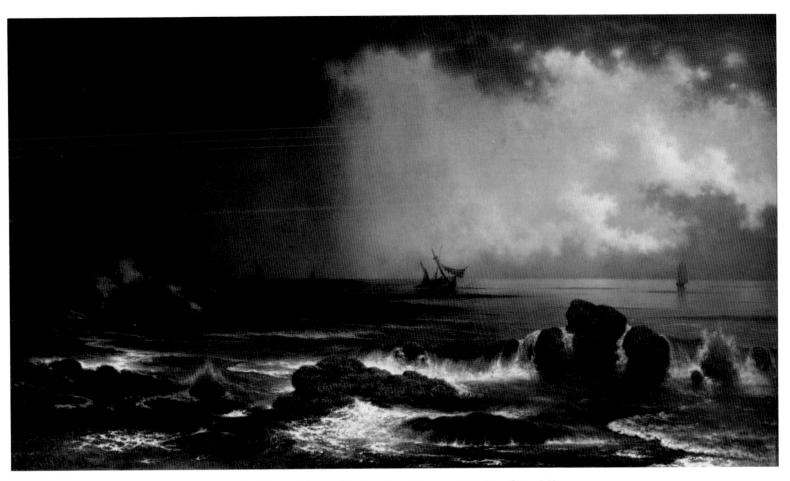

60. Martin Johnson Heade, *Coastal Scene with Sinking Ship*, 1863

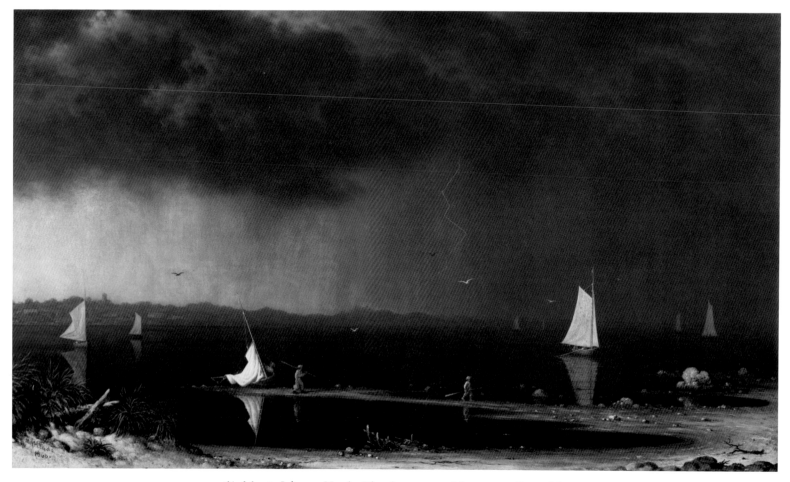

61. Martin Johnson Heade, *Thunderstorm over Narragansett Bay*, 1868

bright hazy atmosphere, and sense of nature as a platform for con-templation and reverie bear distant echoes of Jean Baptiste Corot. In his several views done around Paradise Valley and Bishop's Rock (fig. 66), LaFarge selected elevated points of view, not so much, one feels, to capture any sweeping panorama as to create an almost pri-vate environment of mysterious quiet and emptiness. The timeless-ness of his rocks seems more totemic than geologic. This turn from the outer to the inner eye, and the response to landscape as an ex-pression of feeling, was a direction taken by several artists at the end of the nineteenth century, seen also in the tonalist views painted by Homer Dodge Martin and Edward Bannister. In their work, light seems more evocative than optical, and landscape forms appear ab-stracted into patterns of brushwork and color.

At century's end, yet another course taken by American painters led them into purer examples of impressionism after the French manner. The paintings of George L. Noyes and especially of Childe

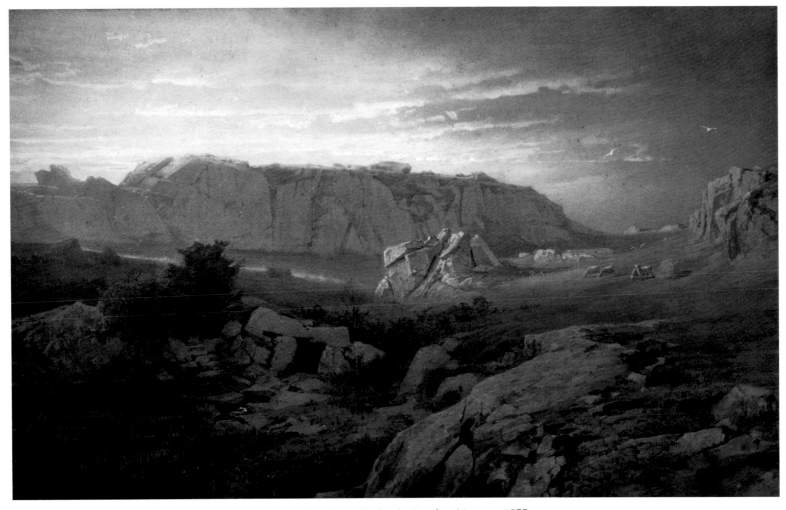

62. William Trost Richards, *Paradise, Newport,* 1877

Hassam (fig. 67) show the favored use of broken brushwork and bright palette associated with their plein-air approach. Given the pervasive and essential consciousness of light, air, and space everywhere in the geography of Rhode Island, it is no surprise that artists should find the impressionist style so readily adaptable to the environment there. At the same time, there are hints of modernism in

their work as well, not least in the attention to flickering brushwork almost having a life of its own on the canvas surface, and to the deliberately imposed abstraction of their square formats.

These various currents carried strongly into the twentieth century. The solid rock, the palpable air, a coastline for work and play: these are enduring elements in the new forms of realism associated

63. Worthington Whittredge, *A Breezy Day — Sakonnet Point, Rhode Island,* c. 1880

94

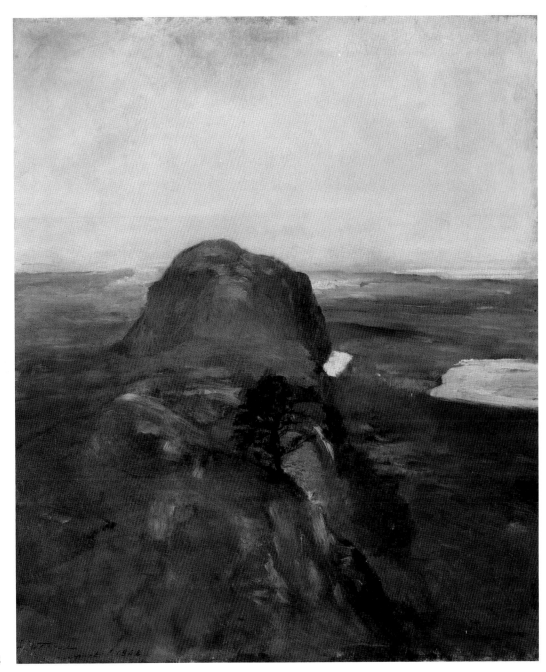

66. John LaFarge, *Bishop Berkeley's Rock, Newport,* 1868

97

67. Frederick Childe Hassam, *Bailey's Beach, Newport, Rhode Island*, 1901

98

7

William Bradford: Artist of the Arctic

WILLIAM BRADFORD was an uneven artist of remarkable interest. His career, passed largely in visiting and painting Arctic scenery, spans much of the second half of the nineteenth century, and as such reflects many of the artistic and critical tastes of the period.

Bradford's lifelong interest in the sea was nurtured in his native New Bedford, the great center of the American whale fishery with a rich artistic tradition that also includes Albert Bierstadt, Albert Van Beest, William A. Wall, R. Swain Gifford, and Albert P. Ryder. Notable figures like Queen Victoria acquired his pictures, and eminent intellectuals and writers visited his studio, among them Henry David Thoreau in New England and Alfred Tennyson in London. Bradford's extensive use of photography reminds us that the second half of the nineteenth century was increasingly scientifically minded. Although we have only just begun to analyze what precise effects the camera had on artistic vision, Bradford shared these interests with a number of his better-known contemporaries like Bierstadt, Fitz Hugh Lane, Winslow Homer, and Thomas Eakins. The fascination with accuracy of documentation had already appeared in the work of John James Audubon and George Catlin, and perhaps the need for explanation and categorization was best demonstrated by one of the century's most influential figures, Charles Darwin. But there was a new romance to science as well, an excitement in the exotic that lay behind the missions to far-off places. In this regard, Bradford was close to painters like Martin Johnson Heade, James Hamilton, and Frederic Edwin Church, all of whom made distant journeys to South America or the Arctic seas. With the relative popularization of the American west by midcentury, artists and scientists alike set out for uncharted territories abroad where that particularly American sense of discovery might still be indulged.

BRADFORD was born in Fairhaven, across the harbor from New Bedford, in 1823. He was brought up a Quaker in his mother's faith, and could claim direct descent from the first Pilgrim governor of Plymouth. Henry Tuckerman, writing in his *Book of the Artists* in 1867, speculated that much of Bradford's calm and self-control as an artist, his patience and care in painting, derived from the Quaker virtues of simplicity and plainness. Furthermore, his early hardships in business probably contributed to his strengthened commitment to become a full-time artist. His father was a ship outfitter and maintained his own dry goods store in New Bedford where William clerked as a youth. But as the young Bradford much later recounted to the New Bedford historian Leonard B. Ellis, he had early become interested in painting, although at first with no sure idea of being an artist. After hours he repeatedly copied from a book of English drawings. He evidently spent most of his leisure time making pencil sketches, and soon also took up painting in the attic of his family's house on William Street. Often when he should have reported to work at his father's store, his mother found him working in the attic and scolded him for allowing his "little horse to stand there pawing the ground for two hours." His father, too, expressed disapproval, but noted that by the time William was thirty he had "spent too much time in painting to succeed" in business. Turning then full time to his art, he began making drawings and oil portraits of the

many whaling vessels in New Bedford harbor. His first sale was such a drawing of the whaler *Jireh Perry*, and by 1855 he could note several similar commissions, which brought increasingly larger sums.

As a seaport town, New Bedford provided an endless panorama of activity for the artist's pencil. Bradford not only knew the local merchants and transient mariners, but his growing familiarity with the variety of arriving and departing vessels offered him lucrative sources of work. Around 1855 he moved into his own studio on Union Street, and for over a year and a half he concentrated on painting portraits of whalers and merchantmen. Most of these he painted in variations of a basic compositional format: the vessel seen broadside slightly off center with one or more other vessels sailing near the horizon to lend interest and animation to the design. His manner of painting at this time was relatively tight, his draftsmanship clear and crisp, his color tones generally cool, subdued, and luminous. The previous years of constant drawing had given him a well-disciplined ability in recording both general effects and specific details accurately. His careful observation of harbor life and full familiarity with ships combined to give his paintings a convincing and fresh character. Dozens of these sketches now gathered in the New Bedford Whaling Museum reveal an astute eye for capturing the telling outlines of a scene, the significant details, and the proper relationships between the different aspects recorded. Some are historically interesting vistas of the harbor's shoreline as viewed from the water; others depict all types of sailboats and ships anchored in the stream or tied up at the wharves; many include figures at work or casually observing the scene at hand. All of Bradford's vessels sit convincingly in the water, and he manages to convey a sense of their structure and rigging without cluttering or confusing his drawing. By controlling the degree of sharpness in his pencil, he brings some sections into clear focus while leaving other details that are peripheral more spontaneously sketched in.

His paintings of whalers done in the 1850s show a similar sureness in delineating the significant features of the vessel, as well as a lively sense of the movement of air and water. While remaining admirable ship portraits in their own right, they are also accurate renditions of the special effects of light and atmosphere present. Occasionally, views like that of *Clark's Point Light, New Bedford* of 1854 (New

Bedford Whaling Museum) also contain some of the more narrative activities occurring ashore. Bradford was to make a mark because, in addition to painting vessels well, he could also portray convincingly the contours and architecture of the local landscape (fig. 69).

Much of his work at this time bears unmistakable similarities to the style of Fitz Hugh Lane (see figs. 3 and 68), the Gloucester artist who had established himself during the preceding decade as the preeminent marine painter of Boston and the northern New England shore. Lane had been in New Bedford in 1845 to draw a lithograph of the town taken from the Fairhaven side of the harbor, and returned again in 1856 (if not before) to paint the New York Yacht Club regatta, which Bradford also painted, probably at Lane's side. In any case, stylistic evidence alone would suggest that the younger New Bedford painter had seen Lane's work. The paintings of both men during the late 1840s and early 1850s possess a common clarity of drawing, interest in narrative detail, cool lighting effects, and in some instances a striking similarity of composition. Whatever the degree of possible influence, this manner emerged as Bradford's first clearly identifiable style of his own. It would change subtly but markedly during the mid-1850s through association with another painter who came to New Bedford at this time, Albert Van Beest.

VAN BEEST had been born in Rotterdam in 1820 and had served as a youth with the Royal Dutch Navy. He had also learned to paint by the time he set off for America in 1845, and although "thoroughly trained in art" according to Samuel Isham, he possessed "no great talent." Bradford had heard of the Dutchman in New York, and, seeking to improve his own work, invited Van Beest to join him in Fairhaven. With a third friend, they moved to the old Kempton Farm (a Bradford family property), where they worked together for three years. In return for the hospitality, Van Beest provided painting lessons for Bradford, and before long the two men began to collaborate in executing several large pictures. One visitor to their studio, Henry David Thoreau, recorded the scene in his journal:

Visited the studio in Fairhaven of a young marine painter, built over the water, the dashing and gurgling of it coming up through a grating in the floor. He was out, but we found there

68. William Bradford, *New Bedford Harbor at Sunset*, 1858

101

painting Van Best [*sic*], a well-known Dutch painter of marine pieces whom he has attracted to him. He talked and looked particularly Dutchman-like.

Another local marine painter, R. Swain Gifford, also joined Bradford and Van Beest's company, receiving for a time instruction from the older painter.

It was a fruitful collaboration for a time, blending the different approaches and styles of the two men. Unlike Bradford's painstaking work in pencil to capture details clearly, Van Beest favored working in India ink. Consequently, his sepia sketches were more fluid, suggestive, and animated than Bradford's rather tight drawings. His subjects too tended to be more lively and action-filled, and he became well known for his pictures of ships in rough seas or storms.

During the winters, Van Beest moved to a New York studio, but over the summers the two men worked side by side, and Bradford's style soon loosened up under the Dutch painter's influence. His subjects were now more active, his compositions more dynamic. He likewise made softer pencil drawings, sometimes using a neutral colored paper heightened with both white and black charcoal, a technique he was to develop extensively years later in his Arctic sketches. About 1856 the two painters undertook several large pictures together, and during such collaboration Bradford's hand would be most evident in the rendering of vessels, while Van Beest usually painted the sky and water. At least two major paintings date from these years, *The New York Yacht Club Regatta* of 1856 (Edgartown Yacht Club) and *Boston Harbor* of 1857. Both men made a number of preparatory sketches for the regatta painting, which include a pencil drawing of the passenger steamer *Eagle's Wing* by Bradford and some sepia washes of clouds by Van Beest. Together the two next executed a large wash drawing of the regatta scene itself, which both men signed. From the varied handling of pencil and brush, it is apparent that Bradford did the tighter rendition of the steamer and several sailing vessels, while Van Beest filled in the more loosely rendered figures, waves, and clouds. The lively juxtaposition of the boats across the surface of the water shows how far Bradford had come from his rather stiff compositional arrangements of the preceding decade. It is unknown whether Van Beest made any further

paintings of the scene, but Bradford did go on to paint in oil a large canvas based on the jointly executed drawing. There is virtually no change in composition: to the left is the steamer *Eagle's Wing*, in the center the schooner *Emblem*, and in the foreground the racing sloop *Julia*. On the extreme right side in the distance appears Clark's Point Lighthouse, situated at the entrance of New Bedford harbor. In contrast to the preparatory wash drawing, the finished oil by Bradford has an overall quality of greater clarity and precision, more characteristic of his work done on his own.

Considering the earlier likely association between Bradford and Fitz Hugh Lane, it comes as little surprise that Lane painted at the same time almost exactly the same view of the regatta, but, not being the native Bradford was, he omitted certain local details such as the *Eagle's Wing* and Clark's Point Lighthouse. But still in the foreground are the *Emblem* and the *Julia*, now seen from the port instead of the starboard side. The following year Bradford and Van Beest collaborated on another large harbor view that is similarly close to Lane. Their *Boston Harbor* (fig. 69) is dated 1857 and again signed by both artists. As was their practice, Bradford appears to have painted the crisper forms of the rowboats and sailing vessels, Van Beest the softer shapes of waves and clouds. The pyramidal arrangement of vessels to one side balanced by smaller boats on the other was a favorite device in most of Lane's Boston harbor views done throughout the 1850s, and suggests that these three men must have been closely associated during this period.

In a talk given at the New Bedford Library on 13 January 1926, Bradford's daughter Mary noted that her father was already seeking new areas to paint by this time, and this search led him between 1854 and 1857 to make trips to Labrador, an area he would return to regularly in the following decades. But these early trips were sparsely financed, and Bradford himself still had little money. His first paintings of the northern waters—views of the Labrador fisheries, occasional icebergs, or rocky promontories of the coast—were typical of his second period, generally under Van Beest's influence. There is still the clarity of drawing that recalls his own early practice as well as the tight style of Lane, while at the same time the rough seas and dramatic seascapes are close to the Dutch manner of Van Beest.

69. William Bradford and Albert Van Beest, *Boston Harbor*, 1857

For the most part, Bradford remained unrecognized in these years beyond his native area, and he did not sell many pictures. The Boston firm of Williams & Everett was known to aid struggling artists and did pass on to Bradford several hundred dollars for the sale of a few pictures. But his paintings sold only infrequently and then usually for twenty-five dollars.

Sometime in the late 1850s or early 1860s, however, his fortunes began to turn. The New Bedford historian Ellis recorded that one day Benjamin Rotch came to the studio to buy some paintings, and ended up paying fifty dollars apiece for several and promised to buy others that the artist had promised to an auction. The auction subsequently produced prices of eighty-four and seventy dollars for his

paintings, and these in turn were given by Rotch to his noted Boston friends, James Lawrence and Augustus Lowell. Thereafter prices increased, shortly to be two hundred and fifty dollars per picture. By 1868 Bradford had sold one through Williams & Everett to the Duke of Argyle for $10,000. Mary Bradford later described her grandfather giving a friend a round-trip ticket to Boston to see the exhibition in which the picture hung. Bradford's father was said to have commented: "That picture cost $10,000. William was a fool to paint it and the man was a fool to pay that for it, but I want thee to see it."

By the late 1850s, Van Beest was spending more and more time in Boston and New York, and it was to the latter city that he finally moved for good not too long before his early death from cancer in 1860. Bradford too began to spend some time in the summers along the shores of Swampscott and Nahant, and for at least several winters in a Boston studio at the corner of Tremont and Bromfield Streets. Reaching maturity as a painter, he inevitably became less dependent on Van Beest, and their fruitful association now came to an end. Probably their different approaches to drawing and painting had much to do with each man going his own way. Mrs. Bradford noted an additional complaint. Van Beest, she recalled, made his sepia washes from cigar stumps, and once Bradford protested the prevalence around the studio and house of saucers with soaking stumps. "You are a geese," was Van Beest's reply.

THE LURE of the Arctic grew increasingly potent for Bradford. With Van Beest's departure, he determined to make more carefully planned trips along the northern New England and Canadian shores. Meanwhile, he made faithfully detailed sketches along Boston's north shore from Cohasset to Nahant to Cape Ann, as well as farther east in the Bay of Fundy. These brief visits to the edges of northern waters, along with the publication of new literature about these regions, intensified the temptation to visit Labrador and beyond. Among the most important books published was Elisha Kent Kane's *Arctic Explorations in the Years 1853, '54, '55,* which appeared in 1856 and was avidly read by Bradford. Another prominent marine painter, James Hamilton, had extensively illustrated Kane's two volumes with dramatic wood and metal engravings of life among the icebergs and floes, the Eskimos, and the midnight sun. It is entirely

possible that these illustrations provided Bradford with sources for his own later paintings and drawings of the north. Kane's original expedition followed a charge from the Secretary of the Navy to "conduct an expedition to the Arctic seas in search of Sir John Franklin," whose ships and entire company had disappeared shortly before. Franklin's loss was to trigger decades of Arctic exploration by explorers from America, England, and the Continent. One of those accompanying Kane was Dr. Isaac I. Hayes, who was to join Bradford on his most ambitious journey to the north in 1869. Kane's lengthy and detailed account of his voyages combined scientific observations and romantic exultations in a balance soon to be repeated visually in the paintings of Hamilton, Church, and Bradford. Straightforward factual notations are followed with exaggerated metaphors describing the awesome *mers de glace* and towering bergs or glaciers. One was nothing less than "a mighty crystal bridge which connects the two continents of America and Greenland." Everything appeared more sublime here: even "the intense beauty of the Arctic firmament can hardly be imagined. It looked close above our heads, with its stars magnified in glory and the very planets twinkling so much as to baffle the observations of our astronomer." One was everywhere reminded that such supernatural effects must be manifestations of a hand larger than man's:

> We have marked every dash of color which the great Painter in his benevolence vouchsafed to us; and now the empurpled blues, clear, unmistakable, the spreading lake, the flickering yellow: peering at all these, poor wretches! every thing seemed superlative lustre and unsurpassable glory.

These were powerful images for Bradford, who now turned all his energies to raising money for an extensive trip to Labrador. Assistance came from his friend, Dr. J. C. Sharp of Boston, who was an occasional visitor to the studio and had discussed with Bradford the possibilities of going to the north. On one occasion he simply said, "Mr. Bradford, I'm thinking that you had better go now. And for that purpose I have just fifteen hundred dollars in the bank." The money helped to outfit a twenty-ton schooner, and, in the late spring of 1861, as the Civil War was about to break out in America, Bradford set sail. It took him about two weeks to reach Labrador,

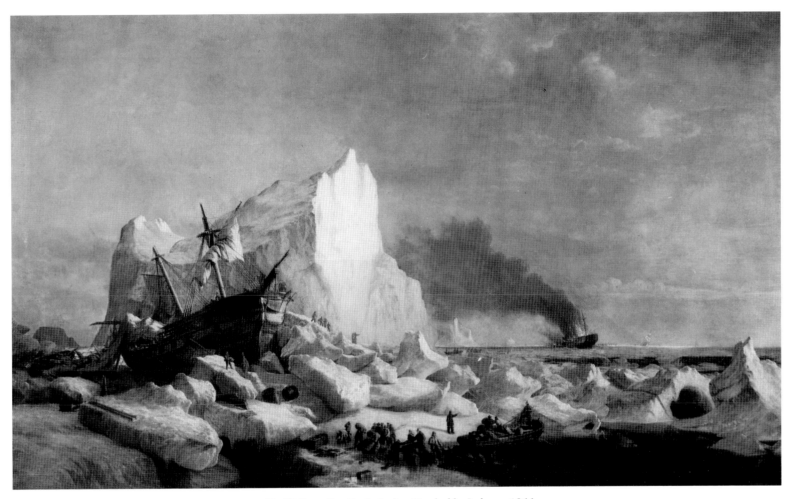

70. William Bradford, *Sealers Crushed by Icebergs*, 1866

and for the next four months he made sketches and photographs while anchored or cruising among the icebergs. The voyage was a great success, and his work as an artist now entered an entirely new dimension. He returned again the next summer and with but one exception for the next six years as well. The voyage of 1865 was particularly successful, with a thorough account having been kept by one of Bradford's friends aboard.

From a large inventory of drawings and wash and oil sketches, Bradford produced upon his return some of the best paintings of his career (fig. 70). He became fascinated with the special effects of light in the north, and several pictures are of the Arctic sun just rising or setting above the horizon. Others contrast the bold promontories of Labrador headlands against expanses of water reflecting strange colors of sunlight. Generally favoring a low horizon line in

these compositions, he could capture the sense of cold vastness in this region, punctuated occasionally by vessels beached ashore, fishermen's huts, or nearby drifting icebergs. His manner of painting is still relatively tight, the paint applied carefully and thinly to recreate the shimmering qualities of the translucent air. His drawing still retains that clarity and crispness of definition associated with his earliest work, but he has now given up almost completely the more active scenes of his period of association with Van Beest. Gone too are looser brushstrokes and thicker applications of pigment characteristic of the Dutch style. With the work inspired by these trips of the 1860s, Bradford's career reached its maturity.

Following each voyage, Bradford returned to work in his studio at the foot of Union Street in Fairhaven. Sometime in the late 1860s or early 1870s, he also took quarters in New York in the Tenth Street Studio Building, where he came to know his fellow New Bedford artist, Albert Bierstadt, along with other frequenters of the building, such as Sanford Robinson Gifford, Worthington Whittredge, and Jervis McEntee. While in Fairhaven, Bradford often took meals at his cousin Mrs. Bryden's boarding house, known jocularly as the Hotel de Bryden.

Bradford's associations increasingly widened, and, through his contacts in New York about 1865, he asked the painter John Frederick Kensett for advice and criticism. An unsolicited tribute came from another friend, like Bradford also a Quaker, the poet John Greenleaf Whittier. Dedicated "To W. B.," Whittier's poem "Amy Wentworth" combines his awareness of the current strife of the Civil War with his admiration for the painter's Labrador seascapes, and reads in part:

> Let none upbraid us that the waves entice
> Thy sea-dipped pencil, or some quaint device,
> Rhythmic and sweet, beguiles my pen away
> From the sharp strifes and sorrows of today.
> Thus, while the east wind keen from Labrador
> Sings in the leafless elms, and from the shore
> Of the great sea comes the monotonous roar
> Of the long breaking surf, and all the sky
> Is gray with cloud, home-bound and dull, I try

> To time a simple legend to the sounds
> Of winds in the woods, and waves on pebbled bounds,—
> A song for oars to chime with, such as might
> Be sung by tired sea-painters, who at night
> Look from their hemlock camps, by quiet cove
> Of beach, moon-lighted on the waves they love.
> (So hast thou looked, when level sunset lay
> On the calm bosom of some Eastern bay,
> And all the spray-moist rocks and waves that rolled
> Up the white sand-slopes flashed with ruddy gold.)
> Something it has—a flavor of the sea,
> And the sea's freedom—which reminds of thee.

Bradford's most ambitious expedition to the Arctic took place in the summer months of 1869. The artist wrote an equally ambitious book, based on this trip, entitled *The Arctic Regions*. The volume, published in London in 1873, was of folio size and was limited to an edition of three hundred copies, each containing one hundred and twenty-five original photographs hand-tipped into the text. Mary Bradford later estimated that this particular voyage of her father's cost some $150,000. A sizable portion of this sum was put up by LeGrand Lockwood, to whom the artist dedicated the book, describing his benefactor as "widely known for his generous patronage of the arts and for his acts of unselfish benevolence." Bradford's earlier trips had incited him to push farther north than Labrador both "to study Nature under the terrible aspects of the Frigid Zone" and especially to pursue "the purposes of art."

Following conversations with Lockwood about these aims, the painter received the backing for his trip, and promptly secured the Scotch whaling steamer *Panther* of 325 tons. Besides Captain John Bartlett, his two brothers acting as officers, and a crew of Newfoundlanders, the scientist-explorer Hayes was along, as were the photographers John B. Dunmore and George B. Critcherson from J. W. Black's Boston firm. Also among the company were two of Bradford's friends; Henry Lockwood, son of the patron; William Benedict, the artist's cousin from New York; and B. Dalton Dorr of Philadelphia. Once the vessel was loaded with five hundred tons of coal, the group departed St. John's, Newfoundland, on 3 July 1869 bound

for Greenland. Within a week they had made Cape Desolation on the southern coast of Greenland. On 13 July "a large party went ashore, sketching, geologizing, botanizing, and shooting. . . . The photographers, too, were not idle. Taking advantage of the comparative quiet which was enjoyed under the berg's lee, they managed to take excellent views in all directions."

Bradford went on to describe in detail aspects of Eskimo life, such as their manufacture of kayaks (one photograph showed "The Ugliest-looking Esquimaux Woman we found"); the geology of glaciers; and the habits, feeding grounds, and hunting of bears, seals, and auk. But above all he wanted to sketch and photograph as much as possible. To this end, he fitted out a studio on the forward deck, and, several times when the sportsmen were enjoying themselves, Bradford "went with the photographers to further enrich our collections. We obtained several fine views and sketches with which we returned on board." He would sketch an unusual iceberg from a number of vantage points, and from close up sought to catch distinctive structure and features. One evening he "remained on deck alone sketching the midnight sun in its various phases, in connection with Wilcox Point and the Devil's Thumb."

From Cape Desolation the vessel made its way northward to Iviktut, situated on Arsut Fjord at about latitude 61°. Here the hills were a mile high, creating one of the wildest and deepest sounds along the coast. Because of their proximity to the magnetic north pole, they now set a course by the sun for the Arctic Circle. Leaving the notable landmark of Black Head to starboard, they steamed into Melville Bay, and on into Karsut Fjord, dominated by one of the loftiest peaks on this coast, that of Kresarsoak or Sanderson's Hope, with an elevation of four thousand feet. Shortly thereafter, the company made Upernavik harbor, where they greeted Dr. Randolph, the governor of the district, whom Hayes had met on the Kane expeditions of 1853–1855 and again in 1860 and 1861. Fifty miles north of Upernavik, the group reached latitude 73° and made a last call at Tessiusak, the most northerly station in the district. Underway from there, the vessel headed for Baffin's Islands, passed Cape Shackleton to starboard, and headed for Wilcox Point. Now, well into Melville Bay, came the first view of the great promontory of the Devil's Thumb. Making her way northward still toward Cape York, the *Pan-*

ther finally came to a stop at latitude 75°, unable to find any further leads through the ice floes. It was mid-August and there was an increasing danger of being iced in. According to Bradford,

> We decided not to venture further unless the pack opened within the next forty-eight hours. This period I proposed to devote to ice studies. I certainly could have found no place better adapted for the purpose. The icebergs were innumerable, of every possible form and shape, and ever-changing. As the sun in his circuit fell upon different parts of the same berg, it developed continually new phases. On one side would be a towering mass in shadow, on the other a majestic berg glistened in sunlight; so that without leaving the vessel's deck I could study every variety of light and shade.

Retracing their steps during the last week in August and the first week in September, Bradford's crew arrived back in St. John's on 3 October, after a trip of three months and five thousand miles. Bradford not only had a number of sketchbooks full of drawings, he also had supervised his photographers in taking a complementary series of extraordinary pictures. In the 10 November (1869) issue of *The Philadelphia Photographer*, Dunmore recorded some of his recollections of photographing on the voyage. After some initial difficulties, such as a broken box of chemicals and two hundred sheets of glass cracked, replacements were made, and he was able to take pictures straight off. Once aboard, he and Critcherson got a carpenter to build them a darkroom; their method was collodion photography rather than daguerreotype, and consequently the albumenized glass would not keep for any length of time. Besides taking pictures of countless icebergs and coastal promontories, they photographed the Eskimos, their huts and villages, and occasional architectural ruins. Some unusual views were taken in the rain, but the most challenging of all were those of the sunlight in the midnight hours. Bradford himself noted the clear transparent atmosphere of the Arctic, which caused difficulty in determining distances and created frequent mirages. Dunmore related similar problems with too much reflected light across the expanses of ice. Among the more memorable instances was the approach of a family of polar bears. Dunmore recalled that "all hands were anxious for a shot, but I told them to let

me shoot first with the camera, which I did, and got two very good negatives of them from the topgallant forecastle."

Bradford's description was somewhat more lengthy:

> The photographers . . . came hurrying on deck with their instruments, and requested the privilege of taking a harmless shot on their own acocunt. The camera was arranged, and in a few seconds the group of bears was indelibly stamped upon the plate.
>
> This feat was more remarkable than the photographing of Jansen's house at midnight, as in this case the bears and the "Panther" were in motion. The promptitude and knowledge of their profession exhibited by Dunmore and Critcherson were worthy of the highest praise, and may certainly be considered as a most unique exposition of photographic skill.

To photographer and painter alike, the trip was an almost indescribable experience, and both were hard put to find language equal to what they had seen. But Bradford had sought to collect these various views not merely for documentary or scientific purposes, but, as he said, for the purpose of art. These were exotic and powerful images of a landscape that had special appeal for Americans in the second half of the nineteenth century. Not unlike the western plains and mountains of America, this northern wilderness possessed a terrible beauty. Its sublime vastness and purity made man especially conscious of his own scale and mortality. He was aware of time and age in the ever-present history of glacial geology and everywhere about him. Such a region was cause for both fear and praise.

IT IS NOT surprising that in describing the dramatic scenery of an Arctic fjord Bradford should find the landscape comparable to Yosemite. With the discovery and exploration of the west during the nineteenth century, Americans increasingly associated the great power and magnificence of this landscape with their own sense of national pride. Somehow the rightness of the American character and the freshness of Americans' ideals were reflected in the untainted wilderness of the continent. The cult of the New World was still very much alive in the nineteenth century, and American artists found perfect images of this raw beauty from Niagara in the east

to the Rockies in the west. A notable example was Bradford's contemporary Albert Bierstadt (fig. 71), who, although born in Düsseldorf, was brought up in New Bedford and returned there regularly after his trips to Europe or the western United States.

The two painters saw each other both in New Bedford and in New York. Like Bradford, Bierstadt also sought a landscape of newness among American plains and Rocky Mountains. His trip from Kansas to California and Oregon in 1863 was especially interesting because he was accompanied by Fitz Hugh Ludlow, an eater of hashish and visionary who kept a vivid account of the trip which he published in 1870 as *The Heart of the Continent: A Record of Travel Across the Plains and in Oregon*. Ludlow's written description perfectly complements the grandiose pictures that Bierstadt painted based on the trip.

Like Bradford and his entourage in Melville Bay, Ludlow and Bierstadt noted the increasing wildness of the landscape as they moved west, gradually leaving all forms of civilization behind them. Natural phenomena, such as storms, and native animals and birds seemed to possess a special primitive beauty. Just as icebergs and glaciers appeared as continental bridges, so too did "the river at our feet, on its way over dusky sand-bars . . . carry the message of the Rocky Mountain snows to the soft current of the Gulf and the mad waves of the Atlantic." Everywhere they were impressed with the awesome scale of nature, whether on the open plains or among the towering mountains. Necessary for capturing this superhuman character were both a language and a painting of exaggeration.

Ludlow's writing was exultant and expansive, and Bierstadt's and Bradford's canvases likewise grew in size as they proceeded, as if in physical response to their spiritual, even cosmic, visions. Both painters were impressed with the solitude they sensed in their respective wildernesses; human beings only infrequently appear in their paintings, and then as relatively small figures amidst the total panorama. The untouched purity of these "new worlds" took on religious associations for the American artist: Ludlow spoke of "going to the original site of the Garden of Eden," and often views in Yosemite reminded him of churches, both in the soaring quality of the buttes and the redwoods and in the mystical sensations induced. One paragraph from Ludlow's description of the Domes of the

3. Winslow Homer, *The Artist's Studio in an Afternoon Fog*, 1894

4. Albert Bierstadt, *Yosemite Valley*, 1866

5. J. Alden Weir, *The Red Bridge*, 1895

6. Martin Johnson Heade, *The Coming Storm*, 1859

7. John Frederick Kensett, *Forty Steps, Newport, Rhode Island,* 1860

8. Jackson Pollock, *Number 1, 1950 (Lavender Mist)*, 1950

9. Barnett Newman, *Vir Heroicus Sublimis*, 1950–1951

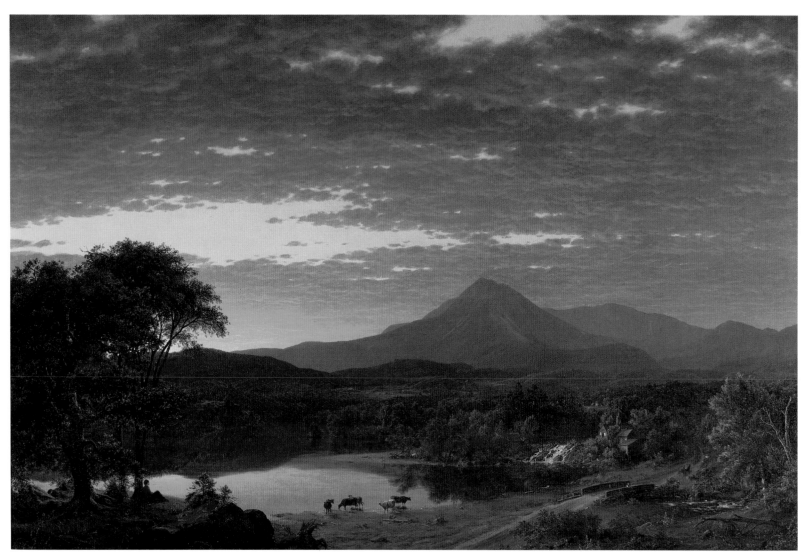

10. Frederic Edwin Church, *Mt. Ktaadn*, 1853

71. Albert Bierstadt, *Domes of the Yosemite*, 1867

109

Yosemite (Bierstadt's 1867 painting of the same subject, now in the St. Johnsbury, Vermont, Athenaeum, is one of his giant canvases) gives a sufficient idea of their feelings:

> Let us leave the walls of the Valley to speak of the Valley itself, as seen from this great altitude. There lies a sweep of emerald grass turned to chrysoprase by the slant-beamed sun, — chrysoprase beautiful enough to have been the tenth foundation-stone of John's apocalyptic heaven. Broad and fair just beneath us, it narrows to a little strait of green between the butments that uplift the giant domes. Far to the westward, widening more and more, it opens into the bosom of great mountain ranges, —into a field of perfect light, misty by its own excess, — into an unspeakable suffusion of glory created from the phoenix-pile of the dying sun.

Another book of great importance on a related subject was published in 1861 by the Reverend Louis L. Noble. This was *After Icebergs with a Painter*, and it was an account of a summer excursion to the Arctic seas in 1859. Noble was earlier known for his sympathetic biography of America's first important landscape painter, Thomas Cole, and now he set off on a new "voyage of life" with Cole's only and distinguished pupil, Frederic Edwin Church. Church was a close contemporary of Bradford's and the major rival of Bierstadt in the 1870s. Moreover, he knew both of the New Bedford painters in New York and shared with them common ideas about the meaning of these distant landscapes. Church probably drew the illustrations that were engraved for Noble's volume, and, like Kane's *Arctic Explorations*, may well have further inspired Bradford to go to the Arctic himself or even provided him with ideas for his own paintings of the icy landscape. Once more the purpose of the voyage was both artistic and scientific, as it was to be for many artists of this generation besides Bierstadt and Bradford. Noble's enthusiastic language and grandiloquent images are throughout punctuated with exclamation points. The icebergs remind him of every conceivable architectural style: Chinese temples, Gothic cathedrals, Roman baths. *Majestic* and *awful* are frequent adjectives to characterize the mysteries of the ice forms and the shimmering colors of the Arctic light.

The painter Church felt himself in the presence of an ancient geology, and this sense of natural history gave him a new consciousness of cosmic time. The sublimity of the experience derived equally from the incredible beauty and the ever-present danger. Magnificence and terror were inextricably joined. Such a vision had to be both physical and spiritual:

> All the sea in that quarter, under the last sunlight, shone like a pavement of amethyst, over which all the chariots of the earth might have rolled, and all its cavalry wheeled with ample room. Wonderful to behold! it was only a fair field for the steepled icebergs, a vast metropolis in ice, pearly white and red as roses, glittering in the sunset. Solemn, still, and half-celestial scene! In its presence, cities, tented fields, and fleets dwindled into toys. I said aloud, but low: "The City of God! The sea of glass! The plains of heaven!"

Church had a few years earlier gained an international reputation with the exhibition of his recently completed canvas of *Niagara* (fig. 78) in 1857, and now, following this 1859 excursion to the north, he painted the first of many Arctic scenes.

Already a devotee of the region by this time, Bradford in all likelihood both saw Church's first paintings of icebergs and read the Noble account. In any case, his own pictures during the next few years and his description of his 1869 trip with Hayes (in *The Arctic Regions*) are very similar (fig. 72).

Like Church and Noble before him, Bradford conjured up a variety of images for the icebergs that he saw: a row of cottages on a hill, a castle on the Rhine, the Coliseum in Rome, pagoda towers, a Titan rising from the sea, a half-buried Sphinx before a pyramid. He too returned repeatedly to the theme of overwhelming isolation:

> Gazing upon such a scene [Wilcox Point, the Devil's Thumb, the *mer de glace*], although illuminated by the midnight sun, the sense of solitude and desolation made a tremendous impression on me. No living thing was visible, neither bird, nor beast, nor insect. The unbroken silence was stifling, for none of us were [*sic*] inclined to talk; I could hear the pulsations of my

William Bradford

heart; a species of terror took hold of me; —words cannot describe it, neither can the pencil reproduce the grandeur and immensity of the scene, while the camera, with all its truthfulness to nature, falls far short.

On another occasion, Bradford noted, "From the elevation attained we had an unlimited view in all directions, and I was never so thoroughly impressed with the idea of desolation." In the photographs and canvases that resulted from this trip, that idea of desolation appeared in the large, only partly filled compositions, the recording of a few scale-giving details, and the stark contrasts of landscape and figures. Altogether, the 1869 voyage of the *Panther* had been a summary experience, and in the decade that followed Bradford's images of the Arctic regions would be popularly accepted as perfect representations of the American idea of wilderness (fig. 73).

72. William Bradford, *Arctic Scene*, 1870

73. William Bradford, *Abandoned in the Arctic Ice Fields*, 1878

William Bradford

A TEMPORARY SETBACK faced Bradford on his arrival in New York in the autumn of 1869: his patron LeGrand Lockwood had defaulted on payment of most of the journey's expenses. Fortunately the painter had both sufficient reputation and many friends, for the debt was paid by others before too long. More importantly, his work had come to the attention of Lord Lorne, who was enough impressed with Bradford's work to urge him to visit England. Accordingly, on 4 April 1872, as recorded by the *Brooklyn Daily Eagle*, "Mr. William Bradford, the painter of Arctic Scenery, sailed for Europe . . . in the steamer Algeria." With him were his daughter Mary and his wife, a Quaker from Lynn, Massachusetts, whom he had married as a youth in 1847 when sketching along the beaches in that area. Little more is known about his wife; a second daughter, Esther, had died in 1856 at the age of seven. Mary, however, was active in her father's behalf long after his death and gave her recollections in a talk at the New Bedford Library many years later.

The artist was well noted for his thoughtful and generous demeanor. In later life, the New Bedford historian Ellis remembered him as "the silver-haired, kindly-faced artist." This warm manner continued to serve him well in England, and he was cordially received by such notables as Professor Tyndall, Lord Lindsay, Sir Henry Holland, and Sir Roderic Murchison. Mary Bradford asserted that her father and Lady Randolph Churchill were the only well-known Americans in London at that time. As a Quaker, explorer, and artist, Bradford was in a unique position: his pictures and his company were equally sought after. Lady Franklin expected him at her table regularly, and when he missed an invitation, she would write, "Mr. Bradford, where are you? I haven't seen you for a week." On one occasion the Bradfords joined Napoleon III, Empress Eugenie, and the Prince Imperial for a lecture at the Brighton Geographical Society. Another time Bradford was briefly out of his London studio, leaving his sixteen-year-old daughter in charge. He instructed that "thee is to show people the paintings." A bearded gentleman was among the callers who meanwhile came in, and Mary courteously showed him around. At the conclusion of the tour he complimented her: "You are a very nice guide." At that point Bradford returned and recognized the famous visitor: "Why, Tennyson, how do you do?"

Without question the artist's most significant achievement was a special commission from Queen Victoria. The painting was an ambitious canvas based on his recent Arctic trip, *The "Panther" off the Coast of Greenland under the Midnight Sun* (1872; New Bedford Whaling Museum), and was hung in the private library of the Queen at Windsor Castle. Besides Victoria and the Duke of Argyle (who had earlier bought a picture from Bradford in America), Princess Louise, Lord Dufferin, the Duke of Westminster, the Baroness Burdett-Couts, and Baron Rothschild also acquired his work. Supported by this glamorous patronage, Bradford determined to publish his large volume, *The Arctic Regions*. When he appeared at the publisher, he was asked for a guarantee of sixty names. Having but six, he found that the publisher would not proceed with so small a list—to which the artist argued, "But look at what names I have." The first on the list was Victoria, and that was sufficient.

Bradford also began in London what was to be a successful second career of lecturing, which would occupy him during the last decades of his life. Mary Bradford tells of the time when her father was to speak before an important group of scientists. Just prior to his introduction by Tyndall, he was overcome with embarrassment until his host proclaimed, "You have seen what no man here has seen before—the birth of an iceberg." The painter followed with an enthusiastic discourse on a subject he now knew well. He gave talks at both the Royal Institution and the Royal Geographical Society of London.

Critical attention to his work in the current periodicals was favorable. *The Art Journal* of 1872, published in London, carried the following note:

A few years ago there were exhibited in London a small series of pictures—by Mr. W. Bradford, an American artist—descriptive of the frozen regions under different aspects. The properties of these works led the observer to the conclusion that in colour, balance, and formal character no such productions could be improvised, and that these were actual transcripts from the icy seas. Although the pictures adverted to were similar in feature, colour, &c., to those of which we have now to speak, the latter are seen for the first time in this country. They are respectively entitled "Crushed in the Ice," "Arctic Wreckers," &c.

The first represents the wreck of one of the numerous whaling fleet that annually fishes these waters. She has been caught between the masses of ice, and is heaved up on a pile of blocks, whereby her bulwarks are destroyed, and her timbers crushed in so far below the water-line as to show the impossibility of repair. Her bowsprit and all her upper rigging are gone, and much of the lower cordage has disappeared. Some of the boats have been saved, and the crew are actively engaged in preserving whatever they can from the wreck. The ill-fated ship lies near a lofty iceberg, which not only rises perpendicularly to a great height above the sea-level, but may have grounded at a depth of hundreds of feet below the surface. The "Arctic Wreckers" are a couple of bears which have discovered a boat that has been left frozen in the ice, and covered with an improvised awning of sail-cloth to keep out the snow. One of the animals endeavors to tear off the covering, while the other tastes, it may be, the provisions which may have been left in the boat. The animals are in excellent condition, and the incident has so much probability about it that it may have been witnessed by Mr. Bradford. "Arctic Summer" differs from the wintry scenes by presenting a comparatively smooth ice surface, and by being generally much warmer in colour, with a bright sky overhead. A more certain sign of confidence in the weather is a ship fully rigged; but although we are to understand that the season is summer, it is an arctic summer, and the entire sea view is a field of ice.

In addition to these pictures, Mr. Bradford had taken, during his sojourn in the icy regions, a series of photographs of the most interesting features of the frozen seas, of which the most remarkable are the mountainous icebergs that are floated off the lofty sea-barriers, and ground at a depth of hundreds of feet below the surface. The pictures of Esquimaux life are interesting, as we see those people in and among their tents of sealskin at Julianastaub, the largest settlement in Greenland, the population being about two hundred and fifty souls. The boats of the Esquimaux are of two forms, one is called kayak, being that appropriated to the male sex, while the oomiak is the name of that used by the women. Among the subjects of the views are "Cape Desolation," "The Devil's Thumb," several in Melville Bay, "Wilcox's Point," "Godhaven, in the Island of Disco," the rendezvous of the whalers as they reach the coast. The cliffs and mountains rise almost perpendicularly from the water-level to great heights; those of the Castle Fiord rise 3,000 feet, while the Cungnat mountains attain an elevation of 5,000 above the sea. These admirable photographs are wonderful as geological studies. Referring directly to the phenomena of the Glacial period, they explain the irresistible forces of which the traces of the action remain, and show the manner in which enormous masses of ice come down over the land, causing vast and extraordinary displacements. There is a view of Upper Navik, which is interesting as the most northern human settlement. Also in South Greenland the remains of a Christian church are shown, which was built by Eric the Red about A.D. 1000.

Mr. Bradford intends publishing, through Messrs. Sampson Low & Co., a selection of these views with descriptive letterpress, which altogether must form the most instructive work on the frozen seas that has ever appeared. We shall have to refer to it again.

The next year *The Art Journal* again took note of Bradford's work:

THE ARCTIC REGIONS.—Last year Mr. Bradford, an American artist of distinction, exhibited a series of views of portions of the icy regions, with a variety of day and night effects peculiar to that part of our globe, rendered with a truth which no artist has ever yet been able to attain, because none has ever before enjoyed the advantages which were opened to Mr. Bradford. In a previous notice we mentioned that the Queen had given a commission for a picture. That work is now finished, and is exhibited, with some others that Mr. Bradford has with him, at the Langham Hotel. It is a small composition of few parts, but a strong interest attaches to it from the entire party having been nearly lost at that spot. The principal object is a large iceberg, rising as usual from a level base to a great elevation. It seems to stand alone: far as human vision can penetrate there is no other block to break the drear monotony of the measureless expanse that stretches away under the eye to the dim horizon. The col-

our of the ice is of the most delicate pink, and it is assumed that such is its natural hue. Her Royal Highness the Princess Louise, Marchioness of Lorne, has also commissioned a picture, being a view of an extent of ice-cliffs—a frozen solitude as usual—but showing the remarkable features into which are resolved the elements acted on by the temperature prevalent there. Mr. Bradford's are the only works which profess incontrovertible truth in the representation of the northern regions; and when we consider the magnitude of the expedition which has been fitted out for the purpose, it cannot be supposed that any other similar scheme will be entered upon for a like purpose. The vessel employed was a steamboat called the *Panther* and her company, all told, consisted of forty persons, of whom Mr. Bradford was chief and director; and among the skilled and scientific hands were artists, photographers, a medical staff, and a variety of persons, to whom the auxiliary operations of photography and certain of the sciences were known. The result is a glorious display of icy landscapes from the far north, abounding with colour which never entered the thought of painters who have not seen the places Mr. Bradford has, and far away from land, yet with every appearance of being sections of coast-scenery.

Returning to America after several years, Bradford was elected to the American National Academy in 1874. Now his European triumphs were well known to his American colleagues, as the painter Jervis McEntee indicated. McEntee entered in his diary on 7 March 1874 that he "had a very pleasant call from Governor Howard of Rhode Island, Mr. Chase and their wives. Bradford who deals in governors and crowned heads brought them in."

Settling into his Tenth Street studio, Bradford generally passed his winters in New York working on paintings from the countless Arctic sketches he had amassed in the preceding decade. During the summers of the 1870s, he had a studio in New Bedford that afforded a good view of the Acushnet River and part of Buzzard's Bay. With plenty of material at hand, he had all the sources for painting that he could foreseeably want. An older man too, he doubtless found hard traveling less appealing. Consequently, he preferred to work more completely in his studio, carefully working up his sketches into elaborately calculated canvases. Just as his methods of working were modified, so also did his later style of painting begin to change.

IN DEVELOPING the last major style of his career, beginning in the mid-1870s and lasting through the 1880s, Bradford made use of two principal sources for his art: the photographs of the Arctic and his pencil drawings. Most of the photographs are very carefully composed, often juxtaposing rising cliffs or icebergs with flat expanses of water. Sometimes bears, sailing vessels, or distinctive bergs are seen isolated against an otherwise empty panorama. Bradford and his photographers had a keen eye for contrasts of light and shadow: the white edges of a berg caught against the dark of sky or water, the dark silhouette of a boat's sails or rigging seen against the white ice. A number of his paintings from the 1870s clearly derive from photographs such as those published in his *Arctic Regions* (fig. 74). The countless shapes of icebergs and the various positions of their vessel at anchor or underway were all available in this remarkable photographic archive.

An even larger inventory of source material existed in the drawings and oil or wash sketches. Whereas the photographs were more useful for overall compositional designs, the sketchbooks contained a myriad of details that could be used to fill in a large canvas. Of the relation between photography and art Bradford expressed no doubt when he wrote:

> The wild, rugged shapes, indescribable and ever-changing, baffle all description, and nothing can do them justice but the sun-given powers of the camera. And even that must fail in part, for until re-touched by the hand the glorious phases of color remain unexpressed.

In short, the photographs could provide some of the documentary evidence that was one basis for his art, but the artist's hand—and presumably his discriminating mind—were necessary for elevating a scene to produce something aesthetically satisfying and instructive.

From the number of sketchbooks and individual drawings that have survived (many of which now are in the New Bedford Whaling Museum), it is likely that Bradford must have filled at least a couple

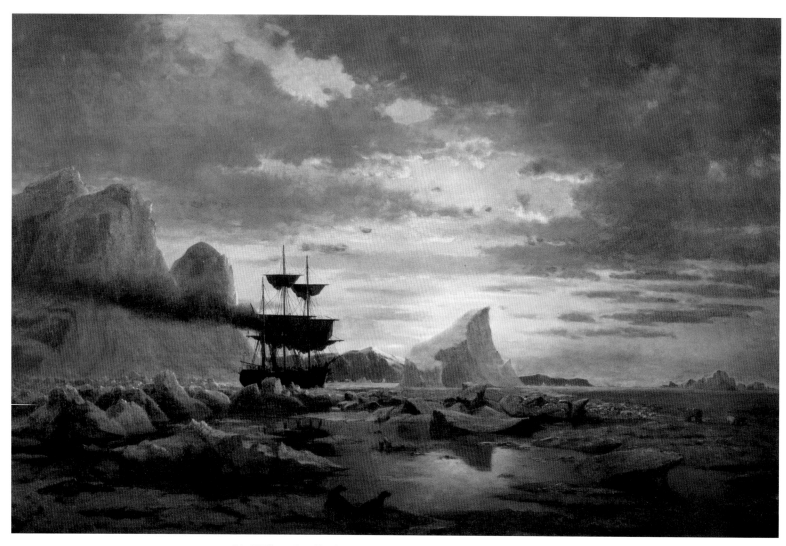

74. William Bradford, *Ice Dwellers Watching the Invaders*, c. 1870

116

of sketchbooks on each of his Arctic voyages in the 1860s. The smaller books he usually opened out flat and on them drew one continuous drawing across two pages, thus accommodating the panoramic qualities of his scenes. These smaller books also seemed to contain the more improvisory and spontaneous sketches. He would note the broad outlines of a particular coastal or mountain view, working only in pencil. With the side of the pencil point he might fill in a few details, and finally he would jot in with words what was to be shadow, snow, "mount dark in distance," "lighter than others," or "bright gray with dk patches."

The larger sketchbooks show that Bradford continued the practice of using contiguous pages for a single view, but also made more extensive use of individual-page drawings. Generally, however, they are more varied in subject, execution, and function. There are sketches of fishing huts and wharves, and several attractive harbor views, one, for example, identified as "in Squam Island harbor Labrador 6th mo 30 1864." Another group naturally enough are of different types of icebergs. In some instances, Bradford depicted only one large berg, perhaps with a vessel anchored nearby to give scale; in others a page might be filled with almost half a dozen small views of icebergs seen from several vantage points to reveal their external characteristics and internal structure. On these larger pages, he also heightened his pencil lines with white and black charcoal, the better to render shadows and three-dimensional effects. From his own account it appears that often the degree of finish was directly related to the measure of his excitement for particular details or views:

> Leaving the others to their various pursuits, I wandered, sketchbook in hand, on my particular mission. But there were so many elements of novelty around me to attract or distract the attention, it was difficult to do more than sketch some outlines, which possibly may be reproduced at some future day.

Still another group of drawings were devoted to various vessels underway by sail or steam, anchored in harbors or alongside bergs, and crushed or abandoned in the ice floes. A few are titled: "Sealer under sealing sail," "Sealer forcing her way through the ice to get where the seals are, under all sail," "Camped out on the ice—sunset." Almost all have a freshness and vigor of observation that is—

unfortunately—often missing from the finished oils that were to come shortly after them. Bradford also interspersed these observations with sketches of figures, sometimes only one or two figures to a page, which usually turned out to be portraits, as for example the one entitled "Patrick Marratty." In these he is interested in catching the familiar gestures of the body, its stance, posture, and movements. He renders convincingly the figure standing, seated, asleep, or working. Occasionally notes are attached indicating "drab leather corduroy breaches, old canvas jacket," or "Blue outer shirt with purple under shirt, Dirty duck trousers." Other pages show groups of men rowing, pushing, or hauling dorries through the ice.

The final type of drawing was more elaborate and combined many of these individual details into possible composite arrangements for future paintings. In these Bradford usually establishes a horizon line as field of reference, and experiments with varying combinations of figures, vessels, and icebergs. Likewise these are more carefully finished with pencil outlines and shadows, as well as black and white chalk heightening. His observations are similarly more extensive: "in the winter sealers carry a topsail on the main mast—which they carry instead of the mainsail"; "ice in ridges and then somewhat level"; "Sometimes the masts are cut away and left while thrown up on the ice"; or, one of the most interesting:

> When the seals have been drawn over the ice to the vessel it [sic] leaves the marks of Blood on the ice. The boats are sometimes turned up gunwhale to each other, and a fire built at the end. Barrells [sic], chests and boats old clothes plank rigging etc on the ice when abandoned.

Bradford was an especially sensitive colorist, and in *The Arctic Regions* he carefully distinguished a whole range of yellowish tinges in the fur of an old polar bear near the steamer one day. Most of the drawings also include color notes. One has at least a dozen different colors indicated, from the more obvious "Blue shirts and red cravats," "yellow sou'westers some with light gray pants," to the more subtle notations of "a very dirty Brown on legs making it a rich warm brown," "delicate green," or "this cake a roseate hue." Within a dozen successive paragraphs of his book, he could refer to inky blackness, dark green hue, palest blue, snow-white wall, satin white,

streaks the color of Prussian blue, pinnacles bathed in sheets of blood-red flame, body jet-black.

This repertory of sketchbook drawings was supplemented by a number of larger wash, oil, and charcoal sketches. Each type provided a means of recording different details or effects, and Bradford moved with care through each, combining or synthesizing as he went along. Using a small brush and dark sepia washes reminiscent of Van Beest, Bradford caught in these intimate paintings the constantly changing atmosphere of the north. With broad loose strokes he could suggest the rocky beaches and promontories, and the tip of the brush permitted him to fill in with more precise detail occasional sailboats or figures. But most notable in such sketches are the broad cloud effects, some with light breaking through, others building up for a storm. Unlike the pencil drawings, these have a fluid, translucent character that adds a distinct quality of mood; at the same time they remain accurate notations of specific weather conditions. Although few have apparently survived, Bradford did indicate the completion of "a number of excellent studies in oil." The ones we do know are usually without figures; in them he has exploited differing directions and widths of his brushstrokes to convey textures, light effects, and mood. These oil studies were on both paper and panel, and possess an immediacy unique in his work.

From the successive stages of the sketchbook drawings of specific details, the different compositional arrangements, and the atmospheric studies in wash or oil, Bradford then moved (when he returned to his studio) to large-scale charcoal drawings. He used pencil outlines filled in with both charcoal and Chinese white. The method was similar to that used for a few details in some of the small sketchbook drawings, but was now employed throughout the fully planned composition. These were in effect final studies preparatory to the painting of a large canvas. Although without color, they contain a wide range of tonal effects and textures. The best examples retain an impressive grandeur worthy of his firsthand experiences.

It was, however, in the next stage of work that an unfortunate tightening and a mechanical character entered his efforts. Before commencing a major canvas in this later period of his career, Bradford got into the habit of drawing an elaborate outline on his primed canvas, which he then began to heighten with charcoal and chalk.

The unfinished *Nares Expedition* in the New Bedford Whaling Museum is one of the more successful results. Other unfinished canvases also show the varying combinations of pencil, oil wash, charcoal, and chalk that he used to block in the major components of a picture before actually applying the colored oil pigments. At their least successful, one becomes increasingly aware of a calculated quality stripped of that suggestive spontaneity found in the prior sketches.

As Bradford became farther removed during the 1870s from his firsthand visions of the Arctic, his pictures relied increasingly on incorporating images from his collection of drawings and photographs. The danger, of course, was repetition, and he succumbed to this temptation frequently in the 1880s. In these years, though, his work was not without originality and innovation. Closely related to the large-scale canvases carefully arrived at through preparatory stages are his few attempts at printmaking. One can well imagine that working on a chromolithograph or etching could assist further in the resolution of a large compositional design. Whereas his chromolithographs had a generally flat and dry character, his etchings possess the same spacious luminosity of his best finished drawings. He clearly understood how to get the maximum effects out of the etcher's needle, and was able to create shimmering textures, a full range of light and dark tonalities, and a convincing sense of space and form. His etchings do not technically imitate his oils; on the contrary, they lend a new dimension altogether to his career as an artist.

In a number of Bradford's canvases of the 1880s, he has obviously reused successful formats, shifting from one canvas to another the same iceberg or vessel but placing it in a slightly different relationship to other elements. It was as if he had created a theater stage setting in which he might repeatedly slide around the props and actors. So a ship with all sails set will appear in more than one picture but moved from one side of the canvas to the other; or figures hauling fishing nets from a dory might be moved from the right foreground in one setting to the center middleground in another. Possibly the mechanical nature of photography had confirmed Bradford in this procedure. In any case, the final step for him was to photograph his own finished paintings propped up on an easel in his studio. This served at least two purposes: he could retain exact visual

records of what he had produced and he could make transparencies to illustrate the lectures he was now giving.

Beyond this there is no better evidence of the intimate relation between painting and photography in the late nineteenth century, whether physically, visually, or philosophically.

A WEAKNESS for the grandiose in subject as well as scale of canvas, calculated repetitiveness, relatively looser brushwork, and frequently hot, metallic colors typify Bradford's late style. Like Bierstadt, he indulged in the melodramatic effects of a vivid sunset, and favored the use of oranges and reds in many of his pictures of the mid-1880s. The drawing is often much less sure and crisp, and for details requiring emphasis the paint is laid on much more thickly than before. Even now Bradford was still capable of major works, and in some of the very large late pictures he carries off the bombastic drama of man and nature beneath the midnight sun.

Instead of going to the Arctic again during the 1870s and 1880s, Bradford traveled widely in the United States. Probably at the instigation of his friend Bierstadt, he spent considerable time in the west. He actually had a studio in San Francisco for seven years, and painted during this time in the Yosemite and Mariposa Valleys as well as in the Sierra Nevada mountains. Evidently, the local artists were not pleased to have an easterner among them. They pejoratively referred to him as "the Chamber Painter" because he chose to use a bedroom as his studio. The writer Bret Harte was especially acerbic, and asked one time during a visit to see Bradford's work, "What are you doing up in a bedroom painting?" The painter replied that the space was ample enough, and all was apparently smoothed over when Mrs. Bradford provided Harte with a drink.

A fair number of Bradford's paintings done in the west are unfinished, and a group of more than two dozen canvases from this period with little more than pencil outlines on them was discovered not long ago. Of the finished works, none is more impressive than his view of *Mount Hood* (1882; fig. 75) and *Sunset in the Yosemite Valley* of 1881 (private collection). Both have a monumentality and power that recall his starkly towering icebergs painted a decade earlier. His Yosemite scenes also bear a striking resemblance to similar views by Bierstadt, both in organization and in the strong, dramatic colors, a

similarity that suggests again that Bradford knew well his colleague's work of this period. He also did a number of oil studies in the mountains of California, with a fluid, textural brushwork, which stand out among the grander melodramas that came from the studio.

Having proved a success as a lecturer in London, Bradford began to go on tour giving illustrated talks during the 1880s. He made use of the photographs taken on the *Panther*'s voyage of 1869 as well as of transparencies taken of his own drawings and paintings in the studio. One of his own photographs, for example, shows a drawing pinned to a board with a notation beneath to "make a transparency of this one above." Ellis noted that Bradford also gave a series of six lectures before the Lowe Institute in Boston. Called "Glimpses of the Arctic Regions," they recounted the Norse discovery of America and concluded with a review of life in the far north and some of the details of the Greeley rescue expedition. They were "illustrated by scores of photographic views, many of which were taken by the artist himself." The reference to the Norsemen is interesting because it reveals how much the artist felt himself in the presence of history's record when visiting the Arctic.

A good summary estimation of Bradford's art and photography at this time may be found in a lengthy article that appeared in *The Philadelphia Photographer* in 1884:

A few hours after the visit by us to the new art gallery of Mr. Ryder, at Cleveland, described on another page, we found in our box at the hotel the following: "Mr. Ryder's compliments, and requests the pleasure of your company to a private view of the paintings of Mr. William Bradford, of New York, from sketches taken by him on his several extensive visits to the polar regions. During the evening Mr. Bradford will give a short lecture with photographic illustrations of the wonders of that mysterious land, the same as those given by him before the Royal Institution and the Royal Geographical Society of London, and also the Geographical Society of New York, on Thursday evening, October 18, 1883, at eight o'clock."

To such a splendid offer as this we could make but one answer, namely, that we would take advantage of the offer. And in due course we put on a thick overcoat, repaired to the scene

75. William Bradford, *Mount Hood*, 1882

of action, and propose now to tell our readers a little of what we saw.

Entering Mr. Ryder's art gallery we found Mr. Bradford in evening dress, meeting his guests. He is a courteous, quiet, rather timid gentleman, highly cultivated, and is a delightful conversationalist. Some twenty or thirty of his magnificent paintings of the Polar regions and the Yosemite Valley were hanging upon the wall in great variety of color and subject. Not being a professional art critic, it would be unbecoming in us to do much more than express our delight at such a treat. Mr. Bradford's reputation as a Polar Sea painter has been long established by his lovely reproductions of the picturesque scenery along the Nova Scotian and Labrador coasts. He is what may be called a *truthful* painter, following nature conscientiously, adorning her, or changing her but little, except where her arrangements do not suit the limits of his canvas. All this excellency of Mr. Bradford's work is easily accounted for when we know the man, noble, generous, broad in his views, full of the intensest, tenderest art feeling, with a quick perception of what is beautiful and effective. As we have said, his pictures present a great variety of the natural bits, which have been caused by pushing and driving and dragging, and discharging and upheaving of nature's forces, creating glaciers and icebergs, and drifts and masses, and pictures grand to look upon, all inspiring, and creating in the breast most earnest desires to see and know more about where they grew.

Not only do we have these lovely bits of nature, which fill the mind with a most profound and poetic feeling and aspiration, but we see here and there, locked up among them, the noble vessel which carried our traveller and his party into the region of coldness. Here and there groups of travellers and natives, snow-bound or ice imprisoned, or else again engaged in the active pursuit of the huntsman, fighting for life with the great monsters which are seen in those strange regions. We of course became greatly interested in Mr. Bradford's pictures, and could fill our magazine this month in their praise, and in descriptions of them, but perhaps a few details concerning his excellent lantern exhibition will interest our readers the most.

We will leave his masterly paintings to the imagination, knowing full well that we cannot give any idea of their intrinsic value or beauty. After the exhibition of his paintings, Mr. Bradford delighted his audience for nearly two hours, exhibiting to them from photographic views made by himself, nearly one hundred splendid transparencies of the people in the cold regions named, of their houses, their means of living, and, above all, the magnificent scenery which is to be found among the ice kings and frost fairies of the fiord and berg.

Mr. Bradford is not only a splendid painter, but an enthusiastic photographer. He was one of the first painters to perceive the value of photography as a helper to the painter. As early as 1863 [*sic*] he fitted out an expedition to the Arctic regions, taking with him two of our old subscribers, Mr. John B. Dunmore, of Black's studio, in Boston, and Mr. George B. Critcherson, of Worcester, upon that eventful occasion. More than seven hundred negatives were made of studies of the coast scenery, of the people, of the fleet, of the travellers, of animals, and the eccentricities of the icebergs, and what not, pertaining to the perilous life in the Arctics.

In conversation with Mr. Bradford he admitted most gladly the great service which photography had been to him. He commented upon the systematic scouting at the idea that photography could help them, indulged in by artists a few years ago, very severely, and, as he warmed up to the subject, he said enthusiastically, "Why, my photographs have saved me eight or ten voyages to the Arctic regions, and now I gather my inspirations from my photographic subjects, just as an author gains food from his library, and I could not paint without them."

"Only a short time ago," he said, "I employed a steam yacht, and followed a whaler from New Bedford a great many miles out to sea, making instantaneous views of her, in various positions and changes of light and shade, and gathering into my stock studies which will be worth their weight in gold, to say the least." The more we conversed upon this subject, the more enthusiastic Mr. Bradford became, and he seemed to exhibit his lantern transparencies with the pleasure and enthusiasm of a real photographer, describing them eloquently, as he did the

production of his own special genius spread over the canvas in the art gallery below.

Mr. Bradford's example has had much to do with inspiring other painters with respect for photography as a help to them, so that now it would be a little difficult to count the number of artists who employ our art to assist them in the production of their splendid results. It is therefore but proper that this fact should be recorded and sent down to posterity within the pages of the photographic magazines. Certainly we are very glad to add our praise, not only, but our thanks for the persistence with which Mr. Bradford has for so many years stood up for the advantages of our art.

William Bradford singlemindedly devoted himself to his art from his early youth to the time of his death. While some periods of his career are more appealing than others, some styles more natural and original, some works more successful, his life is significant in combining several nineteenth-century preoccupations. His experimentation with and mastery of photography, his scientific and romantic bent in exploring the new world of the Arctic, his equal love of fact *and* imaginativeness all mark him as an American artist of undervalued merit. When he died at the age of sixty-eight on 25 April 1892, just eight years away from a new century, he left behind a remarkable testament to a world that Americans would soon find inevitably changed.[1]

8

Fire and Ice in American Art:
Polarities from Luminism to
Abstract Expressionism

THE HISTORY of modern art celebrates the abstract expressionist movement as the first decisive assertion of originality and independence in American painting. Writing of the painters in this group, Clement Greenberg stated in 1955 that "their works constitute the first manifestation of American art to draw a standing protest at home as well as serious attention from Europe. . . . This country had not yet made a single contribution to the mainstream of painting or sculpture."[1] One interesting consequence deriving from this cultural self-esteem has been the emergence in the last decade of serious scholarly and popular attention to America's art of the nineteenth century. As historians more precisely perceived the phases and varieties of early landscape painting, they focused particularly on luminism as a distinctively imaginative national expression.

Indeed, Barbara Novak has argued that "luminism is one of the most truly indigenous styles in the history of American art."[2] Its most noted practitioners included Fitz Hugh Lane, Martin Johnson Heade, Sanford Robinson Gifford, and in varying degrees other painters associated with the later Hudson River School. Luminism as a style was most popular generally between the late 1850s and early 1870s. Its most distinguishing features included spacious landscape compositions, often emphatically horizontal in format, with conscious attention to serenity of mood, glowing effects of atmosphere and light, and thin, tight brushwork suitable to their crystalline visions of nature. Like abstract expressionism a century later, luminism provided a revealing index of the national temperament in its time and place.

It is one of the curious features of historiography that a notably powerful movement or style in contemporary art will often help to reveal similar but previously unappreciated characteristics of an earlier school or mode of art. We know how the example of Van Gogh provided a vehicle for the first modern appreciation of El Greco's work. It is no surprise that in the wake of pop art should follow new interest in the realism of Grant Wood and American art of the 1930s. Natural too are the connections we can now draw between the ambitious earthworks of recent years and the bold large-scale photographs taken across the American west a century ago.

In fact, luminism and abstract expressionism share certain characteristics.[3] Together they form a major parenthesis around the evolution of American art over the last century. Luminism is the culmination of the country's first nationalist expression in painting, the Hudson River School, while abstract expressionism towers as a

central development of twentieth-century art, continuing to possess vital influence today. In their consciousness of the spiritual as well as physical presence of the country's landscape, their celebration of an expansive continental and pictorial scale, their evocation of both personal and national energies, the two movements present telling distillations of the American character.

There are, to begin with, interesting parallels in their developments. The founding figures in each period were Europeans who emigrated to America against a background of political turbulence in Europe—the Napoleonic wars at the beginning of the nineteenth century and the disturbing events leading up to the Second World War during the second quarter of the twentieth. Within a narrow period of ten years just around 1800, a number of painters crossed the Atlantic from England and the Continent, among them Thomas Birch, Francis Guy, Michèle Félice Corné, William Groombridge, Robert Salmon, Joshua Shaw, and, most importantly, Thomas Cole. During the early decades of the new century, this group began the first comprehensive recording of American city views and landscape scenery along the eastern seaboard. Cole particularly came to articulate a national consciousness through his paintings, which we now recognize as the beginning of America's first major landscape style. Out of his ideas and formulas, the luminist style emerged in the hands of the second-generation Hudson River School painters who followed him.

Similarly, two key figures in formulating the basic language of abstract expressionism were European-born: Arshile Gorky, who came to the United States in 1920, and Hans Hofmann, who arrived in 1932. Furthermore, at the beginning of the Second World War, several exponents of surrealism in Europe fled to New York, providing a major stimulus for the course and character of abstract expressionism. Among them were André Breton, Marc Chagall, Salvador Dali, Max Ernst, André Masson, Matta (Matta Echuarren), and Yves Tanguy. Moreover, two of the foremost abstract expressionists, Willem de Kooning and Mark Rothko, also foreign-born, made their way to New York in the mid-1920s. It is a paradox that at these two crucial moments in the history of American art Europeans should have catalyzed the definition of the country's most original and nativist painting.

Incidentally, the greatest collection of Hudson River School and luminist painting ever formed was that of another foreigner, the Russian émigré Maxim Karolik, who presented it to the Boston Museum of Fine Arts in the late 1940s, at the very time when the abstract expressionist movement was approaching its fullest expression.

The art of Cole in the nineteenth century and that of Gorky and Hofmann in the twentieth fused the major conceptual polarities of style pursued by their respective schools. In Cole's work, it was accomplished through his dual attention to the real and the ideal; in Gorky's and Hofmann's, through their combining the pictorial language of autobiographical gesturalism with meditative environments. Yet even though these painters stood as the artistic fountainheads for a succeeding generation, they paralleled one another as well in their acknowledgments of past masters. Cole, for example, wrote that for his understanding of the sublime he had "only to appeal to Claude, G. Poussin, and Salvator Rosa," and proclaimed "Turner as one of the greatest Landscape painters that ever lived."[4] For his part, Hofmann owed an early debt to the work of Robert Delaunay, Vasily Kandinsky, and Piet Mondrian, as well as to aspects of cubism and Fauvism. Gorky even more consciously served an apprenticeship with European masters, admitting in his familiar statement that "I was *with* Cézanne for a long time, and then naturally I was *with* Picasso."[5]

Paradoxically, the American vision has been sometimes explosive, sometimes contemplative, although that paradox has usually reflected the larger struggles of the country divided within itself or uneasy about its relationships abroad. Both luminism and abstract expressionism have two aspects: the dynamic and the calm, the exclamatory and the reflective (figs. 76 and 77). Historians have regularly referred to these polarities, but for the most part have neglected to elaborate upon why they coexisted in each movement.[6] Also, traditional discussions (much more so in the case of abstract expressionism) have tended to define the dualism primarily in formal terms, often at the expense of probing meaning and content.

Although Barbara Novak has pioneered in the philosophical and metaphysical interpretation of Hudson River and luminist painting, she continually returns to formal issues:

76. John Frederick Kensett, *Sunset, Camel's Hump, Vermont,* c. 1851

77. Franz Kline, *Chief*, 1950

For luminist light largely derives its special quality from its containment within clearly defined geometries and sometimes, too, from the opposition of its brilliance to the ultraclarification of foreground detail. . . . the stepped-back planes so characteristic of luminist space are retained, and the small impastos of stroke are carefully aligned so as not to disturb the mensuration.[7]

James Thomas Flexner evidently fears outright any effort to probe the iconographical and ideational substructure of American art, when he writes: "As for iconography: the most useful study for analyzing the content of Hudson River School landscapes would be a subject outside the usual scope of art historians. It would be forestry."[8] This is like asserting that discussion of still-life painting should be confined to cooks.

Discussions of abstract expressionism have devoted comparable attention to formalist aspects, owing both to the influential criticism of Clement Greenberg and to the popular assumption that abstraction cannot possess precise or comprehensible, if any, meaning. We generally think of abstract expressionism's foremost significance as residing in its formal inventions of new pictorial space, line, and figure-ground relationships. In title and explication, Greenberg's important essay, "The Crisis of the Easel Picture," focused on these elements:

This tendency appears in the all-over, "decentralized," "polyphonic" picture that relies on a surface knit together of identical or closely similar elements which repeat themselves without marked variation from one edge of the picture to the other. It is a kind of picture that dispenses, apparently, with beginning, middle, end.[9]

On one level the literal or implied panoramic scale of canvases from both periods surely recalls the continuing American association of its vast landscape with the national identity. The pulsing surges of energy, seemingly uncontainable within the picture's framing edges, characterize equally the view of nature described in Frederic Edwin Church's *Niagara* of 1857 (fig. 78) and that embodied in Jackson Pollock's *Lavender Mist* (fig. 79) almost a century later. The

latter, of course, is no actual landscape, although it is very much an American environment. The title "New York School" given to Pollock and his colleagues refers prosaically to the place of their gathering as well as suggestively to this new American landscape of density, monumentality, and dynamism.

One of the central and significant features of pictures in these two movements is their conscious emphasis on horizontality of format. Church pioneered in this new expansiveness with *Niagara*, whose proportions attenuated the traditional ratio of width to height in order to express a specifically American sensibility of geographic and pictorial space. David C. Huntington quotes the experience of a contemporary observer of Church's work: "Here there is room to breathe. Here the soul expands."[10] Heade was strongly affected by this example, as Theodore E. Stebbins, Jr., has shown, in his landscape paintings of the next decade.[11] Pollock similarly exploited emphatic lateral proportions for many of his canvases, to which Barnett Newman responded by pushing toward a ratio of even more than two to one. Thomas B. Hess has argued that Newman's extra-wide canvases not only attain a greater dynamism but also possess suggestive metaphysical and mystical associations (figs. 80 and 81).[12]

Still, we must explore the reasons for such expressions dominating the artistic imagination in the mid-nineteenth century and again in the mid-twentieth century, as well as for the contrasting stylistic modes running parallel through each school. On a deeper, more shadowy level, there lies the important context of internal national tension combined with divisive foreign involvements dominating both periods in American life. Certainly one of the crucial events in the middle of the nineteenth century was the Civil War—preceded by the contentious forces of westward expansion and issues of national union, as well as by engagement in the Mexican War, and succeeded by the exacerbating effort and failure of Reconstruction.

It is this larger atmosphere and reality of anxious division in the national psyche that helps to explain the growing shrillness and sense of conflict, even a hint of artistic schizophrenia, in the culminating period of luminist painting just around 1870. Some have been unsure how to define exactly what seem to be the shifting edges and center of the luminist movement: who precisely is to be included and excluded; when it began and ended; why most paintings

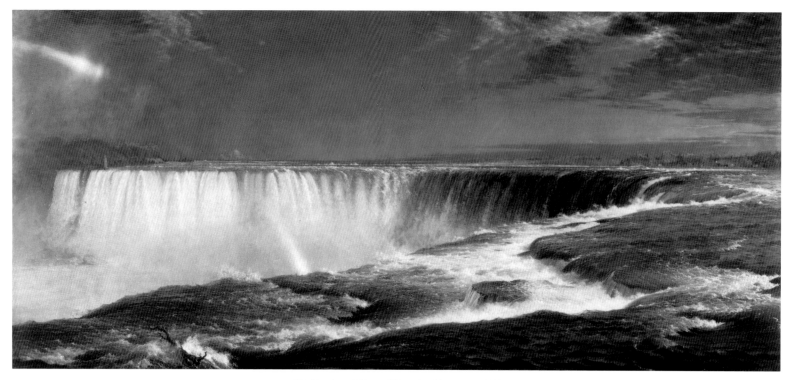

78. Frederic Edwin Church, *Niagara*, 1857

of Lane, Heade, and Gifford surely belong within the canon, while others by their colleagues Church and Albert Bierstadt appear problematic.[13] Many identify Church's splendid *Twilight in the Wilderness* (1860; see fig. 50) as quintessentially luminist for its incandescent red and yellow light and its heroic spiritual message, but remain uncertain about classifying *Cotopaxi* (1862; fig. 82) and his other, similar canvases of the erupting South American volcano. Yet the explosive violence of this series seems to be an equally revealing index of its time—and indeed very much a part of the day's cultural consciousness.

When we turn to Church's friend Heade, we should first acknowledge two significant points about his work and career: that he painted similar visions of threatening forces alongside of extraordinarily serene and contemplative marsh scenes, and that he traveled extensively, almost compulsively, throughout the 1860s and 1870s. But the crucial fact is that his few great storm pictures—*Approaching Storm: Beach near Newport* (c. 1865–1870) *Thunderstorm over Narragansett Bay* (1868), and *Ometepe Volcano, Nicaragua* (1867)—all date from the decade of the Civil War (figs. 83 and 61). In this light we also ought to note that even in his beautiful record of *Lake George* (1862; fig. 84) are a dryness of form and stillness of mood that hover on the foreboding. Finally, one has to wonder if it is due to more than coincidence, more than a shared interest in transient light effects, more than the new availability of hot cadmium colors, that

79. Jackson Pollock, *Number 1,
1950 (Lavender Mist)*, 1950
(Color Plate 8)

80. Barnett Newman, *Vir
Heroicus Sublimis*, 1950–1951
(Color Plate 9)

129

81. Barnett Newman, *First Station*, 1958

the foremost "twilight" pictures of Heade, Church, and Gifford date from the 1860s, when loss of day may well have seemed to signify the loss of national unity.

In this regard, it is worth recalling that Lane, the earliest of the luminist painters, had reached the maturity of his career during the previous decade of the 1850s and died in 1865. He thus never had to face, consciously or unconsciously, the psychic ravages of an America at the close of its Civil War, and his art accordingly is without the apocalyptic or menacing notes sounded by Heade and Church in subsequent years.

Heade was also the prototypical luminist in his peripatetic wanderings. Even his choice of the marshlands for his most familiar paintings is revealing. They were not only scenes of isolation in a nearly uninhabited landscape, with saltwater streams significantly meandering throughout, but also unstable environments, changing with the tides, in a world between land and sea. Heade painted the marshes up and down the Atlantic coast, from Newburyport in Massachusetts to the Everglades in Florida (fig. 85). Beyond this he traveled unceasingly around the United States and abroad, from New York to Boston, to the middle west and the west coast, to South America and Europe more than once.

The middle decades of the century also found Church on the move to South America and the Arctic (fig. 86), while others of his generation such as William Bradford, James Hamilton, and Gifford set off to paint the northern icebergs or sites in the Mediterranean and the Near East. Although such journeying was a pursuit—the pursuit of a wilderness frontier fast disappearing within the continental United States—it was also a flight, the flight from a turbulent and disquieting world at home.

If striking oppositions of mood surface in luminist painting of the Civil War years, there appears to be an equally deep cleavage within abstract expressionist painting between the aggressive gesturalism of Pollock, Franz Kline, and de Kooning and the color-field meditations of Rothko, Clyfford Still, and Newman. Yet the compulsiveness of the one and the brooding calm of the other are fused in their context of a country nominally at peace in the postwar period, but paradoxically engaged in the Cold War, itself a contradiction in terms. We had "brinkmanship" in foreign policy and a "silent gen-

eration" in college: open threats of extreme action by the government, and deep repression of feelings by the student population. Emerging from the Cold War years was America's involvement in Korea and Southeast Asia and all its accompanying internal divisiveness. So again in the middle decades of the present century the United States became embroiled in foreign and domestic discord. The stylistic polarities in American painting make an appropriate index to such broader tensions in the national scene.

The abstract expressionists were not quite the restless travelers many of their luminist predecessors had been; at the same time a measure of wandering and escapism infected their careers too. From various parts of Europe and the United States, they gravitated to New York, often with pauses or ambulations elsewhere. Pollock and Still were typical in coming to New York from western states with stops in many places along the way. Like their literary contemporaries, the Beat poets and writers, especially Lawrence Ferlinghetti and

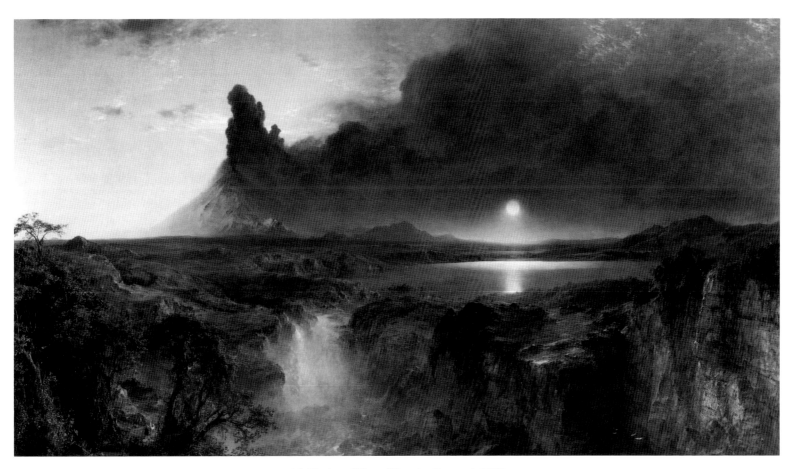

82. Frederic Edwin Church, *Cotopaxi*, 1862

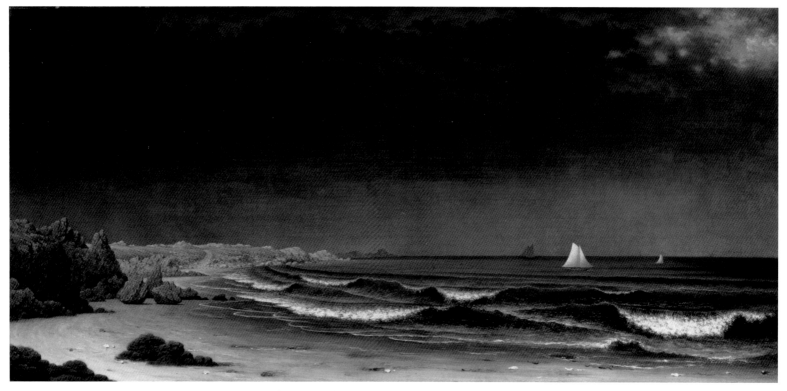

83. Martin Johnson Heade, *Approaching Storm, Beach near Newport,* 1860s

Jack Kerouac, they were (as the latter's book stated) *On the Road.* They moved almost without stop from one part of America to another, as if with the pulsating rhythms of a Pollock painting. The Cold War had been ushered in by the atomic bomb, which led to the realization that all modern life from then on was to be subject to accident and chance. This was an age with no longer fixed absolutes, with mass equal to energy, with no certain center or finiteness.

Partly out of indefatigable idealism, partly out of a premonition of loss, Americans in both centuries adopted a strongly contemplative and spiritual, occasionally even religious, attitude toward their landscape. The luminist canvases of the early 1860s by Lane and Heade,

for example, moved toward a stillness of mood and balanced harmony of design in recording nature that most evokes Emersonian transcendentalism. As they distilled the components of landscape before them into lucid unities and translucent suspensions of time, they implicitly addressed nature's higher, spiritual order.

It is possible that in some instances Heade arrived at even more explicit religious associations. Among his most familiar pictures is his extensive sequence of marsh scenes, with their cadenced placement of haystacks and gently curving streams, at their best achieving a gentle air of timelessness. Unusual in this oeuvre is a small group of related charcoal drawings done in the Newbury, Massachusetts,

marshes during the 1860s. Like Monet, Heade fixed his view on the haystacks in a particular setting and recorded them in the changing light during the day. But, importantly different from the effort by the French artist to capture the instantaneous moment in his shimmering canvases, Heade aspires to a rarefied sense of time enduring beyond the moment.[14]

More than a dozen charcoals done from the same vantage point looking north on the Plum Island River have been located.[15] In the drawings of the morning hours, he shows the shadows cast by a sun still in the east, while their shift to the opposite direction marks his work in the late afternoon. The composition remains carefully consistent throughout: a stream narrows our view from the center foreground into the middle of the scene, with haystacks receding in rows on either side into the distance; just to the right of center the vertical of a small sailboat evenly intersects the flat horizon line. Appearing in the most finely finished drawings of the series are thin striations of clouds, a descending arc of ducks, and a speck of light from the distant lighthouse on the Merrimack River. To demonstrate twilight's descent, Heade appropriately shifted to darker paper and charcoal.

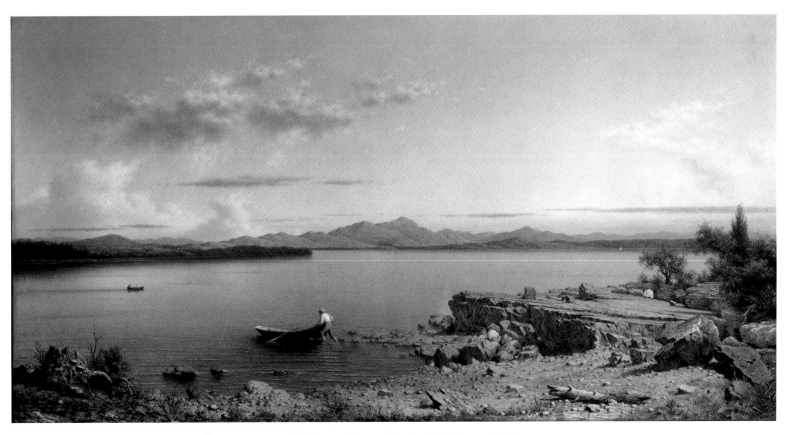

84. Martin Johnson Heade, *Lake George*, 1862

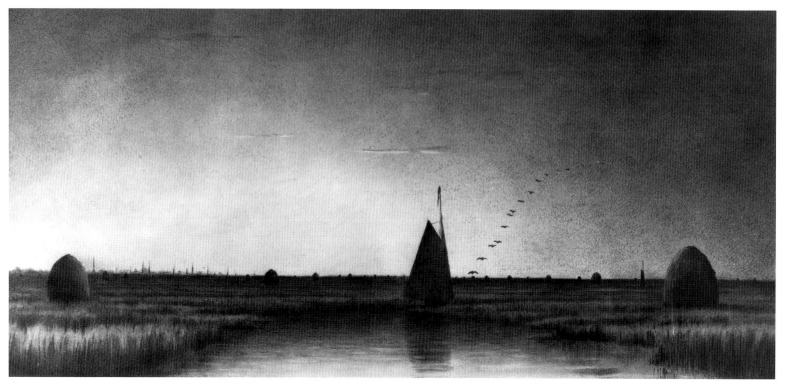

85. Martin Johnson Heade, *Twilight on Newbury Marsh*, late 1860s

As he moved from one sketch to the next, he also introduced tighter order, economy, and refinement into his design. The number of haystacks diminishes; their placement becomes more measured and more evenly centered on the horizon line; the line of descending ducks increasingly complements the foreground contours of the stream (fig. 85). One of the most refined drawings of the group, *Twilight, Salt Marshes* (c. 1862–1868; Museum of Fine Arts, Boston), includes one other conclusive gesture. Where previously the thin horizontal clouds echoed the flat landscape below, here the one major cloud interlocks with the vertical sailboat mast. In purely formal terms, this at last brings a perfect resolution to all of the pictorial elements in a central focusing device, but we cannot help noticing that this delicate intersection also assumes the unobtrusive shape of a cross in the sky.

Such an image of spirituality would have well served the luminist attitude toward American nature and history at a critical time. We know that Heade's friend Church alluded to the same imagery in his own landscapes of these years. In the 1860s he referred to the salvation of the Union by executing a chromolithograph called *Our Banner in the Sky* (Terra Museum of American Art, Chicago), which displayed a vision of stars and red-and-white striped clouds across the blue night sky.[16] Persuasive argument already exists demonstrating that most of Church's work broadly alluded to Judeo-Christian themes. In varying ways, his heroic paintings of *Niagara, Twilight in*

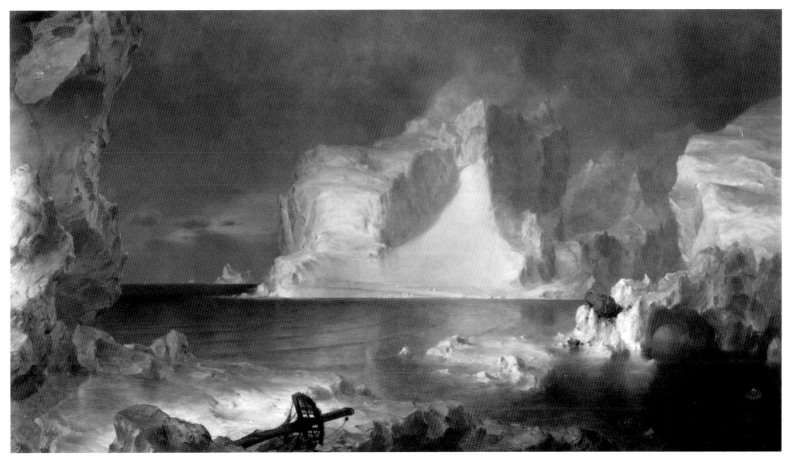

86. Frederic Edwin Church, *The Icebergs*, 1861

the Wilderness, Rainy Season in the Tropics (1866; fig. 87), *The Heart of the Andes* (1859; Metropolitan Museum of Art, New York), and the *Aurora Borealis* (1865; National Museum of American Art, Washington) were exemplary national landscapes of regeneration.

In particular, with some of his 1861 oil and pencil studies for *Cotopaxi*, Church deliberately introduced the symbolism of the cross in the dark rising plume of volcanic smoke intersected by a drifting horizontal band of white clouds.[17] Church was intimating that Americans inhabited a new Eden, a new promised land, and in standing before this sublime grandeur one enjoyed the metaphoric presence of Genesis. Yet like Heade, Church alternated in these great wilderness vistas between cool serenity and explosive melodrama, as if obsessed with the inseparable creation *and* the fall of Adam. As Robert Frost reminds us, creation and destruction are related, and the end of the world (as its beginning) will come by fire and ice:

135

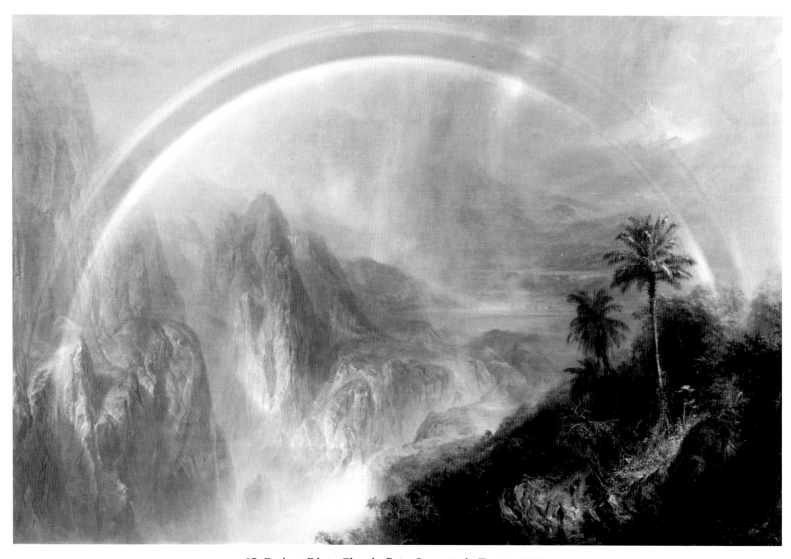

87. Frederic Edwin Church, *Rainy Season in the Tropics*, 1866

Some say the world will end in fire,
 Some say in ice.
From what I've tasted of desire
I hold with those who favor fire.
But if it had to perish twice,
I think I know enough of hate
To say that for destruction ice
 Is also great
And would suffice.[18]

Not surprisingly, we encounter in abstract expressionism ruminations on the powerful forces of Genesis, on the heroic drama as well as pathos of human mortality. Barnett Newman most notably linked the original creation with all artistic activity. Pointedly, he wrote an article titled "The First Man Was an Artist," and asserted that "Man's first expression . . . was a poetic outcry. . . . The purpose of man's first speech was an address to the unknowable. . . . [His] hand traced the stick through the mud to make a line before he learned to throw the stick as a javelin."[19] His huge canvases of raw color, then, were voids on which his line or lines were first marks of creative expression, and thereby defined the world of matter around them.

As Gifford before him had sought the eternal spiritual past in Italy, Greece, and Egypt, as Church had also gone to Jerusalem and Petra, Newman sought spiritual continuity in the Bible, abstracting its content in paintings he titled *Covenant* (1949; Hirshhorn Museum), *Day One* (1951–1952; Whitney Museum of American Art, New York), *Primordial Light* (1954; collection of Mr. and Mrs. Eugene M. Schwartz, New York) and *Stations of the Cross* (1960–1962).[20] There are further echoes of Heade and Church in Newman's art—the monumental scale and raw visual power, the measured disposition of forms across luminous spaces, the aspiration toward metaphysical harmony.

In the oils of Pollock and Rothko, as well, we confront a primordial imagery, whether with pagan or with sacred connotations. Beyond the well-known formal inventions of either artist, there exist landscapes of powerful feeling and spiritual associations. Like their nineteenth-century precedents, these paintings embrace similar polarities of exuberance and tragedy. Rothko especially indicated that he was "interested only in expressing the basic human emotions—tragedy, ecstasy, doom, and so on. . . . The people who weep before my pictures are having the same religious experience I had when I painted them."[21]

These sentiments were strong currents through most of his mature career. In his earlier days, he had discovered a particularly sympathetic note in Nietzsche's essay *The Birth of Tragedy*, which included the declaration (as applicable to Rothko's luminist predecessors as to himself) that "There is need for a whole world of torment in order for the individual to produce the redemptive vision and to sit quietly in his rocking rowboat in mid-sea, absorbed in contemplation."[22] Rothko had also responded fervently on an Italian journey in the 1950s to the frescoes of Fra Angelico in the monastery of St. Mark's.[23] The abstract expressionist's large radiant canvases evoke in modern terms the powerful mystery and immanence of spiritual feeling (fig. 88). Rothko recurrently referred to such transcendent terms as tragedy, irony, and fate.

His cosmic reflections informed his art with both religious and philosophical resonances, appropriately introspective for a period so outwardly secular, materialist, and aggressive. Working in an unsettled and anxious age, Rothko finally took his own life, as others of his artistic generation—Pollock, Ernest Hemingway, David Smith—also met with tragic or violent deaths. It is fitting that some of Rothko's last works found their place in the so-called Rothko Chapel in Houston, created as a conducive environment for meditation.

At the peak of their powers, neither the luminists nor the abstract expressionists were so somber or introspective. Rather, both chose an exclamatory voice toward their country and time, an America in two periods of ascendance before the currents of disunion fully surfaced. The literature of both eras bears equally close links. As we gaze upon a Bierstadt or Church (fig. 89), we might well recall the lines from Walt Whitman's *Song of the Open Road*:

The earth expanding right hand and left hand,
The picture alive, every part in its best light. . . .
 I inhale great draughts of space,
 The east and the west are mine, and the north
 and the south are mine.[24]

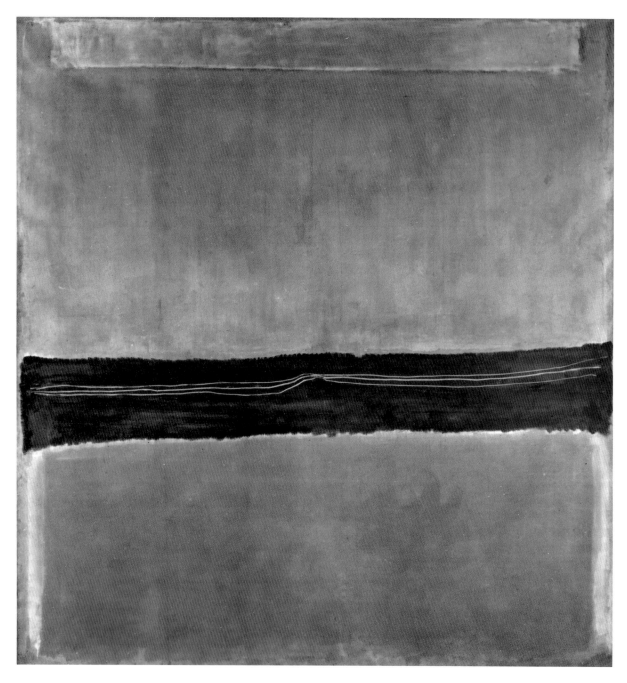

88. Mark Rothko,
Number 22, 1949

138

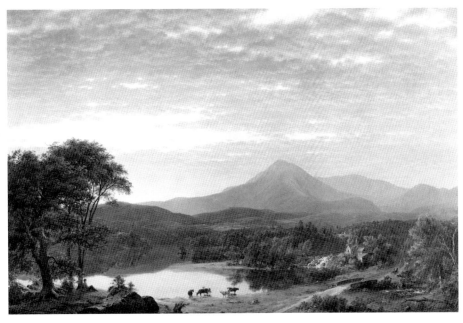

89. Frederic Edwin Church, *Mt. Ktaadn*, 1853 (Color Plate 10)

With full breath and loud voice, here was the same language of praise for the breadth and strength of the American continent.

A native of Long Island (named Paumanok by the Indians), Whitman crisscrossed America in person and in poetry. Just as Whitman had announced he was "Starting from fish-shaped Paumanok where I was born"[25] to go west, Ferlinghetti a century later titled a volume of his poetry *Starting from San Francisco*. With pulsations of energy as reminiscent of Pollock as of Whitman, he began his own self-song:

> Here I go again
> crossing the country in coach trains
> (back to my old
> lone wandering)
> All night Eastward. . . .[26]

It remains to be noted that both of these artistic movements, for a time so unified in style (even if polarized within), ultimately yielded to new modes of realism. In the 1870s it was the dark gravity of Winslow Homer and Thomas Eakins; in the 1970s pop art and sharp-focus realism. However, in these two succeeding periods we see a new thoughtfulness emerging. In later nineteenth-century art, there is the pervasive appearance of elegiac reverie; a century later in conceptual art, there is artistic expression giving primacy to thought. Yet these successor styles in both instances seem part of new waves of artistic pluralism. Whereas American art at the mid-point of both centuries projected enormous self-confidence and optimism, the last quarter of each century saw the introduction of a perplexing and often contradictory multiplicity of styles. Artistic insecurity surely reverberated somehow from larger losses in direction. On the occasions of America's two centennials, time, seemingly having been made to stand still, uneasily quickened pace again.

II

ARTISTS AND WORKS

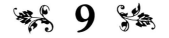

9

Rembrandt Peale's
Rubens Peale with a Geranium

THE TRADITIONAL hierarchy of subjects in European painting ranked mythology, religion, and history as highest in importance, followed by portraiture and landscape, with still life occupying the lowest line of significance. Although early America inherited this tradition, by the time it had declared its political independence at the end of the eighteenth century, it was also ready to assert a new artistic vision for itself. Arguably, part of this cultural originality was the elevation of still-life painting to a place of prime importance both as a major form of expression for painters and as an index of national self-definition. Almost by exclusive spontaneous generation, the Peale family perfected the first great body of American still-life subjects in the decades just before and after 1800. Expressing a new sense of American practicality and informality, the founding father of this remarkable clan, Charles Willson Peale (1741–1827), had created inventive syntheses of the former subject categories. His various family portraits were not just likenesses of individuals but fusions of biography and autobiography (see fig. 95). The famous double portrait of his two sons Raphaelle and Titian pausing at the bottom of a staircase is at once an obvious figure painting and as much a human-scale still life in its formal order and illusionism. For his part, Raphaelle, the eldest son, crafted within a career of attractive but ordinary portraits a supreme group of several dozen still-life compositions. Perhaps his work as a miniaturist had turned his hand and eye to condensations and clarities. Whatever

the impulse, his tabletop arrangements, though relatively conventional in the tradition of northern European baroque precedents, managed to evoke and embody the fresh American aspirations for order and union.[1] Peale's second son, Rembrandt, in turn created one great masterwork for himself and for all American art when he painted the unusual, even startling, portrait of *Rubens Peale with a Geranium* (1801; fig. 90).

This singular work would be an unsurpassed achievement for Rembrandt and has remained one of the most original images in the history of American art. Though it shares with Raphaelle's pictures a love of balance, coherence, and clear finish, it poses an inventiveness all its own. Attempting to understand that originality for its time may help to explain why it has remained so compelling for us ever since in its articulation of an American sensibility.[2]

To begin with, what is depicted? In our very description of the subject, and our notation of its author and date, there is a confluence of associations and timing that speaks to the Peale family's aspirations. The painting is of course first of all a portrait, but one equally of an individual and of a flowering plant. The sitter was Rubens Peale (1784–1865), Charles Willson's fourth son, and he was seventeen at the time of the painting in 1801. He poses beside what has often been called the first geranium brought to America. That it probably was not absolutely the first such imported specimen has been subsumed by the continuing wishful speculation. The artist was

90. Rembrandt Peale, *Rubens Peale with a Geranium*, 1801 (Color Plate 11)

elder Peale's life would continually assert a panoramic ambition for achievements as much in the arts as in the sciences. Certainly the two fields were aligned in one son's tribute to another, seated before him as both would-be artist and scientist. Thus by names and dates alone, this work is partially about beginnings—of young lives, a new nation, an American artistic tradition, a new century. It is a multiple record of newness and originality, a statement of belief in growth, promise, and regeneration, whether in sense of family or of nature.

Surely with this painting Rembrandt Peale began his own artistic maturity. He had been born in Bucks County, Pennsylvania, while his father was away serving in Washington's army. After the Revolution, Charles Willson Peale's professional practice accelerated, as he continued to paint portraits of prominent Americans, pursued his scientific enterprises, and realized ambitious plans for art exhibitions, an academy, and a museum. In this atmosphere, young Rembrandt began to draw at the age of eight, produced his first self-portrait at thirteen, and undertook professional work at sixteen.[3] The elder Peale was familiar with the oldmaster tradition, having studied with Benjamin West in London. But unlike West and John Singleton Copley, who had felt it imperative to conclude their artistic successes abroad, Peale returned to Philadelphia with a personal mission of making contemporary history paintings in America.

Peale's Philadelphia was itself an enlightened environment. It was foremost Benjamin Franklin's city, but in the last decade of the eighteenth century it also hosted Benjamin Latrobe and William Strickland in architecture, view painters like Francis Guy and William Groombridge, the landscapists William and Thomas Birch, and the preeminent portraitists of the Federal period, Gilbert Stuart and Thomas Sully. During this same decade, the city served as the first seat of the new American government, focused on the central embodiment of national paternity in George Washington. Civilized equally in politics and the arts, Philadelphia was in the forefront of defining the nation intellectually and culturally.[4] The Constitution was signed there in 1787, followed by a year of intensive debate over national governance in *The Federalist Papers*. In Latrobe's and Strickland's hands, American architecture took on a powerful new

Rubens's older brother, Rembrandt (1778–1860), himself only twenty-three and born on George Washington's birthday in the middle of the Revolution. As is well known, Charles Willson Peale and his first wife named their children after famous oldmaster artists; the offspring of his second marriage were given the names of illustrious scientists like Linnaeus and Franklin. By such gestures and acts, the

classicism. The former built his first two major banks in Philadelphia in the 1790s, as well as his precocious Greek revival Centre Square Waterworks to meet the city's growing population needs. In addition, fine cabinetmakers and silversmiths were producing high-style decorative arts under prospering local patronage.[5]

By the time Rembrandt Peale was twenty, Philadelphia was home to a number of influential painters. The Birches had arrived from England in 1794, Stuart and Adolph-Ulric Wertmuller came the next year, and the English portraitist and history painter Robert Edge Pine had been settled for a number of years. Peale's father Charles Willson reached a high point in his own professional activities: in 1794 he opened his first art academy and the next year held his first public art exhibition, the Columbianum, followed in 1796 by the opening of his museum of "natural curiosities." His major artistic achievement was his painting of *The Staircase Group* in 1795 (fig. 91), a visual tour de force that depicted his sons Raphaelle and Titian and provided an indelible and immediate family precedent when Rembrandt chose to paint his other brother Rubens. Also in 1795 father and son shared another artistic project: the painting of Washington's portrait. Stuart had already painted his first famous likeness earlier that spring, which possibly prodded the aspiring Rembrandt to undertake his own version. With recent training in life drawing, study of classical casts, and the completion of a few youthful portraits, he nervously readied himself for this first great professional challenge. To proceed confidently, he urged his father to join him with a matching canvas and easel, which "had the effect to calm my nerves, and I enjoyed the desired countenance whilst in familiar conversation with my father."[6] The result was a Washington portrait (1795; fig. 92) of great sympathy and immediacy, rich and descriptive in its textures, direct and unequivocal in its realism, setting a mark of understanding and ability that forecast the near-magical sensitivity of *Rubens Peale with a Geranium* six years later.

In such circumstances, Rembrandt prepared to invent and execute his new painting. Historians of this period have correctly argued that artists felt a certain ambivalence about pure portraiture. On the one hand, Stuart and Sully exemplified the "rage for portraits" in Federal Philadelphia; on the other hand, Peale was one

91. Charles Willson Peale, *The Staircase Group*, 1795

145

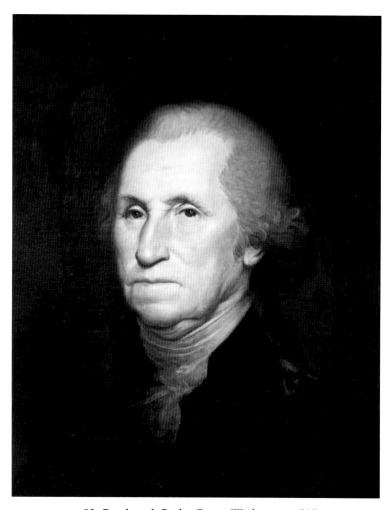

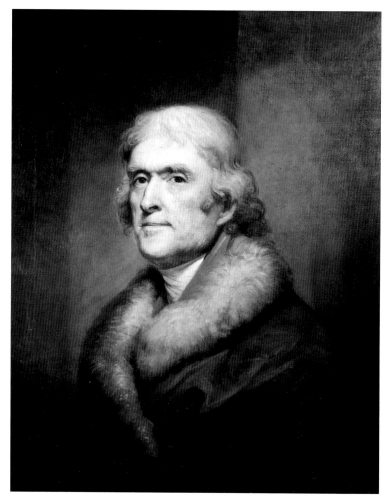

92. Rembrandt Peale, *George Washington*, 1795

93. Rembrandt Peale, *Thomas Jefferson (1743–1826)*, 1805

who felt the calling somehow inadequate, especially as he saw artists like Washington Allston, John Vanderlyn, John Trumbull, and Samuel F. B. Morse attempt with mixed success to meet the shifting tastes of time.[7] Peale aspired to his own form of history painting, as evident in his eventually making ten copies of his 1795 Washington portrait and, after 1824, some seventy-nine versions of the so-called Patriae Pater or "porthole" portrait of the president. These he intended to be "the standard National Likeness" of Washington, certainly embodiments of a grand nationalist iconography.[8] Arguably, Peale's best early portraits were either those of preeminent national figures like Washington and Jefferson (1805; fig. 93) or those of family members, foremost being his father and brother.[9] All of these

94. Rembrandt Peale, *Rubens Peale with a Geranium*, detail of geranium

captured a combination of realism, grace, and psychological immediacy, elements that would be perfectly distilled in the 1801 image of Rubens occupying the left half of that canvas.

And what of its right side? The geranium plant is of course a still life in artistic convention and an exemplum of botanical science (fig. 94). As a subject of concentrated attention, still life was already

very much established in the artistic lexicon of the elder Peale painters. A still-life composition—a plate of peaches with a knife and playful "peel" of fruit skin—literally occupied the center of Charles Willson Peale's first major canvas, his large group portrait of *The Peale Family* (c. 1770–1773 and 1808; fig. 95). Fruit and flowers together were significant emblems of domestic fruition and felicity in his double portrait of *Benjamin and Eleanor Ridgely Laming* (1788; fig. 96). Not only is the couple at ease in the landscape setting, but the central details of flowers at the wife's bosom, ripe peaches in one of her hands, and clover in the other convey a sense of organic harmony joining Man with Nature. Charles Willson also taught his younger brother James the rudiments of painting, and by the 1790s this second Peale was an accomplished painter of portraits, miniatures, and still lifes. Stimulated by both his brother and his nephew Raphaelle, James produced some of the family's most sensuous and elegant fruit arrangements, which culminated in his *Fruit Still Life with Chinese Export Basket* (1824; National Gallery of Art, Washington).

Even more, the treatment of ripe fruit and fresh flowers by the Peales presented the still life as a microcosm of nature, with specimens drawn from the common garden and from scientific investigation. In part, Rembrandt's depiction of his brother is a tribute to Rubens's early interest in botany. As a boy, the latter had studied botany as well as mineralogy, and he had assisted his father in the selection and installation of specimens in the Peale museum. The two brothers worked together for a number of years in their father's scientific excavations and museum projects.[10] Both sitter and painter were immersed in the shared universe of nature and art. Rubens's interest in exotic plants and rare seeds apparently arose as a counter to the frustrations he felt pursuing art with imperfect eyesight. As a boy, he was active in cultivating exotic seedlings for his father, and he had early success in growing tomatoes and the geranium. Thomas Jefferson in particular had difficulty raising the latter, but was captivated by its color and presumed medicinal properties.[11]

Almost at the same time that Rembrandt was painting Rubens's portrait, Jefferson entered the White House, where he proudly displayed this bright and unusual plant in the East Room: "Around the walls were maps, globes, charts, books, &c. In the window recesses

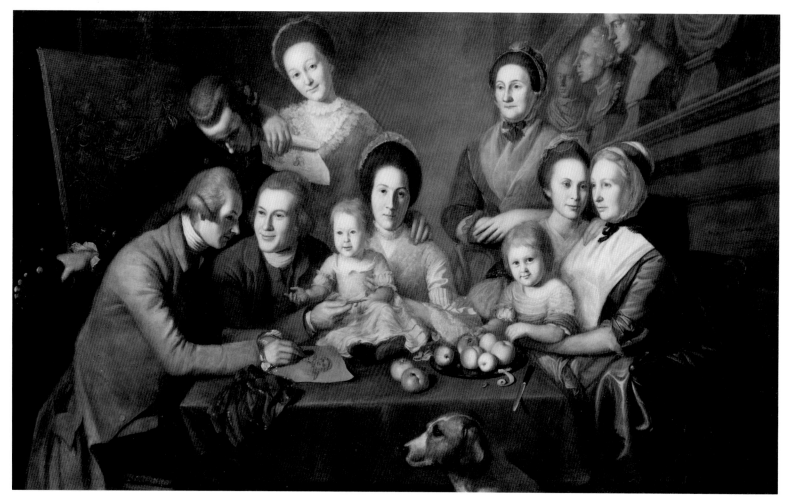

95. Charles Willson Peale, *The Peale Family Group*, c. 1770–1773, and 1808

were stands for the flowers and plants which it was his delight to attend and among his roses and geraniums was suspended the cage of his favorite mockingbird."[12] But in addition to the president's noted interest in this specimen and his wider concern with nature's cosmos, there was a more immediate and influential tradition of botanical and natural science in the Peales' native Philadelphia. Al-

exander Wilson, author of *American Ornithology*, was a fellow naturalist and a colleague of Charles Willson Peale's. (The artist also knew Charles-Alexandre Lesueur, the French artist-naturalist who came to the United States in 1816.) Wilson worked for a time in Peale's museum and had a school on land owned by William Bartram (1739–1823), one of the foremost naturalists of the day (fig. 97).

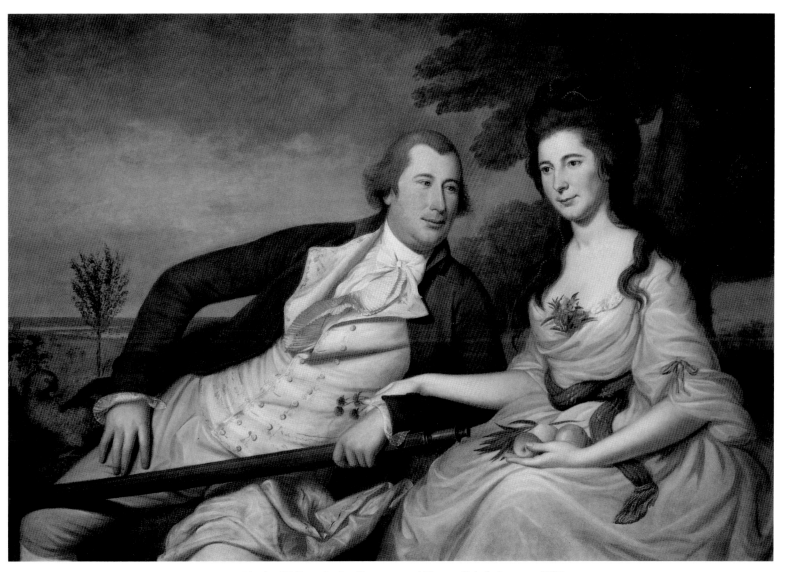

96. Charles Willson Peale, *Benjamin and Eleanor Ridgely Laming*, 1788

by Mark Catesby, whose *Natural History of Carolina, Florida, and the Bahama Islands* had been published in 1754. Bartram kept a journal on his travels and made dozens of watercolors and drawings from life (now in the British Museum), which were described by his sponsor, Dr. John Fothergill, as "elegant performances." Two of his early watercolors of birds were published in George Edwards's *Gleanings from Natural History* (London, 1758), and another large group of drawings illustrated Benjamin Smith Barton's *Elements of Botany* in 1803.[13] Peale honored his friend by including him in his panoramic group painting, *The Exhumation of the Mastodon* (1806–1808; Peale Museum, Baltimore), and by a sensitive portrait in 1808 (Independence Hall, National Historical Park Collection, Philadelphia) showing Bartram with a sprig of white jasmine in his lapel.

In 1798 Jefferson, then president of the American Philosophical Society, appointed Charles Willson Peale to a committee charged with collecting information about the country's natural and archeological antiquities. This led to the Society's partial sponsorship of Peale's 1801 excavations in upstate New York. Not long after, as president of the United States, Jefferson also initiated the ambitious Lewis and Clark expedition to explore and chart the western interior of the American continent. In a sense, these were national ventures determined to claim an ancient natural history for the new nation. Certainly, all these scientific activities linked to Philadelphia and to the Peales provided fertile ground for young Rembrandt's conception.

Other biographical events in the years just preceding his painting of Rubens's portrait may have made Rembrandt further conscious of family generation and regeneration. His younger brother Titian died in 1798 at the age of eighteen, but the next year a new half brother was born and given the same name, and Rembrandt's own first child, Rosalba, was born. A year later, a second daughter, Angelica, followed. We can only imagine that such family growth and change would provide at least one layer of meaning in the tender depiction of a youth and his flowering plant. Simultaneously the family was joined in the adventure of nature's history at work: in the summer of 1801 Rembrandt accompanied his father up the Hudson River to the site of the mastodon excavations, sketching the landscape en route. The elder Peale later recalled that

97. Charles Willson Peale, *William Bartram*, c. 1808

Bartram was born near Philadelphia, the son of John Bartram, America's first great botanist. The son traveled and sketched extensively, having been trained as a young man by his father, for whom he collected and drew specimens during their journeys through the southeastern colonies in the mid-1770s. Peale and William Bartram were certainly familiar with the beautiful and exacting bird sketches

my son and Doctor Woodhouse was astonished with the sublimity of the Science, we were called to Dinner, and although the hunger pressed yet the attraction of the View of the mountains were more forcible. The storm increased, it rained very hard, and thundered—Rembrandt exclaimed the scene was awfully grand he wished to be able [to] paint the affect and staid as long as was prudent.[14]

In fact, Rembrandt had painted at least two strong portraits in 1797 of sitters posed against a landscape background, his Baltimore cousin *Anne Odle Marbury* (private collection) and *William Raborg* (Pennsylvania Academy of the Fine Arts, Philadelphia). A little over a decade later, he was inspired by Jefferson's *Notes on Virginia* to paint a view of Harper's Ferry.[15] Thus, nature in full or in detail was very much in his mind as he turned to the geranium portrait. Of course, there were existing artistic conventions in both European and early American painting for sitters posed with ancillary still-life details or placed beside a landscape view. Copley's mature American portraits most readily come to mind. Aside from those depicting flowered patterns on dresses, curtains, and rugs, or others of women with flowers in their hair or pinned to their bosom, there are more than a dozen well-known female portraits painted by Copley during the 1760s and early 1770s containing prominent still-life elements. Sitters variously hold bouquets or baskets of mixed flowers, branches of cherries or lilies, bunches of grapes, fruit in the folds of their dresses, flowers picked from a nearby bush, a vase of roses, or a glass with a mixed spray.[16] Perhaps most relevant to the Peale legacy are examples like *Mrs. Ezekiel Goldthwait* (1770–1771; Museum of Fine Arts, Boston), who reaches out to rest her hand on a bowl of ripe peaches and apples; *Rebecca Boylston Gill* (fig. 98), and *Mrs. Moses Gill* (c. 1773) who stands beside a pot of tall lilies.[17]

In addition, there is the curious but improbable precedent of Copley's English portrait of *Mrs. Clark Gayton* (1779; Detroit Institute of Art), which must be the first American depiction of a sitter posing before a potted geranium. As the provenance indicates that the canvas descended in the family of the original English owner and did not come to the United States until a sale in the early twentieth century,[18] it is doubtful that Peale knew this image firsthand. The

subject confirms the interest in this uncommon plant in England as well as America during the last quarter of the eighteenth century. A French artist, Henri-Horace Roland de la Porte, also painted a striking still life of a flowering plant in a terracotta pot, *Une Justicia* (c. 1785; National Swedish Art Museums), about the same time, again suggesting a similar vision of increasing scientific realism in this age of Enlightenment.

When we look again at *Rubens Peale with a Geranium*, it is clear that Rembrandt Peale has transcended Copley's conventions in at least two ways: in the utter directness and informality of pose and in the fluid, textured rendering of details. This freshness of presentation in both conception and technique was the perfect reflection of a youthful artist with a bold vision. At the same time, a new sense of immediacy and unpretentiousness was beginning to appear in American painting after the Revolution, as artists sought to adapt European styles to the young republic's democratic character, its celebration of the individual and the landscape. Indicative of this emerging sensibility is Ralph Earl's full-length portrait of *Daniel Boardman* (fig. 99), painted in 1789. Now the figure not only poses comfortably before an expansive New England panorama, he literally stands to one side with the landscape fully occupying its own half of the portrait. Although the stance and the view derive from eighteenth-century English compositions, the relaxed air of the subject and the conscious prominence of American nature establish the very formula for the iconography and design of Peale's portrait just over a decade later. Peale was to go one slight but decisive step further: not only does his emblem of nature occupy an equal half of his canvas, the potted geranium actually stands forward of the figure in a narrow plane just in front of Rubens's torso. Yet the two parts of the portrait are naturally intertwined, as some of the upper leaves and stems start to reach across Rubens's head, while his hands and eyeglasses rest comfortably near or on the clay pot.

This casual pose and gesture of hands sensitively linked to the sitter's work again call to mind some of Copley's more observant and clever depictions. For example, *Paul Revere* (1768–1770; fig. 100), visually balances the rounded form of the silversmith's head with that of the teapot below; moreover, each hand echoes the other, as one serves as prop under Revere's chin while the other cradles the

98. John Singleton Copley,
Portrait of Rebecca Boylston Gill,
1767

99. Ralph Earl, *Daniel Boardman*, 1789 (Color Plate 12)

silver pot.[19] The artist links intelligence with action by such subtle contrasts, at once describing and interpreting his subject's professional creativity. Rubens Peale, by holding his spectacles in one hand and the rim of the pot in the other, connects for us his acts of seeing and doing.

A more immediate influence probably existed in the work of Stuart, who had just settled in Philadelphia in the formative years of Rembrandt Peale's life. At the height of his powers, Stuart had completed one of his masterworks in *Mrs. Richard Yates* (fig. 101) only a year before his arrival in 1795. Here were a lightness of touch and texture, musical harmonies of tone, and a delicacy of line and accent that would inform his best portraits of Washington and other individuals at this time. What particularly enlivens the three-quarter pose, along with the glance that we feel has just momentarily turned from concentration on work, are the subject's two hands caught lifted in the action of sewing. Stuart's sense of the momentary and the personal helps to make his sitter more accessible, an attitude that carries over to the Peale work. But Stuart's influence was also to be felt in transforming Rembrandt's early delicate and linear style into a more painterly and fluid one.[20] The result was an image of his younger brother that at once suggests shyness, modesty, and pride: presenting his remarkable success in cultivating the plant and ready to take his father's mastodon bones on tour to Europe. The painting thus memorializes both accomplishment and expectation.

Closer inspection of some of its details suggests an even more idiosyncratic touch: the wilting leaves of the plant and the presence of two pairs of spectacles, for example. In fact, each gives further insight into Rubens Peale's life and work. The longstanding myth that Rubens's geranium was the first imported to America, a claim that variously appears in some early listings of the picture, goes back to his daughter Mary Jane Peale's will in 1883, which referred to "*The Portrait* of Father with the Geranium, the first brought to this country, and painted on account of the plant which shows that it was in the studio being a little withered."[21] Several subsequent exhibition catalogues repeated this assumption, one in 1923 quoting an old typed label on the reverse of the canvas to the effect that this was "said to have been the first specimen brought to America."[22] But recent historians now believe that geranium seeds were imported and cultivated prior to Rubens's effort in 1801. By this time, there

100. John Singleton Copley, *Paul Revere*, c. 1768–1770

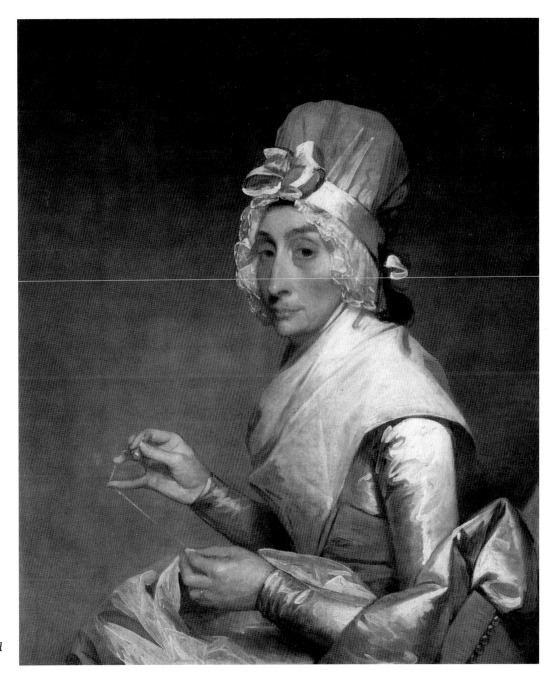

101. Gilbert Stuart, *Mrs. Richard Yates*, 1793–1794

102. Rembrandt Peale, *Rubens Peale with a Geranium*, detail (hands)

was a craze for the plant in England and Europe. Jefferson's example was introduced from South Africa, and one index of the plant's popularity in America was the publication in 1806 of the *American Gardener's Calendar* with instructions for raising geranium seedlings.[23]

Doubtless Rubens's scarlet flower was among the first to blossom from seed, and by all accounts he cared passionately and worried much about his specimens. The geranium that Rembrandt depicted here has but a couple of new blooms, and the wilting leaves hint of the struggle to bring the plant to flower. When the brothers departed for England the year after the painting's completion, Rubens feared that no one would care properly for his beloved rarities.[24] Surely one of the most eloquent details recorded by Rembrandt is that of his brother's right hand reaching across to rest on the lip of the geranium pot (fig. 102). It is a dual gesture, as Rubens both checks the moisture in the soil and claims possession of his creation. In contrast to the bright new flowers above, the middle leaves sag, a lower one has started to decay, and a dead one has fallen off at the lower right. This intimate cycle both illustrates and symbolizes nature's process of regeneration. It is also a process with human involvement, for as

Rubens's two fingers lightly touch the soil, there is above the echoing gesture of the two bare stems arching over to the top of his head. Although contained in the pot, the growing plant in its dirt represents a piece of the larger landscape and a wider natural world.

If Rubens's dedication to his project bore flower, it was as a result of his overcoming handicaps of health and particularly of eyesight, which had inhibited his ability to pursue the family profession of painting. In older age, he wrote about his childhood frailties in the third person, with occasional hyperbole:

> It is said he was so small when 3 or 4 days old, that he was put into a silver mug & the lid shut down over him. . . . I was very delicate in health and our family physician Dr. Hutchins required that I should be kept out of the sun as much as possible. . . . I made little progress at school for my sight was so imperfect. . . . One day . . . I went into the garden and took the watering pot and watered my flowers which I was forbidden to do, and after that time I gradually increased in strength and health.[25]

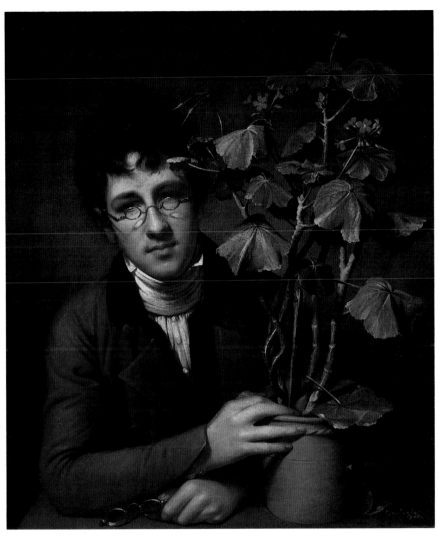

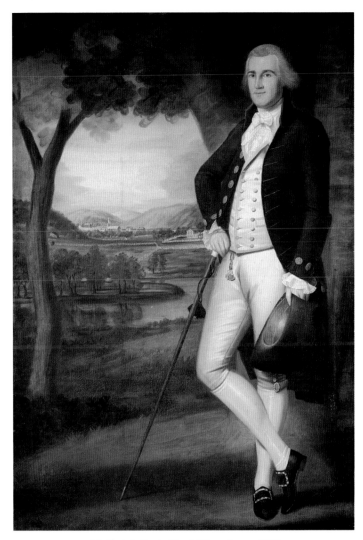

11. Rembrandt Peale, *Rubens Peale with a Geranium*, 1801

12. Ralph Earl, *Daniel Boardman*, 1789

13. Robert Salmon, *Boston Harbor from Castle Island (Ship Charlotte)*, 1839

14. Fitz Hugh Lane, *Boston Harbor, Sunset*, 1850–1855

15. George Caleb Bingham, *Boatmen on the Missouri*, 1846

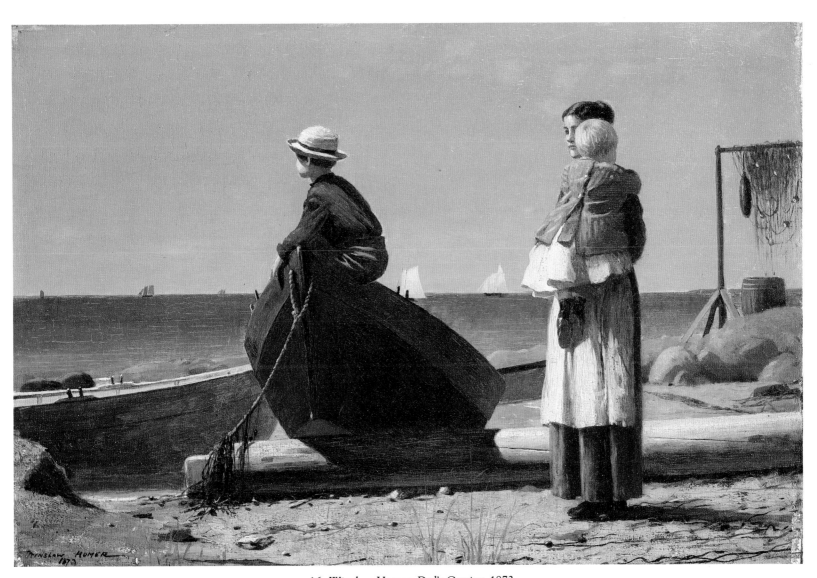

16. Winslow Homer, *Dad's Coming*, 1873

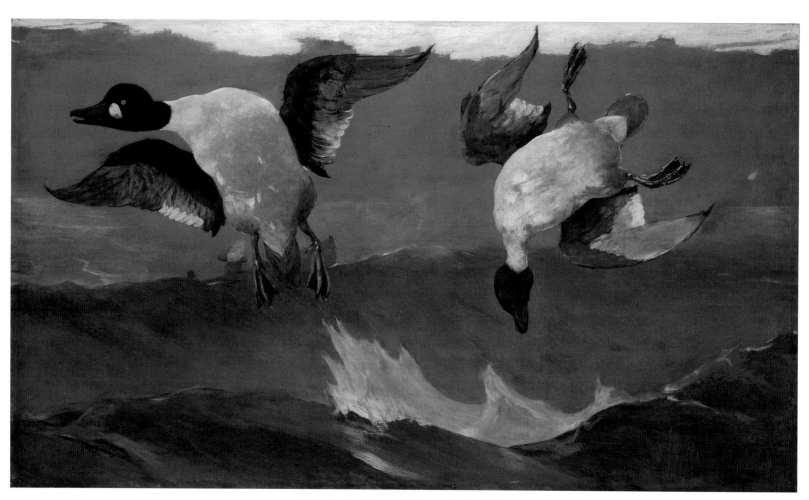

17. Winslow Homer, *Right and Left*, 1909

18. Winslow Homer, *The Cotton Pickers*, 1876

19. Thomas Eakins, *The Old-Fashioned Dress*
(Portrait of Miss Helen Parker), c. 1908

20. Thomas Eakins, *Portrait of John Neil Fort*, 1898

21. Thomas Eakins, *Miss Amelia Van Buren*, c. 1891

22. Raphaelle Peale, *Lemons and Sugar*, 1822

23. John F. Francis, *Still Life: Yellow Apples and Chestnuts Spilling from a Basket*, 1859

24. Severin Roesen, *Still Life: Flowers*, c. 1850–1855

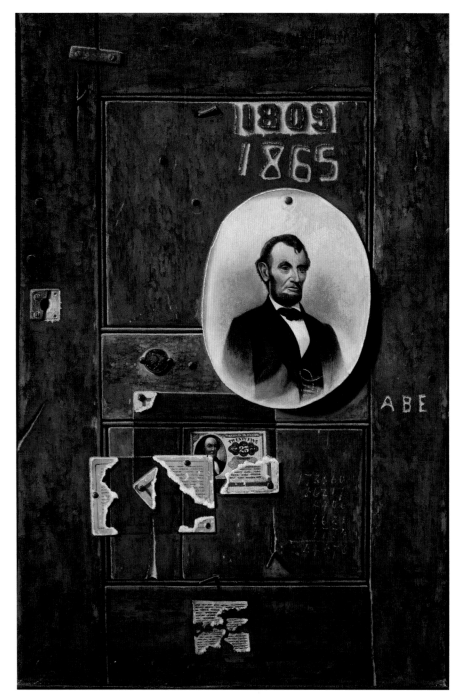

25. John Frederick Peto, *Reminiscences of 1865*, c. 1900

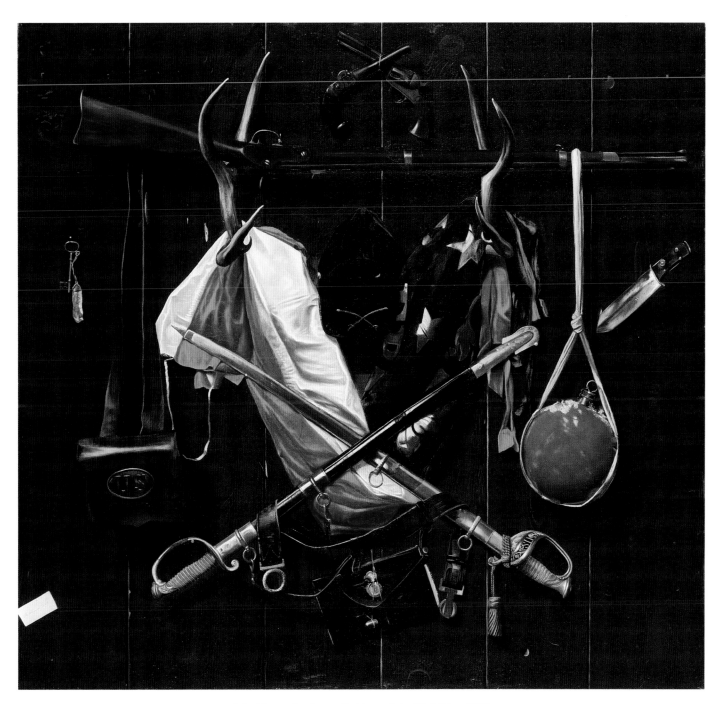

26. Alexander Pope, *Emblems of the Civil War*, 1888

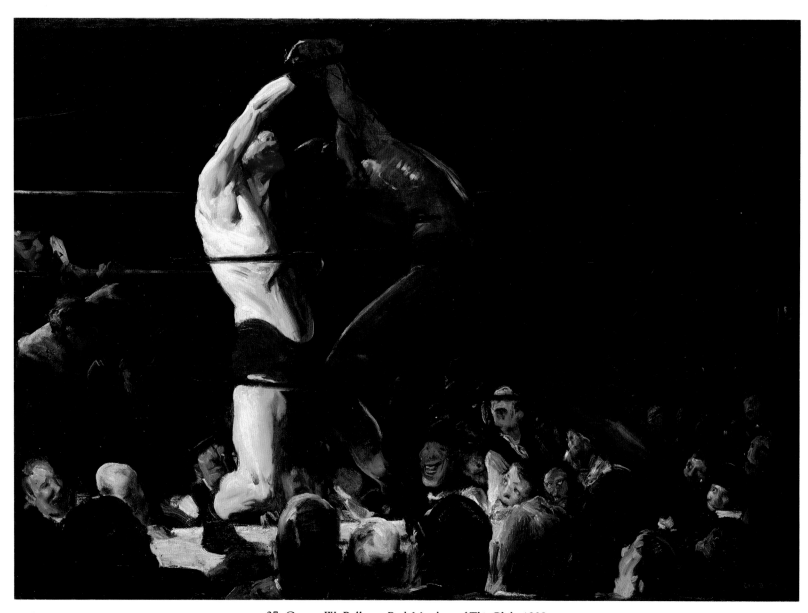

27. George W. Bellows, *Both Members of This Club*, 1909

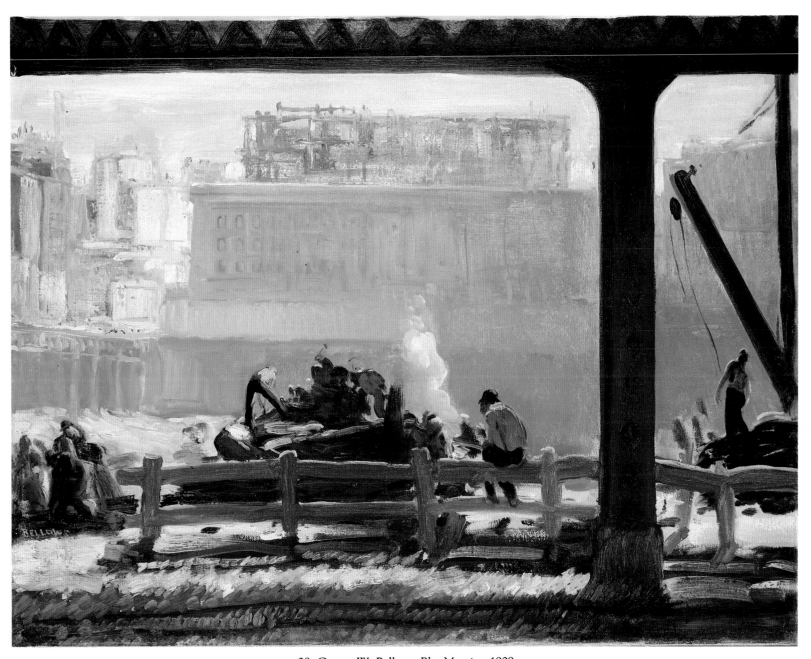

28. George W. Bellows, *Blue Morning*, 1909

29. Albert Pinkham Ryder, *Moonlight Marine*, c. 1890

Poor eyesight also plagued his brother Rembrandt, who wrote about their respective afflictions in his own "Reminiscences" in 1856:

Perhaps there is no recollection of the events of my life of greater value, than my experience in regard to the preservation of sight, which can be duly appreciated by no class of human beings, more than by artists. That I, in my 79th year, am now able to paint all day and read half the night, is owing to the care I have taken of my eyes, after having greatly injured them. . . . I was forty years of age, before I began the use of spectacles. Finding that I was obliged to hold the newspaper close to the lamp, I was induced to get glasses of forty inches focus. I painted with them, and in a little time by judiciously, but not constantly, wearing them, could see with them at all distances. After a few years, it was necessary to employ a shorter focus—thirty-six inches, for reading at night, and occasionally in the day. Another lapse of time demanded a third pair of glasses—twenty-four inches. All these I carried in my pocket, and never minded the trouble of changing them, according to varying circumstances. [26]

No wonder two pairs of glasses should appear as critical details in the portrait of his brother, who evidently had even greater trouble seeing. By Rembrandt's account, Rubens

was so near-sighted, that I have seen him drawing . . . looking sometimes with his left eye, and then turning to look with his right eye, the end of his nose was blackened with his greasy charcoal. He was slow in his progress at school. . . . At ten years of age he only knew two letters, *o* and *i*, never having distinctly seen any others. . . . No *concave* glasses afforded him relief; but at Mr. M'Allister's, the optician, my father being in consultation on his case, there lay on the counter several pairs of spectacles. . . . Taking up one of these and putting it on, he exclaimed in wild ecstasy, that he could see across the street. . . . In London in 1802, he was present at a lecture on optics, by Professor Walker, who declared he had never known another instance of a short-sighted person requiring strong magnifying glasses. [27]

In fact, what Rembrandt described in 1856 as "short-sighted" vision is what we know today as classic farsightedness, in which images come into focus behind the retina of the eye, making distant objects much easier to see than those close up. The true nature of this condition of hyperopia was not fully elucidated until several years later. [28] Before that time, other early nineteenth-century accounts confirm Rubens's poor eyesight and the efforts to correct it. In 1802 John Isaac Hawkins, a scientific associate of Charles Willson Peale's, gave the Peale museum his physiognotrace, a device for tracing small silhouette profiles (once again marrying artistic and scientific functions). It was then that he learned about the artist's son, whom he later recalled:

I knew twenty-five years ago a very extraordinary exception to the use of concave glasses for near sighted eyes, in a young man in Philadelphia; he tried concaves without any benefit, but accidently taking up a pair of strong magnifiers, he found that he could see well through them, and continued the use of strong magnifiers with great advantage.

I now allude to Mr. Rubens Peale. . . . [29]

Yet another family reminiscence tells of Rubens as a boy coming upon a "burning glass" in the upper rooms of his father's museum, headquartered in Philosophical Hall. Accidentally discovering its capacity for improving his sight, he rushed to tell his father but, disoriented, tripped on the stairs and fell into the older man's arms. This incident in 1796 led Charles Willson Peale to order corrective lenses for his son. Five years later, Rubens would pose comfortably in them for this portrait, though at first he evidently suffered the taunts of school friends and simply remarked that "since I find them useful, I do not regard anything they may say about my use of spectacles." [30]

Rembrandt's reference to their father's consultation with John McAllister about making spectacles brings up an active correspondence between these men and between McAllister and Thomas Jefferson as well. In a letter of 1806, the optician wrote to the president regarding the details of a pair of spectacles he had ordered; in passing he noted, "I have done a number of spects with near & distance focus in each eye. I fitted two pair lately for Mssr. Jas. and Charles

Peale for painting miniatures that answer extremely well." He went on to say that careful calculations could make possible limiting the number of glasses to various seeing distances: "By knowing this I may suit your needs with 2 or 3 pairs of glasses than otherwise by a great many."[31] Used sequentially or even in combination, such pairs provided the benefits of today's bifocals and trifocals.

Bifocals were known originally as an invention of Benjamin Franklin sometime before 1784 (fig. 103). In France at the time, he is believed to have corresponded with Jefferson on the subject. During the 1790s, William Richardson, a Philadelphia hardware merchant, was already supplying imported spectacles to Washington and Jefferson. In 1799 he sold the business to McAllister, who continued to do business with Jefferson. McAllister's first shipment of new glasses reached Philadelphia in early 1800, and almost certainly the ones shown with Rubens Peale in his portrait the next year are from that group (fig. 104).[32]

What now requires some examination is how the two pairs of glasses in the painting relate to one another. An absolute answer is not easy, because the sitter's daughter, Mary Jane Peale, in her last will and testament stated that the portrait "was at first painted without the spectacles and afterwards put on."[33] Speculating further on this record, a recent biographer has argued that "he was originally painted holding his spectacles but it was later decided that he would look more like himself with them on. When the second pair was added, the first was never deleted."[34] Here it may be argued that a familial recollection late in life of an event that occurred over three-quarters of a century before was devoted but faulty.

First of all, there is no physical or conceptual evidence to support such an alteration. Conservation study of the surface and X-ray examination of the passage give no hint of measurable pentimenti, local changes in paint thickness, or any reworking of the key area. Nor does a later addition of the upper eyeglasses make any sense imaginatively. To the contrary, these spectacles seem so integral and central to the entire effect and meaning of the painting that they must have been part of the intention and composition from the start. For an individual so dependent on spectacles for the very act of his scientific vision, and here so absorbed in distant thought, yet immediately alert, it is inconceivable that Rubens's portrait could show him without his wearing glasses. Removed, his eyes would read as uninteresting shadowy recesses, and the cheeks below as soft, bland surfaces. The face is too critical to the design and would not have compelling visual character otherwise. As a positive argument, we can only marvel at the harmony of ovals these glasses make, echoing the eyes just above and their balanced shadows below, with the larger oval curves of the head itself, the white shirt collar, and even the foreshortened rim of the clay pot. In a final conceit that could hardly have been an afterthought, the glasses delicately curve across the eyes behind, with the highlights on the rims coinciding exactly with the pinpoint reflections in the pupils. With the eye surfaces so divided, they pun on the very idea of bifocal vision.

Assuming both pairs of glasses were indeed intentional, let us then consider whether these were meant to be identical or interchangeable. As McAllister's correspondence with Jefferson and Charles Willson Peale indicates, it was commonplace for the optician to prescribe several lenses of different powers for varying levels of focus. Rubens Peale unquestionably needed some magnification for his scientific scrutiny of specimens at hand and another type of lens for intermediate and distant vision. With his plant close by and the world before him, two pairs of glasses would have been natural. This does not necessarily argue that the spectacles in his hand were used on occasion to replace those he is wearing. Some careful observers have noticed the very fine horizontal line intersecting the right-hand lens closest to Rubens's thumb and forefinger. This has led to the suggestion that this pair might be an actual example of true bifocal glasses. In fact, this is most probably another of the artist's visual puns, for the left lens does not bear a comparable division line, and what we are seeing is the frame support (the part that extends from the spectacles back over the ear) folded up behind the lens.[35]

One other aspect of this lower pair of glasses is intriguing: the ovals are decidedly larger and the bridge wider than in the set Rubens is wearing. The two frames are clearly different, most obviously in the bridge configuration, again suggesting that Rembrandt did not begin by painting his brother with a generic pair and then, dissatisfied, decide to place the same pair on his face. Recent scientific thinking has offered the most logical explanation: "Perhaps the

103. Charles Willson Peale,
Benjamin Franklin, 1785

104. Rembrandt Peale, *Rubens Peale with a Geranium*, detail
(face and spectacles)

reason for the wider bridge was so that the spectacles could be worn further down the nose, for reading or close work purposes, while at the same time wearing the 'distance' glasses (thus providing a 'two-focal' system)."[36] Optometry aside, this intricate imagery serves to reinforce on a deeper level the links between hands and eyes, between observation and intelligence. That we have concentrated so much attention on this critical element of the portrait profoundly reinforces the thesis that the work is about such abstractions as seeing and vision, perception and art itself.

Up to this point, Jefferson's name has been invoked often enough to indicate his pervasive importance as an intellectual presence at times directly linked to the Peales' world, and as a shaper of the part of American culture pictured in this one focused image. He grew geraniums both at the White House in Washington and at Monticello, and he cared about their nourishment by the human hand, seeing an affinity between the organic life of man and nature: "If plants have sensibility, as the analogy of their organization with ours seems to indicate. . . ."[37] At Monticello his greenhouse was located on the south piazza, where his geraniums and other most delicate specimens might receive the best daylight and warmth. Significantly, this room was also adjacent to his cabinet and library, integrating his entire world of learning, much as man and plant stand in balance next to one another in Peale's painting.

Jefferson had already made, in the words of one historian, "natural history the queen of sciences," when he wrote his one comprehensive book, *Notes on the State of Virginia*, in 1785.[38] Itself an original creation in American literature at this time, it sought to summarize the universe of facts concerning Jefferson's native soil in a matter-of-fact language. His chapters were in effect inquiries into Virginia's boundaries, rivers, mountains, birds, animals, and minerals. A section of "Query VI" was devoted to the principal vegetables, which Jefferson logically subdivided in several ways. He drew distinctions among trees, plants, and fruits; between imported versus native plants; and between gardens versus orchards. Typically he pursued accuracy over pedantry:

A complete catalogue of trees, plants, fruits, &c. is probably not desired. I will sketch out those which will principally attract notice, as being 1. Medicinal, 2. Esculent, 3. Ornamen-

tal, or 4. Useful for fabrication; adding the Linnaean to the popular names, as the latter might not precisely convey precise information to a foreigner. I shall confine myself too to native plants.[39]

In this context the geranium both as image and as specimen was but one notable item in the varied inventory of meats, vegetables, fruits, flowers, plants, and berries depicted in the Peale family's still-life paintings.

Jefferson further contributed to an American vision of newness identified with nature and geography in many of his other great pronouncements, for example: "The Creator has made the earth for the living, not the dead," an assertion of the sovereignty of the present and the future.[40] Most prominently, he announced the political equivalents in the Declaration of Independence: "It is the right of the people . . . to institute new government"; and ten years later in the Bill for Religious Freedom (1786) that he drafted for Virginia, the country's first statement of separation between church and state and freedom of thought.[41] Throughout this period, of course, he was designing and building in phases his house at Monticello, a fresh and creative statement in American architecture, full of practicality, ingenuity, idealism, and humanity. But Jefferson's sense of America as a revolutionary experiment had an even closer chronological parallel to Peale's portrait in his first inaugural address as president, 4 March 1801. The election the year before was not only the first of the new century, it was the first between two organized political parties after the national union under George Washington. In the following year, as young Rubens was posing for his brother, Jefferson stood to proclaim "a rising nation, spread over a wide and fruitful land. . . ."[42] What he said then led two years later to the Louisiana Purchase and, immediately after, to the Lewis and Clark expedition into the northwest wilderness, in which America's grandest ideas of continent and destiny were charged into action. Such imagery and attitudes would dominate American life for more than the next quarter century, echoing passionately in the expressions of Thomas Cole, Ralph Waldo Emerson, and Daniel Webster, who could assert in 1825, "American glory begins at the dawn."[43]

Jefferson's powerful documents stimulated an entire generation to envision the interchangeable ideas of freedom and newness. Follow-ing the signing of the Constitution in Philadelphia on 17 September 1787, Alexander Hamilton, James Madison, and John Jay publicly deliberated in a sequence of eighty-five lengthy essays, known as *The Federalist Papers*, the meaning and implementation of the republic's originating documents. Between October 1787 and May 1788, they discussed the separation and interdependence of powers, the balancing of forces within the structure of government, and above all the desire for unity and stability in order "to form a more perfect Union." Repeatedly the authors turned to a phraseology of invention and originality, as did Hamilton in no. 1: "You are called upon to deliberate on a new Constitution"; or no. 14: "the form of government recommended for your adoption is a novelty in the political world." In the same paper, Hamilton went on to conclude: "They accomplished a revolution which has no parallel in the annals of human society. They reared the fabrics of governments which have no model on the face of the globe. They formed the design of a great Confederacy. . . ."[44] Subsequently, Madison paid a deserved tribute to Jefferson and his role: "The plan, like everything from the same pen, marks a turn of thinking, original, comprehensive, and accurate."[45]

In addition to these political figures, two other intellects of the period are worth citing for their concurrent contributions to this new American age: Benjamin Franklin and Noah Webster. The former held a special place of reverence in Philadelphia as a personification of the Enlightenment, who harmonized (not least because of his ingenious bifocals) farsightedness and clearsightedness. He exemplified the self-made individual, prudent yet inventive, thrifty yet revolutionary, plain yet forceful. Although he died in 1790, a decade before Rembrandt Peale undertook his portrait, Franklin's life and achievements immediately begot a powerful mythology. Actually, his life became a twofold accomplishment: the one he lived and the one he recorded. It is the latter, *The Autobiography of Benjamin Franklin*, first published in part in 1791 and 1793 and reprinted nearly complete in 1818, that made a contribution to American culture and history as original as Jefferson's *Notes*, Hamilton's *Federalist Papers*, or Rembrandt Peale's portrait of *Rubens Peale with a Geranium*.

Although autobiography as a form of literature already existed in Europe and elsewhere, what historians have seen in Franklin's work

as being uniquely American and fresh is its unpretentiousness. He used colloquial expressions, clear images, and an informal manner, which speaks to us with a directness comparable to that of Peale's painting. Like Jefferson, he believed in the glory of the living, active present. As a friend of Franklin's wrote in 1783, he was "connected with the detail of the manners and situation of a *rising* people."[46] While Jefferson and Peale might turn to the example of nature for their metaphors of growth and promise, all shared an outlook in common. Woodrow Wilson wrote of Franklin in an introduction to a 1901 edition of the *Autobiography*: "Such a career bespeaks a country in which all things are making and to be made . . . [the autobiography] is letters in business garb, literature with its apron on . . . setting free the processes of growth."[47]

For all of Franklin's stature in Philadelphia as a diplomat, inventor, and writer, we may readily come back to the subject of *Rubens Peale with a Geranium*, for Franklin also exemplified that city's reputation as America's horticultural capital. Along with the Peales, Wilson, and the Bartrams, Franklin was equally honored as a natural scientist. In fact, Philadelphia could claim several individuals who as professional or amateur naturalists identified or cultivated rare new species of flowering plants, among them the Franklinia, a shrub with showy white flowers; the wisteria bush named after the anatomist Caspar Wistar; and the poinsettia plant discovered in Mexico by America's first ambassador to that country, Joel R. Poinsett.[48] Proudly the young Rubens Peale could take his place in this lineage, for he had himself been the first to introduce the tomato plant to his native city and was now ready to take credit for his early success in growing his scarlet geranium to full maturity.

In the broadest sense, what we have been talking about thus far are the definitions and rhetoric of American character and will. Fittingly enough, the young republic was able to summon up not just a language of independence and new governance, along with original literary and pictorial forms of self-expression, but also a new language itself. Taking on this task at the very same time was the New Englander Noah Webster, who was descended from colonial governors of Connecticut and Massachusetts. After graduating from Yale in 1778, he tutored in law with Oliver Ellsworth and was admitted to practice in Connecticut a few years later. The law had stimulated him to think about the precision of meanings and definitions, the logic and process of explication. He soon began teaching and wrote his first primer on spelling. In 1783 he published *A Grammatical Institute of the English Language, Comprising an Easy, Concise, and Systematic Method of Education, Designed for the Use of English Schools in America*. This appeared in repeated later editions and was followed in 1806 by *An American Dictionary of the English Language*, whose stated purpose was "organizing and clarifying the language."[49] Like other aspects of American culture, design, and customs, these titles imply the nation's gestures in acknowledging its inheritance while declaring its separation. Although Americans still speak English, Webster began the process of claiming new spellings, pronunciations, meanings, and even new words. He was at one with his age in wanting to nurture young seedlings in an American soil.[50] In this same spirit Rembrandt's fraternal portrait of *Rubens Peale with a Geranium* is testimony as much to their father's "Great School of Nature"[51] as to Jefferson's "rising nation, spread over a wide and fruitful land."

10

Robert Salmon's Boston Patrons

ROBERT SALMON'S PATRONS give a clear idea of this important early marine painter's reputation in Boston. In reviewing the list of those who acquired his pictures, we become conscious of the many names then and still prominent. Of the thirty-two individuals whom Salmon himself records as customers, almost all were engaged in Boston's prosperity as a seaport (fig. 105). Some were makers of vessels or sails. Among others interested in his work were Thomas Handasyd Perkins and his son, Thomas Handasyd Perkins, Jr.; Robert Bennet Forbes and John Perkins Cushing, his nephews; and Samuel Cabot, his son-in-law. Together, these individuals begin to provide a picture of contemporary tastes in Boston collecting. In this respect, Salmon's catalogue is the most detailed continuing record over a period of time that tells us who collected in Boston in the first half of the nineteenth century, what they bought, and what they paid.[1]

The artist could hardly have found a more distinguished customer than the elder Perkins. A native of Boston, one of the city's most famous merchants and philanthropists, and a prominent member of the Federalist Party, Perkins was elected to the United States Senate eight times between 1805 and 1829, besides being a presidential elector in 1816 and 1832. He generously supported public institutions as well as individuals like Salmon. Obviously this marine painter could produce the kind of ship and harbor portrait with a polish that Perkins could appreciate (fig. 106). Salmon had not been in Boston a year when his discriminating patron made the first of what would be several purchases.

Samuel Cabot, Perkins's son-in-law, was in 1837 the director of the Boston Bank and the year after president of the Port Society of the City of Boston and its Vicinity.

John Perkins Cushing, a nephew of Perkins, was similarly engaged in Boston's mercantile affairs. Beginning as a clerk in the firm established by his two Perkins uncles, James and Thomas H., Cushing soon became interested in the company's trade with China and the northwest coast. In 1803, at the age of sixteen, he went to China, where he remained for nearly thirty years, a highly respected foreign merchant known as Ku-Shing. Enormously wealthy but broken in health by 1830, Cushing returned to Boston. He built himself a handsome mansion on Summer Street, acquired a splendid estate in Watertown, and erected one of the finest conservatories in New England. He also constructed the sixty-foot pilot schooner *Sylph*, which in 1832 won the earliest American yacht race on record. A collector as well, he would have naturally found appealing the marines of Boston's best practitioner of the day.

Like Cushing, Captain Robert Bennet Forbes was also a Perkins nephew. According to Samuel Eliot Morison, Forbes "had the most original brain, and the most attractive personality of any Boston merchant of his generation. . . . [He] was also one of the pioneer yachtsmen of New England."[2] Entering employment in the Perkins shipping firm at thirteen, Forbes embarked on a colorful career in which he succeeded as sea captain, China merchant, ship owner, and writer. The catalogue of the 1834 exhibition of paintings at the Boston Athenaeum lists six paintings owned by Forbes that were the work of Salmon. Since some of their titles do not plausibly match the sketchy descriptions in Salmon's catalogue, Forbes may have

163

105. Robert Salmon, *Boston Harbor from Constitution Wharf*, 1833

owned even a larger group of paintings than the nine that Salmon mentions.

Other noted Boston names were among Salmon's clients in the 1830s. Henry W. Sigourney was one of the directors of the ferry company operating between Boston and Chelsea. Benjamin Fullerton was a boat builder at 24 Charter Street. Josiah Putnam Bradlee was a merchant and also at one point a director of the Boston Bank. He headed the firm of Josiah Bradlee and Sons, a business with offices on India Wharf engaged both in the Russia trade and whale fishery. As described by those who remembered him, Bradlee was a cheerful gentleman of the old school with a penchant for small clothes and white-topped boots. Samuel Hooper was a junior partner in his father-in-law's shipping firm, Bryant, Sturgis & Co. He subsequently organized his own company, and went on to be elected to the Massachusetts and the United States House of Representatives. Harrison Gray Otis was another distinguished figure in Boston commerce and philanthropy. In an earlier age, Otis had commissioned three successive houses from the noted architect Charles Bulfinch.

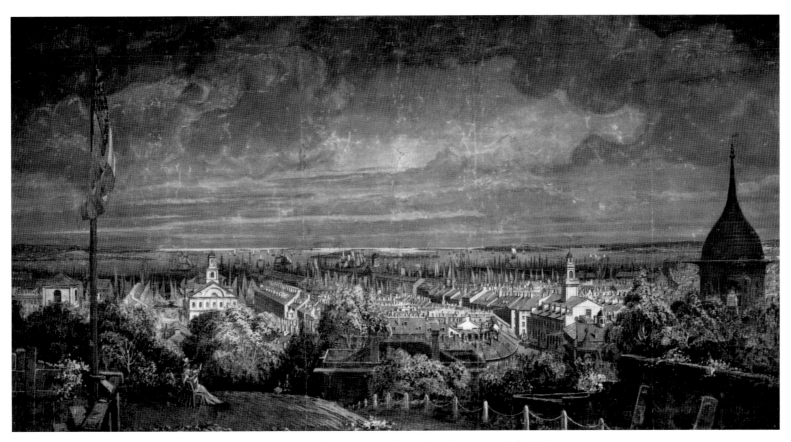

106. Robert Salmon, *View of Boston from Pemberton Hill*, 1829

James Trecothick Austin was an accomplished Massachusetts lawyer and politician, and from 1832 to 1843 state Attorney General. Timothy Williams was another merchant with offices on India Wharf.

One interesting collector's note is recorded by Charles Francis Adams, one of the most illustrious members of that family, a distinguished statesman and minister to Great Britain. Although Salmon did not himself record selling a painting to Adams, the latter set down in his diary, in rather Yankee fashion, his acquisition of a picture by the marine painter. On 5 August 1830 he wrote:

> Having done all my usual duties at the office I thought I would go down to see how the pictures of Salmon would sell. They are all of them very pretty and went so very reasonably that I felt very much tempted to purchase. But I held in exceedingly well until the close, when one came up which I could not resist and immediately repented of the act. But it was too late.

He appended a footnote over a month later, on 24 September:

> My picture came home today and I was confirmed in my opinion of its merit.[3]

Boston's first generation of yachtsmen was also its first generation of art collectors. A number of the men who gave their patronage to Salmon, including Forbes and Thomas Perkins Cushing, were among the first people in Massachusetts to have yachts built for themselves. When the Bostonian Society held a large and popular exhibition of ship paintings in 1894, a painting by Salmon brought interesting information with it. Loaned by Thomas B. Winchester, the picture was of the *Yacht "Northern Light,"* "painted by R. Salmon for Mr. Stephen Winchester Dana, and by him given to Col. Wm. Parsons Winchester, the owner of the yacht, representing it passing down the harbor." Salmon's catalogue does not record the sale of any paintings to a Mr. Dana, but a "Mr. Winchester" did purchase a "loch Lomond sun sett" in 1830 and "an American Sloup" in 1831. The picture of the *Northern Light* would have been painted no earlier than 1839, when this smart schooner was built for Colonel Winchester. The description of Salmon's painting has additional interest, for the *Northern Light* was the subject of the only

painting that Fitz Hugh Lane is known to have based on a picture by Salmon (fig. 107).

Salmon also painted, in 1839, the *Dream*, a schooner yacht owned by the Boat Club, of which Forbes was first commodore (collection of Baron Thyssen Bornemisza, Lugano, Switzerland). The artist's preoccupation with yachts and yachting seems to have been of long standing; among the pictures he exhibited at Liverpool in 1824 was one of a "pleasure yacht." In view of his interest in yachts on both sides of the Atlantic, it is noteworthy to recall a detail from A. T. Perkins's letter of 1881 concerning the four paintings by Salmon that he owned. The red cutter in three of the pictures had belonged, he remembered, to an English nobleman with whom his father, T. H. Perkins, Jr., and Salmon both had sailed.

Through such associations as these, Salmon seems to have had wide acquaintance with the men and affairs of maritime Boston. But Lucius Manlius Sargent also demonstrated that Salmon's patrons were all not of a mold. Sargent was a man of strong opinions and a tireless writer whose leisurely, contentious, antiquarian articles, "Dealings with the Dead," ran for years on the back page of the Boston *Evening Transcript* and were published in book form in 1856. Several other individuals are associated with paintings of special interest.

The "J. P. Davies" who purchased no. 857 was apparently Isaac P. Davis, a trustee of the Boston Athenaeum, where the painting now hangs. It depicts the *Seizure of a French Ship by Boats from the U.S.S. "Constitution"* (1836; fig. 108), and involves not only Davis but his brother John as well as the first lieutenant of the *Constitution*, Isaac Hull. John Paul Russo has sorted out the facts related to the incident and to the painting's subsequent presentation to the Athenaeum.[4] John Davis had distinguished himself in Boston as United States District Judge for Massachusetts, founder and early officer of the Athenaeum, Fellow of Harvard College, and President of the Massachusetts Historical Society. He evidently commissioned Salmon's painting as a present for the now Commodore Hull, commander of the Boston Naval Shipyard and hero of the famous battle of the *Guerrière*. Probably his brother, Isaac Davis, then an Athenaeum trustee and member of the Fine Arts Committee, actually

107. Fitz Hugh Lane, *Yacht "Northern Light" in Boston Harbor*, 1845

167

108. Robert Salmon, *Seizure of a French Ship by the U.S.S. "Constitution," 1800*, 1835–1836

purchased the painting. After receiving the painting from John Davis, Commodore Hull in turn gave it to the Athenaeum in 1835.

Salmon's paintings of Boston harbor and shoreline were among his best (fig. 109), and doubtless had an impact on other younger artists. His *Wharves of Boston* (1829; fig. 110), now in the Bostonian Society, is one of his finest in quality and execution, with a sharpness of light and a clarity of form seldom surpassed anywhere else in his work. Coming but a year after his arrival in Boston, it must have won him immediate respect. The Boston wharves were, in these years, undergoing continual expansion in order to accommodate the increased volume and tempo of shipping activity. Central Wharf was completed in 1819, and during Mayor Josiah Quincy's tenure as mayor (1823–1828) the two-story granite market building designed by Alexander Parris went up on land filled in near Long Wharf. In the spacious rotunda above, Salmon exhibited his paintings a few years later. Visitors to Boston's harbor were naturally impressed with all these facilities.[5]

The presentation of Salmon's *Wharves of Boston* in 1894 to the Society occasioned a brief account in the *Proceedings* of that institution published the next year.[6] The Society had held an exhibition of ship paintings, which had stimulated Dr. Henry P. Quincy to make a gift of the Salmon painting in memory of his late brother, Edmund. Efforts to identify the ship and its strange sunburst emblem on the foretopsail have been unsuccessful. The painting held obvious historical interest in 1895 for Bostonians who had witnessed "the waters of our harbor . . . encroached upon, by the extension of wharves and the laying out of marginal streets, during the last half century."[7]

The Virginia Museum of Fine Arts owns what is perhaps Robert Salmon's summary painting of Boston Harbor: *Boston Harbor from Castle Island* (fig. 111). It is clearly a major work in scale and intention, and brings together many of the earlier elements of his stylistic development. Painted in 1839 toward the end of an enormously productive career in both England and America, the picture recalls details from previous harbor scenes, a composition often favored by Salmon, and a handling of light and color that anticipates future directions in American art. In Salmon's unique manner, it balances busy anecdotal detail and spaciousness of effect, documentation and imaginative design, forms in light and in shadow, sensations of motion and of stopped action, a feeling at once of intimacy and of monumentality.

The picture was commissioned by Henry Oxnard, a trustee of the Boston Marine Society, who also asked Salmon to paint two smaller works for him in March and April of 1839, the first of a pilot boat, the second a scene with a rowboat. Ironically, what was to be one of Salmon's most impressive achievements in this instance did not meet with his patron's favor, for the artist was to record in his catalogue: "No. 994. April 1839. Ship Charlott [sic], painted for Oxnard, did not like it, charged $400. time to paint about 6 weeks. 5 foot by 3 foot 4 Inch."[8]

Boston Harbor from Castle Island views the distant shoreline of the city with the Bulfinch Statehouse visible to the right of center. Appropriate to the canvas's size (40 × 60 inches) is the sense of sweeping openness; every zone of the composition, while filled with activity, does not seem crowded. Figures are most evident in the foreground, two large groups of sailing vessels in the middleground, and the shoreline of wharves and buildings in the background. Rather daringly, Salmon has darkened each of these horizontal areas with a band of shadow, with the passages of water between them caught in bright sunlight. Sailing out of the harbor into the sunlit foreground, the main vessel has been identified as the ship *Charlotte*, 390 tons, which in 1839 was owned by the Packet Lines and mastered by N. Gorham.

Although relying on his favored device of near symmetry for the arrangement of the two major groups of vessels here, Salmon is able to enliven his picture with great vitality by making the sunlit group slightly larger, by contrasting it with the other group in shadow, by showing vessels from different points of view, and by placing the Statehouse well off center. Instead of the rather artificial funneling of attention to the center horizon in *The British Fleet off Algiers* (1829; fig. 112), here there is a more complex and interesting sequence of forms to lead the eye across the picture space. To keep the two main groups of vessels from dividing the composition in half, the artist links them together visually by their repeated diagonal

109. Robert Salmon, *Boston Harbor*, 1843

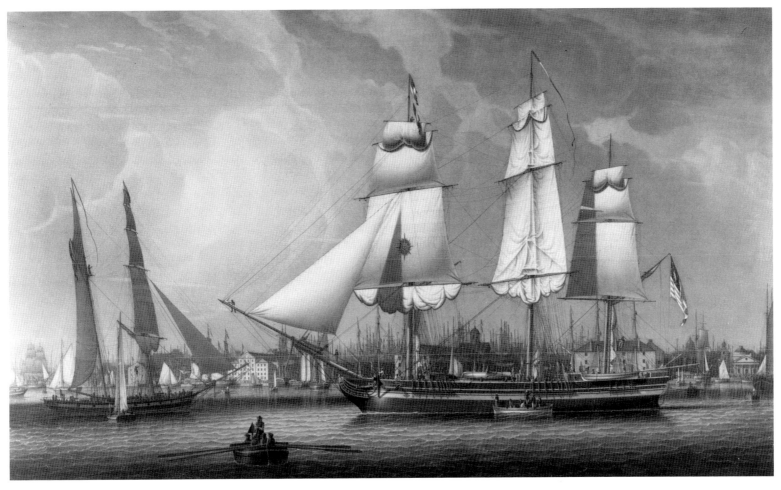

110. Robert Salmon, *The Wharves of Boston*, 1829

movements, and by focusing interest on the silhouette of the State-house in the center background and on the flag-waving group of figures in the center foreground.

Just as the central keynotes of the largest vessels are repeated in the smaller ones, so too do the various figural groups echo one another. Paralleling the movement of the vessels out of the harbor,

their glances also carry from right to left. Reflecting both meteorological accuracy and artistic coherence, Salmon further links the similar rhythms of billowing sails, patterns of waves, and formations of clouds. His intuitive sense of balanced design, seen overall, is evident as well in microcosm, as the rendering of most details will demonstrate; for example, each figural group involves individuals

171

111. Robert Salmon, *Boston Harbor from Castle Island (Ship Charlotte)*, 1839
(Color Plate 13)

seated and standing, gesturing and motionless, darkened by shadow and brightly colored, suggesting vertical and horizontal shapes. Equally, Salmon's handling of color is both restrained and animated. The dominant blues and greens are punctuated by yellows, whites, and reds. It is a picture that tells us much of what is to come in American art, while remaining notably interesting in its own right. On all levels—technical, formal, conceptual—it is a major oil unsurpassed in his final years.

Salmon's work, however, was not merely "an object of fashionable patronage," as one newspaper put it,[9] but equally known to his fellow artists and friends. Once settled in Boston, Salmon found himself virtually the only marine painter in the community. Aside from Washington Allston, moreover, he was the only man in Boston at that time who had devoted his life to painting for many years. It is not surprising that aspiring young artists like Henry Hitchings visited him and valued the opportunity to talk to him and see his work.

The frequent newspaper notices of his work, and the number of his patrons who belonged to Boston families of substance, reinforce the impression that his talents were widely noticed and admired.

The smallness of the artistic world of Boston in that day can be glimpsed in the autobiography of Benjamin Champney, who came to the city in 1834 to work in a shoe store, soon found an opportunity to serve an apprenticeship to William S. Pendleton the lithographer, and in this way commenced a long career as an artist:

At this time there were few artists in Boston. Alvan Fisher and Thomas Doughty were painting landscapes; Salmon, marines; and Geo. L. Brown was exhibiting landscapes and marines painted in his early manner. Gerry & Burt had a place where they painted banners and signs. . . . Both these artists were painting landscapes when possible. Harding was the principal portrait painter. Albert Hoit came to the city about this time,

112. Robert Salmon, *The British Fleet Forming a Line off Algiers*, 1829

as did also Henry Willard. Joseph Ames was just beginning his work, as were also Thomas Ball, and George Fuller a little later on. They were all struggling young men, experimenting as they could in colors, and looking up to Washington Allston as the great master, as indeed he was.[10]

Almost alone among the artists named, Salmon and Chester Harding were not "struggling young men." Harding, however, was a self-taught native American painter; Salmon was one of the handful of British painters of this era who brought to America a different kind of skill, and a fresh link to long-established traditions.

Whether that link was continued in the errant career of Salmon's nephew is unknown. The facts about him and his work are few. In the *Boston Almanac* for 1841, the two marine painters listed are F. H. Lane, 17 School Street, and Robert Salmon, 16 Marine Railway. One of the six "Coach and Chaise Painters" is John M. Salmon, Marlboro Place. In the *National Academy of Design Catalogue* of the Eighteenth Annual Exhibition, 1843, entry no. 345 was: "Landscape from Nature, for Sale . . . J. Salmon."[11] Three watercolors of beach scenes have turned up in the collection of Dr. J. B. Penfold of Colchester, Essex, England; on the reverse of each is written: "Lowestoft Beach, J. Salmon." They are charming and compe-

173

113. Fitz Hugh Lane, *Boston Harbor, Sunset*, 1850–1855 (Color Plate 14)

tent watercolors in horizontal formats that are proportionately longer than any of Robert Salmon's. Each depicts a lighthouse just above the beach from opposite angles. A shipwreck is just visible off shore, and men are attempting to land the lifeboats while avoiding the ledges beneath the breaking waves. The painting of the water is nicely handled; the slabs of rocks, the details of the ships, and the figures collected on the beach are all reminiscent of Robert Salmon's style. But aside from stylistic similarities further documentation is missing. If these airy little scenes are by the nephew, they testify to good instruction from and example set by his uncle. London Directories for 1865 through 1868 list under "Artists" John Salmon, 156 Camden Street, Camden Town, N.W. It is possible that the nephew returned with Robert Salmon to London, but there is no way of verifying this. If this elusive nephew were as talented as Hitchings suggests, he may have produced at least a few works that rival Salmon's own, and it may well be that some unsigned paintings today attributed to Salmon are in fact by the forgotten student.

Although the record of his activities is incomplete after 1842, Sal-

mon's influence did not end so mysteriously or abruptly, contrary to popular thought. He is now definitely known to have had a pupil in Fitz Hugh Lane (fig. 113), as well as probable imitators in William Bradford and Albert Van Beest (fig. 69). Lane was a cripple from youth who had early turned to pencil sketching and lithography. He left his native Gloucester in 1832 to become an apprentice at Pendleton's lithography shop and remained in Boston doing prints and later oil canvases until 1848.[12] Salmon made note of doing on commission several small sketches for Pendleton between 1831 and 1833. At Pendleton's shop, he may also have known John W. A. Scott, who later went into business with Lane as a lithographic publisher, becoming an accomplished painter in his own right after Lane returned to Gloucester.[13] About 1835, Benjamin Champney also was working for Pendleton; his mention of Salmon as one of the comparatively few artists then living in Boston has already been noted. Other details, small in themselves, contribute to the picture. Salmon's lodgings for one year, 1834, are listed in the Boston City Directory as being at the rear of Pendleton's shop on Washington

Street. All that is known of the commissioning of Salmon's painting on the fire at the Old State House, and the making of the engraving based on it, suggests a close relationship in the project among Salmon, Pendleton, and the engraver, James Eddy.[14]

Salmon records the purchase of three pictures (no. 557 and nos. 616 and 617, all in his list of "special pictures") by the Boston portrait painter Francis Alexander. A respected member of Boston's artistic community, Alexander was already becoming a collector as well as a successful artist; in midcentury he was to become one of the first Americans—along with James Jackson Jarves—to collect Italian primitive paintings. He too could have met Salmon through Pendleton, for he drew a number of portraits on stone for Pendleton in the years around 1830.

Another younger artist who took note of Salmon was the sculptor William Rimmer, who in 1865 bought the view of *Sunderland Bridge* (1828) now in the Boston Public Library. Rimmer was born in Liverpool in 1816 but left as a child of two with his father for Nova Scotia. In 1826 he moved with his family to Boston, two years before Salmon arrived. By 1830, at the age of fourteen, he was earning money working variously as a draftsman, sign painter, typesetter, and lithographer. One wonders whether his path may have coincidentally crossed that of Salmon, who also occasionally turned his hand to sign painting and lithography at this time. Rimmer is best known today for his few surviving sculptures, pent up with passion and energy. But his own skill as a draftsman may have led him to respond to a similar ability in Salmon's painting.

Craftsmen of other callings were also among Salmon's acquaintances. In partial payment for sails, Salmon had painted the portrait of John Lothrop, a sail maker with a shop at 113 Commercial Street. Another painting was a gift to Joseph Francis, a boat builder, perhaps as a part of a similar business arrangement. He was the designer of the barge that Salmon had painted for him. Francis was a native of Boston whose reputation was founded on his successful experiments in building unsinkable lifeboats. He began his experiments in the corner of a relative's boat-building plant. By 1819 he had succeeded in building a fast rowboat with supposedly unsinkable features. The boat was exhibited at the Mechanics Fair in Boston that year and received "honorable recognition." The following year,

Francis went to New York in search of orders and financial support, but without success. At last in 1838 he produced a wooden boat that was capable of withstanding the severest tests that shipowners could devise. He patented his idea in the same year, and within fifteen years practically every vessel sailing out of New York carried a Francis lifeboat. By using painting as payment for Lothrop and possibly for a boat from Francis, Salmon could neatly offer his talents in exchange for those of his friends.

As the painter records several times at the end of his catalogue, a number of his pictures were to have Doggett frames. The reference was to John Doggett, a native of Dedham and by 1818 Boston's most eminent frame maker. Known for a high standard of craftsmanship, the Doggett firm experienced steady prosperity through the 1820s and 1830s. Besides frames, Doggett also made furniture and, for Simon Willard, several clock cases. In later years, the firm added imported looking glass plates and carpets to its inventory. Doggett's frames were on paintings by Allston, Gilbert Stuart, and William Dunlap. The latter noted in a letter of 1812 that he was shipping his *Christ Rejected* (1824; location unknown) to "Doggett's great room, a noble place." When the Boston Athenaeum ordered from Stuart a portrait of Thomas Handasyd Perkins for which the artist was to receive $200, they ordered a frame from Doggett at $60.64. This enterprising frame maker was also a collector. For $500 he bought Thomas Sully's *Washington Crossing the Delaware* (1819; Museum of Fine Arts, Boston), and from Stuart he ordered a set of portraits of the first five presidents. He exhibited the set, known as the "American Kings," in various cities, and it was on exhibition in the Library of Congress when a fire there destroyed most of the group.

A final word must include mention of the Darracott family. Miss Darracott was the owner of the copy of Salmon's catalogue in 1881. About her there is little information, although a few pertinent facts about the family have emerged. The Rev. Edward G. Porter published in 1887 his *Rambles in Old Boston, New England*, in which he had a chapter describing Charter and adjacent streets in the North End:

On the east corner of Henchman's Lane, in the large wooden house built by his father, lived George Darracott, a prominent

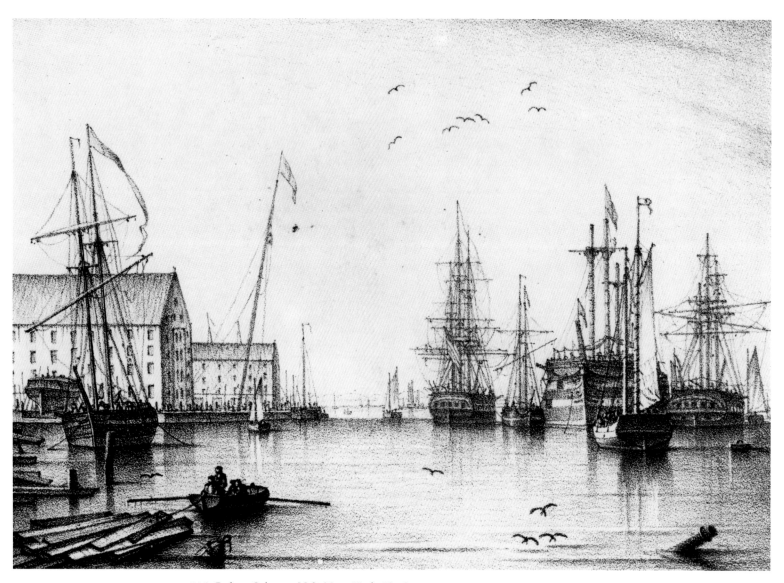

114. Robert Salmon, *U.S. Navy Yard, Charlesto[w]n, Massachusetts*, c. 1830–1835

citizen, who was identified with many public interests, such as the Marine Railway, the Boston Gas Works, and the new Fire Department. The latter was organized largely through his influence, and he was appointed second in command, with William Barnicoat chief. Mr. Darracott's family numbered eight sons and eight daughters, many of whom are still living.[15]

Darracott was probably Salmon's landlord during the time he had his studio at the end of Marine Railway (fig. 114). When Salmon returned to Europe in the summer of 1842, he entrusted Darracott with the settlement of his affairs in Boston. Moreover, Darracott's connection with the fire department suggests that he was instrumental in obtaining for Salmon another commission. This was to make a painting that could serve as a basis for an engraving on a fire department certificate in 1833. It is also more than likely that the "Miss Darracott" of 1881 was one of George Darracott's numerous children.

Together, these various associations of Salmon's help to give us a picture of the artist's world in the Boston of the 1830s. Salmon seems to have been very much a part of the active and wide circle of collectors, artists, and craftsmen who were leaving their imprint on the city at this time.

❦ 11 ❦

George Caleb Bingham's Geometries and the Shape of America

Looking at the configurations of George Caleb Bingham's career, we are struck by the fact that out of a relatively long life (1811–1879) and an extensive working output from about 1830 up to 1879, his truly significant art is confined just to the ten years between 1845 and 1855. But in that decade exactly straddling the midcentury mark, he was a major figure who made some of America's greatest art. To be sure, during the years leading up to this period he made numerous workmanlike portraits and several charming landscapes and genre pieces. In their design and touch, these showed his artistic awareness of precedents by Thomas Sully and Joshua Shaw, and even when he turned to his classic frontier genre pictures in the later 1840s, we know he was indebted to the inherited traditions of seventeenth-century Dutch and eighteenth-century English compositions. Partly as a result of his trip to Düsseldorf in the late 1850s, Bingham modified his style to the more polished finish and dramatic manner of the German school, and his subjects thereafter tended increasingly toward theatricality, contrivance, and obvious sentiment. While there is a clear technical finesse in many of his later portraits, his later history and genre pictures labor under exaggerated gestures, detailing, and narrative message. All the more commanding, then, is his triumphant combination of subtlety and energy in the slightly more than two dozen democratic images painted in the high noon of those central ten years.

Stylistically, Bingham's work of this critical period has a consis-

tent clarity, structure, and solidity about it that we recognize, on one level, as his signature manner and, on another, as an expression of America's supreme moment of self-confident optimism and expansionism. No matter the variety of posture or complexity of detail, Bingham was able to distill both a visual order and a palpability of space and form that spoke directly to the period's aspirations for harmony between the real and the ideal and between man and nature. To achieve this purity of design and volume in his compositions, Bingham relied primarily on a few fundamental geometries for his arrangements of figures in space. These were in linear and planar terms the horizontal and the triangle, but more importantly the solid geometries of pyramid and sphere, purely classical in their serenity, individuality, and dignity.

Indeed the stable pyramid is the organizing form in his most famous painting, *The Jolly Flatboatmen* (1845; fig. 115), but it also served as the basis for groups of boatmen ashore, as in *Watching the Cargo* (1849; fig. 116) and *The Wood-Boat* (1850; St. Louis Art Museum). Transferred to a tavern setting, the formula worked in variants for *The Checker Players* (1850; fig. 117), *The Country Politician* (1849; Fine Arts Museums of San Francisco; fig. 118), and *Canvassing for a Vote* (1851–1852; Nelson-Atkins Museum of Art, Kansas City, Mo.). Bingham made further use of this massing, both for a single figure in *The Concealed Enemy* (1845; Stark Museum of Art, Orange, Texas) as well as for one of his first large group composi-

115. George Caleb Bingham, *The Jolly Flatboatmen*, 1845

179

116. George Caleb Bingham, *Watching the Cargo*, 1849

180

117. George Caleb Bingham, *The Checker Players*, 1850

118. George Caleb Bingham, *The Country Politician*, 1849

182

tions, *Daniel Boone Escorting Settlers through the Cumberland Gap* (1851–1852, fig. 119). He constructed at least three of his other finest boatmen pictures around what might be called an implied or truncated pyramid, namely *Fur Traders Descending the Missouri* (1845; fig. 40), *Boatmen on the Missouri* (1846; fig. 120), and *Raftsmen Playing Cards* (1847; St. Louis Art Museum). Yet a third formal type could be termed the partial pyramid, where we see the massive sloping volume cropped and pushed to the left-hand side of the painting, most notably in *Cottage Scenery* (1845; Corcoran Gallery of Art) and *Shooting for Beef* (1850; fig. 121). Closely related are yet two others that combine different pyramidal geometries for the landscape and figures respectively: *The Squatters* (1850; fig. 122) and *Fishing on the Mississippi* (1850; Nelson-Atkins Museum of Art, Kansas City, Mo.). However modulated, this is clearly the language of classicism, or, more properly in midcentury America, neoclassicism, for which we can find numerous echoing parallels and similarities in the other major art forms of these years.

The circle and the sphere, of course, in their symmetry and unity are also essentially classical forms. Bingham especially delighted in using this volume for both the heads and torsos of his figures, as may be seen in *The Concealed Enemy, Country Politician, The Checker Players,* and *Canvassing for a Vote.* Finally, art historians have well noted Bingham's literal quotations of classical references, particularly renaissance and ancient sculpture.[1] This dominant classicism of both form and content in Bingham's work just between 1845 and 1851 makes us all the more alert to his changes in scale, massing of forms, and spatial organization that appear to occur around 1852 with the large *Election* pictures and most obviously with the Düsseldorf *Jolly Flatboatmen in Port* of 1857 (fig. 123). Given the traditional evolution of stylistic movements, we might see the *Election* canvases (figs. 118 and 124) as a baroque phase of Bingham's work, notable for their density, complexity, asymmetrical organization, and animated contrasts of light and shadow. By extension, the later *Jolly Flatboatmen in Port* represents an emerging rococo style: lively, even fussy, sentimental, and theatrical.

Bingham's classical core of work may readily be placed in the larger context of an exuberant, proud, and self-assured America in the years around 1850. His artistic vision of stability, centrality, and equipoise perfectly matched its time and place. His best art was cre-

ated at almost exactly the midpoint of the nineteenth century and near the geographical center of the country. America's growing population and territorial expansion were rapidly moving west, a trend accentuated by the California Gold Rush of 1849. Said Henry David Thoreau at the time: "Westward I go free."[2] Like the center of a compass, Bingham's world at the confluence of the Missouri and Mississippi Rivers was in the cross-axis of America's great geographical tensions. Born in the east himself, he moved west along with many of his countrymen. That movement of settlers, adventurers, and the railroad from east to west across the continent was still in motion by the 1850s. But while the prairie schooners sailed on one course, steamers and barges moved on the north-south axis of the Mississippi River. Symbolically, this direction was also the locus of the country's growing conflict over slavery, addressed in our literature's two greatest novels on the subject, *Uncle Tom's Cabin* and *Huckleberry Finn.* The former, published by Harriet Beecher Stowe in 1852, significantly coincides with the apogee of Bingham's oeuvre. We know of the sometimes frustrating firsthand involvement that the artist had in politics from the 1840s to the 1870s. He set down his wide-ranging observations on the vitality and foibles of democracy in the *Election* series of the early 1850s.

But American politics especially in this critical antebellum decade focused increasingly on the slavery issue, itself intimately bound up with the frontier territories. On one level, the decade of the 1850s was a high moment of national achievement, but on another the currents of tension and instability were inexorably rising to the flashpoint of civil crisis by the 1860s. Bingham's physical and emotional terrain was bounded by the key events of that time and place—the Compromise of 1850, "Bleeding Kansas," and "Free Soil" Missouri—which debated the inseparable concerns of territory and freedom, slavery and union. With the passions of sectionalism at a feverish high in 1856, Bingham, as politician and artist combined, began to contemplate a pictorial response to the passage of the Kansas-Nebraska Bill of two years before. This legislation purported to decide slavery in certain territories on the basis of so-called "squatter sovereignty," and led only to border warfare and spreading violence.[3] Subsequent hostilities in 1863 finally led him to paint *Martial Law (Order No. 11)* (Cincinnati Art Museum), not finished until 1870 in, by then for Bingham, an unfortunately melodramatic

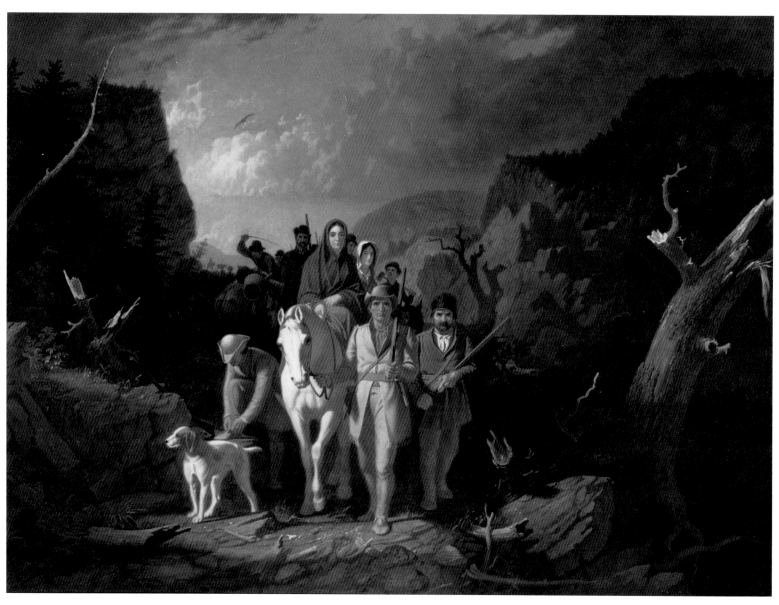

119. George Caleb Bingham, *Daniel Boone Escorting Settlers through the Cumberland Gap*, 1851–1852

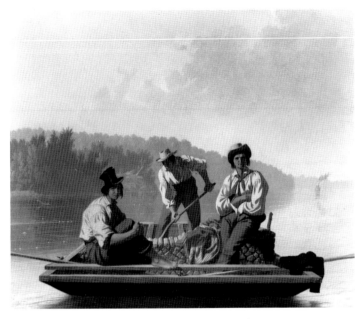

120. George Caleb Bingham, *Boatmen on the Missouri*, 1846
(Color Plate 15)

seen as the moment of brief balance and harmony between nature and the so-called "axe of civilization." For the agents of the new prosperity and growth were those of coming industry and its intrusions into the silent wilderness. New technologies in mass production, communication, and transportation were now having a dramatic impact in all corners of the country. For example, the manufacturing of interchangeable parts affected everything from Samuel Colt's firearms in Hartford to standardized balloon-frame construction of wood buildings everywhere. Samuel Morse's telegraph radically changed the pace of conveying information, and the steam engine perhaps above all was poised to revolutionize travel both on land and on water.[4]

Thoreau's celebrated references to the telegraph and the train engine call to mind the proliferation of railroad images in American landscape painting beginning at this time. Among the most famous were George Inness's *Lackawanna Valley* (1855; fig. 125) and *Delaware Water Gap* (1857; private collection), Asher B. Durand's *Progress* (1853; Warner Collection, Gulf States Paper Corportion, Tuscaloosa, Ala.), and Thomas P. Rossiter's *Opening of the Wilderness* (c. 1858; Museum of Fine Arts, Boston). All of these were significant American visual hymns to the still harmonious relationship between wilderness and technology. First fully articulated in that decade, the relationship would have poignant echoes in America's self-awareness up to the present. Commonplace by the 1850s, the railroad finally linked the entire continent together by the end of the next decade, and steam power in manufacturing as well as in the ironclads was to be decisive for the north in the Civil War. Symbolic of this age's sense of accomplishment was the triumph of the United States in the first America's Cup sailing race against Britain in 1851. Among the several artists who depicted the event was an important contemporary of Bingham, Fitz Hugh Lane, who was also to paint some of the period's most beautiful scenes in his Boston harbor views of the mid-1850s. Comparable to their colleagues' renderings of the railroad, these are tender and celebratory responses to a time of poise between sail and steam.

Although the tensions of change underlay much of the country's affairs in the few years surrounding 1850, this period, which coincides with Bingham's highest achievement, was remarkably in many

style. The point is that Bingham's landscape was literally at the center of American history, and his dominant artistic attention to pictorial order and balance is all the more interesting in this light.

The metaphors of zenith and apogee are applicable not only to Bingham's art but also to many other aspects of America at this moment. The decade of the 1850s was a period of national triumph, in part because of the temporary stasis that followed the ending of the Mexican War in 1848. The consequent political strains were held in check until the end of the 1850s and the inevitable outbreak of the Civil War. Meanwhile, the concept of Manifest Destiny, which had seized the national imagination during the second quarter of the nineteenth century, seemed near its fullest realization in claiming the breadth of the continent for the union. Territorial expansion was more than matched by staggering increases in the country's population and the gross national product. This period might also be

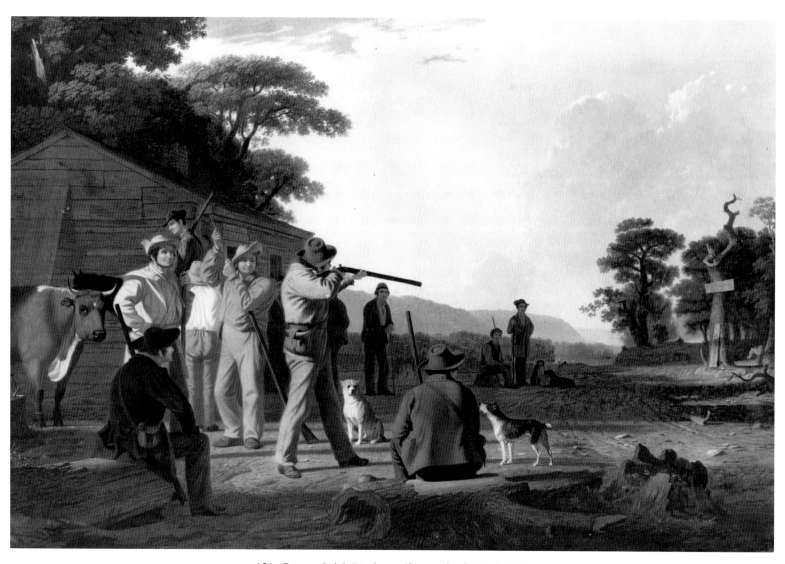

121. George Caleb Bingham, *Shooting for the Beef*, 1850

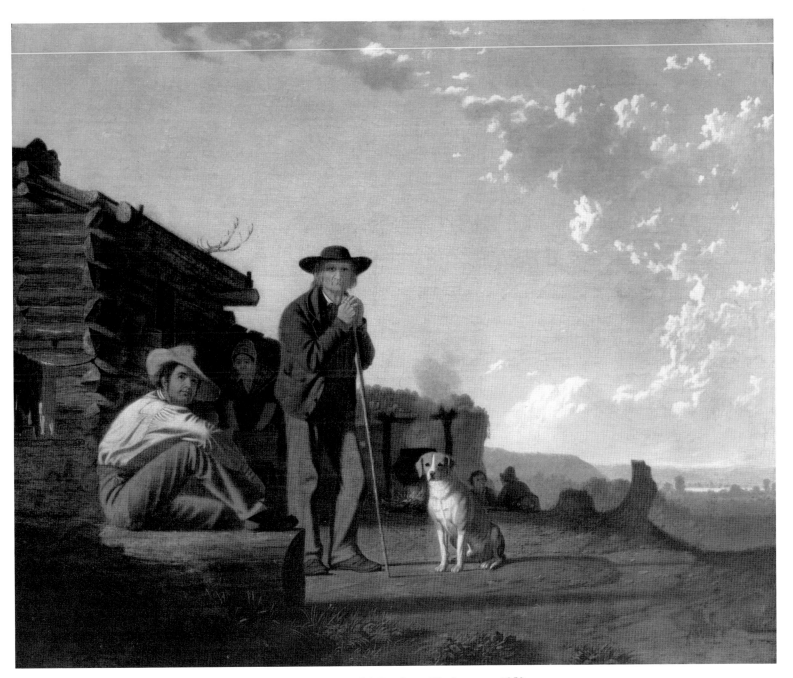

122. George Caleb Bingham, *The Squatters*, 1850

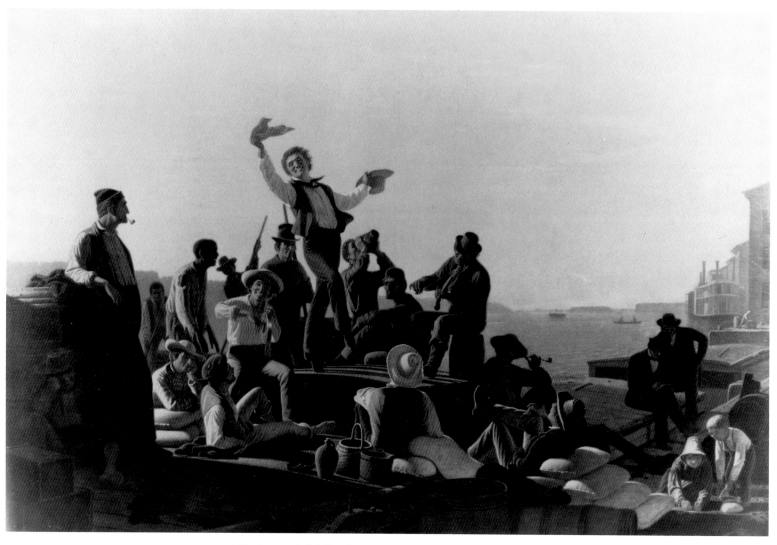

123. George Caleb Bingham, *The Jolly Flatboatmen in Port*, 1857

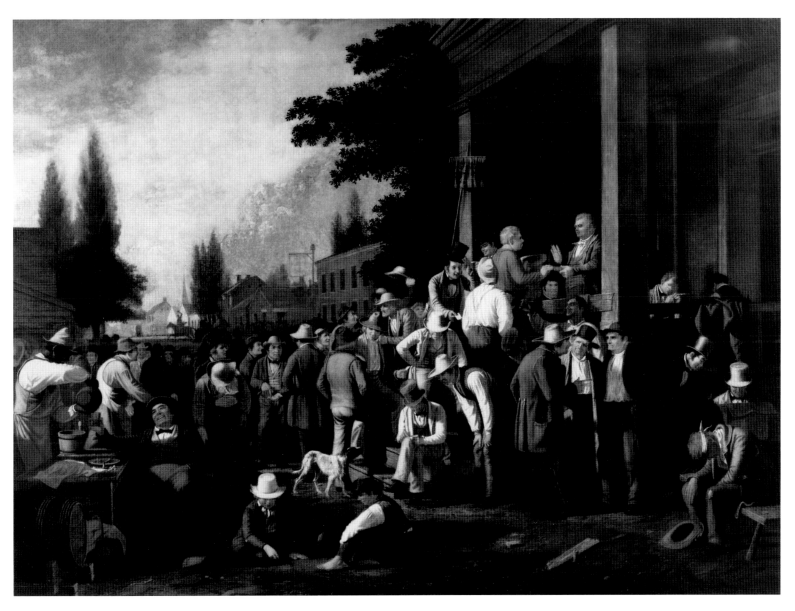

124. George Caleb Bingham, *The County Election*, 1851–1852

quarters a golden noontime of national self-expression. American literary and cultural historians refer to this moment as the "American Renaissance,"[5] noting the unusual if not unprecedented appearance within a five-year span of more than a half-dozen of America's masterpieces of literature. This canon includes *Representative Men* by Ralph Waldo Emerson and *The Scarlet Letter* by Nathaniel Hawthorne in 1850; the latter's *House of Seven Gables* and Herman Melville's *Moby-Dick* in 1851; *Pierre* by Melville in 1852, and *Walden* by Thoreau in 1854; and Walt Whitman's *Leaves of Grass* in 1855. In addition, a number of other nearly as important works were published in close proximity: John Greenleaf Whittier's *Songs of Labor* in 1850; Hawthorne's *The Blithedale Romance*, as well as Stowe's *Uncle Tom's Cabin*, already noted, in 1852; part of Thoreau's *Maine Woods*, in *The Atlantic*, in 1858; and Hawthorne's *Marble Faun* and Emerson's *Conduct of Life* in 1860.[6] More recently, critics have gone further to call this as well the "American Women's Renaissance," for, besides that of Harriet Beecher Stowe, work by Louisa May Alcott and Lydia Sigourney among others, as well as the earliest poetic production of Emily Dickinson, was also appearing in a "rich literary movement . . . when American women's culture came of age."[7]

As historians have shown, this literature embodied many of the tensions and paradoxes of the age, on the one hand "governed by a faith in progress, Manifest Destiny, and human perfectibility," and on the other by an underlying doubt, cynicism, even demonism.[8] But the dominant vision asserted reform and renewal, independence and creativity, typified in Emerson's belief that "unlike all the world before us, our own age and land shall be classic to ourselves."[9] Such dreams of perfection informed not just the art of Emerson and Bingham and their immediate colleagues but, as already suggested, a much broader expression in the American arts at midcentury.

In painting alone, we might argue that genre painting reached its apogee in this period, foremost in Bingham's hands but almost equally with William Sidney Mount, whose masterpiece *Eel Spearing at Setauket* (see fig. 52) coincides with Bingham's first great works in 1845. Likewise, the flourishing of still-life painting at this moment attained an amplitude and ripeness as much in style as in subject, especially in the examples of Severin Roesen and John F. Francis from the mid- and later 1850s. Some painters produced their single

most important pictures in this decade, for example, *Kindred Spirits* (1849; fig. 126) by Durand, and *Blue Hole, Flood Waters, Little Miami River* (1851; Cincinnati Art Museum) by Robert Duncanson—both tributes to nature's spiritual strength. Sharing the clarity and suffusion of light found in Bingham's paintings, some of the most powerful paintings by the luminists date from the decade of the 1850s. Between 1858 and 1859 alone come Sanford Robinson Gifford's *Mt. Mansfield* (1858; Manoogian Collection, Detroit), Martin Johnson Heade's *The Coming Storm* (1859; see fig. 53), and John Frederick Kensett's first versions of *Lake George, Shrewsbury River* (1859; see fig. 39), and *Beacon Rock, Newport Harbor*.

Arguably, America's two purest landscape painters at this time, Fitz Hugh Lane and Frederic Edwin Church, produced in a comparably brief span of years their best body of work, as accomplished and commanding as the volumes by their literary counterparts in the American Renaissance. The planar structures of Lane's compositions and his glowing ambiences of light parallel Bingham's solid geometries and sun-flooded spaces. In Lane's paintings of Gloucester, Salem, and Boston harbor and Blue Hill, Penobscot Bay, and Mount Desert, executed between 1850 and 1860, is an imagery of serenity and well-being, and personal and national self-fulfillment, which is at the heart of the antebellum calm before the storm.[10] At the same time, Church created scenes of blazing light and particularly sunset that were wholly new and supreme in their elocution of the country's heroic course of destiny. Technically and intellectually, they are at the apogee of American landscape painting in the nineteenth century.[11]

These were equally the years of the ascendancy in American sculpture of neoclassicism, whose perfected forms and message could be no better seen than in Hiram Powers's *The Greek Slave* (1843–1851; Corcoran Gallery of Art), and Thomas Crawford's pediment for the United States Capitol, *The Progress of Civilization* (1854–1856). This was also the period when the daguerreotype as a medium was at its finest in the hands of Albert S. Southworth and Josiah H. Hawes, and when Donald McKay gained the pinnacle of clipper ship design with his *Flying Cloud* of 1851 (fig. 127).[12] In both enterprises, Americans balanced utility and creativity. It was another American sculptor, Horatio Greenough, who articulated these ideas most

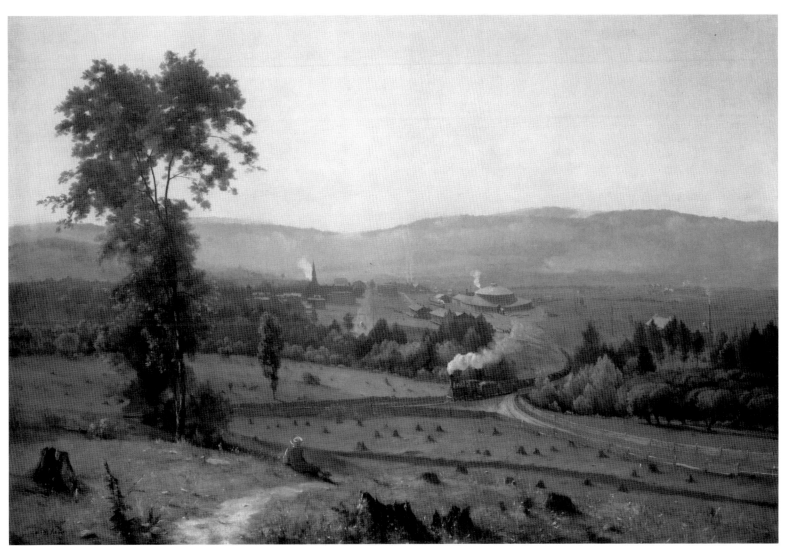

125. George Inness, *The Lackawanna Valley*, 1855

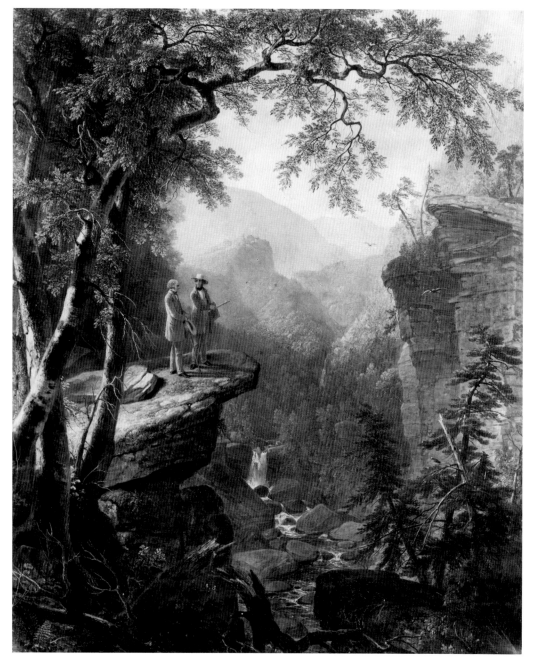

126. Asher B. Durand,
Kindred Spirits, 1849

192

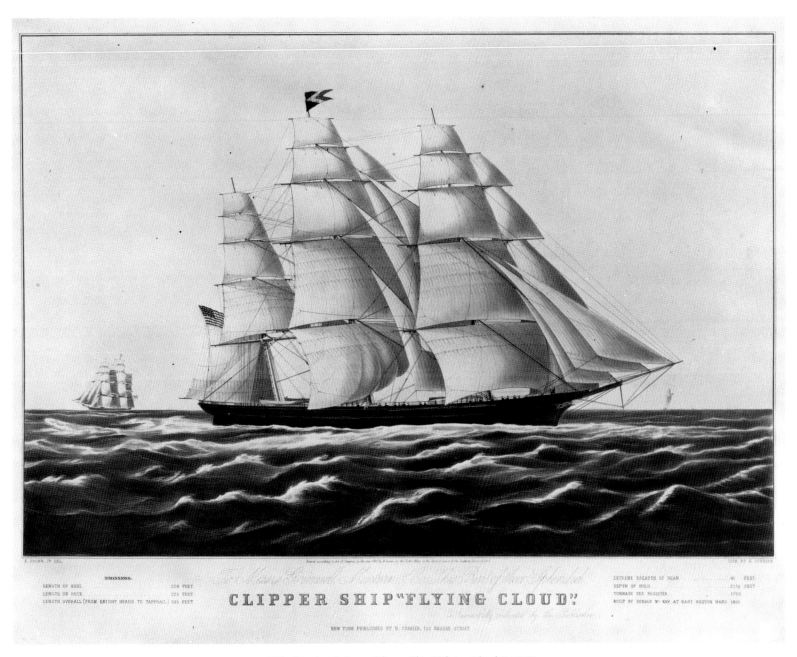

DIMENSIONS:

LENGTH OF KEEL 208 FEET
LENGTH ON DECK 225 FEET
LENGTH OVERALL (FROM KNIGHT HEADS TO TAFFRAIL) 235 FEET

EXTREME BREADTH OF BEAM 41 FEET
DEPTH OF HOLD 21¼ FEET
TONNAGE PER REGISTER 1750
BUILT BY DONALD McKAY AT EAST BOSTON MASS. 1851

CLIPPER SHIP "FLYING CLOUD".

NEW YORK PUBLISHED BY N. CURRIER, 152 NASSAU STREET.

127. Currier & Ives, *Clipper Ship "Flying Cloud,"* 1852

eloquently in the essays published at the end of his life, *The Travels, Observations, and Experiences of a Yankee Stonecutter* (1852). There he argues that "those who have reduced locomotion to its simplest elements, in the trotting-wagon and the yacht America, are nearer to Athens at this moment than they who would bend the Greek temple to every use. I contend for Greek principles, not Greek things."[13] In fact, America in the 1850s relished both Greek principles and Greek things. Classical geometries governed not only painting and sculpture, but the principal forms of architecture at this time as well. Neoclassicism in America had evolved out of imported English Georgian styles at the end of the eighteenth century into a delicate Adam-influenced Federal style, which in turn gave way during the first quarter of the nineteenth century to the increasingly bold and muscular forms of the pure Greek revival. The more linear and planar character of earlier architecture, expressed mostly in wood, gradually yielded to brick, masonry, and granite composed in powerful solid volumes of space and mass. By midcentury, the Greek revival had reached its fullest expression and most widespread influence. One of its major exponents was Robert Mills, who had designed a number of public buildings in Washington and elsewhere. He completed two of his finest works, the United States Treasury Building and the Patent Office in Washington, in 1842 and 1851, respectively, by which time the classical style not only had come to dominate official buildings but was pervasive throughout much of the country in all manner of domestic and anonymous structures.[14]

In terms of organization, the Greek revival style stressed clarity of the various elements, gathered in rhythmic relationships into a unified whole, not unlike the compositional process we have seen in Bingham's art. In terms of character and meaning, the style was readily adaptable and pragmatic, therefore well suited to democratic needs. Moreover, its solidity and sense of balance expressed the developing nation's wish for order and strength. At once simple and bold, Greek revival classicism embodied the republic's common aspirations.[15] As with landscape and genre painting, the upheaval of the Civil War period challenged and transformed these modes of expression, whether by a new romanticism, industrial dynamism, or naturalism. The asymmetries of the gothic soon introduced complexities and irregularities appropriate to changed needs.

Bingham, like America in 1850, held moving forces in balance. His triangles and pyramids suggest both apex and pivot. On the one hand, expressions in American literature, painting, and architecture were at a zenith in the nation's life. On the other, this was a decade in transition—between agriculture and industry, sail power and steam power, sectionalism and union. Artists such as Lane saw the poignant paradox of twilight as both stillness and change. Bingham's dancing flatboatman evokes simultaneously the immediate moment and the transcendant ideal. Exuberantly he occupies center stage, stable vertical set upon solid horizontal, while lifting his feet and snapping his fingers to the pulse of motion and music in the soft still air.

12

Winslow Homer in the 1870s

O F ALL of Winslow Homer's patrons Lawson Valentine was literally central to the artist's life and career. Homer was in his mid-thirties when he first met Valentine, probably before his first visits to the Adirondacks during the early 1870s.[1] Valentine was a friend and supporter of the artist throughout most of this critical decade in his career, commissioning or buying well more than a dozen works of various subjects, dates, and media. Together, they comprise all the essential images of Homer's art during this period; at least a couple are related to key works in the artist's canon, and one watercolor, *The Berry Pickers* (1873; fig. 128), is arguably among the half-dozen greatest pieces dating from this decade of his output.

Since Homer's youth growing up in Cambridge, his family had known the Valentines. The association grew stronger during the Civil War years, when the young artist moved to New York to work for *Harper's*. Lawson Valentine also relocated his varnish manufacturing company there, and Homer's brother Charles joined the operation as a major stockholder and executive officer.

Valentine had first rented a cottage near Walden, New York, in 1870, and probably the following summer Homer also traveled to the area to fish and to sketch. He evidently saw the Valentine family in New York during the following couple of years, undertaking work for Valentine then while drawing closer to the family socially, thanks in part to his brother Charles Homer's already warm friendship with the Valentines. In 1876 Valentine bought property in Mountainville, New York, naming it Houghton Farm after his wife's family name; Homer returned to visit that summer and again two years after, when he painted a flood of pictures, many of which were acquired by the artist.[2] Although many of the Valentine Homers have been dispersed by sale or gift over the century since, remarkably a core group of among the best and most interesting remained in the family's hands, descending first to a son-in-law, Harold T. Pulsifer, whose name is most associated with his long-term loan of the collection to Colby College, and thence to a niece. It is this singular group of eleven works so long held together that engages our attention here, both for the circumstances surrounding their creation and preservation and for what they reveal about a major American painter in the years when he was growing into a great artist.

Virtually all of the pictorial themes that Homer would address in the 1870s are present in the Valentine group. Technically, one of the oils and its preliminary drawing, *Army Teamsters* (1866; fig. 129), date just prior to this chronology. This was a second amplified version of the subject painted after the Civil War at Lawson Valentine's specific request. The imagery of blacks had of course engaged Homer's interest during the war years, when he was on assignment as an illustrator among army lines for *Harper's* magazine, but it was a complex and important subject to which the artist returned on several occasions during the Reconstruction period. In the later 1870s, he produced a number of compelling oils and watercolors of blacks in the south which the art historical literature has only recently begun to probe and illuminate.[3] This was only one of many subjects for Homer in this period in which he was steadily moving from illustration and caricature to a serious, even profound, genre painting.

195

128. Winslow Homer, *The Berry Pickers*, 1873

129. Winslow Homer, *Army Teamsters*, 1866

His watercolor of *A Sick Chicken* (1874; fig. 130) and the 1878 gouaches of young girls as shepherdesses at Houghton Farm belong to a much larger group of works developed in this decade devoted to women posed alone, still and contemplative. Increasingly the isolated individual acquired an ever-greater gravity of form and mood. Just as Homer himself was moving from his own years of late youth into middle age, so too we watch his early preference for recording the activities of children yield to older figures of early maturity, painted with a sense of self-awareness and the nuances of a psychological sensibility. His images of young women in these years may be seen in contrast, on the one side of the decade, to the rather stiff fashion mannequins of such 1860s pictures as the croquet-playing series and *Long Branch, New Jersey* (1869; fig. 131), and, on the other side of the period, to the newly statuesque and heroic fisherwomen facing the elements in his Cullercoats work of the early 1880s. Aloneness was clearly something Homer was beginning to face at this time in his art and in his life.

Another way of exploring the issues of human separateness and relationship was to essay scenes of pairs of children, and Homer's work of the 1870s turns constantly to compositions of two girls, two boys, or a boy and girl, whether jointly holding a bucket or basket, crossing a meadow or beach, seated on a branch or field, or balanced by a fencepost. Two of the Valentine watercolors, *On the Stile* (c. 1878; fig. 132) and its companion showing a farm boy and girl by a fence, concentrate on the subtleties of opposites, the physical and emotional connections balanced on a fulcrum.[4] A further theme evident here was related to the artist's personal life in these years—the relationship between male and female. Other than his art, Homer left almost no documents, statements, or letters about his private life, and historians have indulged in much speculation about his relations with women and especially with the possible lost love he may have courted in Mountainville.[5] It is a fact that in his life he never married and that in his art men and women almost never touch; even figures physically proximate seem psychologically distant. In such a context, the watercolors of a boy and girl beside a fence are particularly interesting as vignettes of surrogate courtship.[6]

Along with these thematic elements in his painting of the 1870s, Homer also made particular technical and formal advances in his

work, which resulted in greater clarity and depth of expression. In fact, he had so mastered command of his material and methods of execution by the end of the decade that he needed to make a decisive break in his routine. His trip to the north coast of England to paint in 1881–1882 proved to be a major turning point in his career, a threshold in his style and vision that carried his art on to the powerful trajectory we associate with his later achievements. But it is during the 1870s that we find his graphic style evolving from often dense and fussy compositions, with a myriad of equally competing details, to designs of much greater clarity, in which major and minor accents are differentiated, and where both picture space and surface read legibly. With his schoolhouse series and the Gloucester waterfront pictures of the early 1870s, we note a new mastery in placing figures effectively in relation to the surrounding elements of architectural or constructed forms. Whether from exposure to it during his Paris trip or later from his friend John LaFarge, Homer at this time became increasingly conscious of Japanese aestheticism; his prints especially, but also some of his paintings, display an undertaking of such devices as cropped forms, spatial compression, and simplified patterning. The angled organization of masses in *The Flirt* (1874; fig. 133) and the stark backdrop in his portrait of the Valentine sisters illustrate something of this spirit.[7]

Above all, the 1870s for Homer were a period of experimentation and expansion in his technical means. His most dramatic achievement was the taking up of watercolor in 1873, but of arguably equal significance was his carrying the medium to an entirely new level of fresh and independent expression in the summer of 1880. An idea of this evolution may be glimpsed in comparing the treatment of watercolor as a form of tightly controlled colored drawing in *Boys Wading* of 1873 (fig. 134) with the looser and more impressionistic handling of washes in the two Houghton Farm watercolors of 1878. But while Homer took up this new medium, he gave up another. Having begun his career two decades before as an illustrator, first in lithography and then in wood engraving, he was at the top of his form by the early 1870s, producing the most successful and accomplished prints of his career. Before he gave up his graphic work as an illustrator entirely at mid-decade, there was a brief period in 1873–1874 when he was energetically creative in several media

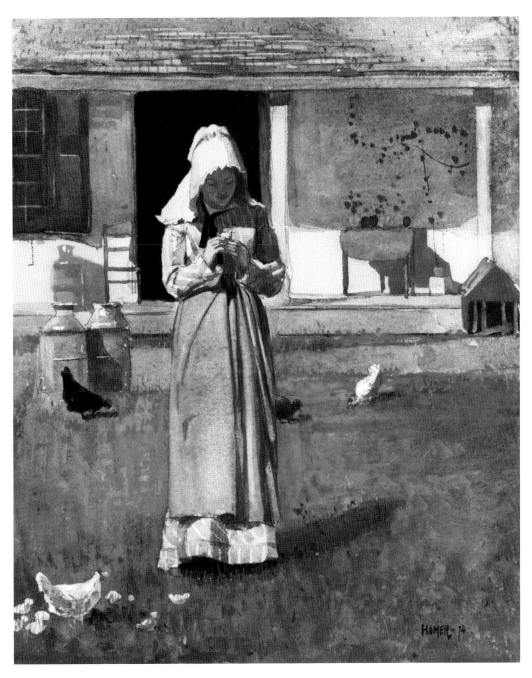

130. Winslow Homer,
A Sick Chicken, 1874

199

131. Winslow Homer, *Long Branch, New Jersey*, 1869

200

132. Winslow Homer, *On the Stile*, c. 1878

201

concurrently: drawing, wood engraving, watercolor, oil sketching, and painting. This is a particularly complex moment, with interconnecting imagery among the media, varying sequences in which he drew figures in one format and again in others, and an underlying exploration of the special properties of each type of expression. For example, while we assume the drawings were his initial renderings of forms or compositional groupings, we can not always be certain in what order Homer composed his versions in watercolor, engraving, and oil.

From these prolific years date such memorable works in both graphic and painted variants as *Dad's Coming* (1873; fig. 138), *The Noon Recess* (1873; National Gallery of Art, Washington), *Shipbuilding, Gloucester Harbor* (1873; fig. 143), *The Nooning* (1873; Wadsworth Atheneum), and *Sea-Side Sketches—A Clam-Bake* (1873; National Gallery of Art). What we can appreciate is that Homer by now fully understood the anecdotal capacity of the engraved illustration. To this end, his prints for *Harper's* and other magazines were more full of narrative detail and obvious storytelling elements appropriate for their general or family readerships. By contrast, he would eliminate diverting or minor details to concentrate on fewer figures in the oils and watercolors, media which allowed him to explore effects of light or setting and even undercurrents of psychological mood.[8]

Perhaps the most unusual aspect of Homer's work in the 1870s was his undertaking of portraiture; in no other decade did he produce more. On its surface, the double portrait of Lawson Valentine's daughters appears to be a comparatively restrained and minor effort, possibly because it was a commissioned rather than a self-generated work. Still, it is probably the period's most telling work of its type. Among the many stylistic transitions we have noted as being underway in Homer's art during the decade, he was centrally concerned with how his figures reflected individuality *and* universality. As a youth he had made occasional sketches and caricatures of his brothers in family scenes at play, and among his early lithographs from the 1850s is a multiple portrait of the Massachusetts Senate. A rather tender drawing of his brother Arthur reading a book by lamplight dates from 1853, and one of his older brother Charles from the

end of the next decade. There are one or two other modest portraits dating from the later 1860s.[9] During the next decade, Homer broadened, varied, and intensified his uses of portraiture. In 1874 he completed a watercolor in upstate New York of his friend *The Painter Eliphalet Terry Fishing from a Boat* (Century Association, New York), essentially an outdoor genre scene, and later that summer a quickly observed sketch of a local Indian at East Hampton, Long Island, *David Pharaoh, the Last of the Montauks* (private collection). Another drawing, of 1878, is also a fusion of portraiture and genre in its depiction of four friends engaged in a card game on the porch of the Valentine guest house.[10] At the end of this period, Homer finished a large and fully realized watercolor portrait of his brother Charles, shown full-length and seated comfortably in a relaxed three-quarter view. For the most part, portraiture was an activity of relative intimacy for the artist. He never married, and his family remained close and important to him throughout his life; not surprisingly, close relatives and friends would provide the primary occasions for his portraits.

In this context, the quiet and sympathetic portrait of Almira and Mary Valentine suggests that the Valentines provided Homer with the emotional support of a second family. Yet the simple design of the central silhouetted pose also relates to another striking series of late-1870s watercolors of women posed alone against plain backgrounds. The most frequently cited are *Portrait of a Lady* (1875; collection of Ogden Phipps) and *The Trysting Place* (1875; Princeton University Library); *The New Novel* (1877; Museum of Fine Arts, Springfield, Mass.) and *Blackboard* (1877; fig. 135); and the young woman seated in *Woman Peeling a Lemon* (1876; Sterling and Francine Clark Art Institute, Williamstown, Mass.), *Woman and Elephant* (c. 1877; Albright-Knox Art Gallery, Buffalo), and *Girl Seated* (1879; private collection).[11] These works have variously been noted as pictures of the New York girl with whom Homer may have had a failed affair at the time. We do not know, despite the elegaic and introspective air of these faces. That they are drawn from a specific individual posing with features as precise and personal as those in any portrait there is no question, but they finally tease with their effect of privacy and distance, if not mystery. They are at once

133. Winslow Homer, *The Flirt*, 1874

134. Winslow Homer, *Boys Wading*, 1873

204

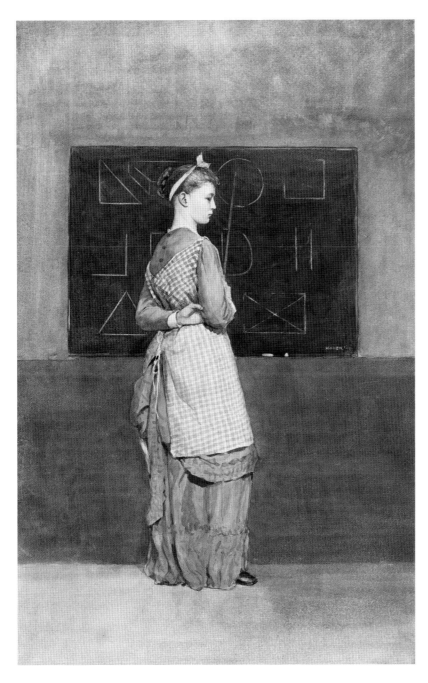

135. Winslow Homer,
Blackboard, 1877

205

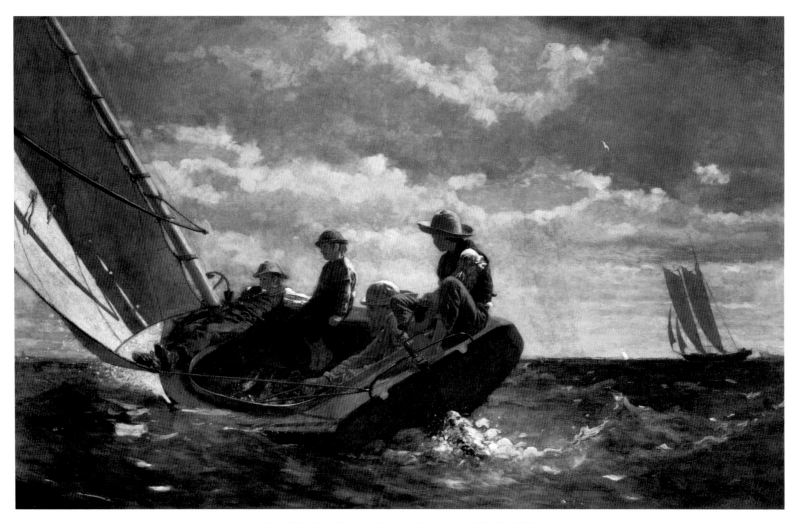

136. Winslow Homer, *Breezing Up (A Fair Wind)*, 1876

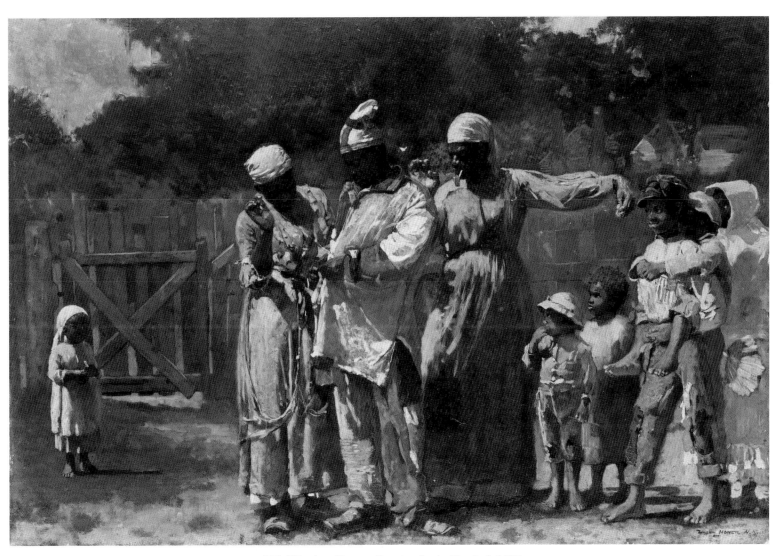

137. Winslow Homer, *Dressing for the Carnival*, 1877

207

portraits and not portraits. The related composition of the Valentine girls only tells how complex was Homer's response to other human beings.

Standing back for a moment from the Valentine-Pulsifer group at hand, let us ask what are Homer's greatest works of this decade. Aware that this can always be a speculative game and that many of his magisterial achievements were to follow in the 1880s, 1890s, and 1900s, we may still identify up to a dozen paintings that will always stand out in the literature on his art. These would surely include *The Country School* (1871; St. Louis Art Museum), *A Basket of Clams* (1873; Altschul Collection, New York), *The Cotton Pickers* (1876; fig. 149), *The New Novel*, and, among the top handful, *Snap the Whip* (1873; Butler Institute of American Art, Youngstown, Ohio), *Dad's Coming, Breezing Up (A Fair Wind)* (1876; fig. 136), *Blackboard*, and *Dressing for the Carnival* (1877; fig. 137). To this list we may confidently add the Valentine watercolor of 1873, *The Berry Pickers*, at the same time noting that *The Flirt* is an alternative version of the famous *Breezing Up*. Thus, from almost any perspective, Lawson Valentine was as astute a patron as he was a supportive friend.

In the decade and a half following the Civil War, Winslow Homer observed with some insight and sympathy the roles of blacks and of women in American society, the changes in education, and the uses of rural child labor and of greater leisure time. He also began to think about age and aging, how youth seems timeless yet impossible to hold. But if he discovered and interpreted a sense of humanity during this period, he also found a new landscape among the valleys of Mountainville and the pastures of Houghton Farm. This was the first time he had painted extensively away from the coast, and in the green expanses of the Adirondacks he saw the analogous rhythms of an inland sea. The rising peaks and rolling hillsides became abstracted settings for human activity and contemplation, pictorial conceptions that Homer would work out for the remainder of his career, a process culminating in such familiar masterpieces as *The Gulf Stream* (1899; Metropolitan Museum of Art, New York), *Kissing the Moon* (1904; Addison Gallery, Andover, Mass.), and *Right and Left* (1909; fig. 147). What Homer revealed, for himself and for us, at the center of his creative enterprise, were the constructs by which man faces himself and the world about him.

13

Winslow Homer's *Dad's Coming*

I N 1873 Winslow Homer was thirty-seven years old, at the exact midpoint of his life. Although Homer's reputation derives from the great works created in the later decades of his life, 1873 marks a period of singular, even critical, productivity. As the year itself may be viewed as a divider between his youth and his maturity, so certain key paintings of that time appear equally to look back in nostalgia and forward in serious thoughtfulness.[1] This period was for Homer one of culmination, transition, and initiative. Eighteen seventy-three was his last prolific year of producing significant engraved illustrations for *Harper's* magazine, and two years later he ceased making wood engravings altogether. At the same time, his style and subject matter were undergoing subtle transformations, as his artistic and psychological interests shifted from lighthearted anecdotal images in the established American genre tradition to more meditative and isolated treatments of the human individual. Furthermore, for the first time, we see him introducing into his art a starkness of imagery and design that would increase and carry into all his later work. Significantly now too, he ardently took up the medium of watercolor. On all counts, this moment in Homer's life and career is an important one to examine; in particular, his painting *Dad's Coming* (1873; fig. 138) proves to be both a luminous and an illuminating achievement of that moment.

As one entering his later thirties, Homer was susceptible to most of the usual uncertainties and realizations we associate with middle age. His career was set in its direction, and he was committed to it. But, having attained a reputable level of achievement, he now faced the unconscious (and possibly conscious) challenge of striving for a more profound level of greatness. In terms of American art, he had mastered existing genre and landscape conventions: now his instinct was to transform them into a new mode of realism, worthy both of a self-questioning age and of an artist's distilled wisdom. On a personal level, Homer always remained close to his family: he was devoted to his parents and especially to Charles, the elder of his two brothers. From his mother, Henrietta Benson Homer, an accomplished watercolor painter exhibiting in her own right, he had inherited the drive to paint and draw.[2]

At the same time, by the 1870s Homer was well on his own. He had made his first independent trip abroad to Paris in 1868, and after his return traveled extensively in the northeast during the early 1870s. Following excursions through New England; the Catskills, White Mountains, and Adirondacks; New Jersey; Pennsylvania; and Long Island—all providing him with ample subjects for his graphic work—he apparently discovered Gloucester, Massachusetts, in the summer of 1873. Here he painted *Dad's Coming*. Even a cursory glance at the work makes clear that by title and image this is a painting at once about family and about isolation.

The figures and setting of *Dad's Coming* have precedents in Homer's work of the immediately preceding years. For example, he had painted the resort shoreline of *Long Branch, New Jersey* (fig. 131) in 1869 and made a related pencil drawing in 1870. Other seashore views of the period include the oil and wood engraving of *Eaglehead, Manchester, Massachusetts (High Tide)* (1870; fig. 139) as well as *Rocky Coast and Gulls* (1869; Museum of Fine Arts, Boston). The latter is considered to be one of a couple of scenes painted during a

209

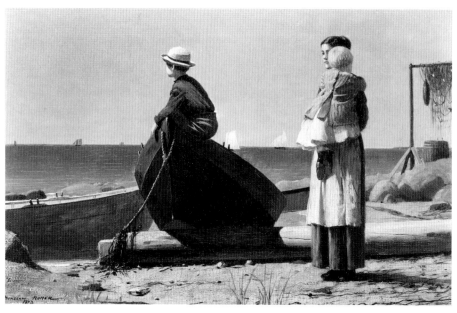

138. Winslow Homer, *Dad's Coming*, 1873 (Color Plate 16)

visit by the artist to Salem and Manchester on Boston's North Shore in 1870. Homer's oil *Shipbuilding in Gloucester* (fig. 140) dated 1871, probably derives from the same locale, although Homer methodically integrated it into other beach vignettes (fig. 141) in pencil, watercolor, and engraving (fig. 143) clearly executed at Gloucester two years later.[3]

In part, these paintings and drawings owe a broader debt in style to the traditions of American genre painting, well established in the decades before the Civil War. The idea of depicting ordinary citizens in everyday situations was perhaps best exemplified in the work of the 1840s and 1850s by William Sidney Mount and George Caleb Bingham (see figs. 52 and 120). Solidly trained as a draftsman and printmaker during this very period of the mid-1850s, Homer had ample opportunity to note the accomplishments of his predecessors, many of whose best-known images received wide circulation through engravings published by the American Art Union. Casual

figures at work or at play populated their compositions set both indoors and out. Often preoccupied with simple tasks, these individuals partake in modest narrative or anecdotal situations. Well into the 1870s, there was a dominant interest in children and youthful pursuits, themes at the heart of the American vision at midcentury. Playful, healthy youths were central to the paintings of Mount, Bingham, Eastman Johnson, and J. G. Brown, as well as to the writings of Charles Dudley Warner and Mark Twain. Indeed, Homer appears to have been quite conscious of such imagery, for the particular figure of a seated boy resting on one arm with legs stretched out, in the foreground of Bingham's *County Election* of 1851–1852 (fig. 124), reproduced as an engraving, reappears reversed in different positions in Homer's watercolor *Four Boys on a Beach* (c. 1873; National Gallery of Art, Washington) and the related wood engraving *Shipbuilding, Gloucester Harbor* of 1873 for *Harper's Weekly*.[4] For him it was as natural to ground his own early art in such an artistic

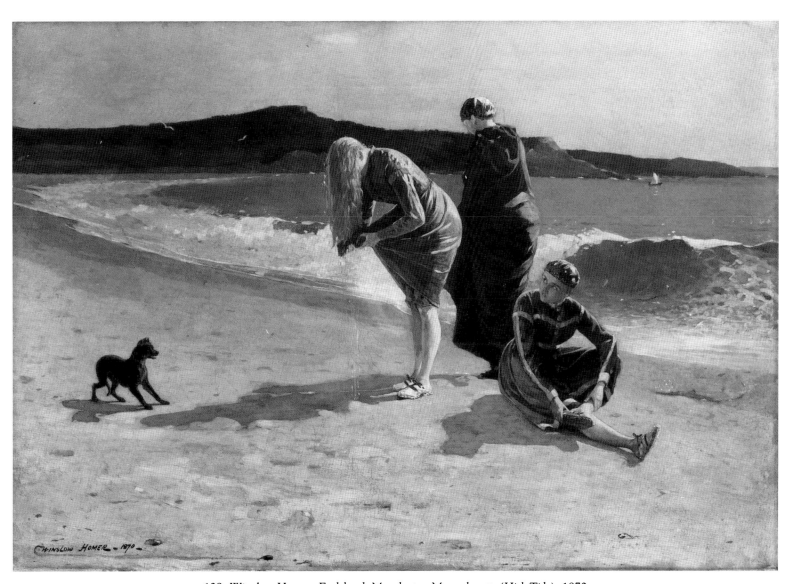

139. Winslow Homer, *Eaglehead, Manchester, Massachusetts (High Tide)*, 1870

140. Winslow Homer, *Shipbuilding at Gloucester*, 1871

ambience as it was to pay poignant tribute to youth, his own now slipping away behind him.

Homer's subjects of the early 1870s also grew out of existing landscape styles, in particular the clear constructions of the New England luminists Fitz Hugh Lane and Martin Johnson Heade. Lane is especially pertinent because his glowing canvases of Maine and Massachusetts harbors were the dominant artistic force in Boston during the very years of Homer's young apprenticeship and first professional practice. Lane was a native of Gloucester, well established, and exhibiting regularly in Boston during the 1850s. He had trained earlier in the same type of lithographic apprenticeship as Homer was then undergoing, and would have offered an exemplary professional model for the younger aspiring artist. Perhaps having seen Lane's Gloucester lithographs or paintings, or even the painter himself, may well have piqued Homer's own interest in visiting Gloucester later.[5] Among Lane's very last oils was a series of small crystalline beachfront views of *Brace's Rock*, done in 1863–1864 (fig. 46). Their clarity of detail, sharpness of horizon, and tightly concentrated scale distill a piece of the Gloucester shore in haunting anticipation of Homer's treatment of another section of beach in *Dad's Coming*.

This severe, jewellike canvas, then, merges two stylistic currents extant in American art, which were to serve Homer's own imperatives of artistic personal growth. Having moved into the Tenth Street Studio building in New York in 1871, Homer was working and exhibiting alongside a number of other American painters who were also on the threshold of celebrated careers. At the time, his mother was exhibiting her watercolors at the Brooklyn Art Association; possibly both parents were then living with or visiting relatives in New York. This period of artistic activity and travel culminated in June 1873, when Homer took rooms in the Atlantic House, overlooking Gloucester's inner harbor.[6]

The following three months stimulated an extraordinary outburst of activity by Homer. His first confidently mature watercolors date from this summer; he also produced several memorable oil paintings, and brought to a high point his production of wood engravings for *Harper's*. In this period, Homer dealt with both subject matter and technique with new facility. Imaginatively he integrated his figural groups into their landscape settings and repeated certain individuals,

often in telling variations, as he shifted from one medium to another. *Dad's Coming* may be seen as Homer's central subject of these months, as well as a distillation of his working methods in drawing, painting, and printmaking.

Among his other oils, watercolors, and engravings dating from this year that are related in spirit to this key picture are *Girls with Lobster* (Cleveland Museum of Art), *Boy in a Boatyard*, *The Boat Builders* (fig. 141), *The Nooning* (Wadsworth Atheneum), and *Boys Wading* and *The Berry Pickers* (fig. 128). These range from images of single boys daydreaming in the noonday sun, one in a farmyard, the other by the wharves, to depictions of youths in pairs, trios, and quartets gathered in summer's leisure activities. Several of the figures seem to reappear in this series; for example, the solitary lad in *Dad's Coming*, wearing his distinctively round hat with its curled-up brim, is close to those posed differently in the watercolors *Boy in a Boatyard* (fig. 142) and *Boys Wading* (fig. 134) and in the engraving *The Nooning*.

The wood engravings that Homer published in these months show similar characteristics. By comparison, his prints of the two preceding years are relatively indifferent and unprepossessing. Perhaps because of his active traveling, he turned out only seven prints in 1871 and three in 1872. The following year, he published eleven, which include some of his best: *The Noon Recess* (National Gallery of Art, Washington, D.C.), *The Nooning*, *Sea-Side Sketches—A Clam-Bake* (National Gallery of Art, Washington, D.C.), *Snap the Whip* (Butler Institute of American Art, Youngstown, Ohio), *Gloucester Harbor* (Nelson-Atkins Museum of Art, Kansas City, Mo.), *Shipbuilding in Gloucester*, *The Morning Bell* (Yale University Art Gallery), and of course *Dad's Coming*.[7] Some of these were obviously recapitulations of subjects Homer had conceived during the previous year or two traveling in upstate New York. But the beach and waterfront scenes were unmistakably inspired by Gloucester and its environs. Here he transposed his young boys and girls from the schoolhouse and country fields to the brightly lit and expansive shoreline. More interestingly, in every case he executed a closely related oil painting, in some instances two oils or watercolors as well as occasional drawings. The print *Shipbuilding, Gloucester Harbor* (fig. 143) was a composite of at least one pencil drawing, a watercolor, and two canvases

141. Winslow Homer, *The Boat Builders*, 1873

(figs. 140 and 141). Like the graphic images at the heart of this process, Homer's related paintings in the series tend to be small, crisp, and economical.

Generally, it is impossible to know with certainty the chronology or sequence of Homer's work on the same subject in different media. Because the engraving of *Shipbuilding* includes several groups of fig- ures and elements treated in isolation respectively in a drawing, a watercolor, and oil studies, we may assume that the print was the final integrated composition. Also the preliminary oil of that title (at the Smith College Museum), depicting a large schooner hull un- der construction, is dated two years earlier. No doubt Homer under- took the pencil drawing and watercolor en plein air during the sum-

mer months on the Gloucester shore, and finally reworked all the components for his engraved illustration after the summer was over. The print appeared in *Harper's* on 11 October 1873. In other situations, the relationship among images is not so clear, although by logic it seems that his illustrations for *Harper's* by definition were reproductive, and for the most part his harbor scene prints date from the end of the summer or early autumn.

Along with the oil of *Dad's Coming*, there exist two closely related images, a watercolor (fig. 144) that undoubtedly preceded the canvas and a wood engraving (fig. 145), published in November 1873, that followed it. All three are virtually the same size, differing from one another only by fractions of an inch. More intriguing are the obvious changes in composition and detail in each version, and the consequent nuances of meaning. The setting of the watercolor, executed outdoors on a brilliantly sunny day, appears to be the same neighborhood as that shown in others done the same summer. For

142. Winslow Homer, *Boy in a Boatyard*, 1873

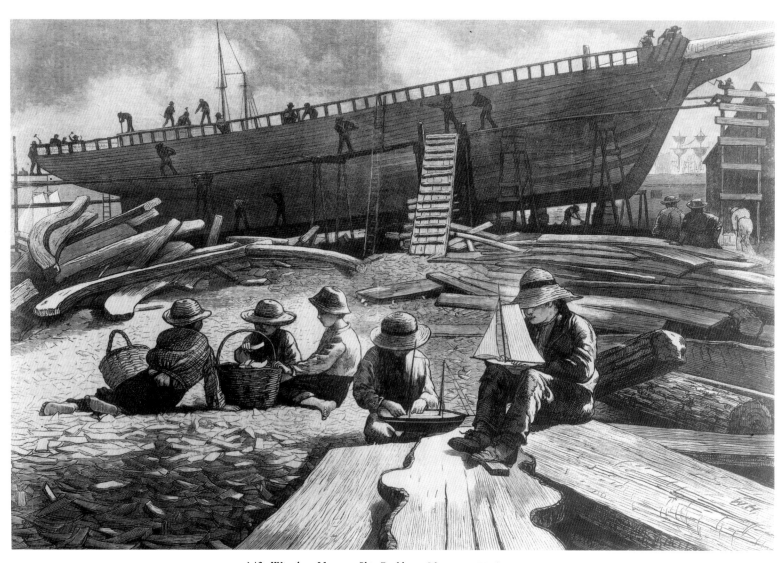

143. Winslow Homer, *Ship Building, Gloucester Harbor*, 1873

example, the large barrel in the right background is similar to ones found in *Boy in a Boatyard* and *Boys Wading*, while the lobster pot and fishing net drying above on the pole and beam are similar to the cranes and pulleys also seen in the right background of *Boys Wading* and *A Basket of Clams* (Altschul Collection, New York). But unlike these related watercolors, the scene *Dad's Coming* looks not into a closed corner of the wharf front but in the opposite direction, out to the open horizon. Homer's juxtapositions of near and far, human and abstract, intimate and expansive introduce a striking new formal power to this work.

Given its freshness of handling, barely finished or sketched in sections, and primary use of broad washes of white and pale blue, we can sense Homer's on-the-spot response to the immediacy of the moment. But with this directness of touch is evident his instinct for gaining compositional clarity and focus. Close to, but not exactly at, the center of the design he placed the combined forms of the boy and beached dory, together emphasized by the largest concentration of dark gray wash. This sense of contrasting tones and strongly silhouetted forms is extended further in the oil painting, and is even more dispersed in the engraved illustration. Such embellishments partly relate to the addition of the second figures in the oil as well as other details delineated in the print. But, in the initial version of the watercolor, only the boy atop the skiff is the principal focus of attention. Even the second dory to the left is barely distinguishable, with its pale blue hull, from the open water beyond. Still, with the large log, the boat is used to help organize Homer's basic composition of three broad horizontals: sky, water, and beach. The dark dory sits at right angles to these crossing bands of color, its sharp prow facing in toward the viewer in contrast to the gaze of the youth turned outward. The boy is perched, as if on a visual fulcrum, at the peak of the hull, seated illusionistically on the horizon line. In reviewing such simple yet subtle geometric intersections and bold foreshortenings of space and form, we have a clue to Homer's fresh experimentation with composition.

The idea of the self-absorbed figure was one that Homer had treated in several variations during the preceding year. In particular, he often painted a young woman alone with a book or gazing out a window, and he either framed the figure with simple geometric planes of architectural details or silhouetted her against a blank wall, just off-center in the composition.[8] With the image *Dad's Coming*, Homer achieved a new level of expression through his austere pictorial design and bold use of silhouette. Now daydreaming acquired a physical and psychological aura of isolation. Having taken this step, he was ready to refine further the possibilities of both his design and his subject. This refinement would appear in the oil painting.

The small but striking canvas represents the overlay of art on nature. In its emotional calm and precision of form, we can see Homer moving from describing his impressions of the moment outdoors to articulating his cerebrations in the studio. Working more painstakingly at an easel, Homer elaborated and strengthened his composition. Still depicting a brilliant, sunlit day, he shifted in the oil painting from the flickering transparency made possible by the watercolor medium to the more solid, pervasive glare of midday light. Of course, the most important changes are the inclusion of the woman and child, the solid modeling of the second dory, and the addition of strong coloring. Notable is the bright red of the baby's jacket, which Homer contrasted with the intense blue of the sea and the yellow beach. This play of primary colors now matches the simplicity of his pictorial construction, and together such formal reductions give a heightened severity to the meaning.

By combining the standing figures with the seated young boy, Homer introduced a further element—contemplation—as each stares off to a different quadrant of the horizon. He called attention to differences in sex, age, even generation. Because the picture was first exhibited with the title *Dad's Coming* at the Forty-Ninth Annual Exhibition of the National Academy of Design in 1874, and was published with the same caption in *Harper's*, historians from William Howe Downes (Homer's first biographer) on have read this image as one of a mother and her two children.[9] The woman and child to the right stand as one, with all the severity of a stone column as sharply self-contained within its silhouette as the form of the boy and dory to the left. The resulting effect is one of irony and mystery; for all the physical and familial proximity of these individuals, they gaze in isolation. Further, while the boy presumably searches the horizon for his returning father, the fixed glances of the woman and baby remain abstract and ambiguous. Intentionally or

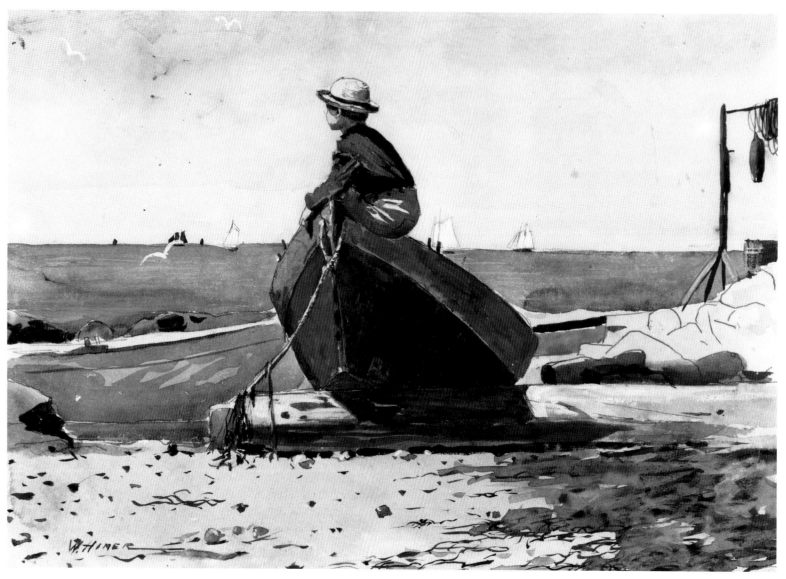

144. Winslow Homer, *Waiting for Dad*, 1873

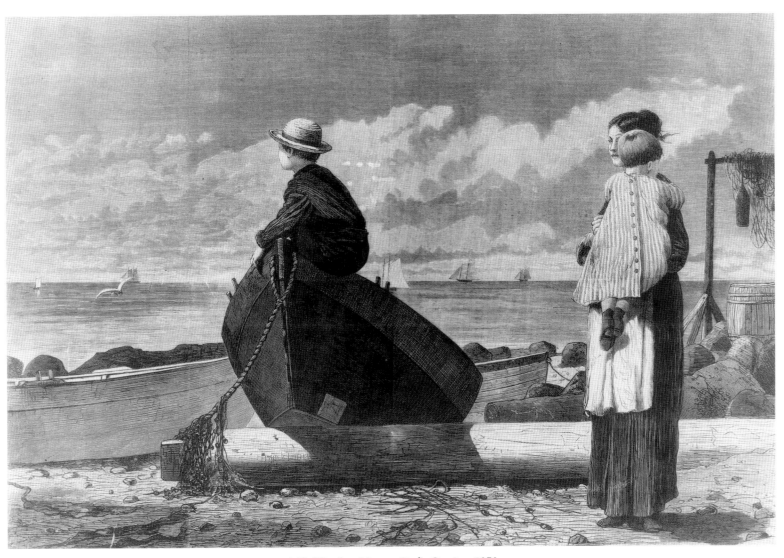

145. Winslow Homer, *Dad's Coming*, 1873

219

not, Homer made his painting into a metaphor of meditation, whether of youth, of loss and independence, or of mortality. During the years between America's Civil War and its centennial, such themes of nostalgia and anxiety surfaced in the national culture. Elsewhere, Homer himself returned to contrasts of generations and the tensions between the closeness and separateness of individuals.[10] However we try to explain *Dad's Coming*, its dry atmosphere, noontime light verging on harshness, and psychological privacy create a seriousness of mood never fully explicable.

The title given to this image first appeared with the engraving published in the 1 November 1873 issue of *Harper's* and its accompanying poem. A more descriptive, though erroneous, title—*Waiting for Dad*—first arose in 1949, and has since alternatively appeared in the literature.[11] The intriguing question is whether the oil was "used as a Harper's engraving," as Gordon Hendricks has asserted, or the print was "used as a motive for a painting finished about the same time," as described by Downes.[12] Naturally, there are differences in certain details between oil and print, owing mainly to the nature of the respective media and techniques required. But in this instance the two works remain unusually similar in comparison to other series of the period by Homer. Most likely his oil served as the model for his illustration, although their exact relationship lacks firm documentation. Certainly, painting and print are closer to one another than either is to the initial watercolor, and this leads one to speculate whether or not the figures of mother and child were added to serve the publication of the accompanying poem. *Harper's* was a family magazine for the general reader and therefore carried sentimental, anecdotal stories. While poems and illustration complement each other, there are notable disjunctions between them in both detail and tone. The verse appeared on the magazine page immediately following the print:

DAD'S COMING!

Out where the waters are sparkling and dancing,
 Crested with sunlight all purple and gold,
Turn the true eyes that so long have been watching
 To welcome the wanderer back into the fold.

Lightly the billows are foaming and tossing;
 Freshens the breeze as the sun goeth down:
Softly the light, ere it dies in its glory,
 Lays on the heads of the watchers its crown.

Now in the distance a white sail is gleaming,
 Flutteringly spread like the wings of a dove;
Nearer and nearer the light breeze is wafting
 The wanderer back to the home of his love.
"See, he is coming! Dad's coming! I see him!"
 Shout, little Johnny! Shout loud in your glee!
Only God heareth the prayer that is whispered
 For thanks that the sailor comes safely from sea.

Ah, happy mother! while clasping your treasures
 How little you think of Eternity's shore,
Where hearts true and loyal have parted in anguish,
 Where souls have gone out to return nevermore!
And eyes that were bright have grown dim with long watching
 While yours overflow with your joy and your pride!
But sing, little Johnny! "Dad's coming! Dad's coming!"
 The husband and father is safe at your side.[13]

It is frustrating to attempt to discover which served as the foil, the painted or the written imagery, for the author and Homer's knowledge of the verses are unknown. At the least it is evident that his painting gives no confirmation that the father in question has been sighted, let alone returned safely from sea. Homer depicted no shouting or singing, no celebration, and certainly no husband "safe at your side." Only with the addition of the woman and child does the implication of a waiting family emerge. Either way, as a requirement for the illustration or as an enhancement of the meaning of the painting, the stolid new figures on the beach serve Homer's own artistic purposes.

We can note a number of revealing changes made in the print in contrast with the canvas: the distance between the forms has widened; Homer added the banks of fair-weather clouds in the sky, and a wisp of the woman's hair blows in the accompanying breeze; the child now wears a striped smock; and the bow of a third rowboat

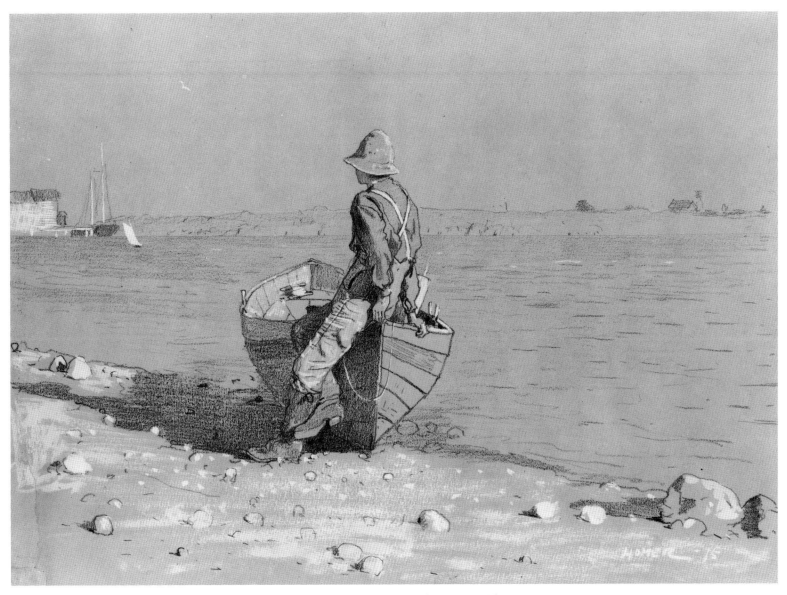

146. Winslow Homer, *Looking Out*, 1875

221

protrudes in the center middleground. To the left a seagull floats across the horizon line, a patch appears on the hull of the central dory, the rocks and barrel receive detailed definition, while seaweed fills more of the foreground. At the same time, Homer eliminated the large rock at the lower left and the spit of land on the right horizon.

Some of these differences reflect logical technical demands. Whereas one can model solid form in color with paint, a print is linear by definition, and the solid geometries of Homer's painting become planar patterns in his wood engraving. Likewise, the rigorous horizontal and vertical construction of the one tends to yield to more varied diagonal and curving forms in the other. Finally, the greater detail in his illustration responds to the inherently descriptive purposes of the graphic medium and the magazine itself. In sum, the entire process for Homer was one of imaginatively integrating line and color, modeled and silhouetted forms, and evocations of the evanescent and the permanent.

The lessons of expressive design that he found in this work frequently animated his compositions in the following years. While working directly out of doors, he was now able to organize the details of a scene with greater visual coherence and interest. In other Gloucester subjects of 1873, and in several inspired by the later experience up to the time of his return to the area in 1880, Homer frequently employed the compositional device of a single boy or pair of youths balanced on the peaked bow of a dory. The figure is seated at the balance point of an imaginery seesaw, suggesting at once tension and rest. Ordinarily placed off-center, the figure serves to link both sides of a composition as well as foreground to background. To

this end, Homer usually intersected the youth's head with the horizon line. The oil *Sunset* (probably 1875; National Gallery of Art, Washington), is unfinished possibly because Homer was still wrestling with the resolution of such design balances between figure and landscape.[14] More striking is his beautiful pencil drawing of 1875, *Looking Out* (fig. 146), whose resting boy and beached dory recapitulate the structure of *Dad's Coming*. Again, the boy's gaze and the sharply foreshortened hull, set almost at right angles to the foreground, lead both subject's and viewer's glance out to the distant activities.

The gazes in *Dad's Coming* reveal something more: their intensity of concentration is a result of human beings looking not just outward but inward as well. Perhaps because it is our natural inclination to read from left to right, our glance turns first to the boy and next to the pair standing to his side. Yet in scanning the horizon, we find that all five of the distant schooners are sailing in the opposite direction, from right to left. Thus, the vessel carrying the missing father is by implication moving even farther from sight. The conjunction of the added figures, the starkness of composition, and the title tied to the poem ultimately lend this seemingly cheerful picture a graver sensibility, which forces the viewer to wonder if Dad will indeed return, a somber question neither fully asked nor answered. We are left with the severity of form and mood, which seems to turn the warm sunlight chilly and unrelenting, and gives even the hanging lobster pot the foreboding gravity of a gallows. Homer's themes were grounded in his age, in both senses of the word. In the summer of 1873, at the fulcrum of his own life, his pivotal achievement was to balance eyesight with insight.

Winslow Homer's *Right and Left*

BEYOND the occasional museum bulletin or scholarly journal essay, there are surprisingly few articles devoted to comprehensive examinations of single important paintings by major American artists outside the larger contexts of an artist's career or of certain focal themes. Even more rare is the monograph published on a single work of American art. Only in Viking's Art in Context series does one find modest volumes treating single works, though just one has been devoted to an American painting. That was *Trumbull: The Declaration of Independence*,[1] and, ironically, we must note that this subject has greater interest for its historical rather than artistic qualities.

When we turn to the art of Winslow Homer, unequivocally one of America's greatest painters, we discover that few major works by him have been the focus of an entire extended study. Among the notable exceptions has been Nicolai Cikovsky's article, "Winslow Homer's *Prisoners from the Front*," for the *Metropolitan Museum Journal* in 1977.[2] It is all the more paradoxical, therefore, that this artist's possibly greatest work, his late masterpiece *Right and Left* (1909; fig. 147) has had no such attention. It, of course, finds its rightful place in all surveys of American art and in often perceptive discussion in the Homer biographies. Yet the only two published commentaries on this work alone are based on press releases provided by the National Gallery of Art. The first dates from the time when *Right and Left* was acquired in 1951, and the second from 1958, when the large Homer retrospective opened at the Gallery and the artist's market reputation was soaring. These pieces for *Art Digest* and *Newsweek* were respectively titled "The Thanksgiving Dinner Was Spoiled" and "Better than Apple Pie."[3]

One of the most imaginative appraisals of the painting came at the conclusion of a larger discussion by Roger B. Stein of American works selected as proposed indices to periods of national culture.[4] In his essay, Stein draws our attention to the almost Whistlerian harmonies characterizing the restrained tonal variations of *Right and Left*, as well as the apparent discord in the composition's spatial ambiguity. In this latter regard, he reminds us of the viewer's unnatural positioning over water, in relationship to the victimized ducks in the foreground, and our uneasy awareness of threatened and brutal disorder. Forcing us to contrast the visual beauties of form in this painting with its aggressive content of death and chaos, Stein argues that this discordance offers an insight into America itself on the threshold of a new century, with all its social, political, and intellectual upheavals impending.

Right and Left indeed possesses a subtle near-monochromy of color, as Stein argues—though actually it is more gray-green than blue and brown. This muted, opaque palette is at first glance strangely unassuming; at the same time, the looming birds appear immediately assertive, still and solid as sculptures, fixed and arbitrary as a still life. This disjunction between calm and boldness gains in expressive power as we begin to explore the crucial factors of the size, shape, and placement of the two ducks. Homer's manipulation of such pictorial issues found perhaps its most original resolution in this painting, which was literally the culmination of a life's work and creative thought.

William Howe Downes, Homer's first biographer, tells how, in the fall of 1908, when the painting was begun,[5] Homer went out in a boat with a friend to observe him firing a shotgun at birds and their

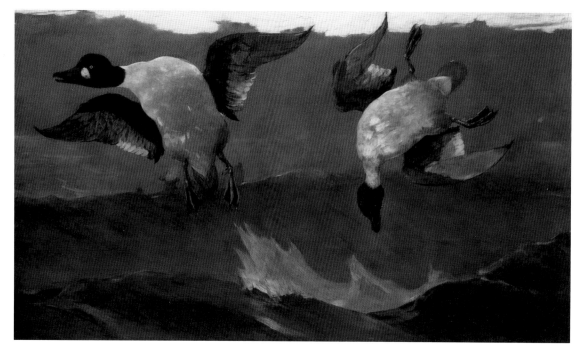

147. Winslow Homer, *Right and Left*, 1909 (Color Plate 17)

positions as they were shot. The artist's nephew, Charles L. Homer, recounted a slightly different narrative to Philip Beam, to the effect that Homer watched from the Prout's Neck cliffs while his friend Will Googins fired blanks up the cliffs from a rowboat offshore.[6] Certainly, the idea of birds in air as a large still-life design had some precedents in Homer's own previous work, though *Right and Left* is by far his most provocative composition in its placement of the viewer in the line of fire with the ducks. This singular confrontation with mortality is surely a key element in the painting's powerful effect on us.

Downes asserts, however, that Homer came to paint this subject when he purchased some ducks for his Thanksgiving dinner.[7] A long-time hunter himself, Homer had many times previously painted hunting subjects, including several devoted to wild birds, along with the other well-known sporting themes depicting deer, bear, and fish. It is not surprising then that the handsome plumage of these Thanksgiving birds might lure him into arranging and studying them for a new canvas. Indeed, the holiday passed without the ducks ever reaching Homer's table, for he was hard at work on his oil of them when he wrote his brother Charles about it on 8 December:

> I do not think I shall leave here before January—then I shall go directly south to Homosassa after about three days in New York.
>
> I am painting when it is light enough—on a most surprising picture but the days are short & sometimes very dark—
>
> I am very well—but how are you & Mattie—
>
> Affectionately
> Winslow[8]

224

Once involved in this even for him "surprising" composition, Homer must have sensed that it would take several weeks of steady work; indeed he did not finish it until January 7, when he dated it with the new year, 1909, and prepared to leave for Florida.

The suggestion of life and death held in vivid balance was a theme preoccupying Homer throughout his mature career. But such a juxtaposition appears to have grown out of a much larger and more complex pattern of pairings, both formal and iconographical, occurring in his art. Homer's imagery, drawn as it is from anecdotal events, nonetheless reflects a consistent pattern of selection and arrangement that demonstrates the artist's ongoing concern for structure. The formula of pairs especially falls within this pattern and allowed Homer to explore certain relationships. While he could represent the people and objects seen in a pleasing or harmonious arrangement, he could also introduce or reinforce the sense of separation among groupings that pairs imply. In his most intriguing composition, he was able to use the pairing formula not only to show separation but also to imply oppositions.

Some Homer works simply convey an image of paired shapes or figures: children playing in a field, men hunting in the woods together, women promenading side by side on the beach, trout leaping from a stream. In other instances, the forms convey both an image and an implication of various degrees of oppositions and polarities, such as male versus female, one animal against another, water striking rock, man battling nature. This instinct of Homer's for paired figures and opposed forces begins early in his work and is readily evident in his illustrations drawn for *Harper's Weekly* magazine and other journals. Although he easily composed multifigured compositions, it is surprising how regularly Homer drew just two individuals and made them the dominant focus of his stronger graphic designs.

One of Homer's best-known graphics is the Civil War engraving known as *The Army of the Potomac—A Sharpshooter*, appearing in *Harper's*, 16 November 1862 (National Gallery of Art, Washington). Although a soldier is shown up in a tree, he is presented close-up, taking aim at some enemy out of our frame of vision, and this striking opposition of seen and unseen combatants is the primary reason for this image's dramatic force. More straightforward are the various courtship pairings he drew for illustrations throughout that decade.[9] There is another series depicting youths at leisure, in single or multiple pairs,[10] and there are several devoted to men working or hunting in the Adirondack woods.[11] One can also find numerous counterparts to these images among Homer's pencil and charcoal drawings of the 1870s and 1880s, for example, those showing children playing on swings or sitting on fences and young women walking together. In one elaborate sequence, Homer sketched a pair of youths carrying, variously, a bucket of clams or berries between them; this underwent a number of metamorphoses in drawings, wood engravings, watercolors, and oils.

Through his paintings, Homer could explore the pairing formula still more fully, and one can trace the resulting themes quite readily. For example, with *Boys in a Pasture* (1874; fig. 148), the subject is the simple, lighthearted representation of children in pairs; and in *Weaning the Calf* (1875; North Carolina Museum of Art, Raleigh), Homer pairs both children and animals as well as various landscape elements. Homer developed differing moods around his depictions of women. In one serene and uncomplicated image, *Long Branch, New Jersey* (1869; fig. 131), two women both constitute the pairing and provide the contrast (one's parasol is up, the other's is down). In other examples, *The Cotton Pickers* (1876; fig. 149) and *Promenade on the Beach* (1880; Museum of Fine Arts, Springfield, Mass.), the mood is shifted from the serene to the somber—even threatening—and an element of surrealism is added.

In some canvases, paired males interact with nature, or male and female pairs fight against natural forces in a battle for survival.[12] In still other works, a lone figure and a natural phenomenon constitute the pairing,[13] or, as in *Northeaster* (1895; fig. 26) and *The Fox Hunt* (1893; fig. 28), differing elements of nature are locked in conflict. In the former painting, sea breakers strike rock in juxtaposed masses of light and dark, liquid and solid, volatile and immutable; while in the latter, two predatory types are locked in their respective flights for survival. One of his most compelling achievements, *The Fox Hunt* pits a red fox in deep snow against the parallel diagonal of two looming crows, fused into a single shape above. Altogether, the monochromatic power of this painting, the sharply incised silhouettes of animal and birds, and the fusion of beauty with violence

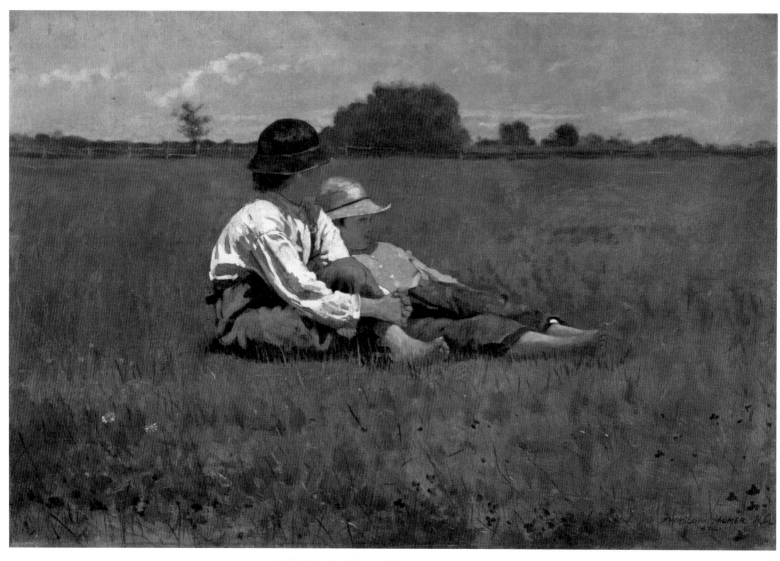

148. Winslow Homer, *Boys in a Pasture*, 1874

226

form an important precedent for *Right and Left* a decade and a half later.

In a related process of pairings, significant figures give way to significant masses, as in *Dad's Coming* (1873; fig. 138) and *Breezing Up (A Fair Wind)* (1876; fig. 136). In the latter, Homer carefully set off the diagonal mass of a catboat in the left foreground with a large schooner on a parallel course in the right distance. The preliminary watercolor had included the tip of Eastern Point and the Gloucester harbor lighthouse; by removing reference to land and substituting another sailing vessel in his oil, Homer at once generalized, animated, and unified his theme.[14]

We may summarize these elements in Homer's stylistic evolution, as it leads up to his culminating image, by looking more fully at *A Temperance Meeting* (1874; fig. 150), a thoroughly characteristic work dating from the center of his career. Here we have two young farmhands, a boy and girl standing statuesquely alone in the foreground of a sloping farmyard. From their still, columnar stance and our rather low vantage point looking up the hill, we tend to see them as taller, more contemplative, and perhaps more adult than they are. Besides their crossing glances, and the obvious contrast of male and female, we also note the familiar repetition of other forms behind in the pair of cows at the upper left and two barn structures at the upper right. Although it is a relatively colorful picture, Homer has kept himself to broad flat zones of almost unmodulated primary hues. The notably high horizon formed by the rising hillside helps to set off the strongly defined figures before us, a device made more radically expressive in *Right and Left*. Even in such a pastoral image as this, there is a gravity of mood, largely deriving from Homer's calculated design

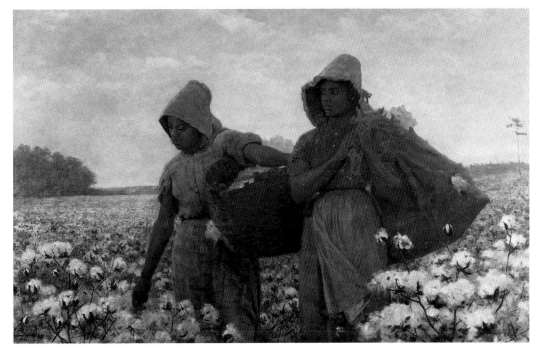

149. Winslow Homer, *The Cotton Pickers*, 1876 (Color Plate 18)

227

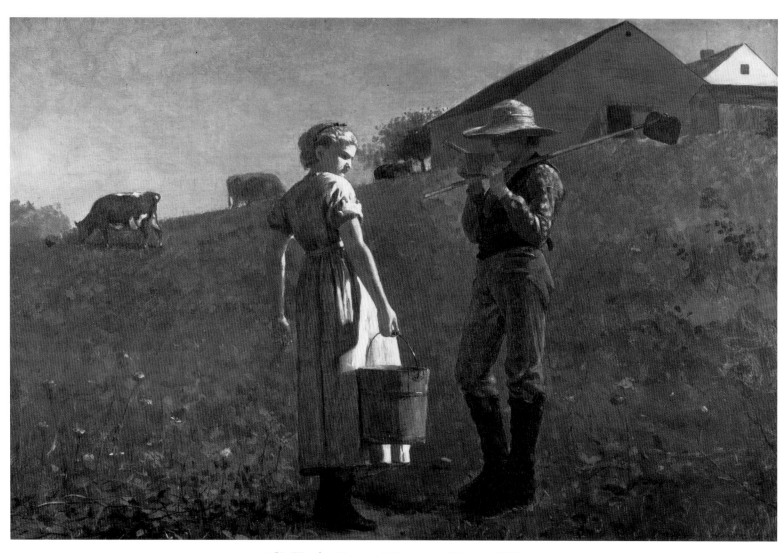

150. Winslow Homer, A *Temperance Meeting*, 1874

and yin-yang subject matter (i.e., complementary opposites), which forecast the charged vision he was to give many years later to a mere brace of goldeneye ducks.

In the imagery of hunting especially, Homer was able to fuse into one whole two parallel and interconnected levels of experience: his personal love of wilderness sporting adventure and his artistic investigation of nature's universal forces. Throughout his mature career, he had regularly depicted scenes, based on firsthand knowledge, of bird hunting and fishing. For the most part, these were narrative and descriptive paintings, encapsulating familiar incidents in the pursuit of game and filled with local details of color and texture. At the same time, he increasingly began to examine the mysterious and inexplicable moments of life and death caught in the balance, whether involving the hunter or the hunted. During the decade of the 1890s particularly we find this interesting interplay between commonplace observation and serious allusion. Also, probably due to his recent taking up of photography, Homer's watercolors achieve a new boldness in juxtaposition of forms, as well as of scale and spatial relationships. A glance at a few paintings from this period will illustrate Homer's probing of both iconographical and formal possibilities.

The watercolor *On the Trail* (fig. 151), painted in 1892, shows a hunter with his two dogs pursuing some unseen game in dense woods. Although the myriad shapes and textures of the colorful foliage are brilliantly executed and our attention is focused on the highlighted central figures, the record of a huntsman's pursuit is a relatively conventional and straightforward genre image. Homer here associates the viewer with the position of the hunting man and hounds, while the game remains obscured somewhere in the distance. This relationship, of course, becomes dramatically reversed in *Right and Left*.

From the same year as *On the Trail* date Homer's watercolor and oil versions of *Hound and Hunter* (fig. 152), both giving us another confrontation between man and animal. Here in a dark corner of the woods at stream's edge (where a series of Homer watercolors also documented a deer coming to the water for a drink and then falling to a marksman's rifle), a youth attempts to secure a deer to his drifting canoe. He glances with some unease at his dog swimming back from midstream, and from this anxious face we become conscious of this vignette's several uncertainties. Is the deer actually dead, and a sinking weight under water to be lashed to the canoe before the dog draws too close and interferes? The youth's rifle rests across the central thwart, presumably just used; but what of the bright eye of the deer just above water, still gleaming as if with life? In this darkly painted and closed environment, humble and anonymous death acquires a mysterious, momentary grandeur.

The fishing watercolors of the 1890s dealt with similar contests in one of Homer's most prolific and accomplished series, resulting from his regular visits to the Adirondack woods and the inland waters of Quebec Province. Now for the first time, he situates the hunted game—in this case trout leaping from Lake St. John and the Saguenay River—pressed against the center foreground. By so doing, Homer gives the fish an exaggerated scale comparable to the canoe and men behind, a dislocation attenuated to the extreme in *Right and Left*. In *Ouananiche Fishing, Lake St. John* (1897; fig. 153) the leaping trout also rises to cross the distant canoe, establishing a surprising intersection of near and far forms equally prophetic of the rowboat locked momentarily behind the rising duck's feet in the later oil.

Ouananiche Fishing, Lake St. John retains a relatively conventional legibility of spatial recession from foreground to distant hillside and sky. By comparison, in *A Good Pool, Saguenay River* of 1895 (Sterling and Francine Clark Art Institute, Williamstown, Mass.), Homer at once compressed and abstracted the pictorial space. Not only is the leaping trout much larger in contrast to the canoe behind, but it is now sharply silhouetted against a flattened curtain of spray and sky. Anticipating *Right and Left*, its horizon and view into depth are obscured. To some extent, the sharp freezing of spontaneous action, as well as the two-dimensional compression of forms, must owe something to Homer's taking his own photographs on these trips. In any case, the result is a subtle transformation of landscape subject matter into quasi-still life. Indeed, about the same time Homer painted *Two Trout* (IBM Corporation, New York), showing gaffed fish hanging against a flat abstracted background of wall.[15] This watercolor of 1889 is as close to pure still life as he would come. More pertinent here are the several inventive variations he made in subsequent years, such as *Fish and Butterflies* (1900; Sterling and

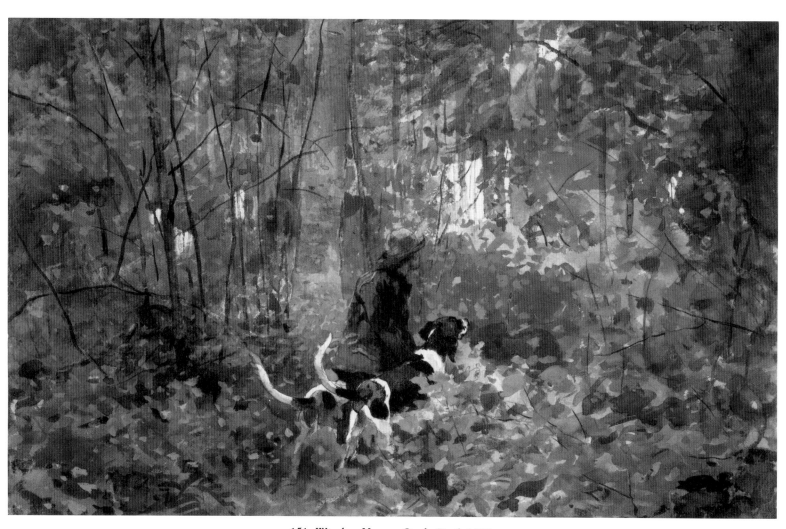

151. Winslow Homer, *On the Trail*, 1892

230

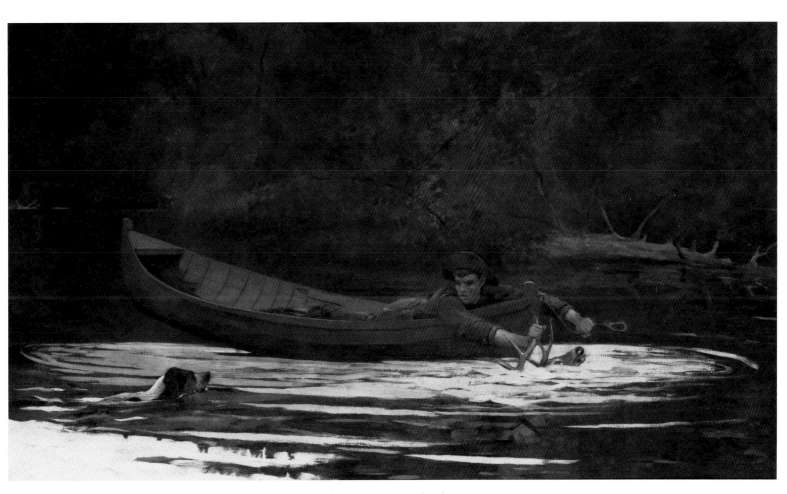

152. Winslow Homer, *Hound and Hunter*, 1892

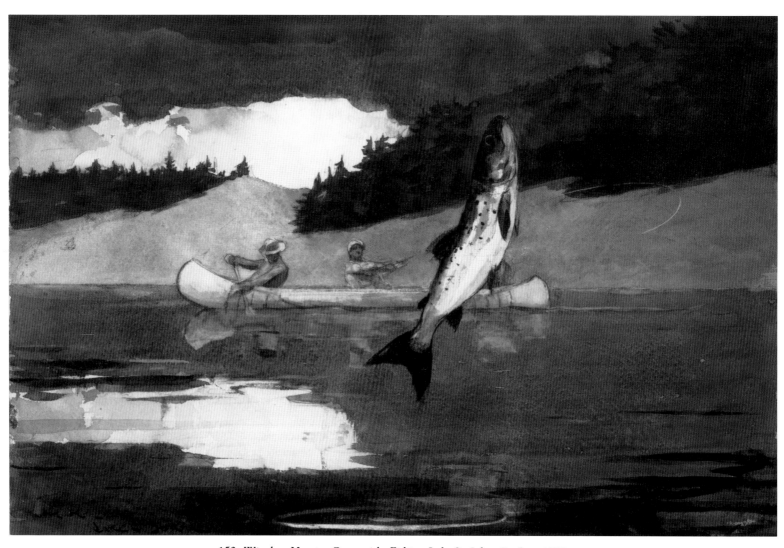

153. Winslow Homer, *Quananiche Fishing, Lake St. John, Quebec*, 1897

232

Francine Clark Art Institute, Williamstown, Mass.), in which the three colorful shapes hang suspended against an impenetrable screen of dark water. These tightly framed landscapes thus approach the intimacy and immobility of a still life. As such, they invite us to contemplate both their formal purity and their lifting of humble sentiment into heroic isolation.

On one level, we may understand this heightened imaginativeness of design and meaning in Homer's late art as the fruition of creative imperatives generated throughout his career. Another way to appreciate the freshness, and modernism, of this vision is to reflect on his pictorial constructs at the turn of the century in the larger context of contemporary Western art. During the decade and

154. Claude Monet, *Waterlilies (II)*, 1907

a half between *A Good Pool, Saguenay River* and *Right and Left*, for example, Claude Monet was concurrently pursuing in his great water lily series a similar abstraction of space. *Les Nympheas* of 1907 (fig. 154) is characteristic in the way in which he appears to bring together the surface of the water with that of the picture plane. Whether we read this as a looking down closely onto the pond's reflections, or a lifting up of the watery plane until the upper horizon disappears, the result is a cropping of any measured or measurable view into traditional depth. The bright patches of water lilies float both literally in nature and figuratively on canvas. Homer's contracting of spatial recession in his fishing watercolors and the ambiguity of environment surrounding the birds in *Right and Left* serve to remind us of how, more than just chronologically, his mature vision partook of twentieth-century art.

Thus we have seen how Homer's last paintings conclude a long, steady evolution of formal and iconographical concerns, which derive at once from his own vision as well as from a wider contemporary context. It is now worth summarizing this development in his specific imagery of birds. A good starting point, and an early benchmark by which to measure the creative distance traveled in *Right and Left*, is his 1869 canvas, *Rocky Coast and Gulls* (Museum of Fine Arts, Boston). Dating from just after Homer's return from Paris, this painting is curiously perfunctory and innovative at the same time. While its bright colors and fresh handling of paint reflect his recent awareness of early French impressionism, it is a view of unfocused visual interest. On the whole, it is an ordinary description of landscape, with the incidental narrative details of four gulls feeding in the foreground. The spatial recession is also relatively conventional, our eyes being carried from the white birds to the spray in the middleground and on to the dots of sailboats on the horizon. Yet just as our glance moves back into space, it seems also to rise upward across the flattened and almost unobstructed planes of beach, rocks, water, and sky. For all the picture's implication of depth, this unusually high horizon and cropped sky have the effect of compacting the pictorial space. A similar strip of bright sky runs across the upper edge of *Right and Left*, though now it is spatially ambiguous and indeterminate, forcing our attention back to the foreground plane. Here we and the ducks are uncomfortably locked into place.

155. Winslow Homer, *Wild Goose in Flight*, 1896–1897

As Homer's interest and pleasure in hunting grew during his later years at Prout's Neck, he turned more frequently to his sporting experiences for pictorial subject matter. About 1896 he drew *Wild Goose in Flight* (fig. 155) in preparation for a large oil he completed the following year (*Wild Geese*, fig. 156). The strong drawing in black and white crayon is interesting for both its foreshortening and its emphatic linear outlining of the bird in flight. Although it clearly relates to the three airborne birds in *Wild Geese*, the drawing matches none of them exactly. Beneath the goose in the drawing are two cursory notations of form cut off at the bottom edge of the page. We can read these variously as suggestions of beach grasses, which will mark the ragged dunes in the oil; or as closeup studies of a

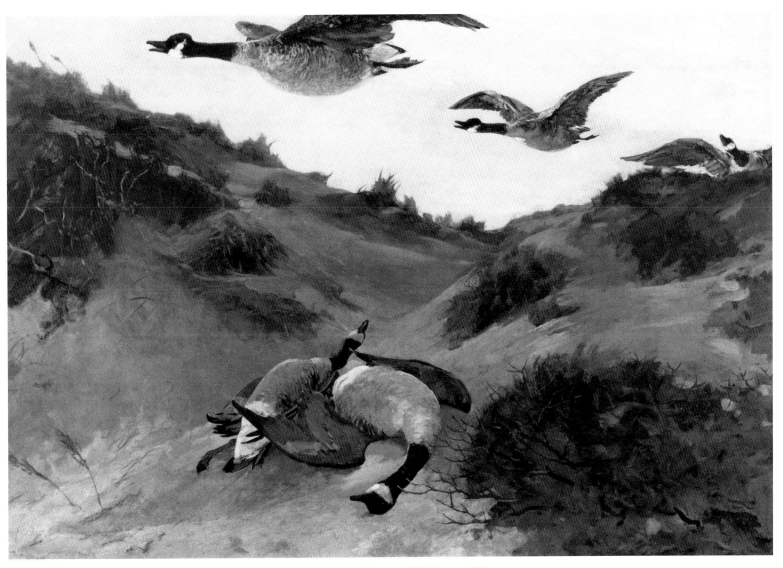

156. Winslow Homer, *Wild Geese*, 1897

goose's webbed feet, plunging downward as they will not in this oil but in *Right and Left*; or as tongues of spray rising from wave crests, also to appear beneath the ducks in the later painting. In any case, it is evident that Homer sought to capture a powerfully expressive contour of his bird in flight, achieved both by the simplified outline and by the tension of a foreshortened torso straining in motion.

The painting of *Wild Geese* employs that now familiar low vantage point and high horizon line. Significantly, it gives us a sequence of actions: three geese rising from the bushes and two fallen at our feet. As in Eadweard Muybridge's photograph of birds in motion, the three upper geese demonstrate the serial wing motions of a single bird lifting off the ground. This notion of a sequential action is of course another important element intensified in Homer's later ducks

under fire. It remains uncertain in *Wild Geese* whether the birds in the foreground have fallen there from a hunter's shot or from flying into a nearby lighthouse.[16] But their inert forms in death establish a characteristic polar contrast to their vital counterparts flying above. *Right and Left* distills this contrast further, to a point of mysterious intensity. Even more, such yin-yang interlocking of the bright and active with the dark and passive—first seen in the explicitly masculine-feminine interplay of *The Life Line*, *Undertow*, and *A Temperance Meeting*—seems to approach the intentional artificiality of a still-life arrangement, yet another compositional device reemployed a decade later.

If all the foregoing constitutes the cumulative imagery leading Homer to his last great work, there remains for our consideration

157. Albert Pinkham Ryder, *Dead Bird*, late 1870s

the external world of art that in varying degrees appears to have contributed its own shaping forces to his "most surprising picture." During the last quarter of the nineteenth century, for example, several of Homer's contemporaries were painting highly personal still lifes of birds in isolation. While there is no evidence that Homer directly knew of their work, such images as Albert P. Ryder's *Dead Bird* (late 1870s, fig. 157) and Alexander Pope's *Trumpeter Swan* (1911; fig. 158) indicate a shared pictorial language. A native of New Bedford, Massachusetts, Ryder began painting in the 1870s simplified scenes of the local landscape, often with a horse or cow alone in the quiet glow of evening light. *Dead Bird* is thought to date from this period of relatively naturalist subjects, though its haunting meditative aura and abstracted treatment also hint of the deeply mystical and hermetic visions he was to paint in subsequent years. Especially relevant here to our comparison with Homer's *Right and Left* is the virtually monochromatic palette (of dark yellow for the bird and sandy brown for the textured ground) of *Dead Bird*; its theme of pathetic vulnerability in the animal world; and the flattening of the bird against a spatially ambiguous background. More speculative is the question of the extent to which this fragile creature is to be associated with Ryder's own brooding personality, just as we may wonder if Homer's scene of surprising confrontation might reveal some inexplicable animus bursting from reclusion at the close of his career.

Like Homer, Pope cared deeply about the natural world, primarily as a conservationist. This led him to paint a series of animal trophy illusions, with the dead game beautifully hung against wooden doors or boards. An earlier version of *The Trumpeter Swan*, dated 1900, for many years belonged to the Massachusetts Society for the Prevention of Cruelty to Animals; presumably it was undertaken to call attention to the impending extinction of that exquisite species.[17] In the 1900 oil (Fine Arts Museums of San Francisco), the great bird hangs alone against a finely paneled door, whereas, in the second version eleven years later, Pope added vines of ivy and a hanging shotgun. These references to nature and man add new visual interest to the composition while retaining the spare two-dimensional design of the earlier work. Again, the calculated still-life arrangement against a partially abstracted background parallels Homer's *Right and*

Left, as obviously does the juxtaposition of bird and gun. But Homer's transcending achievement is that *Right and Left* remains as much landscape as still life, and as such compels a more provocative human involvement.

Scholars simply do not have the evidence, beyond a few pieces of information, to know what works by other artists Homer knew first-

158. Alexander Pope, *The Trumpeter Swan*, 1911

hand. There is accumulating documentation about his respective visits to France in 1867 and England in 1881–1882 to indicate some awareness by Homer of Barbizon art; oriental decorative arts; and English painting, prints, and photography. Even before his trip to England, Homer appears to have gained some familiarity with mid-nineteenth-century English art through his work as an illustrator in Boston. During the 1860s and 1870s, several art magazines carried reproductions of drawings by Edwin Landseer and a number of the Pre-Raphaelites, who strongly influenced illustrators working on both sides of the Atlantic. An especially intriguing possibility is that Homer at some point may have seen Landseer's work in particular, for *Hawk and Heron Hunt* (c. 1855; Museum of Fine Arts, Springfield, Mass.) by the English painter suggests a surprising correlation with *Right and Left*. Not only do we have here an image with the hunters in the background, but the two powerful birds are locked in mortal combat, silhouetted strongly before us, and our vantage point is partially elevated to place the viewer close to this aerial drama.[18]

Based on the few surviving items from his library, we know that Homer owned and frequently consulted an English translation of M. E. Chevreul's *Laws of Contrast of Colour*.[19] More generally, all of Homer's biographers have discussed the painter's friendship with John LaFarge, and through him Homer's exposure to Japanese prints. Albert Gardner reminds us that such prints were brought into the United States as early as 1855, and that LaFarge often conversed about them in New York at the Tenth Street Studio Building, where Homer for a time was also to work.[20] Beam notes that LaFarge was the one artist with whom Homer enjoyed talking about the practice and theory of art, and that LaFarge brought back his own orientalizing watercolors from his trip with Henry Adams in 1886 to Japan and the South Seas.[21]

Homer himself had certainly seen oriental paintings or prints during his Paris trip, when he visited the great international exposition there. In the next few years, he executed several illustrations for *Harper's* that were clearly adapted from Japanese graphics.[22] The Japanese influence was pervasive in later nineteenth-century American and European art, as we well know from the work of James Whistler and Mary Cassatt. Among the most popular graphics were the colorful prints of Hokusai (Tokitaro Kawamura) and Ando Hi-

roshige, and several authors have convincingly suggested the influence of the former's *Mt. Fuji* series (c. 1823; Art Institute of Chicago) on such compositions by Homer as *Guide Carrying Deer* (1891; Portland Museum of Art) and *Kissing the Moon* (1904; Addison Gallery, Andover, Mass.).[23]

Since we do not know which specific Japanese prints or screens Homer could have seen in Boston, New York, or elsewhere on his travels, it is worth citing just a couple of the most characteristic and accessible examples. Hiroshige's *Eagle Swooping Down from the Sky* (1857; Freer Gallery of Art, Washington), from his series Famous Views of Edo, is typical of the numerous woodblock engravings that he executed featuring various birds in landscape settings. Giving particular attention to the colorful plumage and distinctive silhouettes of each species, Hiroshige often set his birds in dramatic contrast to flat expanses of open sky or earth. Here in fact we have the startling shape of the eagle's arcing wings fixed in visual tension with the earth receding far away below. This device of a boldly patterned form in the foreground set directly against space is precisely what Homer so effectively employs in *Right and Left*. More intriguing is the question of whether Homer could have seen Maruyama Okyo's large painted screen *Geese Flying over a Beach* (Edo period, 1780s; Freer Gallery of Art, Washington). Charles L. Freer acquired this work in 1897 (incidentally the year Homer painted his oil of that subject), and, although he maintained most of his collection in Detroit, he did lend this screen occasionally for viewing in New York and other places on the east coast.[24] Certainly, its cunning contrast of the two birds in flight and the evocatively open space are fully appropriate in spirit to Homer's last bird painting.

Within the history of the graphic arts in America, it is tempting to associate two potential sources with Homer. The first is Eadweard Muybridge's monumental photographic series of stopped-action photographs known as *Animal Locomotion: An Electro-Photographic Investigation of Consecutive Phases of Animal Movements*. This the noted photographer had begun in 1872, completed in 1885, and published beginning two years later. The eleven folio volumes included nearly eight hundred photoengravings, devoted to documenting all manner of movements by men, women, children, horses, and other animals. Some two dozen prints in the final vol-

ume, *Wild Animals and Birds*, depict various birds at rest and in flight, including cranes, geese, and ducks. Because this subgroup constitutes a small proportion of the whole project, and the horse series in particular had attained a certain fame through the widely publicized commission for Leland Stanford, historians have infrequently examined the bird photographs.[25] Yet Muybridge's stopped-action frames of such birds as the cockatoo and eagle in flight (1887) display striking patterns and profiles that suggest interesting correlations with Homer's ducks. And we should not forget that Homer himself, with a strong feeling for the graphic arts in his career, was in these same years taking his own photographs.

The second graphic precedent from the native tradition, even more demonstrably close to *Right and Left*, is John James Audubon's folio rendering of the *Goldeneye Duck*, engraved in color by Robert Havell as plate CCCXLII in the ambitious four-volume *Birds of America* (New-York Historical Society).[26] Attempting to record all the species he could find across North America, Audubon began supervision of his publication in 1827 and brought it to conclusion eleven years later, with a total of 435 plates documenting 497 species. The original watercolor is somewhat softer in handling than Havell's print, which shifts Audubon's blue sky more toward gray-green and hardens his fluid cloud layers to the scalloped design we see here. Obviously a set of the prints would have been far more available to Homer, and indeed the lower cloud edge in the engraving especially anticipates the lower cresting wave in his oil.

It was Audubon's achievement to combine an ornithologist's desire for accuracy of identifying detail with an artist's sensibility for pure, expressive form. His aim foremost was to capture the distinguishing physical characteristics of each species and, where possible, to intimate something of its habitat and behavior. Here he is interested in illustrating the subtle differences in plumage and size between the male on the left and the female to the right. As Audubon noted, this bird was "equally fitted for travelling through the air and the water,"[27] and, appropriately, he shows one swooping downward, the other swiftly rising. Homer employs a similar contrast of motions, in reverse, though he is less concerned with the scientific marks of gender. More crucially, he removes his birds from the neutral and generic presentation of Audubon and gives them a vital,

immediate specificity. Audubon further observed of the goldeneye: "Happy being! . . . endowed with a cunning . . . which preserves you from many at least of the attempts of man to destroy you."[28] This last involvement of man, in the presence of the hunter behind and ourselves in front of the birds of *Right and Left*, is the new and consummate drama.

Whatever the imagery of art or mind that gestated in the creation of this painting, Homer labored physically over its execution. If we now come back to the work itself for closer scrutiny, the eye can readily see that this is a thickly painted canvas, with occasional overlayers of pigment and reworkings of certain portions (figs. 159 and 160). The pasty and opaque quality of the paint textures contributes to our sense of an ultimately impenetrable space. We probably want to read the faintly glinting light on the sea under the left-hand duck's wing as a mark of expanding distance, yet its meaning remains elusive, uncertain. Just the tiniest touch of red appears at the intersection of this light gray zone with the darker gray above, and a second one is visible at the same level in the center of the picture. Are we to understand this as the obscured rays of late wintry sunlight? Another gratuitous short stroke of red appears between the two ducks in the upper center, but this describes nothing identifiable. Hints of similar red pigment are apparent as an underlayer across much of the upper gray-white strip of cloud. These various suggestions of red are related to, yet different from, the more orange blast of the shotgun below and function as reminders of light as well as blood.

As Roger Stein has already observed, this is a notably monochromatic painting. Intentionally this restraint forces the viewer to probe the nuances of the existing color variations and to appreciate gradually the visual force that emerges to surprise us in this canvas. Between the upper passage of warm reddish-gray clouds and the lower green-white wave crests, Homer fixes the more neutral tans of the two ducks. Almost twenty years before, LaFarge had made critical remarks to Homer about using too much brown in his paintings. In response Homer executed *West Wind* (1891; fig. 24) with a virtually monochromatic palette of browns and beiges.[29] The resulting austerity was completely expressive of the bleakness of a lone woman battling the elements at the rise of a sand dune. In *Right and Left*, as

159. Winslow Homer, *Right and Left*, 1909, detail (X-ray of left half of painting)

240

160. Winslow Homer, *Right and Left*, 1909, detail (artist's signature)

in other late canvases, Homer again exploited a unifying palette of somber tonalities to complement the starkness of his subject matter.

The heavy overpainting at the top edge of the oil is evident. It is also clear from an X ray of the left-hand bird that Homer modulated the contours of its outstretched wings to the left and its white breast above. In each area he has lowered the profile slightly and rounded it off. This brushwork serves to sharpen those two straining parts of its body, while also strengthening the rhythms of the repeating arc forms. Homer corrected or reworked on occasion both his watercolors and his oils. In some instances, he is known to have cut down a watercolor to new proportions, and in 1893 he repainted the entire left half of an oil he had begun in Tynemouth a decade earlier.[30] The adjustments we find in *Right and Left* are not so radical, but rather reflect the care and intensity of his creative energy in this work.

Although the title of the painting seems perfect for the image and one apparently satisfactory to Homer, it was not his invention. Downes tells us that the artist gave the work no title when he sent it to Knoedler's gallery in New York for exhibition and sale. A visiting sportsman is said to have exclaimed "Right and left!" on seeing the painting, having in mind the hunter who brings down a bird with succeeding shots from his double-barreled shotgun.[31] Randall Morgan of Philadelphia bought the canvas and loaned it for the first time in 1910, under the title by which it has since been known, to an exhibition at the Pennsylvania Academy of the Fine Arts. The painting remained in the Morgan family until it was acquired for the National Gallery in 1951.

The sportsman's exclamation has been taken for granted ever since, though it has been by no means clear or agreed which duck has been shot first and just what moment of mortality we are witnessing. The remark of the Knoedler's visitor would suggest that he assumed both birds had been shot dead. Samuel Green states that the duck on the left is "arising from a stormy sea, the other shot down and falling."[32] By contrast, Roger Stein reads death first in the rising duck from "the flash of the gun behind the limp webbed feet of the left hand bird."[33] Yet we do not know which blast from the shotgun, the first or the second, is depicted in the distance. If the second, then both birds have been hit. Yet the one on the left does seem strangely alert in its rising posture, in its indication of quick

motion to our left, and in its bright yellow eye, which fixes us as much as its sense of direction. If we are witness to the first shot, the left-hand bird may have limp feet; but these surely may be due as much to rapid upward flight as to death. Yet who is to say categorically that the duck to the right is the one shot, for his downward dart is utterly typical of the species diving from an unexpected threat. The fact is that Homer gives us these multiple ambiguities and leaves them mysteriously unanswered. A more proper and profound reading would be that we observe that very moment when the shotgun blast explodes, but has not yet hit, or is—at the instant we arrive—hitting the first bird. In short, we are present at that mystical split-second juncture *between* life and death. In truth these ducks are as much alive as dead, in all the ironic meanings of the term "still life."

Homer was not a religious individual or artist, yet this painting addresses those ineffable issues of the relationship between body and spirit. Although the postures of his birds derive foremost from the ornithology of Audubon's observed world, we make inevitable psychological associations with a fall to death and a rising up to life. Like Pope's *Trumpeter Swan*, Homer's ducks spread out their wings in the pose of martyrs, recalling both a crucifixion and ascension. The mystery of life and death here leads us to meditate on not mere survival but immortality for these living creatures who momentarily stay air, water, and gravity.

Such a work of art has increased significance every time we come to it, and Homer's *Right and Left* is as strong as any painting ever produced in America. It has continued to summarize Homer's own contribution to the native realist tradition, while also exerting an influence on American painters of subsequent generations. We need only glance at Andrew Wyeth's sweeping tempera *Soaring* (1950; fig. 161), to realize its distant legacy. Wyeth, one of the leading interpreters of American realism in the twentieth century, has chosen to exploit the forceful evocation of similar dislocations in scale, an unexpected aerial vantage point, and figural abstractions belonging equally to art and nature. The lonely alienation viewers feel in Wyeth's painting in part belong to the modern spirit.[34] Commented Wyeth many years after painting *Soaring*: "I admire Winslow Homer's *Right and Left*. It's very American, very powerful, and a mar-

161. Andrew Wyeth, *Soaring*, 1950

velous piece of very abstract design, taken from nature without getting sentimental. It's a very contemporary picture and, I think, his most outstanding."[35]

In its own modern way, *Right and Left* embodies those intimations of chaos and disorientation that Henry Adams described in his *Education* in 1906: a world on the threshold of disorder and relativity, moving away from sure, fixed absolutes of the past. Like Homer, Adams was fascinated with polarities and opposites (the Virgin and

the dynamo, *Mont-Saint-Michel and Chartres* and *The Education*, male and female, unity and multiplicity). In this view, we can regard the painter's ducks as if in some magnetic field of force, at a point of tension rather than rest. Yet Audubon lyrically saw the common goldeneye able to "arise on whistling wings, and swifter than Jer Falcon, speed away."[36] Homer, too, saw nature transcendent, in this work above all.[37]

15

Thomas Eakins's Late Portraits

POIGNANT almost beyond possibility, weighted with age in the personal as well as the period sense, the late portraits of Thomas Eakins are among the supreme works of his career. For one thing, they are unsurpassed in the history of American art, and moreover call to mind no less than the great figural images of Rembrandt, whom Eakins not surprisingly admired. Eakins's late portrait paintings literally culminate his artistic life; they hold up as deeply American in their rough realism; and the best of them by no means fail in comparison with his Dutch predecessor.

A speculation worth arguing is that Eakins and a few contemporaries created their best work at the ends of their lives, which also happened to fall after the turn of the century. Our greatest landscape painter, Winslow Homer, produced his most profound images after 1900, and quite possibly his single most important painting, *Right and Left* (fig. 147) in 1909, a year before his death. By comparison, John Frederick Peto, one of America's most creative still-life painters, invented many of his most moving subjects in the half-dozen years before his death in 1907 (fig. 200). Together, the work of these artists moved American painting toward two crucial elements of modern art: subjectivity and abstraction. As such, their late art fully belongs to the twentieth century—in the way that of Claude Monet and Paul Cézanne does—both chronologically and stylistically.

Although concentrating on landscape, still life, and portraiture, respectively, Homer, Peto, and Eakins further share a preoccupation with the ultimate mystery of mortality. Note the suspended balance between life and death in *Right and Left*, and the resonant titles of Peto's still lifes: *Old Companions* (1904; collection of Jo Ann and Julian Ganz, Jr., Los Angeles), *Old Souvenirs* (1881–1900; Metropolitan Museum of Art, New York), *Discarded Treasures*, c. 1904. Even as the frailties of old age intruded into their own final years, these painters probed ever deeper into the human condition, meditating on matters of human and natural decay. At the same time, it is also to the point that they celebrated more than lamented the mutability of life, Peto and Eakins in particular by dwelling on the regenerative life of art. Whereas Peto titled other late works *Things to Adore: My Studio Door* (1890s; Santa Barbara Museum of Art) and *The Ordinary Objects of the Artist's Creative Mind* (1887; Shelburne Museum, Shelburne, Vt.), and constantly returned to books as his subject, Eakins was delineating his most devastating—and loving—portraits of other creative and thinking individuals.

The question of why Eakins so relentlessly concentrated on the human form and face through his later career has drawn a number of explanations—the well-known critical abuse he suffered over his early masterpiece, *The Gross Clinic* of 1875 (The Jefferson Medical College of Thomas Jefferson University, Philadelphia), and again with *The Agnew Clinic* fourteen years later (University of Pennsylvania); his falling out with the Philadelphia art establishment and forced resignation from his teaching job at the Pennsylvania Academy; the sequence of deaths among his close relatives in the later decades of his life. These setbacks variously textured a natural reaction to turn inwards, to withdraw into the self, to scrutinize more closely individual human nature. Still, Eakins's growing attention to portraiture ought not to be explained simply in negative terms. To the contrary, the human figure in action or at rest had been at the

162. Thomas Eakins, *Walt Whitman*, 1887

portraits executed in the first decade of the twentieth century (including a couple dated to 1898–1899). Actually, his last productive year was 1910, with one haunting image of *Dr. Edward Anthony Spitzka* (fig. 180), begun in 1913, left unfinished at his death in 1916. To be sure, a few other types of pictures were completed in this late period, most notably the boxing series (*Taking the Count* [fig. 172] and *Salutat* [fig. 215] of 1898, *Between Rounds* [fig. 216] of 1899), *The Wrestlers* of 1899 (Columbus Museum of Art), and three variations on the William Rush theme from 1908 (Brooklyn Museum; Honolulu Academy of Arts). But these are all recapitulations of earlier athletic or studio images, going back to Eakins's first Schuylkill rowing pictures of the early 1870s and to the first William Rush painting in 1877. By contrast, the late portraits did not merely continue a lifelong concern; in their intensity and spareness, their thoughtfulness instead of action, they emerge as something mysterious and original and enduring.

To be sure, Eakins painted some very beautiful and moving portraits before 1900, among the best known being those of *Walt Whitman* (1887; fig. 162) and *Amelia Van Buren* (c. 1891; fig. 190), but these stand as singular, powerful precedents for the extensive series that Eakins undertook in his last decade. More characteristic of figure painting from the mid-1880s to mid-1890s are the large-scale portraits put in genre settings, for example, *The Pathetic Song* (1881; Corcoran Gallery of Art), *Lady with a Setter Dog* (1885; Metropolitan Museum of Art, New York), and *The Concert Singer* (1892; Philadelphia Museum of Art). These images of Mrs. Eakins, Weda Cook, and others possess that meditative, devotional air so characteristic of the artist's best work, though it is noteworthy that part of their expressive power derives from the shadowy details of a surrounding environment. The almost bare corner of a room, along with the detachment of the principal figure from others nearby, contributes to our consciousness of human isolation. When Eakins includes more than one figure in a composition, he has each one usually engaged in a separate activity, with individual glances reinforcing private preoccupations.

Besides concentrating increasingly on the single figure, alone in an undefined environment, during his last period, Eakins also moved from subjects of action to inaction. While he had generally favored

heart of his subject matter from the beginning, and in part the shocks of later life helped to crystallize for Eakins a conscious and positive focusing of his artistic energies. The heroic and affirmative timbre of his late oeuvre, the sheer sense of human will and endurance, should convince us that he painted these faces not by default, but out of artistic imperative.

What we want to examine here are selected examples of Eakins's

moments of pause or suspended action even in his earlier work (scullers at the beginning or end of a stroke (see figs. 213 and 214), Dr. Gross briefly turning from an incision), he now relied more on such expressive details as lips parted in speech or song, or a neck tendon taut from a head tilted in thought. In the later portraits, Eakins closes in on his sitters in physical proximity as well as scrutiny. Whereas before the narrative details of an environment, whether landscape or furniture, carried some of the emotional weight in a picture, now Eakins employs only a furrowed brow, reddened eyes, tensed cheek muscles, or chapped lips as indices of psychological or spiritual presences.

With variations, of course, he worked in three principal formats for his subjects—the figure fullstanding, seated, and bust-length—and these categories may each be divided into three further subgroupings of profile, three-quarter, and frontal poses. During the period of the late portraits, he did paint examples in all these categories, though several qualifications can be drawn. Figures posed and glancing directly frontally are the rarest, probably for a number of reasons. Standing or being seated and facing straight outward tended to be awkward or boring; the torso particularly seems static and without interest. For a different reason, the bust portrait facing forward was an infrequent undertaking possibly because of its unnerving frankness in directly confronting the viewer's eyes.

Figures painted in profile were not especially common for Eakins either, largely one suspects because they tended to be too contrived or idiosyncratic. Appearing to be his most productive and agreeable format on all scales is the three-quarter stance. Generally speaking, one finds that, as Eakins moved from the profile to the three-quarter to the frontal pose, the power and beauty of the results intensified. Likewise, as he shifted from the standing to the seated to the bust-length figure, his image gained in strength, as if the closer he moved to the head—the eyes and face—the more probing and sharp became his perceptions.

Another provocative speculation is to consider whether Eakins was a finer painter of women or of men. Lloyd Goodrich has estimated that Eakins portrayed perhaps a third more men than women, yet with some arguable exceptions his portraits of women generally emerge as the greater achievements. Of course, one would cite the

163. Thomas Eakins, A. W. Lee, 1905

portraits of *Walt Whitman* and A. W. Lee (1905; fig. 163) as among Eakins's most powerful male portraits. The heroic quality of the former carries much of the painter's deeply sympathetic attitudes for the poet, seen as some transcendent blind Homer. The face of Lee, on the other hand, seems more of a death mask than a record from life.

But when Eakins portrayed the unrefined or awkward features of women, he usually did so with tenderness and compassion; see, for example, *Signora Gomez D'Arza* (1902; fig. 164) or *The Old-Fashioned Dress* (c. 1908; fig. 165). Only the portraits of the artist's father, Benjamin Eakins, and of his father-in-law, William H. Macdowell, register comparable sympathy, and this almost certainly for relatives close familially and emotionally.

We may test these observations more fully by examining selected examples of Eakins's late portraits in the various format types. There are only a couple of significant full-length profile portraits. That of *John McLure Hamilton* (Wadsworth Atheneum) from 1895 falls a few years before the specific period in question. *The Young Man* (Kern Dodge) of around 1902 (Philadelphia Museum of Art) has caught the youthful profile and casual stance with sensitivity, but this work remains unfinished, a special problem in Eakins's late career. Perhaps most representative of this particular category is the 1899 portrait of *David Wilson Jordan* (Hirshhorn Museum). A figure of some authority with strongly silhouetted nose and elegant gloves in hand, Jordan nonetheless seems an artificial image, as a consequence of the broadly turned back and almost hidden glance. That the dark clothing hardly makes a pattern of sufficient visual interest is a clue to the painting's ultimate weakness.

More successful were the occasional profile portraits of individuals seated or bust-length, such as *Cardinal Martinelli* of 1902 (Armand Hammer Collection, Los Angeles) and *William Merritt Chase* of 1899 (Hirshhorn Museum). In the former, the austere profile set in that spare interior appropriately suggests an abstraction of thought and a clarity of vision suitable to the subject's stature and spirituality. With the portrait of Chase, something of the contrived air of David Jordan, painted contemporaneously, remains apparent. At the same time, by painting only the bust of his fellow artist, Eakins more successfully manages to convey those qualities of refined cosmopolitanism associated with Chase's art and character. Thus the profile at least suits the pince-nez glasses, carefully trimmed beard, and buttonhole carnation—all quite believable for one who claimed he would rather go to Europe than to heaven.

By turning his figures even slightly into three-quarter poses, Eakins was able to explore richer and more complex variations of personality (fig. 166). In some ways the full-length figure still presented the most challenge, though Eakins's unerring sense of anatomy enabled him to record deftly the gravity and mass of a torso, the connected tensions among bones and musculature, and the expressive resonance of a personal stance or gesture. In the later portraits, he refined as well his attention to details of costume or furniture as complementary accessories to the physical and psychological presence of his sitter.

During the late 1880s and early 1890s, Eakins had completed a few very moving full-length portraits, as varied as the dark and thoughtful image of *Mrs. Letitia Wilson Jordan Bacon* (1888; fig. 167) and the colorful *Frank Hamilton Cushing* (c. 1895; Gilcrease Institute, Tulsa, Okla.), clothed in and surrounded by Indian artifacts. Something of their hermetic, brooding air also finds its way into the central standing figures of certain group compositions, such as Dr. Agnew in *The Agnew Clinic* of 1889, a decade later. By 1900 Eakins had arrived at his sparest and most eloquent settings to date.

Now there were a growing number of unfinished pictures, as in the portrait of the Philadelphia architect *John J. Borie* (c. 1900; Dartmouth College). The full portrait with accessories reached its summary the same year in *Mrs. William D. Frishmuth* (fig. 168) while that set in an evocatively empty surrounding culminates with the portrait of Louis Kenton, well known as *The Thinker* (1900; fig. 169). In the latter especially we are made conscious again of the artist's indebtedness to similar paintings by Velázquez, wherein we feel equally the palpability of light and thought.

The late portrait in this format that best fuses the spare interior with the accompanying devices of furniture and costume is *The Old-Fashioned Dress*, painted of Helen Parker about 1908. Eakins worked through two preliminary sketches, refining, as he proceeded, the angular features, and attenuating the upright stance. Poignantly hoping that he would make her "just a little pretty," Helen Parker stands before us fragile and vulnerable. The deliberate contrast between the age of the dress and the youth of the sitter is enhanced by the nearby chair, with its own stiff anatomy and carved embellishments. Here Eakins touches many of the grace notes of his late work: ambivalence between nostalgia for the past and awareness of worldly decay, tender beauty in the ordinary, and recognition of time as an agent

164. Thomas Eakins, *Signora Gomez D'Arza*, 1902

of change. He does not give us the traditional *memento mori*, but the more difficult reminders of living.

Interestingly, the most exquisite of the three-quarter-view seated portraits also involves a remarkable handling of a woman's dress: this is the portrait of *Susan Santje*, also known as *The Actress* (1903; fig. 170). The very same chair reappears, but now more fully and also in three-quarter view. Indeed, instead of the narrow vertical stiffness it acquired in *The Old-Fashioned Dress*, Eakins here gives it a throne-like amplitude, a personality as object and theatrical prop, suitable to the real or imagined stage of the sitter. In a period when Eakins was otherwise moving toward a more monochromatic palette and the tonal drama of chiaroscuro, brilliant color dominates this painting. The intense pink of Santje's flowing dress has lesser echoes throughout the composition: in the rug pattern, highlights on the chair, window curtain behind, and postage stamp on the letter fallen to the floor. Again languor and vitality, sad exhaustion and self-possession, seem held in tension. Does this incandescent pink speak of blood or passion, of burning energy, of feminine delicacy or sensuality? Seldom has color smoldered with such feeling.

Ordinarily Eakins's later three-quarter views of individuals painted bust length are without much color, and rely instead on carefully modulated contrasts of tonal values within a restricted or near-monochromatic palette. Among the strongest and most familiar in this group are the saddened images of *Addie*, painted in 1899 (Art Institute of Chicago) and again the next year (Philadelphia Museum of Art), and *Signora Gomez D'Arza*. In the latter, the actress's harsh features seem to carry a transcendent serenity of stoic thought. An embroidered dress sets off the strong head, as it does in the 1903 portrait of *Alice Kurtz* (Harvard University Art Museums). Perhaps only by concentrating so closely on the face in these bust-format pictures could Eakins reveal such human vulnerability through mere details like Kurtz's strained neck tendons and bright watery eyes.

With similar care, Eakins draws our attention to the idiosyncratic details of flesh and presence in his 1898 portrait of *John N. Fort* (fig. 171). Fort was a music and art critic in Philadelphia.[1] His interests were thus those of Eakins, and the artist gives us a figure of thoughtful bearing. His face may also be one of those in the background

165. Thomas Eakins, *The Old-Fashioned Dress*
(Portrait of Miss Helen Parker), c. 1908 (Color Plate 19)

166. Thomas Eakins, *The Critic (Francis J. Ziegler)*, c. 1890

167. Thomas Eakins, *Letitia Wilson Jordan*, 1888

audience of *Taking the Count* (fig. 172), painted in the same year, seated in the first row at the far right.[2] This large boxing scene has other identifiable individuals in it, including Eakins's father, seen second from the left in the ringside seats. The artist often did this with his big group pictures, partly because familiar faces close at hand might serve as useful models. But this was also another reminder that Eakins's own life was literally very much a part of his art, and conversely that all his paintings were, in a sense, pieces of his autobiography.

Without having known Fort personally ourselves, what are we to make of him nearly a century later? Eakins gives a few pertinent clues. The raised eyebrows suggest a quizzical nature, the broad forehead a certain intelligence, the angular forms a toughness and sharpness, and the glinting spectacle rims, which boldly intersect the eyes, a sense of perception. There are several V-shaped forms repeated in the central axis of these features—the coat lapels, tie knot, white collar, moustache, nose, and brows—which are reinforced by sharp accents of light. This vertical core of illumination, from the tie pin up to the glass rims, locks our primary concentration on the features of a man whose processes of considered thought constitute his foremost strength of character.

This is one of the few late pictures of this type in which Eakins included the sitter's hand, and one must assume that its presence was intentional. At the lower left it is quite subdued in shadow, and almost abstracted in its generalized form. At the same time, its slightly diagonal placement serves to echo the glance of Fort's face and eyes, while the clear round cuff repeats the strong silhouette of his bald head above. Clearly, Eakins saw explicit need here to remind us, appropriately in the image of an art critic, of the links between head and hand, that is, between the reflection and the writing about art, even between perhaps the ideals and the practice of art. It is worth noting that Eakins had earlier used the same compositional device in his portrait of *The Veteran* of 1884 (fig. 173). The subject here was George Reynolds, a favorite student, model, and assistant, who was also engaged in the creative coordination of his mind and hands.

The Fort portrait is notably dark, almost monochromatic, in its coloration. This may have possibly derived from Eakins's work in

168. Thomas Eakins, *Portrait of Mrs. William D. Frishmuth*, 1900

169. Thomas Eakins, *The Thinker: Portrait of
Louis N. Kenton*, 1900

252

170. Thomas Eakins, *The Actress (Miss Suzanne Santje; Mrs. Keyser)*, 1903

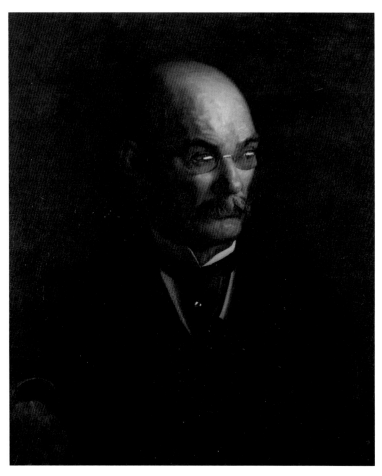

171. Thomas Eakins, *Portrait of John Neil Fort*, 1898 (Color Plate 20)

tary reds in the flesh tones above. All this suits the somber, near brooding, air of the picture.

We may summarize Eakins's absorption in this category of pose by observing how he has changed his rendering of his father from the version of 1882 called *The Writing Master* (fig. 174) to the portrait painted in 1899 (fig. 175). It is significant that we are not especially aware of looking at a figure older by some seventeen years in the later work. Rather, we move from a narrative treatment of someone engaged in work—to be sure, preoccupied with the disciplined task of calligraphy before him—to a laconic record of the human presence in thought. Whereas earlier Eakins employed a carefully structured form to fuse the work of head and hands (as he had with Max Schmitt, Dr. Gross, and many others), in the later portrait he approaches more closely the solidly modeled head in isolation. We are certainly conscious of concentrated thinking in both images, yet in the late work the contemplation is at once more detached and hermetic.

This kind of intense scrutiny of human beings not surprisingly found Eakins turning most often to those subjects around him who were closest spiritually, intellectually, or emotionally: priests, fellow artists, and his own family. Besides the late portraits of Benjamin Eakins, we may also note the extensive series of paintings and photographs made by Eakins in these years of his father-in-law, William H. Macdowell. Above all, there are the occasional pictures of his wife and himself. These constitute some of the most powerful examples of the last and most difficult of the general categories, the frontal pose. Here was the most direct confrontation of all, and there were few individuals besides himself and Susan Eakins whose glances he was both willing and able to engage so uncompromisingly.

There are a couple of early frontal portraits, for example, the youthfully innocent and open face of *Harry Lewis* of 1876 (fig. 176) and the distilled wisdom of age in the rendering of *Walt Whitman* in 1887. Frontal portraits in full-length or seated formats are exceedingly rare. There are some of Philadelphia doctors, but these seem rather perfunctory for Eakins. Others give us the figure facing directly forward—*Mrs. Samuel Murray* (1897; University of Nebraska), *Frank B. A. Linton* (1904; Hirshhorn Museum), *Mrs. Louis*

photography at this time, for he took many portrait photographs in these years, many of sitters he was painting at the same time. No photograph of Fort by Eakins is currently known, though its fineness of certain details and sharpness of light and dark certainly relate to his parallel work with the camera. As with his handling of light in this painting, the colors that are used are strongest at the center, especially in the rich dark blue-green of the tie and the complemen-

172. Thomas Eakins,
Taking the Count, 1898

255

173. Thomas Eakins,
The Veteran, 1884

174. Thomas Eakins, *The Writing Master: Portrait of the Artist's Father*, 1882

Husson (1905; National Gallery)—but their glances are directed slightly to the side, as if looking just over our shoulder, or are clouded in a stare withdrawn from us.

Mrs. Eakins first looks out at us in the 1885 painting known as *Lady with a Setter Dog*. Married only the year before, she already bears a saddened demeanor prophetic of the troubles gathering about

Eakins's artistic and personal life. On the one hand, Susan's relaxed pose on the chair; her book, hand, and face set in gestures of openness; the dog's equally comfortable stance; the rug placed obliquely to the picture plane and small works of art casually seen in the back corners; and the use throughout of warm tonalities of reds, browns, and blues all speak of a shared domestic felicity. At the same time,

175. Thomas Eakins, *Portrait of Benjamin Eakins*, c. 1899

176. Thomas Eakins, *Portrait of Harry Lewis*, 1876

177. Thomas Eakins, *Mrs. Thomas Eakins*, 1899

178. Thomas Eakins, *Self-Portrait*, 1902

this head strongly bent forward and the reddened rims of Susan's eyes are aching voices of encroaching pain. All this remains apparent in the late portrait of *Mrs. Thomas Eakins* (1899; fig. 177), in which the same tilt of the head and weighted eyelids now give even fuller expression to the intervening accumulations of adversity. But Eakins no longer has need of the genre elements and interior setting of the earlier picture. As he began the last phase of his career, he was able to locate all feeling in the human face.

His own *Self-Portrait* (fig. 178) three years later conveys the same union of burdened flesh and spirit. The broad brushwork of these paintings, the isolation of the head in light and dark, the textured background, as well as the diagnosis of psychological presence, to-

259

gether recall Eakins's admiration for Rembrandt. Though the American did not paint the large number of self-portraits that either the Dutch master or Van Gogh did, Eakins's image of himself in the context of his other work reveals that almost all his late portraits were a form of autobiography. In other creative and sympathetic individuals, he found mirrored the tribulations of his own life and art. This is why we can see the same self-scrutiny and self-possession that Rembrandt records in his own image not just in Eakins's parallel portrait of self but in his other supreme portraits as well.

Certainly one of these is that of *Mrs. Edith Mahon* (1904; fig. 182), a pianist who, one feels, has experienced her own tension between the promise and failure of art. The hard set of her mouth and the glistening eyes suggest a not ordinary sorrow. Yet this wounded countenance forces us to face some recognition of our own painful mortality, even as it retains some mysterious detachment quite its own. Note at the upper right a highlighted fragment of the familiar Eakins chair, otherwise so lost in the enshrouding darkness as to be almost dematerialized. We ourselves are almost moved to tears of sympathy as we meet in Mrs. Mahon a singular sensitivity in accepting the deteriorations of age.

This sense of time's passage and decay is one of the underlying currents of the Brown Decades. On the surface the 1890s were gay and gilded, but the end of the century also brought with it elegiac intimations of loss. Eakins unenviably grasped the deeper consciousness of a personal life, as well as a way of life, running out. Few of his contemporaries addressed these disquieting themes. One who did was John F. Peto, another native Philadelphian ten years younger than Eakins, who attended the Pennsylvania Academy in the 1870s, when Eakins was teaching there. One has to wonder if the seeds of Peto's mature style were not nurtured then, for in his later paintings of books arranged on tabletops and shelves we discover a similar attention to worn objects, evocative textures and colors, and the projection of an uneasy self into one's subject.

Discarded Treasures coincidentally dates from the same year as *Mrs. Mahon*, and bears a comparable aura of gravity, in the somber coloring, sheer weight of masses, and deep seriousness of feeling. We may find a further parallel in the poetry of Emily Dickinson, another reclusive and misunderstood figure in American culture of the later

nineteenth century. Her enigmatic and secretive lines tightly follow one another to create similarly subjective and self-contained environments. As Peto did, she turned to the imagery of books as one emblem of self and art. She could allude to the liberating life of books: "There is no Frigate like a Book / To take us Lands away"; and to the exhaustion in art: "Unto my Books—so good to turn— / Far ends of tired Days—." We should remember that Eakins also painted at least two major portraits of individuals surrounded by a library of books, *Professor William D. Marks* (1886; Washington University, St. Louis) and *Riter Fitzgerald* (1895; Art Institute of Chicago).

A further interesting comparison between Eakins and Peto is that occasionally late in their careers they were unable or found it unnecessary to finish certain pictures. Unfinished paintings are a subdivision of Eakins's last portraits worth considering separately. They appear rarely before 1895, but become relatively numerous after 1900. Often he left details barely sketched in, a background ambiguously empty, a torso crudely blocked out, as in the compelling, even brutal, painting of the concert singer *Mrs. W. H. Bowden* (*The Singer*) (1906; fig. 179). Still, the work is quite complete in its autopsy of the human personality.

On one level, we can read this as incapacity or inconclusiveness, an index of a late career yielding to final anxieties. Here the later portraits of Gilbert Stuart at the close of his own embattled life offer a revealing precedent. For example, the strongly modeled head of the aged *John Adams* (c. 1800–1815; National Gallery of Art, Washington) almost floats in the sketchy darkness around him, while in other canvases of the 1820s Stuart hardly brushed in background at all. One is reminded of the work of another Adams, Henry, who was writing and publishing his *Education* at the same time that Eakins was painting *Mrs. Edith Mahon* and *Mrs. W. H. Bowden*. In a chapter significantly titled "Chaos," he recalled the death of his sister. Badly injured when thrown from a cab, she contracted a gradually paralyzing tetanus. Adams watched as "hour by hour the muscles grew rigid, while the mind remained bright." In the face of disorder, whether from within or from without, Eakins similarly held to the head and mind as the body wasted away.

Comparison of Eakins and Adams brings to mind as well the most

179. Thomas Eakins, *A Singer (Portrait of Mrs. W. H. Bowden)*, 1906

261

180. Thomas Eakins, *Dr. Edward Anthony Spitzka*, c. 1913

thoughtful sculptor of his generation, Augustus Saint-Gaudens, and in particular his most profound work, the *Adams Memorial*. We have already noted Eakins's comparable treatments of the seated female figure in *Lady with a Setter Dog* and *Susan Santje*. From the same period dates the unfinished seated portrait of *Mrs. Joseph W. Drexel* (*The Model*) (c. 1900; Hirshhorn Museum). Blocked out in broad masses and with downcast eyes suggesting a timeless contemplation, the painting evokes a mystery as haunting as that embodied in the *Adams Memorial* (1886–1891; fig. 181).

An aura of brooding loss and failure pervades both these works by Eakins and Saint-Gaudens. Yet the powerful, near-abstract patterns of stone and paint in each instance create some realm of permanence both artists sought beyond the erosions of mortal time. These figures further share a settling of penumbral darkness: as we come into their presence, we do so at once physically and mentally. The interiors created here are first spatial enclosures and second human forms, themselves containers of palpable thought and spirit.

Henry Adams expressed his own anxieties about the turn of the century. The chapter titles throughout the second half of his *Education*, devoted to the 1890s and the early 1900s, ring with the notes of an elegy: "Silence," "Indian Summer," "Twilight," "The Abyss of Ignorance," "Vis Inertiae," "A Law of Acceleration." He saw the life of an age, as Eakins saw the life of individuals, slipping away into something unknown. Peto's piles of books teeter on the same edge of disorder. The title of one still life, *The Writer's Table: A Precarious Moment* (1890s; Manoogian Collection, Detroit), reinforces this generation's uncertainties, perceived equally in the acts of art and of living.

Adams's prophetic vision of the new century he and Eakins were then just beginning centered on the new energies of the dynamo. This machine represented an unknown universe to Adams, open-ended and not apprehensible by past scales of measurement. The accelerating advances of science captivated him, and it is worth recalling that Eakins, too, held a lifelong interest in science. His mastery of anatomy, mathematics, and photography is well known, and played a profound role in his art as he sought to construct pictorial space, to situate objects and people in it, and to coordinate the organic relationships within the human form. Each man saw the threatened chaos of career in the unknown forces of a new age, and, disturbed more than despondent, attempted to gain a saving self-possession.

Appropriately, Eakins's final painting was a portrait of a professor of anatomy at the Jefferson Medical College, *Dr. Edward Anthony Spitzka* (fig. 180). The artist was already ill with several ailments when he began this commission around 1913. He had brushed in the highlighted volumes of head and hands as part of an intended full-length composition, but the work remained truly unfinished at his death in 1916. We are uncertain whether this specter of an individual is materializing or disintegrating before us. Like the death of Adams's sister, the literal body of the canvas was cut away some time after it was painted. How fitting that Eakins's last testament should be the image of a renowned brain surgeon, whose "mind remained bright," even as the artist and the canvas itself succumbed to their own mortality. What remains in this brushwork is the actual object of art and the presence of the artist.

✤ 16 ✤

Locating Augustus Saint-Gaudens

IN THE HISTORY of American sculpture, and especially in his own day, Augustus Saint-Gaudens has stood preeminent. At the midpoint of the nineteenth century, Hiram Powers and Horatio Greenough achieved fame with their neoclassic marbles, especially *The Greek Slave* (1843–1851; Corcoran Gallery of Art) and *George Washington*. In the early twentieth century, Daniel Chester French created some of our best-known national monuments, such as his *Lincoln Memorial* (1919) in Washington, D.C. By the third quarter of this century, the powerful and original oeuvre of David Smith had emerged as a rival to the ranking of Saint-Gaudens's work in the history of American sculpture. But although his predecessors may have produced some memorable national icons for their day and his successors some imaginative formal inventions, Saint-Gaudens shaped a large body of images that demonstrated technical creativity even while they assumed a sure hold on the national imagination. In its subjective power and expressive feeling, the art of Saint-Gaudens can stand worthy comparison with two of the artistic giants of his time: the American painter Thomas Eakins and the French sculptor Auguste Rodin. As we have seen, Saint-Gaudens's *Adams Memorial* (1886–1891; fig. 181) calls to mind the profound psychological content and mysterious aura of Eakins's poignant late portraits (figs. 180 and 182). At the same time, the suggestive abstraction and haunting grandeur of that same bronze form lose nothing by citing the French master's name.

Saint-Gaudens's life spanned the second half of the nineteenth century, and he was very much a man of his age. Born abroad but brought up in New York, he studied, traveled, and worked in Eu-rope. Moving with increasing ease through the cosmopolitan world and the sophisticated circles of intellectual and social colleagues, he gained an international reputation in sculpture comparable to that enjoyed by his contemporary John Singer Sargent in painting. Both were sought after for portrait commissions, and both produced works for some of the best-known names of the period. But it was Saint-Gaudens's special achievement to have merited his public recognition for memorials that satisfied genteel tastes at the same time that his art grew in power and originality, as it did throughout his career. More than anyone in America, he was responsible for carrying sculpture from allegorical neoclassicism to heroic realism, from single- to multiple-figure compositions, and from stone carving to bronze casting. In this respect, his metal forms belong to the modern industrial age, just as wood had suited the sculpture of William Rush and the architecture of the Federal Period, or stone the sculptors and builders of the Neoclassical Era.

The forces that shaped Saint-Gaudens's vision were complex and overlapping. First of all, he acquired a sense for history and important events early in life. His memories of Lincoln in New York and the Union troops leaving for the Civil War provided those visual kernels that years later found artistic expression in his monuments to Lincoln, Shaw, Farragut, and Sherman. His apprenticeship as a cameo cutter instilled in him at the outset of his career a confident instinct for sculpture in relief. Thereafter, almost all his major pieces would rely on two-dimensional and pictorial compositions, even when forms were modeled in three dimensions. The larger figures are often carefully framed by architectural elements in the presence

of pedestals or walls. Clear viewpoints for his sculpture are well defined, with the frontal plane usually holding the ensemble in stately order. Despite vast differences in scale, this kind of planar clarity and self-containment issued from the form and technique of the cameo, which for Saint-Gaudens acted as an aesthetic liberation, not a limitation. From the cameo evolved work in every scale, including the public monument, the small portrait relief, and the most beautiful coin—the twenty-dollar gold piece—ever produced in the United States.

Saint-Gaudens's academic training in New York and Paris also contributed strongly to the character of his subsequent work. First at the National Academy of Design and later at the Ecole des Beaux-Arts, the essentials of academy teaching formed his approach to the making of art: concern with narrative and historical subjects; the role of drawing the figure; and exposure to classical precedents, whether from literature, old master paintings, or ancient or Renaissance sculpture. Enhancing his formal education were the inspiriting experiences of walking tours of Rouen, Naples, and Switzerland, and periods of living in Rome and New York. In Europe he had opportunities to see sculptural monuments set in public parks, squares, and other urban spaces; and even the slightest familiarity with the great architectural achievements of the Renaissance and baroque periods demonstrated the possibilities for collaborative sculptural programs and embellishments. The examples that Saint-Gaudens is known to have drawn upon for his own figures make clear that he was capable of borrowing from tradition with purposeful discrimination. More important, he was able to transform those precedents into an imagery resonant for his own time.

Finally, there is the more amorphous but certain element of personal associations in Saint-Gaudens's life. These immersed him variously in the worlds of art, commerce, politics, and patronage. During the 1870s, he met the influential architect Henry Hobson Richardson, and he joined the Tile Club, some members of which remained close friends for the rest of his life; many brought other artists—both visual and literary—into his ever-widening circle of friends, reaching as far as the Cornish, New Hampshire, community that grew up in the environs of Aspet, his home and studio. Even a cursory review of portrait reliefs by Saint-Gaudens makes clear his

181. Augustus Saint-Gaudens, *Adams Memorial*, 1886–1891

contact with wealthy industrialists like Cornelius Vanderbilt (fig. 183); with fashionable painters like Sargent, Jules Bastien-Lepage, Francis D. Millet, and William Picknell; and with literary men like William D. Howells or Robert Louis Stevenson (fig. 184). If there was a common quality running through these pieces, it was Saint-Gaudens's particular ability to fuse realism and idealism, observation and abstraction, human immediacy and expressive feeling. Just as Thomas Eakins through his later career elected to paint the faces of many fellow artists, architects, writers, and musicians, so did Saint-Gaudens engage himself, on one level, in objectively delineating the facial features of others and, on a different level, in contemplating the features of art. With unsurpassed craftsmanship, equally he mastered ordinary factuality and noble design.

A fusion of historical reality and idealizing allusion exists with variations in all of Saint-Gaudens's major pieces. In his first success-

182. Thomas Eakins, *Portrait of Mrs. Edith Mahon*, 1904

266

183. Augustus Saint-Gaudens, *Portrait Relief: Cornelius Vanderbilt I*, 1882

184. Augustus Saint-Gaudens, *To Robert Louis Stevenson in His Thirty-seventh Year*, 1887

185. Augustus Saint-Gaudens, *Farragut Monument*, 1877–1881

186. Augustus Saint-Gaudens, *Shaw Memorial*, 1897

ful commission, the *Farragut Monument* in New York (1877–1881; fig. 185), he set the powerful portrait head of the admiral on a figure indebted to Donatello's *Saint George* (1415; Or San Michele, Florence). For the *Shaw Memorial*, unveiled in Boston in 1897 (fig. 186), he may have had in mind Diego Velázquez's great baroque painting of the *Surrender at Breda* (1634–1635; Prado) or perhaps even *The Defeated Persians under Darius*, a Roman mosaic after a Hellenistic painting (c. 20 B.C., Museo Nazionale, Naples), all exemplars for a heroic battle composition. The angel of mourning hovering over Colonel Shaw recalls the many precedents of Victory that appeared on classical altar reliefs and triumphal arches. The central image of Shaw, realized in full, free-standing profile, anticipates the grand three-dimensional figure of General Sherman (fig. 188), completed in New York in 1903; both emerge from the sculptor's consciousness of the imposing equestrian monument in the long tradition of western art. The most notable models would have been the Roman statue of *Marcus Aurelius* (c. A.D. 166) on the Capitoline Hill in Rome, and its two great successors of the Renaissance: Donatello's *Gattamelata* (c. 1443–1453) in Padua and Verrocchio's *Colleoni* (c. 1481–1496) in Venice.

At the same time, Saint-Gaudens never surrendered his art totally to either historical emulation or detached idealism. The modeling of Lincoln's head proceeded with a life cast of the face as a guide; a life portrait of Sherman was done when the artist first began work in New York in 1886; Saint-Gaudens recruited blacks off the streets to serve as living models for the faces of the soldiers marching to their deaths beside Colonel Shaw; a naked model posed on a barrel for Sherman's figure astride his horse. Even the abstracted form of the *Adams Memorial* evolved only after an assistant had sat before the sculptor with a blanket draped over his head and body.

Saint-Gaudens's architectural elements also had sources in traditional forms, although he made a point of adapting them to his contemporary needs. Thus, the symbolic wings of the empty Roman chair beside his *Standing Lincoln* (1884–1887; fig. 187) possess appropriate formal dignity and allude to the office of head of the republic. The high pedestal of the *Farragut Monument* derives from familiar ancient and Renaissance examples but is modified to suggest the bridge of a ship, where the admiral resolutely stands facing into the

187. Augustus Saint-Gaudens, *Standing Lincoln*, 1884–1887

271

188. Augustus Saint-Gaudens, *Sherman Monument*, 1903

wind. Elsewhere, the pedestal for the *Sherman Monument* bears a water-leaf molding and bronze olive wreaths—details with classical associations of honor and triumph. Sometimes these decorative motifs merely embellish portions of the whole scheme; occasionally, they also carry precise iconographical meanings. As solid volumes, the architectural components give formal unity and purity to the total conception. Perhaps more importantly, particularly in his artistic collaborations with Stanford White, Saint-Gaudens composed his sculptural masses so that they relate firmly both to the surrounding setting and to the presence of the viewer.

The *Shaw Memorial* occupied Saint-Gaudens's attention for almost two decades, from the first discussions of the commission with Richardson in 1881 to the time of the unveiling ceremonies at the Boston Common in 1897. Not only one of his most successful achievements, it is also one of his most representative. In the unsettled years of the late nineteenth century, there was much nostalgia for the nation's Civil War leader, Lincoln; despite the trauma of that conflict, Americans on the threshold of an uncertain new age could look back on the midcentury period with romantic feelings. In an age when Americans could still think of war's losses and self-sacrifice as heroic and worthy acts, Saint-Gaudens took on a supremely fitting subject when he decided to memorialize Colonel Shaw and his black regiment. His solution was largely a pictorial one. The narrative of events is abstracted into the basic figural elements of Shaw, his footsoldiers, and the allegorical angel, all moving laterally, in different levels of relief, across the architectural stage from left to right. The cropping of forms at either side, and details such as feet caught just beginning a new stride, suggest a photographic immediacy, while the bold rhythm of forms at once maintains compositional unity and conveys a sure sense of purpose.

This mixture of the literal and symbolic received its fullest three-dimensional treatment in the *Sherman Monument* (fig. 188), begun in the mid-1880s and shown at the Universal Exposition in Paris in 1900 before its final unveiling at the edge of New York's Central Park three years later. Here the carefully observed portrait, the classical equestrian tradition, the symbolic references to Victory, and the formally articulated architectural base are all masterfully combined. The hovering angel has become a fully realized, independent

figure standing in front of Sherman's horse. She draws her inspiration from such powerful historical models as the Hellenistic *Nike of Samothrace* (c. 200–180 B.C.; Louvre) and Delacroix's *Liberty at the Barricades* (1830; Musée d'Orsay), both of which were accessible to Saint-Gaudens in the Louvre. She appears in his work under many guises and in differing scale, from Liberty on the 1907 gold coin to the full-sized relief of *Amor Caritas* (1880; Saint-Gaudens National Historic Site, Cornish, N.H.). Such personification of virtues was commonplace in all the arts during the last quarter of the nineteenth century, especially in sculptural programs and mural decorations for public buildings. Instead of the more intimate enclosure of architectural frame and shallow terrace devised for the Shaw composition, Saint-Gaudens placed the figures in his Sherman design on a high pedestal. This approach tends to keep the viewer at a certain distance and literally presents the group as elevated in fact and idea.

The spectator's relationship to a sculpture was a central aspect of Saint-Gaudens's most profound and abstract creation, the *Adams Memorial* (fig. 181). If the *Sherman Monument* later took the artist to his fullest expression of realism on the one hand and allegory on the other, the difficult commission from his friend Henry Adams to memorialize his wife carried the sculptor to a contrasting level of abstraction. It is true that Saint-Gaudens had cultivated from the beginning a feeling for pure design; for the nature of textures, surfaces, and materials in their own right; for the perfected relationship among planar and solid geometries. But with this work he moved a step farther, toward something paradoxically simpler and yet more enigmatic.

The circumstances of the *Adams Memorial* made it unique in Saint-Gaudens's oeuvre. It was a personal commission and a private memorial. It could not celebrate a death of valor because the death was a suicide, an anguished and inexplicable act. Moreover, the widower and patron, Henry Adams, was a religious skeptic and, because Marian Hooper Adams had taken her own life, both overt symbolism and explicit portraiture seemed inappropriate. The setting was not to be a public park, but a semiprivate grove, Rock Creek Cemetery in Washington, D.C. (more remote and less familiar than Rock Creek Park). And, most importantly, Adams intended the resulting bronze figure and quiet grotto to mark his final resting place

as well as his wife's, providing evidence that the shrouded bronze individual should not be considered as the personification of Grief. Adams directed in his will that there be no inscriptions "or other attempt at memorial, except the monument I have already constructed." In other words, the work was intended to state itself fully, without narrative explanation. Having no title, it exists generically. To this end it calls on a universality of imagery and a bold purity of design.

Both from Henry Adams's own writing and from Homer Saint-Gaudens's amplification of his father's memoirs, it is known that the artist sought a generalized image that went beyond both individuality and sexual identity to suggest not necessarily immortality but a "philosophic calm" waiting in the "mystery of the hereafter." To achieve this, Saint-Gaudens drew freely on elements from eastern as well as western art, arriving at a form with associations that transcended national iconography. John LaFarge, friend of both the sculptor and the author, thought of the sculpture as a Japanese *Kwannon* (a figure of enlightenment and salvation in the Buddhist religion; see fig. 189) the sculptor himself studied images of Buddha in photographs and drawings. This "sympathy with a religious attitude of the East" (recalled by Homer Saint-Gaudens) was fused with sculptural precedents from the ancient and classical western tradition as diverse as the stylized tomb figures of Egyptian kings and queens, the draped individuals in Greek temple pediments or marble grave reliefs, and the heroic forms of Michelangelo's Sistine Ceiling, most relevantly the seated figure of Jesse in one of the spandrels. Precise interpretation of this large, restful piece has eluded visitors to this day. The closest definitions Saint-Gaudens gave were, in a letter, "the Peace of God" and, in notes around a preliminary sketch, "mental repose" and "calm reflection." In his *Education*, Adams wrote of the work as embodying "the oldest idea known to human thought."

If the subject of the *Adams Memorial* remains mysterious and suggestive, so too does its style, which relies on only broadly defined details. Saint-Gaudens conceived of the figure as "sexless and passionless, a figure for which there posed sometimes a man, sometimes a woman." Its hooded but strong face and nearly abstract folds of clothing create a powerfully simplified presence that, importantly, is

189. John LaFarge, *Maua, Our Boatman (Samoa)*, 1891

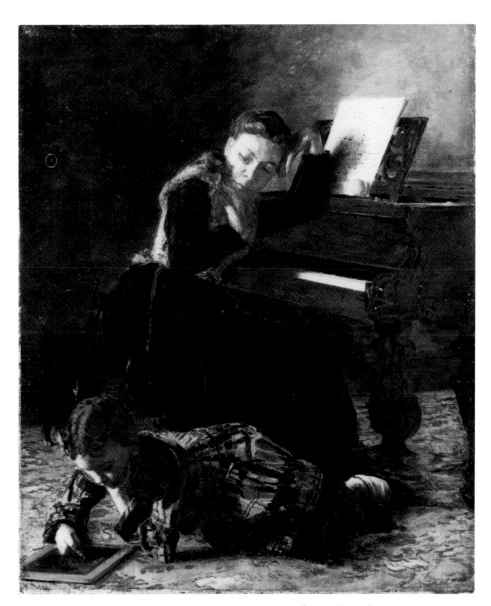

190. Thomas Eakins, *Miss Amelia Van Buren*, c. 1891
(Color Plate 21)

191. Thomas Eakins, *Home Scene*, c. late 1870–1871

275

slightly larger than life. The conception of a meditating figure was typical of the genteel tradition at the close of the nineteenth century; the reverie for a past departed and a present in transition gave rise to poignant expressions of loss and change. Women seated wistfully in shadowy interiors, often with a hand drawn to the cheek in a posture of detached thought, were subjects treated by several of Saint-Gaudens's contemporaries, most notably Thomas Eakins (figs. 190 and 191), Thomas Dewing, Edmund Tarbell, William Merritt Chase, and James McNeill Whistler.

A comparison of the *Adams Memorial* with works by Eakins is particularly revealing, for both the hand raised to the chin and the figure, seated in what has been described as an arboreal room, have direct counterparts in Eakins's paintings of women seen in a moment of meditation and placed in front of plain walls or darkened corners of rooms. But it is also the feeling that in both Eakins and Saint-Gaudens we, as human beings, are brought into the charged meaning of the work of art. Adams insisted that "the interest of the figure was . . . in the response of the observer." Indeed, that is the special way in which the painter and sculptor engage our own sense of mortality. The work of art turns our glance back upon ourselves. In Adams's crucial phrase, "like all great artists, Saint-Gaudens held up the mirror and no more."

John F. Peto and the Idea
of Still-Life Painting in
Nineteenth-Century America

BEFORE TURNING to thematic considerations in John Frederick Peto's career proper, we need to address the nature of still life generally and some aspects of the subject specifically in the American tradition. Although the field by definition has its own distinctive iconography, discussion of American still-life painting has for the most part taken place in a vacuum, isolating the material both from other contemporary subjects and from a larger cultural context. Specialized studies as well as general surveys have tended to see still life in a near-hermetic tradition with an idiosyncratic development of its own. As a consequence, some surveys neglect still-life painting, not knowing how or where to place it, or insert self-contained sections among the broader ongoing narratives devoted to other subjects or media.

Yet as paintings done in America, images by Peto, along with those of other still-life artists, do bear aspects of a national style. Collectively, they have a character on an artistic genetic chart, so to speak, marking both place and time. First of all, historians have often called attention to the American artist's penchant for rendering the palpable, real world, in which solid forms are naturalistically defined and purposefully placed.[1] However cramped Peto's tabletop compositions sometimes are, they share with works by other important American still-life painters, like Raphaelle Peale and John F. Francis, an insistent physical realism and convincing spatial ambience. These are down-to-earth impulses that might be thought of as traditional virtues in a democratic country.

American painting, including its history of still life, has also expressed a continuing concern for the practical and functional. This is particularly evident in the aims of the earliest explorer artists, such as John White, coming to the New World in the late sixteenth century, when artistic images were primarily documentary records or scientific illustrations. The same motivation dominated the nineteenth-century ambitions of George Catlin's Indian and John James Audubon's bird paintings. This is a tradition Americans have valued because tradition is measurable, and it places a premium on technical ability. In this regard, William Harnett's painting has seemed readily accessible and admirable for its exquisite finish and polished illusionism. He appears to record a finite world of objects with precision and finesse, and this ability has been a clue to his high repute from the beginning. In comparison, Peto's roughness, non-illusionism, and mysteriousness have seemed alien, both somehow distant in spirit from the viewer and out of the American mainstream. The often melancholy deterioration of his imagery has additionally ap-

peared to run counter to American assumptions of optimism and progress. Thus we can begin to perceive the ways in which Peto's art emerges from an American tradition at the same time as it is seen to represent something disturbing and new.

Much of American still-life painting in the nineteenth century was indebted in fact or in spirit to Dutch seventeenth-century precedents. So too were aspects of genre and landscape subjects, not surprisingly since the cultures in the two countries in these respective centuries shared similar values. Both were nations grounded in Protestantism, giving rise to moralizing impulses; in commerce and mercantilism, investing value in material well-being; and in scientific exploration, finding expression in adventurous pioneering and technical ingenuity. Dutch pictures were collected by American patrons, copies were exhibited in the annual exhibitions at the Boston Athenaeum and elsewhere, and prints after Dutch compositions were widely familiar to aspiring American painters. Some images were thus known in original form, others indirectly through eighteenth-century English derivations.[2] In the cases of Peto and Harnett, we can see that certain German and Dutch baroque models underlie their own versions of tabletop and rack picture compositions.

As Ingvar Bergstrom has pointed out in his book *Dutch Still-Life Painting in the Seventeenth Century*, the interest in still life for artists reflected a larger emerging fascination with the things and activities of everyday life. Even earlier these interests coincided with the rise of naturalism at the beginning of the Renaissance (about 1400). We are familiar with the development of perspective at this time as a methodology for bringing intellectual order to our perception of both pictorial and actual space. Similarly, this period saw the first modern flourishing of the natural and biological sciences. These new disciplines encouraged the impulses to categorize and specialize. Concurrently in painting, artists also more rigorously devoted themselves to a clear hierarchy of subdivisions in subject matter, from history and mythology to landscape and portrait painting. Although long considered the least significant of types, still life itself was increasingly subdivided. By the seventeenth century, there were clear categories of, for example, food, fruit, flower, and so-called *vanitas*

still lifes—each with its own elaborate, specific iconographical symbolism.[3] Many of these types were in turn inherited by the American tradition, although seldom without highly particularized symbolic formulations or references. One obvious instance in which Peto adapts associational details from Dutch prototypes is in his treatment of candlesticks and oil lamps as metaphors of worldly transience.

If the background of Dutch art provides one perspective on the character of American still-life painting, comparison with the French school suggests other considerations. Although certain aspects of Jean Baptiste Chardin's work may well have had an effect on Peto,[4] in general the refinements of touch and artifice in eighteenth-century French painting do not find counterparts in the more businesslike realism of American images. Likewise, American painting rarely concentrates on the formal values of pure paint, brushwork, or color that characterize the still lifes of Edouard Manet and Auguste Renoir. Paul Cézanne's aesthetic issues of how the mind's eye perceives masses and spatial relationships exist at some distance from the American preference to hold to image-making as illustration, decoration, or storytelling.

Theodore E. Stebbins, Jr., has drawn a revealing comparison between the flower paintings of Martin Johnson Heade and those of Henri Fantin-Latour. While he makes a case for Heade's likely having been influenced by his French counterpart, he shows significantly how for the French artist

> energy and enthusiasm are conveyed through brushwork, a rich sense of color, and swiftly painted highlights, and while Heade's composition resembles it superficially, his painting belongs to a quite different tradition. Muting any sense of the artist's presence, eliminating visible brushstrokes, his painting is truly *about* the flowers themselves. . . . Heade seems almost fearful of his medium . . . the rich surface of the French painting gives it a quality of immediacy.[5]

A similar self-effacement is apparent in most American still-life paintings, from Raphaelle Peale to Severin Roesen to Harnett. But in Peto we face a more unexpected handling of paint textures, color, and pure shapes for their expressive and aesthetic values. Such con-

cern for the components of art for their own sake is infrequent in the history of American art, and this helps to explain why Peto has gained only partial favor with American taste.

But we need to do more than appreciate American still-life painting in a national context, for it is also possible to examine artists as exemplars of particular stylistic periods. There is no reason why we should not be able to see still life in relation both to other subjects painted in the same period and to the broader cultural attitudes of that moment. The following observation is characteristic of the blurring of the very stylistic distinctions needing clarification:

> Place a Harnett still life of the middle 1870's next to a Raphaelle Peale of 1815 and it is impossible to believe that they are separated by two generations, that the one belongs to the era of James Madison and the other to that of U. S. Grant.[6]

Possibly at first glance the two artists (figs. 192 and 193) may appear to share concerns with intimately scaled tabletop compositions, carefully highlighted details, and meticulously polished surface textures. But if in fact we compare closely representative works by Peale and Harnett, we find overriding differences in subject matter that suggest quite separate cultural visions. Indeed, still lifes by these two artists are as different stylistically as the Federal architecture of Thomas Jefferson is from the Romanesque idiom of Henry Hobson Richardson. Surely in Peale's still life as in Jefferson's Monticello, for example, a stylistic expression of certain ideas of perfection and order in the early Republic is to be seen, just as the somber, weighty arrangements of Harnett and Richardson offer clues to the materialistic period following the Civil War, called the "Brown Decades" by Lewis Mumford.

We need no more confuse these still lifes just because of their nominal similarities of subject and finish any more than we should fail to distinguish between the respective classical forms in the two styles of American architecture. Narrowing the point further, we can make distinctions in building form and aspiration between periods so close as the Federal and Greek revival; concomitantly, there is an intellectual world of difference between the images of Peale and those of Francis or Roesen only a generation later. Architecture may

seem a surprising stylistic analogue in this discussion, but it is a useful one. For although one medium is two-dimensional and nonfunctional, and the other solid, spatial, and practical, both rely on the conceptual arrangement of solid volumes and ultimately reveal parallel cultural expressions.

More obvious, perhaps, are the associations one might draw between still life and, say, landscape or figure painting of the same period. It is a short distance aesthetically from Raphaelle Peale's still-lifes to Charles Willson Peale's portrait compositions (fig. 96); both share a refined calculation of design and illusion that marks much painting of the Federal Period generally. By extension, the brooding darkness in a Harnett or a Peto finds affinities in the lone figures painted by Thomas Dewing and Thomas Eakins. But it is in architectural examples, initially so apart from still life in the world they occupy, that comparisons may help to frame this specialized subject matter of painters in a broader cultural background. A sequence of pairings will indicate the ways in which the imagery of painting and architecture can together illuminate key moments throughout the nineteenth century.

Raphaelle Peale's painting *Lemons and Sugar* of 1822 (fig. 192) is an archetype of Federal Period style.[7] Beginning about 1815 and continuing up to his death a decade later, Peale painted a series of similar food compositions in this delicate, tight manner. As the eye begins to clarify Peale's discrete objects, the mind comes to realize how much the artist is engaged in the play of pure forms held in graceful and economic balance. The work savors the elevated tastes of Federalist society in the young Republic but also the aesthetic sense of ideal, abstract relationships. This latter concern for art itself was partially an inheritance from the artist's father, Charles Willson Peale, who gave to his several children both the talents and the names of artists.

The senior Peale was a figure of protean abilities and achievements. Well known as an inventor, scientist, patriot, museum founder, and artist, he led a life shaped by the spirit of the eighteenth-century encyclopedists and philosophes. With his friends Jefferson and Benjamin Franklin, Peale embodied in America the aspirations of Europe's Enlightenment. His works were among the first

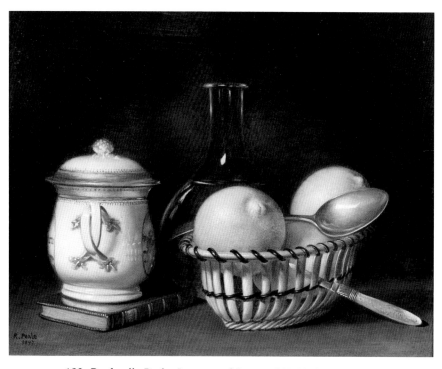

192. Raphaelle Peale, *Lemons and Sugar*, 1822 (Color Plate 22)

by an American artist to essay a comprehensive variety of subjects from history and portrait to landscape and still-life painting. In addition, he adapted and transformed often traditional modes and formulas of subject matter by creating fresh combinations better suited to the generally more informal and practical needs of his countrymen. This encyclopedic vision became a stimulating legacy to the many members of Peale's family who took up careers as artists and scientists over several succeeding generations. In his own work he left precedents for virtually all the specialized subjects taken up in the paintings of his children and grandchildren.

Many of Peale's major canvases, for example, depicted himself or various members of the family. An early group portrait, *The Peale Family* (c. 1770–1773 and 1808; fig. 95) is a conventional figural

image, but also one that includes references to other works of art and to the practice of art itself. One member holds palette and brushes in hand; a second is actually drawing; nearby are a canvas depicting the muses and a row of sculpted busts; on the table sits an elaborate still life; and the family dog poses in the foreground. This enumeration shows how Peale has infused his portraiture with family history and elements of genre and still life. In various, occasionally whimsical, combinations he continued to make aspects of his professional life part of his art. Peale himself stands close to center stage in his *The Exhumation of the Mastodon* (1806–1808; Peale Museum, Baltimore) and *The Artist in His Museum* (1822; Pennsylvania Academy of the Fine Arts, Philadelphia), while two of his painting sons constitute the subject of *The Staircase Group* (1795; fig. 91).

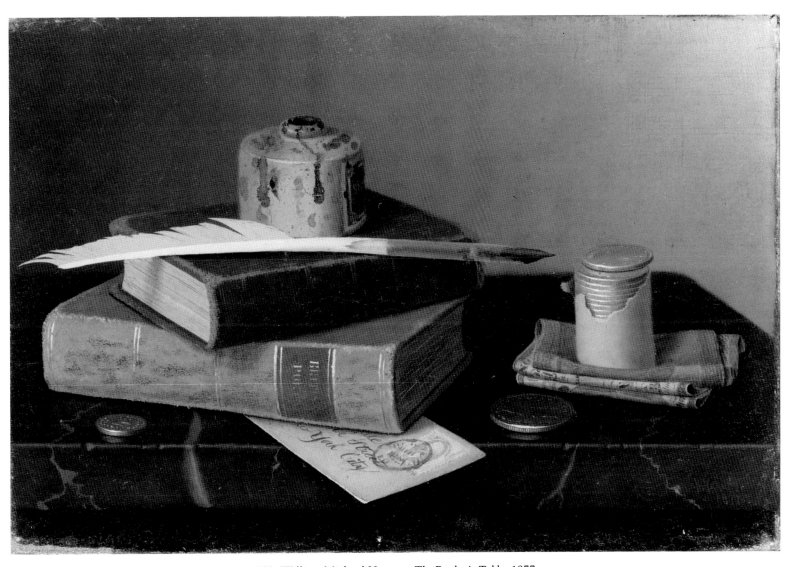

193. William Michael Harnett, *The Banker's Table*, 1877

Perhaps it is not surprising that Raphaelle, who stands in the fore-ground of *The Staircase Group* as an artist, gave his attention in his own still lifes to lovingly arranged and finely wrought objects. In-stead of two balanced figures at ease on a set of steps, in *Lemons and Sugar* dining room objects gracefully rest together on a table surface. They appeal equally to our senses of taste and sight, for throughout we may savor the efforts to render unblemished surfaces and essential geometries and to achieve a right order among the elements. Peale's technical dexterity is capable of a mirror-sharp illusionism. The re-sult is a glowing clarity of light within this close dark space that evokes an almost devotional attention to the objects. This attention is paid equally to their reality as art and to their reality as things.

The care given to this arrangement is everywhere evident, as jux-taposition and echoes of forms carry throughout. At each lower cor-ner the eye is led in by the complementary diagonals of books and knife; in turn, the entwined handle of the sugar pot matches the spiral motif circling the basket opposite. Silver contrasts with china, china with leather, and glass with each of them. The organic nestles with the manufactured. The linear, the planar, and the spherical are in tangent with one another, and so are concave and convex forms. Soft rough textures play against hard gleaming ones, light falls on dark, and translucent materials reflect antiphonally with opaque counterparts.

Austere yet elegant beauty such as that in *Lemons and Sugar* may also be said to characterize the design of America's best Federal ar-chitecture; this comparison carries our analysis onto a larger stage. Consider, for example, the Massachusetts State House (1797) by Charles Bulfinch. Immediately visible are the same aspirations for clear relationships, hierarchical order, and equilibrium among the disparate parts. Planar and cubic geometries intersect logically and gracefully. Stone, brick, white-painted wood, and gold leaf are dis-tinctly separate yet proportionately balanced within the whole. In his eloquent examination of early American architecture, William H. Pierson, Jr., has pointed out the important introduction of com-plex curved shapes in the Federal style, most particularly its favoring of repeated circular and elliptical forms.[8] Such elements of design are apparent here in Bulfinch's dome and tower—as they are in

Peale's grouping—and even more so in interior details of the State House.

Similar qualities are to be found in the contemporary buildings of Samuel McIntire and Jefferson, qualities Pierson has described as controlled reserve and chaste serenity. If to him a Bulfinch structure is "an experience of proportions,"[9] then McIntire's Pingree House (1805) in Salem, Massachusetts, represents a "system of sharply de-fined self-contained and independent parts, rhythmically joined in a coherent decisive whole."[10] And Jefferson's Monticello (1793–1809) in Virginia can be characterized as "disarmingly simple at the same time that it is intricate; it is practical at the same time that it is easy, flowing, and gracious; it is dignified and yet is filled with charming informality."[11]

What the Federal Era in all its forms gives us is an almost aristo-cratic refinement of taste, a natural consequence of Federalist ideas themselves, especially in New England, derived from inherited En-glish manners. Certainly in architecture the graceful precedents of the Adamesque style abroad shaped American ambitions. It is in this spirit that we can appreciate the shared language of style relating Peale's designs with the world of McIntire's carved fireplace mantles, Bulfinch's oval drawing rooms, and Jefferson's central rotundas. But theirs was also an age that valued the practical in combination with the ideal.

Intellectually, the philosophical cast of the eighteenth-century Enlightenment had stamped the very conception of the new Repub-lic and consequently the taste and thought of Americans in the years before and after the Revolution. Scottish and French thinkers es-pecially had stimulated the pursuit of systematic methods of inquiry, which led most notably to the reasoned shaping of America's found-ing political documents.[12] Declarative, calculated, orderly, Jeffer-son's list of grievances accumulated rhythmically within the total structure of the Declaration of Independence. The authors of the Constitution sought to translate vision into reality as they shaped the larger framework of a new government, while in *The Federalist Papers* James Madison, Alexander Hamilton, and John Jay con-ducted an elevated dialogue on the Constitution's provisions and operation. In so doing, this generation drafted its own design for

political order, in which the rights of citizens were placed—*E pluribus unum*—in equilibrium with the social whole.

Looking again at the pyramidal massing of both Peale's and Bulfinch's forms, we are not far from the spirit of political phrases linking America's great ideas in triadic sequence. Recall how the Declaration at the outset asserts the rights of "Life, Liberty and the pursuit of Happiness," and closes by pledging "our Lives, our Fortunes and our sacred Honor." In its turn, through checks and balances, the Constitution delineates a tripartite system of government composed of the executive, legislative, and judicial. Seen in the context of such values, Peale's still life is a small-scale but legible index of this noble period in American history.

Whereas Peale's work can provide some insight into a cultural vision of the first quarter of the nineteenth century, the still lifes of John F. Francis (fig. 194) present a very different style, belonging to the next generation at work through the second quarter of the century. Having begun his career as a portraitist who arranged his solidly modeled figures in clearly defined spaces, Francis turned almost entirely to still-life subjects about 1850. As a native Philadelphian, he well knew the painting tradition established by the Peales, and his own compositions initially strike us as similar. *Still Life with Apples and Chestnuts* (1859; Museum of Fine Arts, Boston) depicts a familiar compact gathering of foods, strongly illuminated on a table surface, all seen close up and set off by a screen of darkness behind. There is the continuing delight in a calculated positioning of varying rounded volumes and an enlivening play of different surface textures.

Sustained inspection, however, reveals crucial dissimilarities in content, technical handling, and overall feeling between the work of Peale and that of Francis. Peale's colors, limited mainly to yellows and whites, seem delicate and refined, whereas Francis manipulates a much stronger palette of the same hues but with denser patterns and contrasts of color complementaries. His yellow apples and basket, for example, are partly framed by the strong blue lines bordering the draped napkin. The bright blue and white pitcher at the left sits adjacent to the warm yellow of the cider-filled glasses. Spots of red and green mottle the surfaces of the central group of apples, while

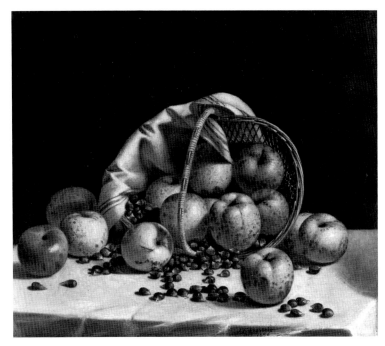

194. John F. Francis, *Still Life: Yellow Apples and Chestnuts Spilling from a Basket*, 1859 (Color Plate 23)

the tone of the background shifts from warm reddish brown at the left to a dark green on the right.

Francis's brushwork and rendering of textures are correspondingly more vigorous as well. The paint has a more plastic and rougher density, in contrast to the creamy smoothness of Peale's pigment. In addition, Francis has selected objects of different taste, in the sense of both flavor and of style. Not Peale's sugar and lemons suggesting a quiet tea, nor his leather-bound book perhaps of poems, decanter possibly of sherry, gleaming silver, and imported china—instead Francis assembles a market basket and plain tablecloth, heavy glass goblets, and sturdy serviceable pitcher. Replacing Peale's calm reserve are food and drink about to be eaten: the cider is poured, an apple cut apart. But there is also a greater clutter in Francis's work, intensified by the basket being tipped on its side, pouring apples and

nuts out toward us. Even his composition is physically larger than Peale's standard scale of painting, as if we have now entered a more expansive and energetic world. In contrast to Peale's perfect fruits serenely in place, the richer textures and coloring and the blemished surfaces in the work of Francis enhance our awareness of a robust and ripe immediacy. No longer viewing a chaste grouping on some Hepplewhite sideboard, we now face a more workaday kitchen setting in Victorian America.

In this instance, the appropriate architectural analogy is the Greek revival movement, which dominates American building modes from the late 1820s well into the 1860s. Though ultimately derived as much from classical sources as the previous Federal manner of Bulfinch, the pure neoclassical style looked beyond English Adamesque translations to the original masses of Greek and Roman precedents. Alexander Parris's Quincy Market in Boston was one of the first and most powerful examples of this new taste. Completed in 1825 as part of the active expansion in commerce during Josiah Quincy's mayoralty, it represented the first flourishing of Greek forms to pervade all types of public and domestic architecture in America. During the 1840s and 1850s, columned temples and grand rotundas came to house everything from courthouses and banks to college halls and private dwellings. This was an intentionally bold and impressive style of building, suited to the nation's newfound strength and optimistic pride in its sense of collective promise.

Unlike the thin planar qualities of Bulfinch's brick surfaces, his attenuated wooden columns, and elegant but fragile-looking dome, Quincy Market suggests a striking clarity of cubic mass, partly created by the use of sharply chiseled granite blocks, thickly proportioned forms, and a solid interlocking of all the parts. The whole effect is more muscular and monumental, one characterized by Pierson as "sharply in tune with the everyday working world of America." "Nothing could have been more expressive of the broad common strength of the new nation than the primitivism of Neoclassical forms. . . ."[13] With a similar language of analysis, he describes Robert Mills's Monumental Church (1812) in Richmond, Virginia, "with all essentials stripped away and only the bare bones of the geometry to define the spaces," and the same architect's Treasury Building in Washington (1836–1842) with its "bold articulation of the masonry construction," stylistic elements having a direct appeal "to the ordered taste of a pragmatic society."[14]

In later political terms, Jefferson's intellectual and aesthetic sensibility had yielded to the physical energies and emotional populism embodied in the presidency of Andrew Jackson. Though Jackson had left the White House by 1845, his personality initiated a celebration of the common man and an expansionist sense of democracy's triumphant self-reliance. The age of Jackson defined a new popular faith that continued to fire the American imagination up to the Civil War. One phrase above all proclaimed for that moment "The right of our manifest destiny to overspread and to possess the whole of the continent which Providence has given us for the . . . great experiment of liberty."[15] One hopes that such political vocabulary will not now seem so distant from its cognate expressions in the architecture of Parris and the painting of Francis. The dense central massing of forms in both is but one index of an almost aggressive amplitude and down-to-earth assurance shared in the golden years of antebellum America.

Emerging not long after the neoclassical style and flourishing during the third quarter of the nineteenth century were art forms inspired foremost by nature. In still-life painting this meant a new concentration on botanical and floral subjects, while in architecture the gothic revival style reflected the organic complexity and variety of the natural world. The work of Severin Roesen depicts an earthly abundance much in the same spirit as Francis's painting, but with an even more lavish and extensive enumeration of nature's bounty. Roesen was a German-born artist who emigrated to New York just before mid century and then settled about a decade later in rural Pennsylvania for the rest of his career. He obviously brought with him a style of meticulous coloring and jewel-like detail indebted to the prevailing manner taught in the Düsseldorf School. This approach well suited the aspirations of Americans to chronicle the details of their landscape with a fervor as much scientific as it was romantic.

Among the principal influences shaping this vision in still-life painting after midcentury were the writings of John Ruskin and Charles Darwin. In their respective ways, both called attention to the specific identity of living things, Ruskin through his *Modern*

Painters (published in London in 1844 and in New York in 1847) and *The Elements of Drawing* (1857), Darwin through his *On the Origin of Species*, which appeared in 1859. For all of nature's components Ruskin argued that "we have to show the individual character and liberty." More specifically, he proclaimed that "the flower exists for its own sake—not for the fruit's sake" and that "A flower is to be watched as it grows."[16] Darwin in turn stimulated a widespread popular consciousness of the scientific method and more particularly an appreciation of the processes of organic life.

In this climate, artists turned with fervor to painting floral arrangements indoors and out. Roesen never went so far as others to render flowers, leaves, or grasses in their natural environment, though occasionally he sketched in vistas of open landscape behind corners of his still-life compositions. His *Still Life: Flowers* of the mid-1850s (fig. 195) is a typical assemblage, in which we confront almost an inventory of nature's lushness. Across his shelves are settled three different containers—large glass bowl, basket, and bird's nest—in which rest a profusion of spherical forms to nourish our senses of sight, touch, and taste. We are invited to indulge in a rich variety of colors, textures, and shapes from the wide range of flowers at the left to the several fruits and eggs on the right, with smaller berries and grapes as transition in the center. There is a comparable breadth of floral species extending from the exotic orchid to the common daisy, but with each of nature's creations exuberant in its individuality.

Clearly, nature was deserving at once of study and of praise. Scientific examination led to a more accurate and comprehensive understanding of the natural world, while celebration served to reveal an ultimate divine presence. Thus, a flower had both an objective and an expressive reality. Roesen addressed the former through the precision of his scrutiny and the latter through the ideal artifice of his arrangement.

There are illuminating parallels in thought and observation to be found in the contemporary writings of Henry David Thoreau, and almost at random one can come across similar verbal descriptions of nature throughout his essays. Take, for example, this lengthy but evocative passage on hazel blossoms recorded in his journal for 28 March 1858:

I go down to the railroad, turning off in the cut. I notice the hazel stigmas in the warm hollow on the right there, just beginning to peep forth. This is an unobserved but very pretty and interesting evidence of the progress of the season. I should not have noticed it if I had not carefully examined the fertile buds. It is like a crimson star first dimly detected in the twilight. The warmth of the day, in this sunny hollow above the withered sedge, has caused the stigmas to show their lips through their scaly shield. They do not project more than the thirtieth of an inch, some not the sixtieth. The staminate catkins are also considerably loosened. Just as the turtles put forth their heads, so these put forth their stigmas in the spring. How many accurate thermometers there are on every hill and in every valley! Measure the length of the hazel stigmas, and you can tell how much warmth there has been this spring. How fitly and exactly

195. Severin Roesen, *Still Life: Flowers*, c. 1850–1855 (Color Plate 24)

any season of the year may be described by indicating the condition of some flower![17]

Although Roesen depicts his floral group on an interior tabletop, while Thoreau looks at his blossoms in their actual habitat, both take us into a private corner of nature and measure the component organisms with comparable accuracy. Thoreau's first sentences repeatedly express a stance of noticing, observing, and examining. He seeks to locate things in place by taking their measurement, at one point citing exact numbers and at another mentioning a thermometer in both a literal and a metaphorical sense. He perceives analogous relationships with these blossoms in the laws of the cosmos (the "crimson star" at twilight) and in the cycles of organic life ("the turtles put forth their heads"). Tempering such abstractions is the technical scientific nomenclature ("staminate catkins"). But above all Thoreau asserts the equation of nature's growth with the "progress of the season." As with Roesen's painting, we are in the presence of an imagery of promise and fruition.

The architectural parallel here is the gothic revival style, especially as it flourished in the country villa and cottage. Among the most influential theorists and practitioners of the type were the architect Alexander Jackson Davis and the landscape gardener and architectural critic Andrew Jackson Downing. Together they set aside the concept of the marble-white purity and volumetric clarity of neoclassicism to design structures in relationship to their natural settings. Pronounced Downing in his first book, *The Fruits and Fruit Trees of America* (1845): "architectural beauty must be considered conjointly with the beauty of the landscape or situation."[18] To this end, he argued for colors, textures, and detailing that would harmonize with a building's surroundings. Like nature herself, this was to be an architecture of variety, surprise, irregularity, and dynamic relationships. Instead of the stable balances of discrete parts in the Greek revival, the gothic aspired to fluid organic rhythms, asymmetrical tensions, and lively contrasts consistent with the terrain and foliage nearby. Thus, replacing the solid masses and cleanly enclosed spaces of neoclassical structures was the imaginative introduction of trellises and airy balconies, verandas and porches, cupolas and turrets.

Davis's residence for Henry Delamater (1844) in Rhinebeck, New York, is typical of the gothic revival manner, whose picturesque nature has been well summarized by William H. Pierson, Jr.:

Its fragmented irregular shapes, its lofty tapered profiles, its constantly shifting surfaces, its interlacing proliferous forms [are] all so reminiscent of the world of natural growth. . . .[19]

Like Roesen's still life, this is an artificial composition drawn from but not belonging to nature. Pierson's description of Lyndhurst (1865), Davis's great masterpiece in Tarrytown, New York, is equally apropos here:

each arch, each molding, each tracery bar conveys the impression of being there as a result of natural growth. . . . the later windows of Lyndhurst seem to emerge from the substance of older parts as living organisms, capable of perpetual renewal, and appear more as blossoms on a flowering tree than as cut flowers arranged for a special occasion.[20]

This Darwinian sensibility animates the foliate vitality of both Roesen's and Davis's work. In addition, the gothic revival reminds us of its ultimate derivation from church architecture of the Middle Ages. In this regard, its spiritual function and expressiveness also seemed especially suited to mid-nineteenth-century American ideas about the Edenic purity of new world geography and the divinity of nature. Indeed, most contemporary landscape painting—witness Frederic Edwin Church's triumphant *Twilight in the Wilderness* of 1860 (fig. 50)—presents us with a similar fusion of religion, art, and science. Roesen's still life marks a burst of glory before the romance of science and the immortality of the spirit yielded to a darker, more worldly vision.

That shift in sentiment becomes apparent by the last quarter of the century, and brings us in this sequence at last to the still-life subject matter of Peto and the work of Henry Hobson Richardson as its architectural counterpart. It should now be evident that when we turn to the work of Peto and Harnett, we are indeed in a different intellectual and stylistic generation from that of Raphaelle Peale and the contemporaries of James Madison. With Peto's *Lamps of Other Days*—(c. 1890; fig. 196) one of a series begun in the 1890s—the

196. John Frederick Peto, *Lamps of Other Days*, c. 1890

still life returns indoors to the darkened tabletop setting favored previously by Peale. The visions of immortal freshness and the bursting optimism in praise of the present seen in Darwinian flower painting now give way to a world of objects visibly subject to mortal wear and tear.

Peto belonged to a generation who came to maturity during the post–Civil War years of the 1870s, that unsettled, turbulent, and transitional period of Reconstruction. Industrialism and technology, in an earlier time agents of romance, were increasingly intruders and disturbers of nature's peace. The planting of the golden spike at Promontory Point in Utah in 1869 marked the triumphant bridging of the continent by the railroad, but it also signaled new strains for the country, engendered by territorial expansion and regionalism. Corruption marred political life at the local and national levels. Above all, this was a time in America of great accumulation and expenditure of wealth. Still-life painting not least mirrored the obsession with a world of things. Personal property and possessions, whether the gathered objects of one's library den or collected antiques and artifacts, emerged to claim the private tabletop stages painted by Harnett and Peto. Similarly, they along with their colleague John Haberle delighted in rendering acquisitions of personal value and illusions of paper currency.

It borders on oversimplification to assert a change in national life from innocence and optimism to complexity and cynicism, yet unquestionably the tone of America's self-perception and of artistic expression was different. Speaking of the earlier nineteenth century, Henry James talked about Nathaniel Hawthorne's career as being "passed, for the most part, in a small and homogeneous society."[21] And in reference to Franklin Pierce and the same period, James described "our hero" as

an American of the earlier and simpler type—the type of which it is doubtless premature to say that it has wholly passed away, but of which it may at least be said that the circumstances that produced it have been greatly modified. The generation to which he belonged, that generation which grew up with the century, witnessed during a period of fifty years the immense, uninterrupted material development of the young Republic;

and when one thinks of the scale on which it took place, of the prosperity that walked in its train and waited on its course, of the hopes it fostered and the blessings it conferred—of the broad morning sunshine, in a word, in which it all went forward—there seems to be little room for surprise that it should have implanted a kind of superstitious faith in the grandeur of the country, its duration, its immunity for the usual troubles of earthly empires. This faith was a simple and uncritical one, enlivened with an element of genial optimism, in the light of which it appeared that the great American state was not as other human institutions are, that a special Providence watched over it, that it would go on joyously forever, and that a country whose vast and blooming bosom offered a refuge to the strugglers and seekers of all the rest of the world, must come off easily, in the battle of the ages. From this conception of the American future the sense of its having problems to solve was blissfully absent; there were no difficulties in the programme, no looming complications, no rocks ahead.[22]

James went on to argue, in sentences often quoted, that

The Civil War marks an era in the history of the American mind. It introduced into the national consciousness a certain sense of proportion and relation, of the world being a more complicated place than it had hitherto seemed, the future more treacherous, success more difficult.[23]

In poetry we may note the shift from the exuberant celebrations of self, country, and art by Walt Whitman in the 1850s to the private and solemn musings of Emily Dickinson in the 1870s.

When we return to Peto's painting and the comparison with Richardsonian architecture, it is significant that we enter the enclosures of a library. Here we are in the presence of knowledge assembled and arranged in books, with Richardson providing an impressive shelter for their public use and Peto piling them up for private contemplation. Despite the differences in medium, there are several formal similarities between Peto's work and the neo-Romanesque Crane Memorial Library (1880–1883) in Quincy, Massachusetts. Both painter and architect indulge in expressive surface textures, dark

earthbound forms massed on a solid platform, and bold cubic volumes held together in an asymmetrical design.

More interesting is the notion that for both Peto and Richardson the library was a kindred place to the artist's studio, where resided creativity and the stuff of culture. With Peto's imagery before us, let us listen to one of Richardson's assistants describe the architect's private study:

> The skylight . . . was concealed by a curtain of soft India silk, diffusing its rosy light over the bewildering mass of riches. . . . A huge table was filled with the rarest volumes, bric-a-brac and choice bits generally; bookcases and couches ranged along the walls; casts and vases showed off beautifully in the subdued light against deep maroon walls. . . . There were stupendous volumes in sumptuous bindings inviting study. Away off in a quiet corner lay some happy pupil in blissful repose, reveling in the resources of the land of plenty. . . . This room was a magic source of inspiration.[24]

In this mood and context of late Victorian America, we may begin to appreciate the shape of Peto's vision.

Finally, we might consider some observations on the distinctive nature of still-life painting itself. Ingvar Bergstrom has provided a working definition of the subject useful for initial attention: "a representation of objects which lack the ability to move . . . and which are for artistic purposes grouped into a composition."[25] The operative phrase here is *for artistic purposes grouped*, reminding us that still life is perhaps the most artificial of all artistic subjects, and the one most concerned with the making of art. Before actually painting, an artist has crucial preliminary decisions to make regarding his selection and arrangement of forms. Unlike other subjects, such as landscapes or portraits, still lifes do not preexist around us, so besides the acts of choice and interpretation there is that of invention, itself an aesthetic process. In composing a still life in one's mind or in physical actuality, the painter must address such formal properties as shapes, textures, colors, or sensuous associations. Thus the foremost concern of still-life painting is pure artistic form.

In this regard, it is not accidental that the great cubist breakthrough from the analytic to synthetic phases during 1912–1913 took place via still-life components. As a revolutionary innovative style dealing with fundamental issues of artistic form and perception, cubism in the hands of Pablo Picasso and Georges Braque sought to reconcile the illusion of three-dimensional objects with the reality of a two-dimensional surface, the surface and the interior of forms, multiple sources of light, and different vantage points assumed simultaneously. To this end ordinary objects from the kitchen and café tables provided neutral and unsentimental shapes of particular formal power. Bottles, playing cards, fragments of newspapers, mandolins, and pipes variously possessed expressive contours or insistently flat surfaces, whereby their juxtaposition or overlapping could create provocative ambiguities between opacity and transparency. In such ways cubism was successfully able to examine afresh the nature of illusion and representation in art. Its achievement would not have been possible to the same degree with the associations of personality or demands of likeness in portraiture or with the spatial assumptions of a landscape view. Rather, the centripetal aspect of still life has always drawn special attention to its inherently abstract and conceptual character.

A still life refers both to itself and to its creator. The artist stamps his presence through an overlay of roles: as conceiver, selector, arranger, transformer, and finally as painter. As John F. Peto's still-life paintings offer an index, respectively, to his culture, his time, and himself, we discover that his work is indeed about America, autobiography, and art.[26]

Images of Lincoln in
John F. Peto's Late Paintings

THREE TYPES of painting in John Frederick Peto's late career deserve special focus, for they represent the culminating originality and complexity of his art. The first type involves just a small number, which depict papers or photographs against a wooden wall surrounded by an illusionistically painted frame. The second group explores various manifestations of the Lincoln imagery affixed in different ways to plain walls. The final series comprises some dozen of Peto's rack pictures dating from 1879 to 1904. Together these recapitulate the evolution of his aesthetic ideas and rekindle our fascination with the always protected details of his personal and professional existence.

Peto's obsession with Lincoln imagery found expression in about a dozen canvases painted regularly through the 1890s and early 1900s. Although he did not grow up with his parents but lived instead with his grandmother, Mrs. William Hoffman Ham, until he was in his mid-twenties, Peto cared enough for his father to have painted in 1904 an unusual trompe l'oeil tombstone plaque, *Memento Mori for Thomas Peto* (private collection), reminiscent of the family business signs. And during the decade following his father's death in 1895, Peto painted a series of so-called rack pictures notable for their imagery of Lincoln, whom the painter appears to have identified as another lost father figure. In one of these paintings, *Reminiscences of 1865* (1897; fig. 197), a painted calling card next to the Lincoln photograph appears to read in part, "Head of the House." A hanging bowie knife obliterates the first word, as if refer-

ring to two lives cut down by death, individuals who were heads of national and personal families, respectively. Such psychological issues only hint at the complex meanings Peto buried in his later still-life paintings.

Alfred Frankenstein first commented on the connection, citing family stories about Thomas Hope Peto picking up a blood-stained bowie knife on the Gettysburg battlefield.[1] In several of the pictures, an oval engraving of the familiar Lincoln face is juxtaposed with the knife, sometimes hanging threateningly nearby. About half of the group that have come to light are varying arrangements of these and other flat objects nailed to sections of old wooden doors, with the balance employing the crossed tapes in a letter rack motif. Incised in most of these are such details as Lincoln's nickname "Abe" or his birth and death dates of 1809 and 1865 (fig. 198). Occupying the center of *Reminiscences of 1865*, the knife hangs like a large and heavy guillotine over the representation of Lincoln's bust.

The source of this likeness, an engraving, was a commonly reproduced and available print; Peto owned a copy, which he made use of for almost all of these paintings. It shows the tears and abrasions of much handling, but Peto also strengthened certain details with pencil, such as Lincoln's hair and beard, and he repeatedly pressed into the outlines of the president's face, presumably as a means of transferring it exactly, like a cartoon, to his canvas surface. In a number of cases, the measurements of the oval and its interior details coincide directly with this print, though Peto concerned him-

197. John Frederick Peto,
Reminiscences of 1865, 1897

291

self mainly with the planes of light and dark and a few essential linear features.

Peto experimented with different formats, and some works in the series are less than successful because the details have a generalized and simplified air bordering on the perfunctory. One of these is interesting chiefly for its attempt to exploit the expressive effects of an unusually narrow vertical canvas and a subtle range of subdued colors—tan, ochre, and the palest of blue and lavender. In another singular case, *Lincoln and the Phleger Stretcher* (1898; fig. 199), he set his painted oval engraving on the back of a canvas, a perceptual conceit that has occasionally appealed to other painters in both the nineteenth century and our own time. Disturbing to certain viewers has been the patently unfinished likeness of Lincoln, though this is a familiar Peto device, to remind his audience that the image is the result of an act of painting. It complements the trick of delineating the canvas's back on its front. Given Peto's sensibility, it treats Lincoln as a private and discarded memento.

The idea of making a picture of the reverse side of a canvas and its stretcher was one with precedents in earlier European art, most notably in the work of Cornelis Gysbrechts from the second half of the seventeenth century.[2] Like other forms of deception painting, it found its way into the American tradition, and not long before Peto tried his example, the Long Island painter William M. Davis produced *A Canvas Back* (c. 1870; Museums of Stony Brook, N.Y.). Little is known about Davis save that he was an acquaintance of the well-known genre painter William Sidney Mount and did at least one other complicated trompe l'oeil painting.[3] Aside from its similarity of conception to Peto's *Lincoln and the Phleger Stretcher*, the inscription at the top of the Davis canvas is startlingly close to the writing in a number of other Peto compositions. At present no solid connections can be drawn between the Long Island and Philadelphia painters, but obviously illusionistically painted frames held an interest for other artists of this period.

This imagery continues to thrive in contemporary art, especially in the witty and provocative canvases of such pop painters as Jim Dine, Jasper Johns, and Roy Lichtenstein. Not surprisingly, their methods and themes share much with those of Peto and his generation. Dine has collected works by John Haberle, and both Johns and

198. John Frederick Peto, *Reminiscences of 1865*, c. 1900 (Color Plate 25)

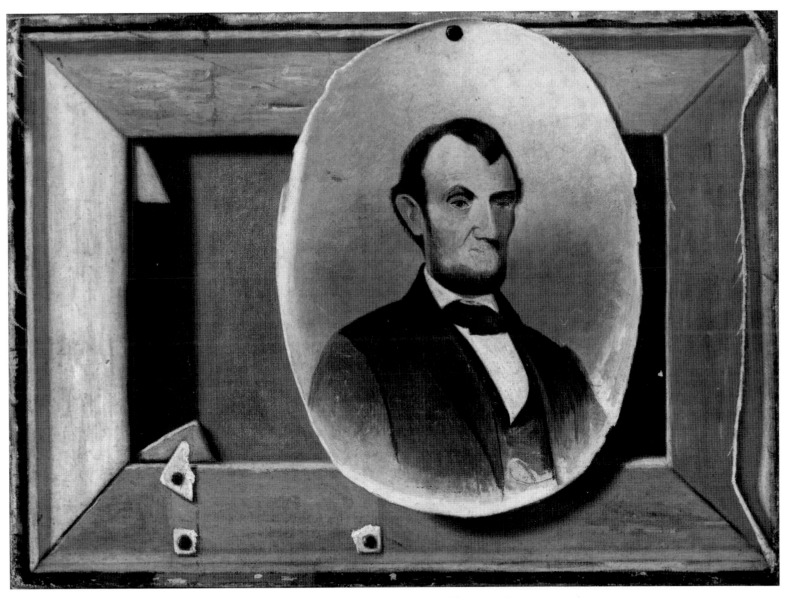

199. John Frederick Peto, *Lincoln and the Phleger Stretcher*, 1898

Lichtenstein have freely drawn on the trompe l'oeil examples of Peto and William Harnett. In particular, Lichtenstein undertook in the 1970s a series of canvases depicting stretchers with attached studio items, which consciously recall details from Haberle, Harnett, and Peto. Lichtenstein's style of large-scale, glossy, comic book painting is but a modern form of deceptive realism, addressing both what we see and how we see.

Although Peto did few paintings of illusionary frames and canvas backs, they were indicative of his imaginative experimentation with imagery in his late career. The one recurring subject that serves as a transition from these formal inventions to his last important series of rack paintings is the Lincoln theme. The oval engraving of the president's figure dominated several later canvases by Peto that displayed relatively plain wood surfaces. In their austere flatness and their visual provocations, Peto continued to invest his paintings with touches of wit and mystery. He amplified the Lincoln presence with a variety of associative details. In some, as in a second work with the title *Reminiscences of 1865* (c. 1900; Minneapolis Institute of Arts), he included other official images—contrasting pieces of currency, for example, such as the twenty-five-cent shinplaster and tarnished coin fixed to the door (fig. 198). Here Peto imposes a more severe linear order than usual on his whole design by the generally balanced and repeated rectangles throughout.

More chaotic is the randomly cracked panel and dispersed arrangement of *Lincoln and the Star of David* (fig. 200), dated 1904, which manifests the advancing decay often portrayed in Peto's late works. Lincoln was the first American president to be assassinated, and the legacy of hatred and distrust left by his death stirred powerful emotions to the end of the nineteenth century. With the panic of 1893 and the collapse of the banks, Americans faced new challenges of despair and survival. On the one hand, there had been the triumphs of American industry, the railroads, and corporate development. Howard Mumford Jones writes of the parallel visions of John D. Rockefeller, Sr., and Walt Whitman of America as "a happy, wasteless, and plentiful society."[4] On the other hand, the disorder apparent in various spheres at the turn of the century gave rise to bitterness, sectional strife, and turbulence. As ineffectual presidencies and further assassinations followed Lincoln's, a fin de siècle

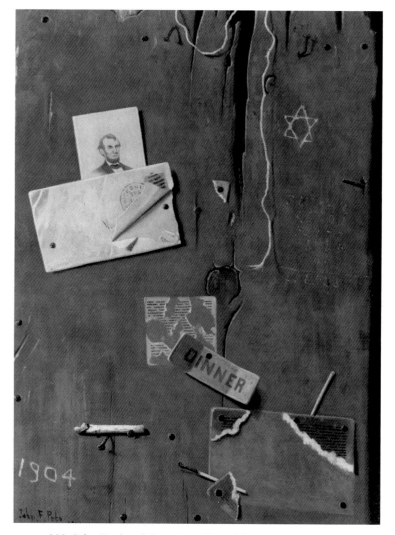

200. John Frederick Peto, *Lincoln and the Star of David*, 1904

sense of being adrift overtook much of American culture. Peto's ragged conjunction of the martyred president and the associations with suffering in the sign of the Star of David appear to draw no less from the tribulations of the period than from those of self.

A more provocative psychological connection is to be raised between Peto's use of the incised star and his larger designs of the letter racks themselves. Aside from their general similarities of linear form on different scales, we have to wonder if there is not some shared emotional content here as well. It is true that Peto's first rack pictures of 1879 and the early 1880s begin as mostly literal and whimsical transcriptions of office boards with the practical possibility of serving as business advertisements. However, in the later rack paintings, beginning in 1894, not only do we see the Lincoln imagery making its reappearance (concurrent with Peto's mourning over his father's death), but we also face a new mood of strain and assault in the form of the rack's tapes. At least in the Lincoln series these crisscrossed lines now bear the full physical and spiritual burdens initially hinted at in the earlier small signs.

Coloristically, the letter rack paintings are very beautiful canvases, with their rich, impenetrable grounds of black or dark green and intense patches of isolated pinks, yellows, oranges, and blues. They were much admired in their day, as contemporary newspaper commentaries affirm. One of the Lincoln series elicited the following description on the occasion of a visit that Peto and his wife paid to his in-laws in Lerado, Ohio:

A piece of realistic painting which shows great achievement of skill in this special line of art in which Mr. Peto stands almost alone, is a canvass [sic] two and a half by two feet, a card rack, under the crossed red tapes of which are stuck a number of letters and papers, prominent is a copy of the Commercial Gazette. There are also letters, a postal card and an engraving of Abraham Lincoln in the lower left corner, and other such articles as belong to the office of a newspaper. The work is done so deftly and with such regard for the truth of form, perspective, light and shadow, and the conditions of realistic art, that the most acute observer is deceived. He does not think he is inspecting a painting, but believes he sees before him a genuine card rack with the actual article inserted.[5]

Peto, and for that matter Harnett too, did not always receive such favorable criticism of his illusions, and other rack paintings were to be damned for being so visually deceitful as to border on the immoral. At the same time, the admiration for technical dexterity and straightforward literalness is a long-standing American trait. In fact, Peto almost never attained the completely deceptive effects that his viewers believed or wished they saw. Reality in the service of art, rather than vice versa, instead led him generally to ends more disturbing, unpredictable, and thought-provoking.

Although the personality of Lincoln seems to have had focal meaning for Peto personally, reminiscence of the Civil War was more broadly shared with many of his generation. Termed the first great modern war,[6] in terms of mass brutality and slaughter and the use of steam technology and advanced firearms, the conflict shattered the fabric and self-confidence of the nation. By century's end, the natural deaths of its veterans heightened the poignance of memory, and numerous artists turned to subjects much like Peto's. Typical cases in point are *Union Mementoes on a Door* (1889; private collection) by George Cope and *Emblems of the Civil War* (1888; fig. 201) by Alexander Pope. The former painter worked mostly around his native West Chester, Pennsylvania, while the latter grew up and trained in Boston; both turned to large door still lifes during the later 1880s in response to the influential example of Harnett, especially his popular *After the Hunt* (1885; Fine Arts Museums of San Francisco). For his part, Cope preferred to render with extreme naturalism the often blond wood graining of his background, compactly massing his hanging objects at the center. With Pope the elements are more ambitiously dispersed, though he relies on some of Harnett's circular and diagonal motifs for his design. Like the antler horns, these are the trophies of manly conflict, reminders (in uniforms, bugles, pistols, dress swords, and battle flags) of past glories. Although their basic compositions and subject matter relate to Peto's series, he alone personalizes the significance of Lincoln and the family bowie knife as almost enigmatic presences.

We have seen how Peto probably tied his father's death to Civil War motifs, through most notably the Lincoln portrait, the pistol, and the bowie knife. The theme of the gun is one pervasively embedded in the traditions of nineteenth-century America, from the hunting of animals on the western plains and self-defense in settling the frontier to the romance of militarism fueled by the several wars during those decades. As life grew more difficult and complex, the

201. Alexander Pope, *Emblems of the Civil War*, 1888 (Color Plate 26)

gun became a reminder of clear, aggressive solutions and of militaristic pride. The chivalric ideals and actions of an earlier generation of warriors stood in contrast to the sense around 1900 of impending uncertainty, impotence, and upheaval. Following the Civil War, waves of violence arose with the force of a cult. As the demand for arms escalated, Samuel Colt for one doubled production at his factory in Hartford.[7] No wonder weapons held evocative associations for Peto and his colleagues.

The passions of the Civil War and the romance of youth cut down surfaced as well in literature of the period, most familiarly in the writings of Stephen Crane and Walt Whitman. On the basis of his readings of the war's history and visits to some of the battlefields, Crane constructed his popular novel *The Red Badge of Courage*. From the point of view of a common private, he gives the terrible conflict a poignant immediacy. Although vivid details and a sense of ordinariness are intended to convey a documentary flavor of reality, Crane invests his story, written in 1895, with values belonging more to the end of the century than to the early 1860s—concerns with the unknown, boredom, self-doubt, panic, and confusion. The youthful narrator remarks that "The battle was like the grinding of an immense and terrible machine to him. Its complexities and power, its grim processes, fascinated him. He must go close and see it produce corpses."[8] Crane was writing in a generation anxious about abstract forces larger than individuals and out of their control. Caused first by the Civil War, this anxiety intensified with the further upheavals in national life during subsequent decades. On the minds of the novelist, the painter, and their contemporaries were questions regarding the nature of both personal and national mortality. Thus did the exploits and personalities of an earlier period of crisis come to have significant emotional appeal for turn-of-the-century America.

Likewise, Whitman's poetry was engaged in a mixture of itemized facts and imaginative reminiscence. Time's veil affected him as much as it did Crane or Peto: "Dusk becomes the poet's atmosphere. I too have sought, and ever seek, the brilliant sun, and make my songs according. But as I grow old, the half-lights of evening are far more to me."[9] In his recollections of the Civil War, the sacrifice of Lincoln's death held heroic meaning for Whitman. Written in the aftermath of the assassination, the memorable "When Lilacs Last in the Dooryard Bloom'd" came to occupy a central position in the later editions of *Leaves of Grass*. In the light of Peto's fascination with the imagery of Lincoln and the Star of David, it is worth noting here that Whitman in his first lines describes the slain president as a "powerful western fallen star," a metaphor repeated throughout his poem. Well known in Philadelphia and America by his last years, Whitman himself died in 1892. It may not be too much to speculate that the great poet's passing, like that of Peto's father three years later, could have been a factor in the artist's turn to more somber rack pictures during the mid-1890s.

Whitman's direct experiences of the war years as an army nurse in Washington occasioned an accumulation of journalistic notes and

observations that he finally published as *Specimen Days* in 1882. These record the commonplace details of death's horror and, as time passed, the romantic overlay of majesty seen in great causes. The loss of a beloved father figure like Lincoln was a parallel obsession for Peto and Whitman. To both, the past event and present recollection fused. In 1882 the poet looked back to 1865 (as the painter was to do in the 1890s):

> I find in my notes of the time, this passage on the death of Abraham Lincoln: He leaves for America's history and biography, so far, not only its most dramatic reminiscence—he leaves, in my opinion, the greatest, best, most characteristic, artistic, moral personality. . . . The tragic splendor of his death, purging, illuminating all, throws round his form, his head, an aureole that will remain and will grow brighter through time, while history lives, and love of country lasts.[10]

In introducing a modern edition of *Specimen Days*, the critic Alfred Kazin reminds us that Whitman identified the cause of the nation, and its embodiment in the slain president (who was killed on Good Friday 1865), with no less than the sacred theme of Christ's Passion[11]—an association that strengthens Peto's visual alignment of his Lincoln engraving with a Star of David.

This particular subject of Peto's allows us another projection forward to a corollary image of our own time. Close to a century after Lincoln's death, America witnessed the assassination of President John F. Kennedy. Amateur historians have since indulged in discussion of the many coincidences of circumstance and individuals involved in each event, but the important comparison to be drawn here is that with Kennedy's death another bubble of national optimism burst and the country plummeted into despair, self-doubt, and contention. Many Americans were nostalgically preoccupied with lost leadership and promise in the years following. Not surprisingly, the image of his grieving widow pervaded the national consciousness, perhaps exemplified in the multiple silkscreen canvases produced at the time by pop artist Andy Warhol. Kennedy's own presence was the subject for Robert Rauschenberg's *Retroactive I* (1964; fig. 202), which might be described as a collage landscape created by a mixed technique of oil painting and silkscreening on the canvas. He employed or suggested different modes of production at once (photography, printmaking, and conventional painting), and equally he assembled various disparate images of the Kennedy years. In so doing, Rauschenberg joined form and content to describe the complex, often inconsistent and incoherent character of modern America, as Peto had given visual expression to the national temper of his day.

One further variant in Peto's Lincoln series remains. In at least two of the later rack paintings, the detail recurs with enough prominence to warrant consideration. *Card Rack with Jack of Hearts* (c. 1900; fig. 203) calls attention to the new element of the playing card jammed behind the strip of tape opposite a picture of Lincoln. So far as is known, Peto introduced and repeated just this face card in his compositions, and again, so far as is known, just in the Lincoln subjects. We can only guess Peto's motivations here, but given the patterns of themes described so far, he obviously wished to juxtapose the two similarly sized images of the president and the knave. We may wonder whether that figure stands as an ironic emblem for the beleaguered Lincoln or for the knavish assassin John Wilkes Booth.

We can think of the jack variously as prince, knave, or even joker. In some games he serves as an esteemed and useful wild card. Somehow Peto saw a correlation to Lincoln in the game of chance, with its both calculated and unexpected discards. That correlation took on a more ominous cast in a smaller canvas of 1903, *Hanging Knife with Jack of Hearts* (private collection). Here the Lincoln face is not present at all; instead, the Civil War bowie knife looms over the jack below.

The example of Jean Baptiste Chardin provides an especially appropriate precedent from the eighteenth century. Among the most touching of that master's vignettes of humble pleasures and daily pursuits are his paintings of youths absorbed in leisurely pastimes—blowing soap bubbles, playing knucklebones or shuttlecock, making drawings, and essaying the house of cards (fig. 204). This last is the title of several paintings on this subject, a couple of which interestingly depict a jack of hearts sticking up from a drawer in the foreground. As with his paintings of pure still lifes, Chardin treats this genre subject with the same stillness of mood and clarity of construction. The house of cards itself is a fitting metaphor for the

202. Robert Rauschenberg, *Retroactive I*, 1964

298

203. John Frederick Peto, *Card Rack with Jack of Hearts*, c. 1900

299

204. Jean Baptiste Siméon Chardin,
The House of Cards, c. 1735

playfulness, fragility, and dreaminess of the eighteenth century. At the same time, the dreamy intensity, the purity of form and color, and the precariousness of the game perfectly convey the essential idea of youth. The knave on the one identifiable playing card is a final touch in keeping with the gaming instincts of a young man.[12] Whatever the degree of Peto's consciousness of this tradition, he certainly followed in its spirit.

This dual concern for the emotional associations and the formal character of things returns us to the zenith of cubism. Picasso's *Card Player* of 1913–1914 (fig. 205) carries this theme into modern abstraction, but his introduction of newsprint and playing cards at the center is an intellectual gesture that we have already seen made, more traditionally, by Peto. In Picasso's overlapping forms and repeated silhouettes radiating out from the middle, one discerns the sense of table, cards, and finally the figure of the player and walls of the room behind. Thus does the still life take on the richness and fullness of its environment, at the same time that its basic components assert and manipulate the language of art. In this sense, for Picasso as for Peto, the cardplayer is an extension in turn of the joker, the harlequin, the performer, the magician, the artist himself. With cubism the textures, colors, and patterns of items like cards or letters are central to organizing pictorial design. As metaphors and as literal things, such details are instruments of art's playful transformation. The cubist still life ultimately makes a significant comparison with Peto's work in the way that both can be seen to join the ordinary world at everyone's hands to the interior realm of the artist's ruminations.[13]

In contrast to Harnett's objectivity, Peto became increasingly subjective, if not autobiographical. As he did, his paintings gained in confidence and expressiveness; at their best they possess qualities altogether different from those of Harnett but nonetheless comparable in their beauty. What is important to recognize are the ways in which Peto modifies the traditional trompe l'oeil mode. Whereas his paintings do not spell out a literal story, their elements often evoke narrative or anecdotal associations. While he works with effects of illusionistic rendering of forms in space, visual trickery is seldom an aim in itself. Most of all, whereas he is capable of totally convincing effects of deception, Peto prefers to exploit, rather than suppress,

the mark of his brushwork. Finally, his vision of the genre is more than decorative; instead of a neutral and self-effacing stance, he makes his forms express deeply felt emotion. This deeper resonance of feeling has made his art seem less accessible or understandable than that of Harnett, contributing to a reputation of uncertain significance.

There are useful parallels to be drawn with some of Peto's contemporaries, among them Albert P. Ryder, whose intimate moonlight marines also evoke a private contemplative world (fig. 206). Like Peto's paintings, they derive their power from the impulses toward abstraction and generalization of form, color exploited for nondescriptive functions, and patterns based on the seen things of this world but transformed into independent musical rhythms. More of a visionary than Peto, Ryder pursued a similarly reclusive course, and his generally small canvases, often repainted over the years, present an intimate, hermetic world. Like Peto, Ryder moved beyond observation of the immediate with a poet's sense for the symbolic and subjective. Whether landscape or still life, these works represent distillations of thought and ultimately elevate their subjects beyond the moment.

Peto's most thoughtful art of this period has analogies as well with some of the major currents in American literature. Henry James in his short biography of Nathaniel Hawthorne touched on the changes in mood and outlook that he felt marked American life after the Civil War.[14] In 1904 James returned from an expatriate period abroad to record his impressions of the country. Over several months, he toured the places of his past, often disturbed by the evidence of decay he noticed especially in the cities. Having written his observations in the same years as Peto's last somber still lifes, James published *The American Scene* in 1907. Though treating a different subject, his description of the streets in lower Manhattan uses phrases we would find applicable to Peto's disheveled racks:

confusion carried to chaos . . . a welter of objects and sounds . . . the interesting, appealing, touching vision of waste.[15]

Visiting Richmond, Virginia, James saw the legacy of the Civil War, "the collapse of the old order":

205. Pablo Picasso, *Card Player*,
1913–1914

206. Albert Pinkham Ryder, *Moonlight Marine*, c. 1890 (Color Plate 29)

only echoes—daubs of portraiture, scrawls of memoranda, old vulgar newspapers, old rude uniforms, old unutterable "mid-Victorian" odds and ends of furniture, all ghosts as of things noted at a country fair.[16]

Just a year or two before, in 1906, another figure central to this age was summarizing his awareness of modern complexity and disequilibrium. Henry Adams was a historian conscious of his family's shift of power from politics to art. In *The Education of Henry Adams*, he treated the self as an object and so equated autobiography with art, just as Peto made his still lifes a projection of himself. Contemplating the past, sometimes nostalgically, brooding on loss, worrying about mortality, seeing art as holding a clue to harmony and order, giving factuality poetic form—Adams shared these acts with Peto. And with both men the preoccupation with disorder and death increased toward the end of life.[17]

Like Peto, Adams drew a line from Lincoln's assassination to the unraveling of affairs in his own time: "he saw before him a world so changed as to be beyond connection with the past . . . his life was once more broken into separate pieces."[18] Adams also had on his mind the imminence of a new energy and of chaos. What unsettled him and his generation in 1900 was the sense of an age beginning, defined only by mystery, chance, and tension:

> Man had translated himself into a new universe which had no scale of measurement with the old. . . . Satisfied that the sequence of men led to nothing and that the sequence of their society could lead no further, while the mere sequence of time was artificial, and the sequence of thought was chaos, he turned at last to the sequence of force.[19]

These intimations of collapsing order are the modern marks as well in Peto's culminating years. His concern with the assaults on basic colors and geometries make the squares and rectangles of his office boards a map of his cultural terrain. More than one critic has drawn a comparison between Peto's designs and the abstractions of Piet Mondrian later in the twentieth century. The analogy is one of both form and meaning. We know how Mondrian's early views of the Dutch countryside and seashore systematically evolved through a cubist-influenced period to his mathematical and philosophical compositions of the 1930s onward. In purely formal terms, these works are examinations, like Peto's, of balanced designs on flat planes. But we ought not detach them entirely from Mondrian's native landscape and period of work. Even though he relentlessly pursued the resolution of fundamental relationships—horizontal and vertical, line and plane, the three primary colors and neutral black and white—as a purely aesthetic problem, his painted planes remain distillations of nature. After all, a Dutch artist would retain a deep consciousness of his flat lowlands, punctuated by spires and trees, an orderly countryside subdivided by crossing canals, a compact geography making maximum use of its available surface. For an artist, too, whose native country was being overrun by a foreign army, and whose life outwardly was being disrupted by crisis, it would be natural to find harmony and clarity within the realm of art. When Henry Adams asserted that "Chaos was the law of nature; Order was the dream of man,"[20] he was speaking of a modern world as unsettling for Peto's generation as for Mondrian's.

George Bellows's Boxing Pictures and
the American Tradition

THE ASSERTIVE boxing images of George Bellows (figs. 219 and 220) have long had an interest in their own right as one of the central and recurring themes in his career. They were among his most popular pictures in his lifetime and have remained compelling for audiences to this day. His reputation as an artist perhaps resides most familiarly in this series. Of all his subjects, this best embodies his respective talents as a passionate observer of sports and as a bold recorder of individual human figures. But these works, so much a part of his career and his period, may also be viewed against the broader background of sporting themes treated periodically throughout the earlier history of American art. Bellows at once updates and transforms this tradition with his own forceful personality.

Subjects of sport and games belong within the larger context of the American out-of-doors as a natural setting for vigorous exercise or sociable relaxation. Americans from the beginning thought of their landscape as a benign new world and a predestined place of strength and beauty. Whether engaged in exploration, settlement, self-preservation, or spiritual renewal, Americans felt at home in their geography to the extent that, for much of the nineteenth century at least, nature came largely to define the national identity. Genre themes depicting the commonplace activities of everyday life and the shared experiences of the ordinary citizen did not become popular until the first quarter of the nineteenth century, when leisure time was increasingly available. Before then, the necessities of survival in the colonial world, the all-consuming drama of the Revolutionary War, and the struggles to make a new nation work in the Federal Period focused artists' talents on the practicalities of executing portraits for posterity and recording the features and historic actions of the Republic's founding figures.

A few early genre paintings of importance are known, among the most engaging being *Sea Captains Carousing in Surinam*, painted by John Greenwood around 1758 (St. Louis Art Museum). While related to the colonial wish for recording individual likenesses, this is less a group portrait than a lighthearted caricature of figures indulging themselves in an exotic adventure. Such themes of collective pleasure were rare in the colonial period, and only at the end of the eighteenth century do artists begin to paint them, as well as more specific gaming images, more frequently. Typical are Jeremiah Paul's *Four Children Playing in a Courtyard* (1795; private collection), and the spirited winter panoramas in New York City painted by Francis Guy. His *Tontine Coffee House* (1797; New-York Historical Society) and *Winter Scene in Brooklyn* (c. 1817–1820; fig. 207), depict lively vistas of the busy urban streets and architectural façades of that day. These follow in the tradition of early Flemish painting, particularly the sweeping village views packed with children and peasants done by Pieter Bruegel the Elder in the 1560s. Although Bruegel's themes were primarily religious and allegorical, he did set them in familiar contemporary and local surroundings. Guy's canvases are more typically American in their straightforward delight in recording, with-

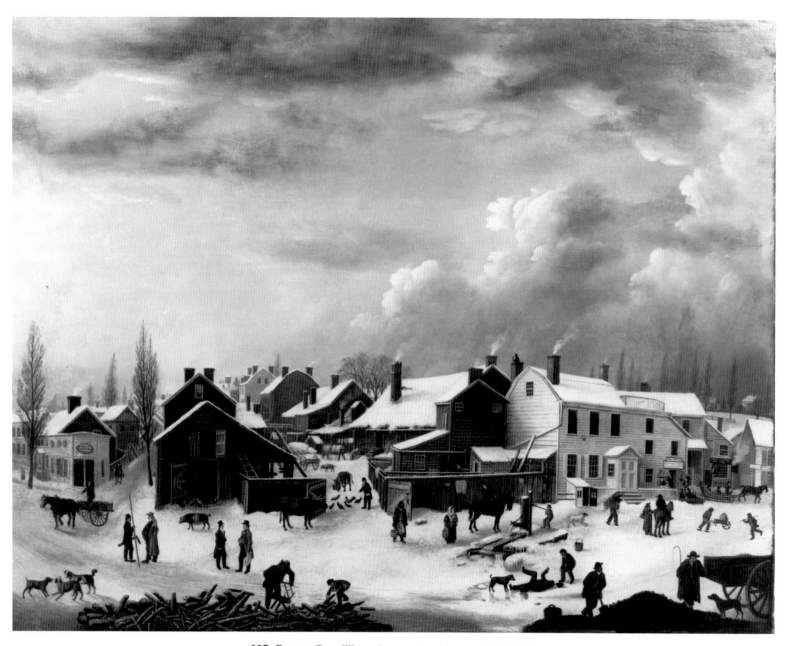

207. Francis Guy, *Winter Scene in Brooklyn*, c. 1817–1820

out any philosophical underpinnings, the daily pursuits of pleasure and industry among the citizenry. These are topographical in delineating not just the growing townscape of the young Republic but also the comfortable and self-possessed presence of people in their environment.

The easygoing accommodation of man and environment finds one of its fullest expressions in the pastoral vignettes that preoccupied many American artists during the middle third of the nineteenth century, as they began to chronicle more aspects of both their natural surroundings and their everyday affairs. Games were but one activity that took place in this benevolent world of rich harvests, agreeable climate, and pleasing geographical features. Henry Inman, a characteristic painter in this period, captures its essential spirit in *Mumble-the-Peg* (1842; fig. 208). The game depicted is more a pleasant pastime than a vigorous sport and is appropriately rendered in bright colors and gentle curves. The concentration on two youths is but a part of the larger American sense of the nation's presence in the morning of life. Not surprisingly, at this same time Thomas Cole's series *The Voyage of Life* (1840–1842; figs. 35–38) was enjoying enormous popularity, with the second picture *Youth* especially inspiring untold numbers of copies by other artists. Thus, the game in this golden age of national promise mirrored an air of optimism and calm reflection.

Competition of another sort, along the coastal waterways and on the open oceans, also provides an index of the period's high spirits. During the 1840s, the design and manufacture of the great clipper ships led to races for the Pacific trade, testing American ingenuity and marrying practicality with remarkable beauty of form. In 1851 the establishment of the America's Cup signified the new challenge of international yacht racing. Thomas Buttersworth, an émigré from England, devoted much of his later career to documenting the dramatic scenes of these graceful vessels maneuvering at sea. Also known as an accomplished marine painter, his contemporary Fitz Hugh Lane painted a particularly colorful canvas of the first challenge, *The Yacht "America" Winning the International Race* (1851; fig. 209). Appropriately, the artist sees the triumph taking place on moderate seas under sunny skies and fair-weather clouds. Lane's delineation is crisp and solid: his composition is orderly and spacious,

filled with a literal and implied radiance that would come to dominate the so-called luminist paintings of his mature career. Though an image of more formalized sports than is Inman's playing children, this canvas too belongs to a moment of exuberant prosperity, when the nation held command of the seas and individuals had the wealth to build and sail pleasure yachts.

Gaming in the imagery of this period was ordinarily a gentlemanly activity, hardly one of combat or violence. Even such sports as fishing and shooting were typically depicted by A. F. Tait and others as merely hearty pursuits of men at ease in their surroundings. One of the games most often treated by American artists at midcentury and perhaps most representative of these sociable avocations was card playing. It was an occasion for both individual contest, as two figures faced each other with a deck of cards, and shared experience, as others gathered around with different degrees of interest. Between about 1840 and 1870 the subject engaged artists as varied as Richard Caton Woodville, William Sidney Mount (fig. 210), Albertus D. O. Browere, Eastman Johnson, John Rogers, Thomas Anshutz, and George Caleb Bingham. The last used a simple pyramidal composition for several related pictures, *The Checker Players* (1850; fig. 117) and *Raftsmen Playing Cards* (1847; St. Louis Art Museum), also known in a smaller version. The simple design, basic primary colors, and solid geometries of his figures contribute to a stable, earthy image of rugged frontiersmen at one with the wilderness setting made placid by the limpid light. Bingham conveys the sense of an orderly world through his balanced forms and equilibrium of men and landscape. The facing cardplayers seem less a confrontation than a union of opposites. The combination of two combatants, surrounding onlookers, and a circumscribed arena sets an appropriate precedent for Bellows's indoor scenes of a half century later.

During the second half of the nineteenth century, boxing subjects begin to interest painters and illustrators. Often these were the work of nonacademic folk artists taking delight in depicting a popular community activity, as is the case with *Bare Knuckles* by George A. Hayes (c. 1870–1885; fig. 211). The carefully patterned rhythms of forms and the even placement of figures attest to the naive painter's heightened instincts for expressive two-dimensional design. In its conscious posing of the boxers, the tiered arrangement of the

208. Henry Inman, *Mumble-the-Peg*, 1842

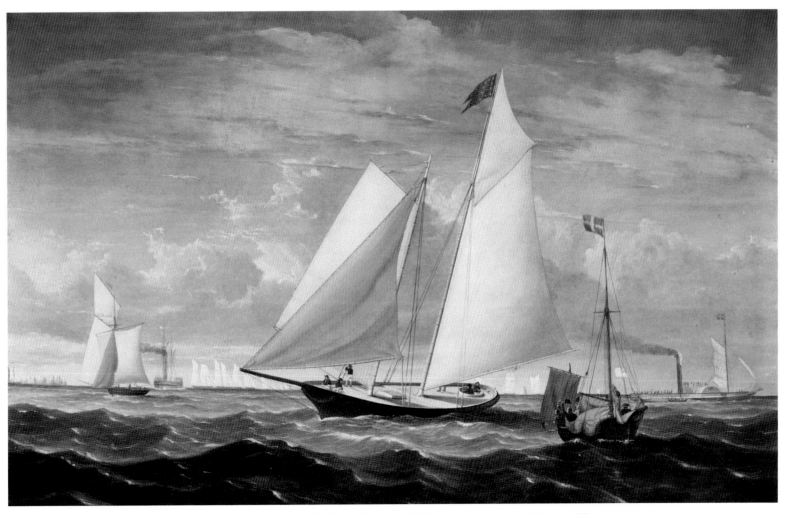

209. Fitz Hugh Lane, *The Yacht "America" Winning the International Race*, 1851

210. William Sidney Mount, *The Card Players*, c. 1845–1850

310

observers, and the outdoor setting above all, this painting belongs more to the classic, timeless spirit of Bingham's pictures than to the intense, dynamic immediacy of Bellows's vision. Yet, the anecdotal character of *Bare Knuckles* and the theme's interest for the untrained artist suggest the broadening popularity of the subject. In this regard, the boxing match as an ordinary genre subject would very much be

an element adopted by the Ashcan School and by Bellows in the early twentieth century.

This kind of generalized narrative image was one that gained broader familiarity through popular illustrations. Undoubtedly one of the most accomplished and widely known firms producing such sporting prints through the later nineteenth century was that of Cur-

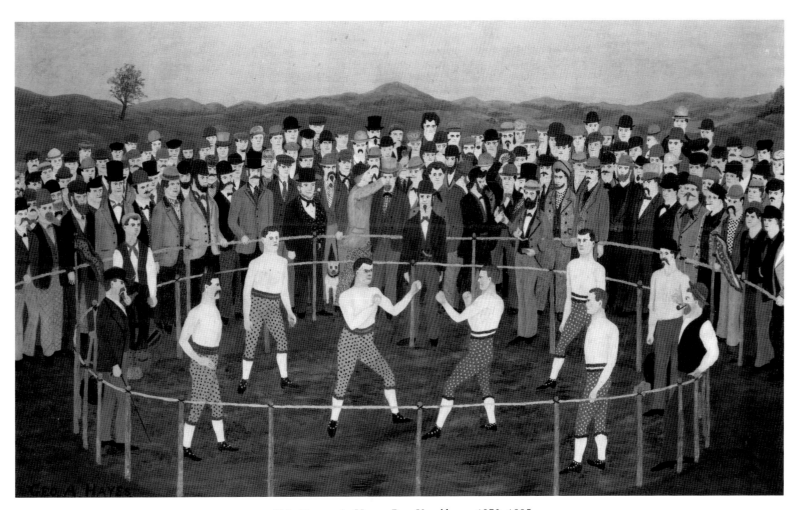

211. George A. Hayes, *Bare Knuckles*, c. 1870–1885

rier & Ives. They issued prints in a full range of categories, including fishing and trapping, hunting, cock fighting, billiard and card playing, rowing, and baseball. Some of these simply illustrated the adventurous spirit of camping and hunting, others the particular details of different competitive sports. Even in other subjects depicted by the firm's artists, one finds a related interest in themes of challenge and adventure, whether the races of sidewheelers on the Mississippi or of locomotives crossing the plains.

Among the other miscellaneous sports that Currier & Ives illustrated less frequently in lithographs was boxing. Paired combatants in a boxing ring appeared in both humorous political caricatures and documentary prints of championship fights. Among the former were a number published in the years after the Civil War, depicting the battle between the states as a contest between the respective forces of good and evil, personified by Lincoln and Jefferson Davis. At the same time, the firm began to issue prints portraying the major boxers of the day in England and America. In two lithographs published side by side on a page, *Tom Sayers, Champion of England* and *John Morressey* assume contrasting poses in outdoor boxing rings, a juxtaposition meant to suggest their pairing rather than the actual meeting. Sayers faces off in another fight of 1860, as seen in an image probably lithographed shortly thereafter, *The Great Fight for the Championship between John C. Heenan and Tom Sayers of England.* Here the two meet in the ring on 17 April 1860, when (in the words of the caption details) "the Battle lasted 2 hours 20 minutes, 42 rounds, when the mob rushed in and ended the fight."

This type of commemorative print experienced relatively wide circulation and ultimately entered the popular consciousness as a commonplace replicated image. The successor to the multiple prints sold by Currier & Ives was the magazine or newspaper illustration, as may be seen in *James J. Corbett and Robert Fitzsimmons*, reproduced in the *Police Gazette* of 15 December 1894. While the setting is no longer explicitly out-of-doors as in previous depictions, it remains vague and generalized, with the figures assuming classic fixed poses. While Bellows would draw on this graphic tradition, especially through his association with Ashcan colleagues who were trained as newspaper illustrators, he would bring to the iconography a new vitality of interpretation, composition, and style.

Instead of the commemorative and ceremonial elements of the subject, Bellows sought to record the dynamics of the moment, the immediacy of action, and the contending physical forces in a densely packed arena. Moreover, Bellows would alter the spectator's view from that of aesthetic observer to that of embroiled participant. These new psychological and physical sensations were in part the result of artistic considerations that came to preoccupy many painters at the turn of the century. To appreciate fully this transformation in American art over the last decades of the nineteenth century, we need to follow the stylistic changes that took place in the major currents of realism. In particular, a summary glance at the work of Winslow Homer and Thomas Eakins will sharpen our perspective on Bellows's place in this tradition.

Possibly more than any other American painter, Homer exemplifies the national fervor for the out-of-doors, youthful leisure, and physical exercise. *Snap the Whip* (1873; fig. 212) is one of the most familiar and appealing works of his early career, rooted in the mood of optimism and well-being we have already noted in Bingham's painting. Homer's own apprenticeship as a graphic artist and emerging career as an observer of domestic life in post–Civil War America grounded his work in the lively genre precedents flourishing at midcentury.

An improvised game among boys on a sunny day is a benevolent activity in a gentle outdoor setting, all befitting the country's sense of identity. But Homer's career carried through the end of the century, and his outlook became graver and more philosophical in later decades, as the nation experienced the new pressures of expansion, regionalism, technological and industrial development, and international relations. Homer's love of the out-of-doors, the experiences of nature in different seasons and weather, and the enjoyment of hunting and fishing trips are directly reflected in all periods of his career.

But there is a marked transition in his attitude about these subjects, especially during the 1880s. From the lighthearted tone and reportorial manner of *Snap the Whip* and such companion works of the 1870s as *Breezing Up (A Fair Wind)* (1876; fig. 136) Homer moved toward an increasing starkness of design and content in his subsequent paintings. *Right and Left* (1909; fig. 147) represents the

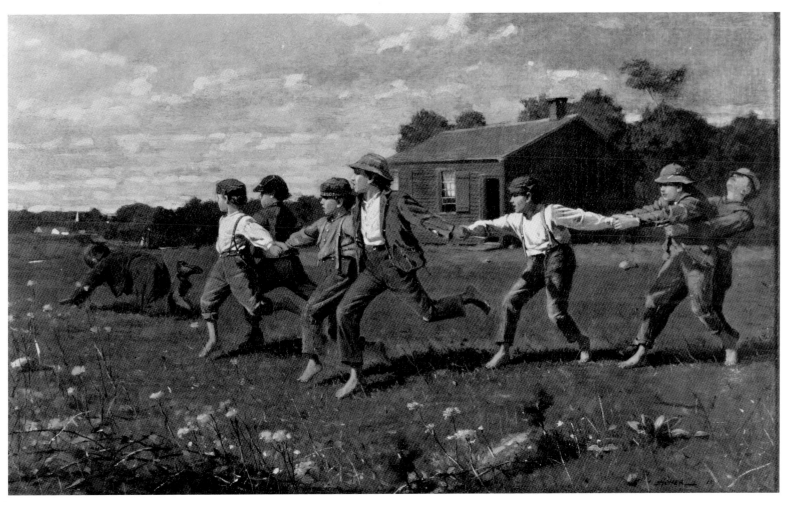

212. Winslow Homer, *Snap the Whip*, 1873

culmination of his career and of the change in his late style. Now Homer's composition is more abstract, his palette more severe, in keeping with the mortal drama forced directly on the viewer. This sporting scene bears a disturbing seriousness of meaning and feeling. As a painting actually of the twentieth century, it gives a hint of the modern world's questions about survival and life in the balance.[1]

Homer's contemporary Thomas Eakins also brought his later art to a comparable level of heroic realism. In contrast to Homer's Yankee restraint and self-imposed seclusion on the Maine coast, Eakins lived most of his life in genteel Philadelphia, trained in its academy and familiar with the beaux-arts traditions of cosmopolitan Europe. But he too loved sports and outdoor exercise, and the rigors of athletics provided Eakins with a consciousness of discipline that infused both his early and his late sporting scenes. In another parallel to Homer, Eakins moved from indoor and outdoor genre scenes of direct factual observation to increasingly contemplative and psychologically charged depictions of the human presence.

Eakins took great pleasure in sailing with friends on the Delaware River, sculling alone on the Schuylkill, and hunting railbirds with his father in the nearby marshes. He commemorated all of these activities under sharp sunlight in several canvases of the 1870s. Typical is *The Biglin Brothers Racing* (c. 1873; fig. 213), in which we see Eakins's training in mathematics, perspective, and anatomy fused to achieve a spatial design of total clarity, order, and integration. Usually Eakins's figures compete less against each other than against the abstractions of time and change. It is a vision unmistakably tempered by ideas of contemporary science, whether the insights of modern medicine or recent developments in still photography. Beyond describing a familiar sporting pleasure, Eakins also addresses relationships in his pictures, that is, the connections of individuals to each other and the place of people in their environment. In a perfect way then, the clear mathematics of his linear constructions complement the coordination, rhythm, and equilibrium that his oarsmen must bring to their pursuit (fig. 214). He shows the organic machinery of the body functioning efficiently both within itself and in relation to the surrounding physics of nature.

Although Eakins's rowing paintings suggest a more scientific realism than we have seen in Homer, *The Biglin Brothers Racing* stands

firmly in the existing American traditions of lively genre and plein-air landscape subjects. When Eakins took up athletic themes again at the end of his career, he had shifted his attention indoors. Around the turn of the century, he completed a series of major boxing pictures, which are the precedents most frequently cited for Bellows's examples a decade later. Though there are smaller related oil studies, three large canvases form a trilogy devoted to the prowess, exertion, and vitality necessary for the sport. *Salutat* (1898; fig. 215) is the most classical and traditional in its allusions, with the victorious boxer acknowledging his triumph as he leaves the ring. His poised stance in the arena recalls that of a Roman gladiator, while his fine physique is indebted to life studies of anatomy from the drawing classes taught by Eakins's French master Jean Léon Gérôme. The cheering spectators are more involved observers than those rendered in previous boxing scenes and look forward to Bellows's animated audiences. Yet Eakins always remains the scrutinizing portraitist,[2] and, along with the subtle differences in physiognomy, he seeks to record the range of human responses, just as he had in his great medical arena paintings. Bellows might occasionally give a clue to identify a specific figure at ringside, but usually he preferred to generalize his audience as a turbulent enveloping mass.

The most important fact about Eakins's series is that it shows almost no action. For him the boxing arena is a place for complex human interactions, as much psychological as physical. To this end in both *Taking the Count* (1898; fig. 172) and *Between Rounds* (1899; fig. 216) large colorful banners of circus stars hang from the balconies in the background; they are artificial images of performers contrasting with the boxers actually before us. The referee, attendants, and crowds behind bring other degrees of engagement to the match, each with his own imperatives of concern and response. As both titles confirm, the moments shown are those between the bursts of action, not the apex of the action itself. In one a boxer knocked down awaits a mandatory count, while in the other a fighter rests in his corner. We sense that each is thinking about going back into combat, but for now we join the pictorial viewers across the ring in marking time's passage. Below both platforms are men keeping track of the two different intervals, each a rest period of fixed duration. In part Eakins is examining sequential aspects in the ceremony of this

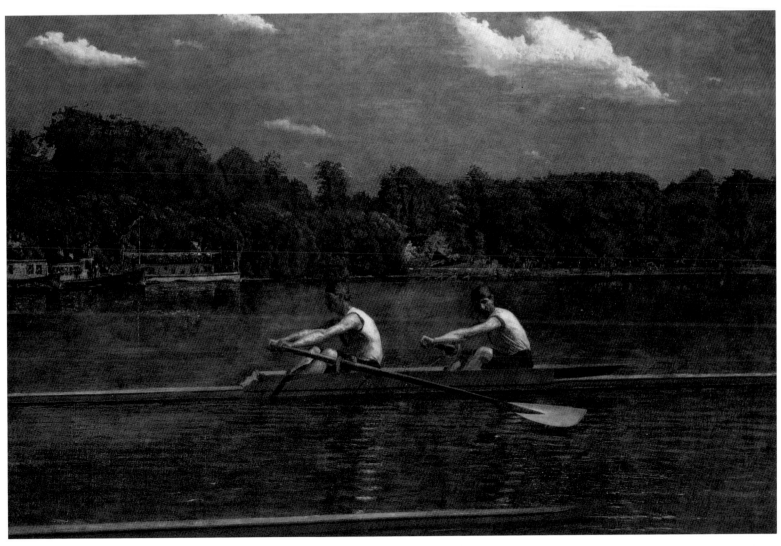

213. Thomas Eakins, *The Biglin Brothers Racing*, c. 1873

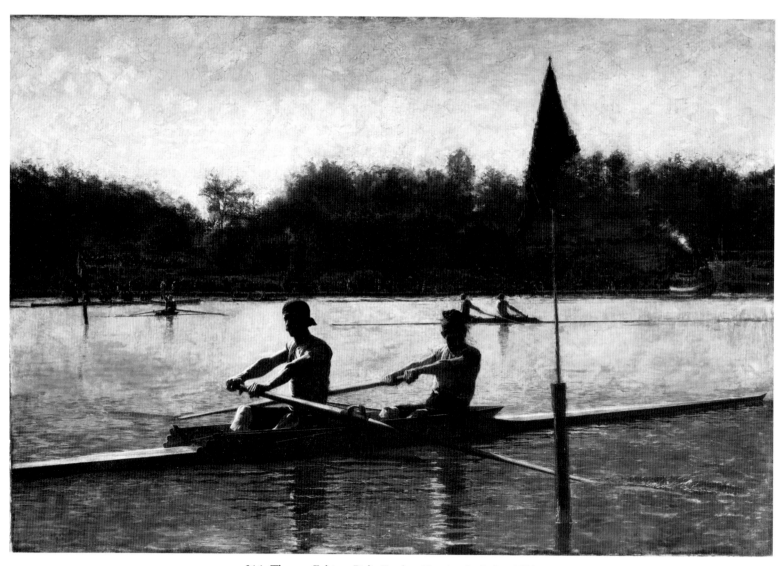

214. Thomas Eakins, *Biglin Brothers Turning the Stake*, 1873

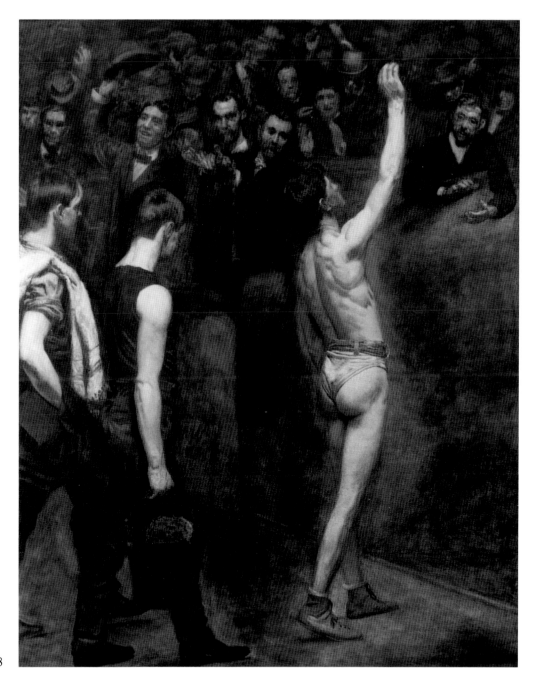

215. Thomas Eakins, *Salutat*, 1898

317

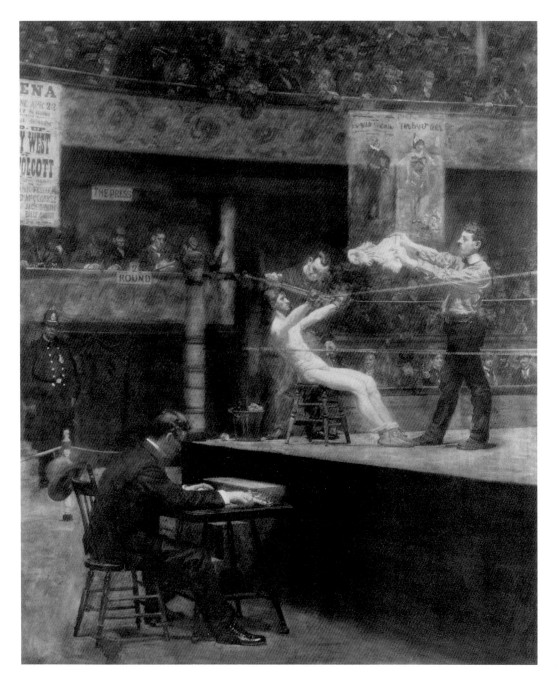

216. Thomas Eakins,
Between Rounds, 1899

318

sport, the marshaling of one's energy and thoughts as one contemplates victory or defeat. His sense of drama and his vigorous realism in the powerful rendering of human form set the stage for Bellows's efforts. But the younger artist will crucially replace this cerebral tension with a physical energy that he and his colleagues enthusiastically believed was at the heart of the new century.

As we have seen in his rowing paintings, Eakins did have some interest in depicting figures in motion, and this concern reappeared in occasional later works such as *The Swimming Hole* (1883; Amon Carter Museum, Fort Worth). During this period, he had begun to correspond with Eadweard Muybridge about the latter's experiments with motion photography. Eakins himself actively made use of the camera in his later career, photographing the human figure, as did Muybridge, in sequential stages of certain motions or activities. When in his paintings he adapted the poses he had caught with the camera, the figure seemed isolated in a stilled and clarified moment. Eakins's attention to psychological presence led him to pursue photography largely as a means for portraiture. By contrast, Muybridge undertook the massive compilation of serial action photographs of humans and animals that he published beginning in 1887 under the title *Animal Locomotion*. Plate 336 shows *Men Boxing, Open Hand*, and here we come much closer to Bellows and modern ideas of spontaneous dramatic action. In this regard, the camera's ability to freeze an unexpected moment, an awkward or unposed gesture, reveals a strain and excitement that Bellows would similarly seek to capture in paint.

Bellows's work then comes at the confluence of several elements in earlier American art: the inherent love of narrative in the genre tradition, the Eakins style of direct recording and strong realism, the broad impact of popular illustration, and the sense of immediacy made possible by photography. But Bellows's subjects and manner of handling paint also reflect the collective aspirations of his own generation. His thick impastos, expressive contrasts of light and dark, close-in viewpoints, and involvement of the spectator are all aspects of his friends' work and occasioned the collective title of Ashcan School. Flourishing in New York in the first decade of the twentieth century, this group consciously chose as their modern landscape not the countryside but the back streets and lower-class gathering places

of the city. The bright delicate scenes of the impressionists and The Ten were too nostalgic and pretty for these younger painters: only in the city of growing skyscrapers, throngs of immigrants, and densely packed streets were to be found the new energies of the day.

Some of the older painters whom Bellows joined under the Ashcan rubric were already members of The Eight, a loose association of friends who practiced very different styles of art but who were commonly devoted to asserting new subjects and styles for their generation. Under the leadership of Arthur B. Davies, they organized the notorious Armory Show of 1913, a turning point in breaching entrenched aesthetic conservatism in America. During this period, several artists turned to confront the implications of avant-garde abstraction; others were given the Ashcan label for promoting their commonplace urban subjects and manner of bold realism. Bellows did not formally participate in the causes of The Eight, being almost a generation younger than its leaders (he was born in 1882). Robert Henri, the foremost teacher of his time, was born in 1865. Henri was a charismatic personality and instructor. When Bellows arrived in New York from Columbus, Ohio, in 1904, the older man befriended him and drew Bellows into this artistic circle.

Henri himself had been enrolled at the Pennsylvania Academy and had studied with Thomas Anshutz, Eakins's most able student and assistant. After a period of experimentation with impressionism, at the end of the 1890s Henri returned to a style of dark tonalities and broad handling. Inspiration for this manner came from the seventeenth-century masters Diego Velázquez and Frans Hals and the mid-nineteenth-century precedents of Edouard Manet. Also, at the turn of the century, Henri met and received support from William Merritt Chase, who had himself studied in Munich during the early 1870s. There Chase had had his own exposure to Hals and Velázquez as their work was revived in the modern styles of Gustave Courbet and the German Wilhelm Leibl. Although Chase later went on to evolve a more impressionistic mode of painting, he did reinforce Henri's turn to a tonal bravura. After 1900 Henri taught in Chase's New York School of Art and thus became an important artistic link in the tradition of dark realism inherited from the seventeenth century, reinterpreted by the nineteenth, and transmitted to the work of the young painters of the early twentieth.

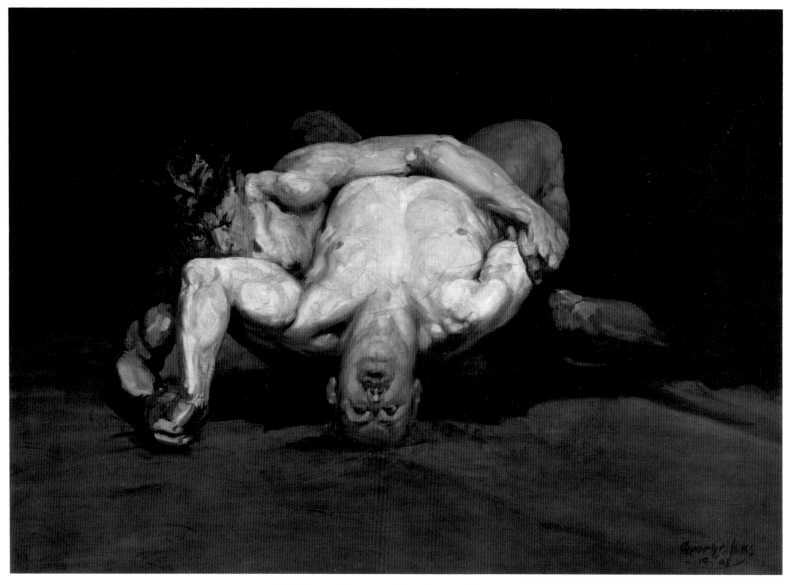

217. George Benjamin Luks, *The Wrestlers*, 1905

320

The other colleagues who joined Henri in New York—George Luks, John Sloan, William Glackens, and Everett Shinn—had begun their careers as newspaper artists in Philadelphia, dashing off on-the-spot drawings of people and activities seen firsthand in the streets around town. Thus, the joined lineage of realism and reportage descended directly into Bellows's immediate circle of associates. Some became known for portraits of humble workers, immigrants, and orphans; others for depictions of life in the city parks, cafés, and waterfront docks. In just a sampling of their subjects, we can see those themes that became a shared language for the group, including Bellows. George Luks's *The Wrestlers* (1905; fig. 217) presents the imagery of a vigorous masculine world and a sport of strenuous physical combat. It is a precedent particularly striking in relation to Bellows's boxing pictures, which follow a couple of years later. Our view is almost at ground level and close to the two men locked together in maximum tension. Luks's paint strokes are broad and energetic; his figures are spotlighted in a rugged silhouette within the surrounding dense black.

When these men were not visiting athletic clubs for subjects, they sought similar entertainment in cafés, nightclubs, and circus arenas. From the same period date Shinn's *Theater Box* (1906; Albright-Knox Art Gallery, Buffalo) and Glackens's *Hammerstein's Roof Garden* (c. 1903; fig. 218). Simultaneously Stanford White was designing perhaps the city's most famous palace of pleasure, the original Madison Square Garden. The packed crowds, front-row view, artificial lighting, and excitement of performance were basic ingredients of such Ashcan pictures, whether the audience was upper crust or working class. The cropped or odd angle of vision, blurring of forms, and vigorous execution only enhanced a sense of immediacy and of the physical interaction between spectators and performers.

Studying with Henri and aligning himself with the social concerns of Luks and Sloan, Bellows naturally adopted themes of the masses at work and play. He too loved the filled arena and the press of bodies. He had come from the midwest and later spent vacations on Monhegan Island, Maine, and in upstate Woodstock, New York, and thus always derived pleasure from the rugged natural landscape. To the end of his career, he concurrently painted indoor and outdoor scenes, often with strikingly similar modes of composition. How-

ever, alone among his colleagues, he had been a professional athlete and had loved sports from early youth. He played basketball and baseball first in high school and then at Ohio State. During his upperclass years, he played on a semiprofessional baseball team, earning the nickname "Phenomenon of Ohio State" and meriting an invitation to join the Cincinnati Reds. His love of sketching began equally early, and by the time he decided to foresake the confines of home for New York, he was able, in recording events, to enjoy the roles of both observer and participant.

His two sets of boxing pictures (figs. 219 and 220) serve as brackets around his mature career, and in examining briefly other scenes preoccupying him during the 1910s and 1920s, we come to note how consistently he approached a diversity of subjects. Indeed, despite the singular force and unity of the boxing suite, seeing it in context makes us realize how much Bellows enjoyed the spatial expanse of the arena, using this device as well for many of his landscapes, whether set under natural or artificial light. The spirit of entertainment, the physical exuberance, and the emotional fusing of a crowd found in the boxing pictures are also apparent in Bellows's paintings of political and recreational gatherings like *The Sawdust Trail* (1916; Milwaukee Art Museum), and *Riverfront No. 1* (1915; Columbus Museum of Art). In the first, we stand at eye level with the platform, while in the second, strong diagonals and tonal contrasts animate the riverside enclave.

Of course, not all his works are composed in this way, though Bellows did employ the device of contesting figures within a defined enclosure with striking consistency. As might be expected, he undertook paintings of several sporting subjects, including fishing, polo, and tennis. These were more genteel than the gritty activities he witnessed in the boxing clubs of New York, but he brought to them all a similar focused energy, spotlit drama, and broad brushwork. Consider *Polo at Lakewood* (1910) or *Tennis Tournament* (figs. 221 and 222), painted ten years later: though given relatively spacious settings under turbulent skies, they show the different sportsmen at straining intensity, confined within the marked edges, respectively, of the polo field and tennis court. These rectangles of landscape, circumscribed by patterns of lines and the forms of spectators, readily translate into the platform and ropes of Bellows's box-

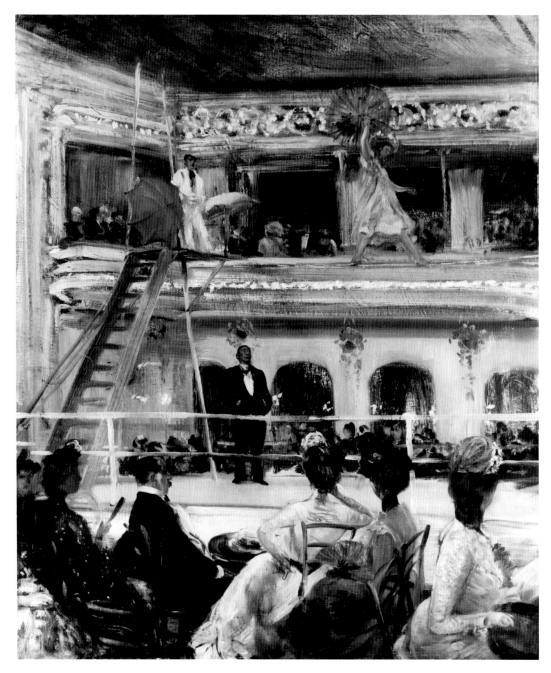

218. William J. Glackens, *Hammerstein's
Roof Garden*, c. 1903

322

219. George Wesley Bellows, *Both Members of This Club*, 1909 (Color Plate 27)

ing rings, which acquire traditional visual force through the dark compression of their indoor nighttime settings.

Thus, it appears that Bellows's boxing paintings combine to maximum effect his pictorial methods, at once drawing on an approach to composition that he often used elsewhere and contributing something of their stylistic force to many of his other subjects. Even in pictures with little or no human presence and no relation to sports, we can see how concerned Bellows remains with composing and handling paint for powerful expressive purposes. Significantly, in 1909, the same year in which he completed one of his first great boxing canvases, *Both Members of This Club*, he painted *Blue Morn-*

ing (figs. 219 and 223). Contrasts of light and shadow, foreground lines and background masses again set off a pyramid of straining figures at the center. In its bold gestures of paint, suggestion of observers and laborers, and above all lines of fence and iron structure, we observe another urban arena of dynamic activity.

A few years later, after his first summers on Monhegan Island, Bellows began to produce a number of small oil studies of surf crashing on the rocky cliffs. Not since the monumental late seascapes of Winslow Homer in the previous two decades had an American artist attained such expressive capacity with the manipulation and texture of paint. Small panels like *Churn and Break* (1913; fig. 224) have all

220. George Wesley Bellows, *Club Night*, 1907

324

221. George Wesley Bellows, *Polo at Lakewood*, 1910

222. George Wesley Bellows, *Tennis Tournament*, 1920

326

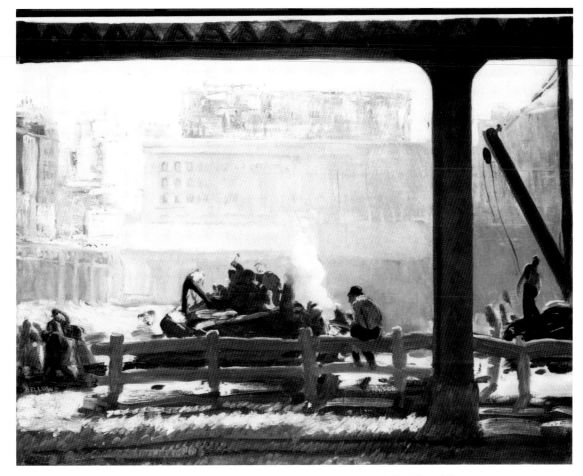

223. George Wesley Bellows, *Blue Morning*, 1909 (Color Plate 28)

the freshness and immediacy of on-the-spot observation, yet they are by no means records of confused spontaneity. These generalized forms struggle toward an effective composition, as we recognize Bellows's penchant for contrasting verticals, horizontals, and diagonals. As in his boxing rings, contesting forces strike one another, here water against rock, light and liquid against dark and solid. Even the turbulent foreground serves as a palpable platform for the viewer as implied witness of the ferocious battle at center stage. Most of all,

corporeal paint conveys a spirit of the here and now, which is Bellows's special accomplishment. For as we turn back to concentrate on the boxing paintings themselves, we are soon aware of his ability to use paint to record both what he saw and what he felt. With all his best works—and the boxing group may be posed as a summary achievement—the literal paint describes fact, in a conventional sense, at the same time that it carries subjective energies, in a much more modern sense.

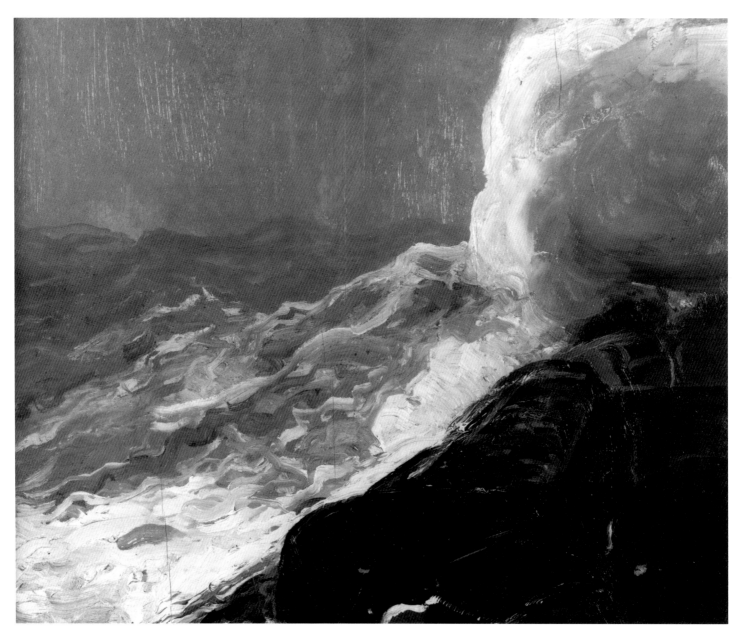

224. George Wesley Bellows, *Churn and Break*, 1913

328

Acknowledgments

These essays first appeared in the following publications (titles are not given unless they were different when the pieces were originally published). They have in some cases been reprinted with minor editorial modifications.

1. "The Lure of Mount Desert and the Maine Coast." *Paintings by Fitz Hugh Lane* (exhibition catalogue, National Gallery of Art). Washington, D.C., 1988, 72–93. Courtesy of the Trustees of the National Gallery of Art.
2. *Record of The Art Museum, Princeton University* 49, no. 1 (1990): 3–23.
3. "Homer's Maine." *Winslow Homer in the 1890s: Prout's Neck Observed* (exhibition catalogue, Memorial Art Gallery of the University of Rochester). Rochester, N.Y., 1990, 86–96.
4. *The Waters of America: Nineteenth-Century American Paintings of Rivers, Lakes, and Waterfalls* (exhibition catalogue, The Historic New Orleans Collection and New Orleans Museum of Art). New Orleans, 1984, 3–8.
5. "The Luminist Movement: Some Reflections." *American Light: The Luminist Movement, 1850–1875, Paintings, Drawings, Photographs* (exhibition catalogue, National Gallery of Art). Washington, D.C., 1980, 97–102. Courtesy of the Trustees of the National Gallery of Art.
6. *The Eden of America: Rhode Island Landscapes, 1820–1920* (exhibition catalogue, Museum of Art, Rhode Island School of Design). Providence, 1986, 11–15.
7. *William Bradford, Artist of the Arctic* (exhibition catalogue, DeCordova Museum and The Whaling Museum). Lincoln and New Bedford, Mass., 1968.
8. *The Natural Paradise: Painting in America, 1800–1950* (exhibition catalogue, Museum of Modern Art). New York, 1976, 38–57.
9. "America's Young Masters: Raphaelle, Rembrandt, and Rubens." *Raphaelle Peale's Still Lifes* (exhibition catalogue, National Gallery of Art). Washington, D.C., 1988, 72–93. Courtesy of the Trustees of the National Gallery of Art.
10. *Old Time New England* 60, no. 3 (Winter 1970): 86–93. "Robert Salmon's 'Boston Harbor from Castle Island.' " *Arts in Virginia*, 14, no. 2 (Winter 1974): 14–27.
11. "Bingham's Geometries and the Shape of America." *George Caleb Bingham* (exhibition catalogue, St. Louis Art Museum). St. Louis, 1990, 175–81, 188.
12. *Winslow Homer in the 1870s: Selections from the Valentine-Pulsifer Collection* (exhibition catalogue, The Art Museum, Princeton University). Princeton, N.J., 1990, 13–17.
13. *Essays in Honor of Paul Mellon, Collector and Benefactor*. Washington, D.C., 1986, 389–401. Courtesy of the Trustees of the National Gallery of Art.
14. *Studies in The History of Art*, vol. 9 (National Gallery of Art). Washington, D.C., 1980, 59–85. Courtesy of the Trustees of the National Gallery of Art.
15. *Arts Magazine* 53, no. 9 (May 1979): 108–12. "*Portrait of John N. Fort* by Thomas Eakins." *Studies in the History of Art*, vol. 1 (Williams College Museum of Art). Williamstown, Mass., 1978, 2–16.
16. Foreword to *The Work of Augustus Saint-Gaudens* by John H. Dryfhout. Hanover, N.H., and London, 1982, ix-xii.
17. *Important Information Inside: The Art of John F. Peto and the Idea of Still-Life Painting in Nineteenth-Century America* (exhibition catalogue, National Gallery of Art). Washington, D.C., 1983,

37–55. Courtesy of the Trustees of the National Gallery of Art.

18. "Images of Lincoln in Peto's Late Paintings." *Archives of American Art Journal*, 22, no. 2 (1982), 2–12.

19. "Bellows' Boxing Pictures and the American Tradition." *Bellows: The Boxing Pictures* (exhibition catalogue, National Gallery of Art). Washington, D.C., 1982. Courtesy of the Trustees of the National Gallery of Art.

For assistance in the preparation and publication of this volume, grateful thanks also go to Lynda Emery, Elizabeth Powers, and the Spears Fund of the Department of Art and Archeology, Princeton University.

Notes

Chapter 1

1. Useful summaries of the geological history of the Mount Desert Island area are to be found in Russell D. Butcher, *Field Guide to Acadia National Park, Maine* (New York, 1977), "Rocks and Landforms," 28–37; and Carleton A. Chapman, *The Geology of Acadia National Park* (Hulls Cove, Maine, 1962), "The Geologic Story of Mount Desert Island," 11–32.

2. See Butcher, *Field Guide*, 29; and Chapman, *Geology of Acadia National Park*, 28.

3. See Butcher, *Field Guide*, 34; and Chapman, *Geology of Acadia National Park*, 29.

4. *Northeast Harbor, Reminiscences, by an Old Summer Resident* (Hallowell, Maine, 1930), 12.

5. Morison, *Mount Desert Island*, 7.

6. See Samuel Eliot Morison, *Samuel de Champlain: Father of New France* (Boston, 1972), 27–46. This biography is a full and sympathetic account of Champlain's life and achievements, and provides the basis for the précis of his encounter with Mount Desert related here.

7. Quoted in Samuel Adams Drake, *Nooks and Corners of the New England Coast* (New York, 1875), 29. A slightly different free translation appears in Morison, *Mount Desert Island*, 9. A facsimile of the relevant pages from Champlain's original published narrative is included in Charles Savage, *Mount Desert: The Early French Visits* (Northeast Harbor, Maine, 1973), 6–7.

8. Morison, *Champlain*, 46.

9. Ibid., 233.

10. Quoted ibid., 54–55.

11. Quoted in George E. Street, *Mount Desert: A History* (new ed., Boston, 1926), 108–9.

12. Quoted ibid., 110.

13. Henry David Thoreau, *The Maine Woods* (Apollo ed., New York, 1961), 111. Subsequent references are to pages in this edition.

14. Drake, *Nooks and Corners*, 30. See also Morison, *Mount Desert Island*, 61; and *Northeast Harbor, Reminiscences*, 45. The *Ulysses* sank in 1878, and all sidewheelers were replaced by the *Mount Desert* until 1894, when the larger *J. T. Morse* covered the route to Mount Desert. During the later nineteenth century, steamers operated by the Maine Central Railroad connected with train service to Hancock Point at the head of Frenchman's Bay. Local steamers operated between Bangor, Bar Harbor, and most of the villages around the coast of the island. See Morison, *Mount Desert Island*, 63. In the first quarter of the twentieth century, ferry service operated from Trenton on the mainland, taking those who had arrived in Ellsworth by train, until a causeway was constructed across the narrows with the advent of the automobile.

15. See Street, *Mount Desert*, 295–96. Tracy's manuscript is now in the Morgan Library, New York.

16. Quoted ibid., 271.

17. See Wally Welch, *The Lighthouses of Maine* (Orlando, Fla., 1985), 8–45.

18. See ibid., 49–59. Morison noted the construction of a lighthouse on Mount Desert Rock as early as 1830, and the subsequent erection of the East Bunkers Ledge daymarker, but believed that there were no other aids to navigation in the area before the Civil War. See Morison, *Mount Desert Island*, 38, 47.

19. See Welch, *Lighthouses*, 64.

20. See Morison, *Mount Desert Island*, 33.

21. See Street, *Mount Desert*, 281, 296.

22. Drake, *Nooks and Corners*, 49.

23. See Morison, *Mount Desert Island*, 45.

24. Street, *Mount Desert*, 296.

25. See Drake, *Nooks and Corners*, 42; and Butcher, *Field Guide*, 13.

26. Quoted in Street, *Mount Desert*, 32.

27. See Drake, *Nooks and Corners*, 48; and Lloyd Goodrich, *Thomas Eakins*, 2 vols. (Cambridge, Mass., and Washington, D.C., 1982), 2:137. John Singer Sargent also visited the area in 1921–22, and painted a portrait of his artist friend, Dwight Blaney, sketching deep in the woods on Ironbound Island in upper Frenchman's Bay. He also did an oil, *On the Verandah* (1921; collection of Mr. and Mrs. David Blaney), showing the Blaney family on the porch of their summer home on Ironbound. But both of these are essentially portraits, with neither really concerned with any of the panoramic vista of Mount Desert nearby. See Gertrud A. Mellon and Elizabeth F. Wilder, eds., *Maine and Its Role in American Art 1740–1963* (New York, 1963), 108–9.

In addition, a few prominent photographers have produced a body of images in the Mount Desert region, for example, Seneca Ray Stoddard and Henry L. Rand at the end of the nineteenth century, and George A. Tice in the early 1970s. See John Wilmerding, ed., *American Light: The Luminist Movement, 1850–1875, Paintings, Drawings, Photographs* [exh. cat., National Gallery of Art] (repr., Princeton, N.J., 1989), 138–45; and Martin Dibner, *Seacoast Maine: People and Places* (New York, 1973), 2, 8, 82, 122, 126, 128, 156, 178, 199, 202, and 206. Also in the late 1960s, Walker Evans visited the painter John Heliker and photographed his kitchen, but no landscape, on Great Cranberry Island, off the Mount Desert coast.

Chapter 2

1. Thomas Cole, "Essay on American Scenery," *The New England Monthly Magazine*, n.s., 1 (January 1836): 1–12 [delivered in 1835]; quoted in John W. McCoubrey, ed., *American Art, 1700–1960: Sources and Documents* (Englewood Cliffs, N.J., 1965), 101–2.

2. Ibid., 103.

3. Ibid., 105.

4. Louis Legrand Noble, *The Life and Works of Thomas Cole*, ed. Elliot S. Vesell (Cambridge, Mass., 1964), 270.

5. Ibid., 270–71.

6. The Art Museum, Princeton University, gift of Frank J. Mather (1940), acquired from Thomas Cole's granddaughter, Mrs. Florence H. Cole-Vincent. For a discussion of the sketchbook, see Louis Hawes, "A Sketchbook by Thomas Cole," *Record of the Art Museum, Princeton University* 15, no. 1 (1956): 2–23. In the most recent comprehensive monograph on Cole by Ellwood Parry, no mention of this sketchbook or its drawings is made, and only passing commentary is given to the Maine trip. See Ellwood C. Parry, III, *The Art of Thomas Cole: Ambition and Imagination* (Newark, Del., 1988), 304–8.

7. See the discussion of this theme in Cole's art by Charles C. Eldredge, "*Torre dei Schiavi*: Monument and Metaphor," *Smithsonian Studies in American Art* 1, no. 2 (Fall 1987): 14–33.

8. See Howard S. Merritt, *Thomas Cole* [exh. cat., Memorial Art Gallery of the University of Rochester] (Rochester, N.Y., 1969), nos. 23, 30, 33, 34, 48, and 50.

9. Samuel Eliot Morison, *The Story of Mount Desert Island* (Boston, 1960), 38.

10. For the original names of Mount Desert's mountains, their sources, and current nomenclature see ibid., 75–76.

11. Noble, *Life and Works of Thomas Cole*, 270.

12. See Morison, *The Story of Mount Desert Island*, 44.

13. McCoubrey, *American Art*, 109.

14. Probably Henry C. Watson, review of the "Twentieth Annual Exhibition of the Academy of National Design [*sic*]," *The Broadway Journal* (3 May 1845); quoted in Parry, *The Art of Thomas Cole*, 308.

15. Parry, *The Art of Thomas Cole*, 304.

16. Ibid., 305.

17. Quoted in Hawes, "A Sketchbook by Thomas Cole," 8.

18. J. L. Stevens, Jr., in the *Gloucester Daily Telegraph*, 11 September 1850; quoted in John Wilmerding, *Fitz Hugh Lane* (New York, 1971), 54.

Chapter 3

1. For a fuller discussion of this subject, see John Wilmerding, "The Lure of Mount Desert and the Maine Coast," in *Paintings by Fitz Hugh Lane* (Washington, D.C., 1988), 106–27; "Benson and Maine," in *Frank W. Benson: The Impressionist Years* [exh. cat., Spanierman Gallery] (New York, 1988), 10–15; and chapter 1 in this volume.

2. The details are fully given in Philip C. Beam, *Winslow Homer at Prout's Neck* (Boston, 1966).

3. Beam suggests that the pure landscapes were painted in the autumn after the departure of the summer visitors (ibid., 93).

4. See ibid., 30–31 and 88–89.

5. Among the most notable are *Mink Pond* (1891; Harvard University Art Museums), *Hunter in the Adirondacks* (1892; Harvard University Art Museums), *The Adirondack Guide* (1894; Museum of Fine Arts, Boston), *Rum Cay* (1898–1899; Worcester Art Museum), and *The Turtle Pound* (1898; Brooklyn Museum). See Helen A. Cooper, *Winslow Homer Watercolors* (Washington, D.C., 1986), 162–217.

6. See ibid., 168, 176; also Nicolai Cikovsky, Jr., "Homer Around 1900," in *Studies in the History of Art* 26 (1989): 133–54; and Beam, *Winslow Homer at Prout's Neck*, 92.

7. For example, *Woods at Prout's Neck* (1887; private collection) and *Among the Vegetables* (*Boy in a Cornfield*) (1887; Murjani Collection). Cooper, *Winslow Homer Watercolors*, 158–59.

8. For additional discussion of this group, see John Wilmerding, *Winslow Homer* (New York, 1972), 141, 167; and Beam, *Winslow Homer at Prout's Neck*, 61–62, 92, 125.

9. A fuller analysis of this theme is given in "Winslow Homer's *Right and Left*," chapter 14 in this volume.

10. Cooper, *Winslow Homer Watercolors*, 200–1; and Beam, *Winslow Homer at Prout's Neck*, 104–5, 118, 126–30.

11. See Gordon Hendricks, *The Life and Work of Winslow Homer* (New York, 1979), 227–35.

12. Beam, *Winslow Homer at Prout's Neck*, 110; and Cooper, *Winslow Homer Watercolors*, 161.

13. See chapter 14.

14. See especially Henry Adams, "Mortal Themes: Winslow Homer," *Art in America* 71, no. 2 (1983): 112–26; and Thomas B. Hess, "Come Back to the Raft Ag'in, Winslow Homer Honey," *New York* (11 June 1973): 75–76.

15. Cikovsky, "Homer Around 1900"; and Adams, "Mortal Themes."

16. Beam, *Winslow Homer at Prout's Neck*, 114–16; and Cikovsky, "Homer Around 1900."

17. See Albert Boime, "Blacks in Shark-Infested Waters: Visual Encodings of Racism in Copley and Homer," *Smithsonian Studies in American Art* 3, no. 1 (Winter 1989): 18–47.

18. For example, see those reproduced in Hendricks, *Life and Work of Winslow Homer*, 170–73; and Beam, *Winslow Homer at Prout's Neck*, 122–23.

19. See Beam, *Winslow Homer at Prout's Neck*, 143–45; and chapter 14.

Chapter 4

1. Thomas Cole, "Essay on American Scenery," *The New England Monthly Magazine*, n.s., 1 (January 1836): 1–12 [delivered in 1835]; quoted in John W. McCoubrey, ed., *American Art, 1700–1960: Sources and Documents* (Englewood Cliffs, N.J., 1965), 103.

2. See John Seelye, *Prophetic Waters: The River in Early American Life and Literature* (New York, 1977), 84, 89.

3. See ibid., 11.

4. Ibid., 7.

5. See ibid., 79.

6. Quoted ibid., 207.

7. Cole, "Essay on American Scenery," 100.

8. Ibid., 104, 105.

9. Ibid., 105, 106.

10. Ibid., 106.

11. Quoted in Louis Legrand Noble, *The Life and Works of Thomas Cole*, ed. Elliott S. Vesell (Cambridge, Mass., 1964), 214, 215.

12. Ibid., 216.

13. Cole, "Essay on American Scenery," 106.

14. Ibid., 105.

15. Ibid., 103.

16. Fitz Hugh Ludlow, *The Heart of the Continent: A Record of Travel Across the Plains and in Oregon* (Cambridge, Mass., 1870); quoted in Richard Shafer Trump, "Life and Works of Albert Bierstadt" (unpublished Ph.D. dissertation, The Ohio State University, 1963), 112.

17. Ibid., 118.

Chapter 5

1. Henry David Thoreau, *Thoreau: The Major Essays*, ed. Jeffrey L. Duncan (New York, 1972), 205.

2. F. O. Matthiessen, *American Renaissance: Art and Expression in the Age of Emerson and Whitman* (London and New York, 1941), 659; see also chapter 11 in this volume.

3. Ralph Waldo Emerson, "Historic Notes of Life and Letters in New England," quoted in Matthiessen, *American Renaissance*, 6.

4. Matthiessen, *American Renaissance*, 243, 275, 281, 351.

5. Nathaniel Hawthorne, *The Scarlet Letter*, quoted in Matthiessen, *American Renaissance*, 262; see also 273–74.

6. Matthiessen, *American Renaissance*, 355; see also 255.

7. Emerson, "Nature," in *The Complete Essays and Other Writings of Ralph Waldo Emerson* (Modern Library ed., New York, 1950), 6.

8. Matthiessen, *American Renaissance*, 29; see also 15–17.

9. Ibid., 31, 40, 47, 68.

10. Ibid., 51, 62; and Emerson, *Complete Essays*, 5–7, 10, 20, 47, 413.

11. Quoted in Matthiessen, *American Renaissance*, 95; see also 88, 91–92.

12. Thoreau, *Major Essays*, 26.

13. Henry David Thoreau, *A Writer's Journal*, ed. Laurence Stapleton (New York, 1960), 38.

14. Thoreau, *Journal*, 103.

15. Herman Melville, *Moby-Dick; or, The Whale* (Modern Library ed., New York, 1950), 2.

16. Ibid., 166. See also Matthiessen, *American Renaissance*, 286–89, 408.

17. Walt Whitman, *Leaves of Grass* (Mentor ed., New York, 1954), 255. See also "Thou Orb Aloft Full-Dazzling," 355, and "Song at Sunset," 377.

18. Ibid., 400.

19. Matthiessen, *American Renaissance*, 517, 565, 599, 652.

20. Quoted in John I. H. Baur, "American Luminism: A Neglected Aspect of the Realist Movement in Nineteenth-Century American Painting," *Perspectives USA* 8 (Autumn 1954): 93.

Chapter 6

1. Henry James, "The Sense of Newport," in *The American Scene* (Bloomington, Ind., and London, 1968), 209–25.

2. Ibid., 210, 212.

3. Ibid., 214–15.

4. Thornton Wilder, *Theophilus North* (New York, 1973), 14–16.

5. John Updike, *The Witches of Eastwick* (New York, 1984), 9.

6. James, "The Sense of Newport," 210.

7. Ibid., 215–16.

8. *The Notebook of John Smibert* (Boston, 1969), 3.

9. Jedidiah Morse, *The American Geography; or, A View of the Present Situation of the United States of America* (Elizabethtown, N.J., 1789), n.p.

10. James, "The Sense of Newport," 210.

11. Ibid.

12. Interestingly, one of the greatest collectors of American eighteenth-century furniture and nineteenth-century paintings, especially the work of Heade, was Maxim Karolik, for many years a resident of Newport.

13. James, "The Sense of Newport," 217; and Updike, *The Witches of Eastwick*, 9.

14. James, "The Sense of Newport," 212.

15. Ibid., 215.

16. Ibid., 216.

17. Morse, *The American Geography*, n.p.

Chapter 7

1. The primary source material on Bradford is of course his own book, *The Arctic Regions* (London, 1873). Contemporary biographies are included in Henry Tuckerman, *Book of the Artists* (New York, 1867), 552–56; and in Leonard B. Ellis, *History of New Bedford* (Syracuse, N.Y., 1892), 98–103. A more modern treatment is in John Wilmerding, *A History of American Marine Painting* (Boston, 1968), 186–98. Other contemporary material of related importance may be found in Elisha Kent Kane, *Arctic Explorations*, 2 vols. (Philadelphia, 1857); and Louis Legrand Noble, *After Icebergs with a Painter* (New York, 1861). Information of related interest is in Fitz Hugh Ludlow, *The Heart of the Continent: A Record of Travel Across the Plains and in Oregon* (Cambridge, Mass., 1870); and in Richard Shafer Trump, "Life and Works of Albert Bierstadt" (unpublished Ph.D. dissertation, The Ohio State University, 1963).

The following articles also contain useful Bradford material: Mary A. Bradford, "Library Book Talk: Miss Mary A. Bradford Tells of the Life and Works of Her Father," 13 January 1926 (offprint in Fairhaven Public Library); "Jervis McEntee's Diary," *Journal of the Archives of American Art* 8, nos. 3 and 4 (July-October 1968): 3, 26; "Arctic Scenery," *The Art Journal* (London) 9 (1873): 255; "The Paintings of Mr. William Bradford, of New York," *The Philadelphia Photographer* 21 (1884): 7–8; William Herbert Rollins, "Instantaneous Photography with Wet-Plates," *The Philadelphia Photographer* 28 (1917): 120–21; J. L. Dunmore, "The Camera Among the Icebergs," *The Philadelphia Photographer* 6 (1869): 412–14; "The Arctic Regions," *Image* 1, no. 8 (November 1952): 1; "William Bradford, Eminent Fairhaven Artist" (undated offprint in Fairhaven Public Library); Mrs. Elwyn G. Campbell, "Artists of this Vicinity," 1921 (offprint in Fairhaven Public Library); David Loeffler Smith, "New Bedford Artists of the Nineteenth Century," *Antiques* 92, no. 5 (November 1967): 689–93; ibid., "A City and Its Painters" [exh. cat., Swain School of Design, New Bedford Free Public Library, and the Whaling Museum] (New Bedford, July-August 1965).

Chapter 8

1. Clement Greenberg, " 'American-Type' Painting," in *Art and Culture: Critical Essays* (Boston, 1961), 209, 228. Sam Hunter echoed the same sentiments in his *American Art of the 20th Century* (New York, 1973), 229: "The first painting movement to bring American artists world-wide notice after the Second World War was Abstract Expressionism."

2. Barbara Novak, *American Painting of the Nineteenth Century: Realism, Idealism, and the American Experience* (New York, 1969), 95.

3. Among the first publications to make the significant connections were Robert Rosenblum's *Modern Painting and the Northern Romantic Tradition: Friedrich to Rothko* (New York, 1975); and *Art in America* 64, no. 1 (January-February 1976), "American Landscape Issue."

4. Louis Legrand Noble, *The Life and Works of Thomas Cole*, ed. Elliot S. Vesell (Cambridge, Mass., 1964), 83, 86.

5. Quoted in Julien Levy, *Arshile Gorky* (New York, 1966), 15.

6. For example, Sam Hunter, *Modern American Painting and Sculpture* (New York, 1959), and Irving Sandler, *The Triumph of American Painting: A History of Abstract Expressionism* (New York, 1970), especially chapters 7 and 11. See also Barbara Novak, "Grand Opera and the Small Still Voice," *Art in America* 59, no. 2 (March-April 1971), 64–73.

7. Novak, *American Painting*, 122, 131.

8. James Thomas Flexner, *Nineteenth Century American Painting* (New York, 1970), 9.

9. Clement Greenberg, "The Crisis of the Easel Picture," in *Art and Culture: Critical Essays* (Boston, 1961), 155.

10. David C. Huntington, *The Landscapes of Frederic Edwin Church: Vision of an American Era* (New York, 1966), 69.

11. See Theodore E. Stebbins, Jr., *The Life and Works of Martin Johnson Heade* (New Haven and London, 1975), 35, 44, 107.

12. Thomas B. Hess, *Barnett Newman* (New York, 1971), 69ff.

13. See *Luminous Landscape: The American Study of Light, 1860–1875* [exh. cat., Fogg Art Museum] (Cambridge, Mass., 1966).

14. See Novak, *American Painting*, 129ff., and John Wilmerding,

The Genius of American Painting (New York and London, 1973), introduction, 19ff.

15. See Stebbins, *Martin Johnson Heade*, 56–63, 283–85.

16. Huntington, *Frederic Edwin Church*, 61.

17. Ibid., 17–20. As Huntington further points out (199), Church's teacher and the founder of American landscape painting, Thomas Cole, had himself explicitly used this symbolism earlier in his series on *The Cross and the World*.

18. *Complete Poems of Robert Frost* (New York, 1949), 268.

19. Barnett Newman, "The First Man Was an Artist," *The Tiger's Eye* (New York) 1, no. 1 (October 1947), 59–60; quoted in Sandler, *Triumph of American Painting*, 189.

20. For the fullest discussion and interpretation of these religious themes, see Hess, *Barnett Newman*, passim.

21. Quoted in Seldon Rodman, *Conversations with Artists* (New York, 1957), 93–94, and in Rosenblum, *Modern Painting*, 215.

22. Quoted in Peter Selz, *Mark Rothko* (New York, 1961), 14.

23. Ibid., 9.

24. Walt Whitman, *Leaves of Grass* (Philadelphia, 1891–1892), 122–23.

25. Ibid., 18.

26. Lawrence Ferlinghetti, *Starting from San Francisco* (rev. ed., New York, 1967), 5.

Chapter 9

1. For a discussion of Raphaelle Peale's still-life painting as an exemplum of American ideas and culture in the Federal period, see John Wilmerding, "The American Object: Still-Life Paintings," in *An American Perspective: Nineteenth-Century Art from the Collection of Jo Ann and Julian Ganz, Jr.* [exh. cat., National Gallery of Art, Amon Carter Museum, Fort Worth, and Los Angeles County Museum of Art] (Washington, D.C., and Hanover, N.H., 1981), 85–111; and ibid., "Important Information Inside: The Idea of Still-Life Painting in Nineteenth-Century America," in *Important Information Inside: The Art of John F. Peto and the Idea of Still-Life Painting in Nineteenth-Century America* [exh. cat., National Gallery of Art] (Washington, D.C., 1983), 36–55.

2. In 1986 one historian took note that "this portrait of *Rubens Peale with a Geranium*, 1801, has recently been acquired at auction by the National Gallery of Art in Washington, D.C., from the collection of Mrs. Norman Woolworth. The fact that it brought the record price for an American painting signals the growing interest in Rembrandt Peale's too long neglected art." Carol Eaton Hevner, "Rembrandt Peale's Life in Art," *The Pennsylvania Magazine of History and Biography*, no. 1 (January 1986):3. Rather, it may be argued that, while fresh attention to Peale is part of a larger reexamination of historical American art, the record price reflected more the long recognized importance of this picture alone and the belief that it, quite apart from Peale's career, somehow held the power of a profound national icon.

3. Biographical information from Carol Eaton Hevner and Lilian B. Miller, *Rembrandt Peale, 1778–1860: A Life in the Arts* [exh. cat., The Historical Society of Pennsylvania] (Philadelphia, 1985).

4. For a summary of the artistic state of Philadelphia at this time, see Beatrice B. Garvan, *Federal Philadelphia, 1785–1825: The Athens of the Western World* [exh. cat., Philadelphia Museum of Art] (Philadelphia, 1987).

5. See ibid., 38–41.

6. Quoted in Hevner and Miller, *Rembrandt Peale*, 32.

7. See ibid., 18–20.

8. Ibid., 66–67.

9. See, for example, *Thomas Jefferson* (1805; New-York Historical Society); *Charles Willson Peale* (1812; Historical Society of Pennsylvania); and *Rubens Peale* (1834; Wadsworth Atheneum). Ibid., 22, 33, 55, 77.

10. Ibid., 76.

11. See the entry on this painting in *The Eye of Thomas Jefferson* [exh. cat., National Gallery of Art] (Washington, D.C., 1976), 346, no. 600.

12. Margaret Bayard Smith, *First Forty Years of Washington Society*, quoted ibid., 346.

13. Biographical information from George C. Groce and David H. Wallace, *The New-York Historical Society's Dictionary of Artists in America, 1564–1860* (New Haven, 1957), 34–35; and Edgar P. Richardson et al., *Charles Willson Peale and His World* (New York, 1982), 110–11, 124–26, 193.

14. Quoted in Hevner and Miller, *Rembrandt Peale*, 92.

15. See ibid., 37–39, 92.

16. See Jules David Prown, *John Singleton Copley*, 2 vols. (Cambridge, Mass., 1966), 1: nos. 96, 119, 122, 128, 161, 165, 170, 186, 188, 256, 258, 259, 310, 327.

17. Ibid., 1: nos. 273 and 327.

18. See ibid., 2: no. 384.

19. See ibid., 1:74–75, for a discussion of this painting.

20. See Hevner and Miller, *Rembrandt Peale*, 21–22.

21. Mary Jane Peale's last will and testament, Peale-Sellers Papers, American Philosophical Society, Philadelphia.

22. *Exhibition of Portraits by Charles Willson Peale and James Peale and Rembrandt Peale* [exh. cat., The Pennsylvania Academy of the Fine Arts] (Philadelphia, 1923), 75. See also *Pennsylvania Painters* [exh. cat., The Pennsylvania State University] (Pittsburgh, 1955), no. 11; *American Art from American Collections* [exh. cat., The Metropolitan Museum of Art] (New York, 1963), 76; and Stuart B. Feld, "Loan Collection," The Metropolitan Museum of Art *Bulletin* (April 1965), 283.

23. See Carol Eaton Hevner, "*Rubens Peale with a Geranium* by Rembrandt Peale," in *Art at Auction: The Year of Sotheby's, 1985–86* (New York, 1986), 114–17; Carol Eaton Hevner, "Rembrandt Peale's Portraits of His Brother Rubens," *The Magazine Antiques* 130, no. 5 (November 1986): 1,010–13; and Edwin M. Betts et al., *Thomas Jefferson's Flower Garden at Monticello* (rev. ed., Charlottesville, Va., 1986), 72–73.

24. For his efforts to improve farming methods as well as his horticultural expertise, Rubens was elected a member of the Academy of Natural Sciences in Philadephia in 1813.

25. "Memorandum of Rubens Peale," Peale-Sellers Papers, American Philosophical Society, Philadelphia, 1–4; quoted in Hevner, "Rembrandt Peale's Portraits," 1,011.

26. Rembrandt Peale, "Reminiscences," *The Crayon* (3 June 1856), 164–65.

27. Ibid.

28. Letter from Charles E. Letocha, M.D. (24 February 1986), in the curatorial records, National Gallery of Art.

29. John R. Levene, *Clinical Refraction and Visual Science* (London, 1977), 171.

30. Charles Coleman Sellers, quoted ibid., 171–72.

31. John McAllister to Thomas Jefferson, Philadelphia, 14 November 1806, in the Library of Congress; transcript courtesy of Charles E. Letocha, M.D., in the curatorial records, National Gallery of Art.

32. Information from Charles E. Letocha, M.D., in letters to the National Gallery, 4 February 1986, 24 February 1986, and 7 March 1986; in the curatorial records, National Gallery of Art.

33. Mary Jane Peale, last will, 1883.

34. Hevner, "Rubens Peale," 116.

35. See Levene, *Clinical Refraction*, 172.

36. Ibid., 172.

37. Quoted in Betts et al., *Jefferson's Flower Garden*, 72–73. See also Peter Hatch, *The Gardens of Monticello* (Charlottesville, Va., n.d.), 11.

38. R.W.B. Lewis, *The American Adam: Innocence, Tragedy, and Tradition in the Nineteenth Century* (Chicago, 1955), 15.

39. Thomas Jefferson, *Notes on the State of Virginia* (1785), in *The Portable Thomas Jefferson*, ed. Merrill D. Peterson (New York, 1975), 68.

40. Quoted in Lewis, *American Adam*, 15.

41. See *The Portable Thomas Jefferson*, xx, 235.

42. Quoted ibid., 290; see also xxx–xxxii.

43. Quoted in Lewis, *American Adam*, 5.

44. Alexander Hamilton, James Madison, and John Jay, *The Federalist Papers* (New American Library ed., New York, 1961), 33, 104.

45. Ibid., 313.

46. Benjamin Vaughn to Franklin, 31 January 1783, quoted in the introduction to *The Autobiography of Benjamin Franklin*, ed. Leonard W. Labaree et al. (New Haven, 1964), 6.

47. Woodrow Wilson, introduction to *The Autobiography of Benjamin Franklin* (New York, 1901), vi–x.

48. Acknowledgment for this information to D. Dodge Thompson, National Gallery of Art.

49. See Alice DeLana and Cynthia Reik, eds., *On Common Ground: A Selection of Hartford Writers* (Hartford, Conn., 1975), 23.

50. That optimistic vision in large part held the national imagination through the country's first century, even with the interrupt-

ing crisis of civil strife and self-questioning in the 1860s. By the centennial of 1876, a colonial revival in architectural and design styles was underway, and the cult of American youth was never more possessing, as citizens celebrated their origins and the course of destiny. Mark Twain's novels and Winslow Homer's paintings conspicuously placed youth in the center of the American landscape. In particular, the latter's *Breezing Up* (A Fair Wind) (1876; fig. 136), set a group of boys beside an old man in the catboat's cockpit, a reminder of history's passage, but also a dream in maturity of renewable freshness.

Another picture completed that same year in Peale's native Philadelphia was *Baby at Play* by Thomas Eakins. Since Peale's day, that city had remained a center of American scientific studies. Mindful of the upcoming centennial, Eakins began work on his monumental composition of *The Gross Clinic* (1875; The Jefferson Medical College of Thomas Jefferson University, Philadelphia), a tribute to modern Philadelphia medicine and the foremost surgeon of the day, Dr. Samuel Gross. At the same time, Eakins also conceived a pictorial homage to Philadelphia's first important sculptor, *William Rush Carving His Allegorical Figure of the Schuylkill River* (1876–1877; Philadelphia Museum of Art). *Baby at Play* was a portrait of Eakins's niece, Ella, the first child of his sister, at play in the family's back courtyard. Like the dramatic clinic picture of the preceding year, this one focused on a central figure engaged in connecting the concentration of mind with the action of the hand. But instead of depicting the fulfillment of experience, this showed the beginnings of learning. Aside from its personal meanings for Eakins, could it also have been a companion salute to another early Philadelphia artist? Among its most noteworthy details is a large potted plant on the ground to the right. Although vague and without flowers, its bare stems and large leaves could well characterize a geranium. Having acknowledged the history of local medicine and sculpture, Eakins could have equally intended here a private recognition of his city's first family of painters and explicitly Rubens Peale's geranium plant, for Eakins similarly cared about the creative role of the artist and about the joining of art and science. Whether tribute or tradition, it certainly recalls Rembrandt Peale's earlier meditation on human intellect and perseverence. See Jules David Prown, "Thomas Eakins'

Baby at Play," in *Studies in the History of Art*, vol. 18 (Washington, D.C., 1985), 121–27.

51. See Charles Coleman Sellers, *Charles Willson Peale* (New York, 1969), 331–52.

Chapter 10

1. "Catalogue of Robert Salmon's Pictures, 1828 to 1840, from his own notes, now in possession of Miss Darracott, 1881." Manuscript, Boston Public Library.

2. Samuel Eliot Morison, *The Maritime History of Massachusetts, 1783–1860* (Boston, 1921), 241.

3. Charles Francis Adams, *Diary* (24 September and 5 August 1830), reel no. 60 of the microfilms of The Adams Papers, Massachusetts Historical Society.

4. John Paul Russo, "Hull's First Victory. One Painting: Three Famous Men," *The American Neptune* 25 (January 1965): 29–34.

5. *Proceedings* of the Bostonian Society at the Annual Meeting (8 January 1895), 37–40.

6. Ibid.

7. Ibid.

8. See John Wilmerding, *Robert Salmon: Painter of Ship and Shore* (Boston and Salem, 1971), 42, 97.

9. *Boston Daily Advertiser* (25 June 1830). Quoted in Wilmerding, *Robert Salmon*, 111.

10. Benjamin Champney, *Sixty Years' Memories of Art and Artists* (Woburn, Mass., 1900).

11. *National Academy of Design Catalogue of the Eighteenth Annual Exhibition* (1843), 21.

12. See John Wilmerding, *Fitz Hugh Lane: American Marine Painter* (Salem, 1964).

13. Ibid.

14. Eddy, like many others associated with Pendleton, had an interesting career, which contributed to the development of an audience for art in America. For Pendleton in the 1830s he did detailed work on stone as well as copper, producing many lithographed maps. At one point in his career, he earned a living in New York as

a portrait painter and art dealer, and imported made-to-order copies of old masters—an activity characteristic of the time and of the awakening of taste and of interest in the arts that was taking place.

15. Rev. Edward G. Porter, *Rambles in Old Boston, New England* (Boston, 1887), 241–42.

Chapter 11

1. For example, the *Dancing Satyr*, from Casa del Faune, Pompeii (Museo Nazionale, Naples) has been cited as a distant source for the dancing figure in the *Jolly Flatboatmen* series. See also the marble *Doryphorus* (Museo Nazionale, Naples) for *The Emigration of Daniel Boone*; *The Dying Gaul* (Louvre) for the foreground figure in each of the *Election* paintings; and the *Apollo Belvedere* (Vatican, Rome) for *Martial Law (Order No. 11)*. See E. Maurice Bloch, *George Caleb Bingham: The Evolution of an Artist* (Berkeley, 1967), figs. 56–57, 87–89, 94–99, 164–166.

2. Quoted in James M. McPherson, *Battle Cry of Freedom: The Civil War Era* (New York, 1988), 42.

3. See the discussion of Bingham's artistic responses to these political events in Bloch, *Bingham: Evolution*, 215–19.

4. See the discussion of some of these themes in McPherson, *Battle Cry*, 4–16.

5. The definitive pioneering study is F. O. Matthiessen, *American Renaissance: Art and Expression in the Age of Emerson and Whitman* (London and New York, 1941).

6. Ibid., 659.

7. David S. Reynolds, *Beneath the American Renaissance: The Subversive Imagination in the Age of Emerson and Melville* (New York, 1988), 339, 387.

8. Ibid., 54, 91.

9. Quoted in Matthiessen, *American Renaissance*, 12; see also Reynolds, *Beneath the Renaissance*, 94–96, 412–19.

10. The key works for Lane here would be *Lighthouse at Camden* (1851; private collection), *Entrance of Somes Sound from Southwest Harbor* (1952; private collection), *Gloucester Harbor* (1852; Cape Ann Historical Association, Gloucester), *Salem Harbor* (1853; Mu-

seum of Fine Arts, Boston), *Boston Harbor, Sunset, Blue Hill* (c. 1850–1855; fig. 113), (c. 1855; private collection), *Lumber Schooners at Evening on Penobscot Bay* (1860; fig. 48) and *Ships and an Approaching Storm Off Owl's Head* (1860; Collection of Senator and Mrs. John D. Rockefeller IV, Washington, D.C.). For a fuller discussion of the artist and these paintings, see John Wilmerding et al., *The Paintings of Fitz Hugh Lane* (Washington, D.C., 1988).

11. For Church the list would include *Twilight, "Short Arbiter Twixt Day and Night"* (1850; fig. 49), *Beacon Off Mount Desert* (1851; Private collection), *Grand Manan Island, Bay of Fundy* (1852; Wadsworth Atheneum), *Mt. Kataadn* (1853; fig. 89), *The Andes of Ecuador* (1855; Reynolds House, Winston-Salem, N.C.), *Twilight* (1856; Albany Institute of History and Art), *Sunset* (1856; Munson-Williams-Proctor Institutes, Utica, N.Y.), *Niagara* (1857; fig. 78), *The Heart of the Andes* (1859; Metropolitan Museum of Art, New York), and *Twilight in the Wilderness* (1860; fig. 50). For further discussion, see John Wilmerding, ed., *American Light: The Luminist Movement, 1850–1875, Paintings, Drawings, Photographs* [exh. cat., National Gallery of Art] (repr., Princeton, N.J., 1989).

12. See Matthiessen, *American Renaissance*, xxxvi.

13. Quoted ibid., 149.

14. See William H. Pierson, Jr., *American Buildings and Their Architects: The Colonial and Neo-Classical Styles* (New York, 1970), 214, 417.

15. Ibid., 376, 386, 416, 436.

Chapter 12

1. Gordon Hendricks, *The Life and Work of Winslow Homer* (New York, 1979), 87.

2. Ibid., 122–25.

3. For example, see Peter H. Wood and Karen C. C. Dalton, *Winslow Homer's Images of Blacks: The Civil War and Reconstruction Years* (Austin, Tex., 1988); and Albert Boime, "Blacks in Shark-Infested Waters: Visual Encodings of Racism in Copley and Homer," *Smithsonian Studies in American Art* 3, no. 1 (Winter 1989): 18–47.

4. For a fuller discussion of Homer's treatment of pairs, both as form and as content, see chapter 14 in this volume.

5. See Hendricks, *Life and Work of Winslow Homer*, 125; Lloyd Goodrich, *Winslow Homer* (New York, 1944), 56; Helen Cooper, *Winslow Homer Watercolors* (Washington, D.C., 1986), 43–44; and Henry Adams, "Winslow Homer's Mystery Woman," *Art and Antiques* (November 1984): 38–45.

6. For additional discussion of the themes of closeness and separation in Homer's work, particularly his landscapes, see chapter 3 in this volume.

7. The Japanese influence on Homer is more extensively covered in chapter 14 in this volume.

8. For a discussion of some of these issues of interrelated technique and subject, see chapter 13 in this volume and Nicolai Cikovsky, Jr., "Winslow Homer's *School Time*, 'A Picture Thoroughly National,' " in John Wilmerding, ed., *Essays in Honor of Paul Mellon, Collector and Benefactor* (Washington, D.C., 1986), 46–69, 388–401.

9. See Hendricks, *Life and Work of Winslow Homer*, 21, 23, 74.

10. Gordon Hendricks identifies the men in *The Card Game* as Wakeman Reynolds, George Rice, Charles McNeely, and Joe Warren. See Hendricks, *Life and Work of Winslow Homer*, 85, 113, 137.

11. See Cooper, *Winslow Homer Watercolors*, 40–47.

Chapter 13

1. Even the numbers, 73 and 37, form a rare conjunction of mirrored figures looking in opposite directions. For a discussion of the significance of the decade of the 1870s as a whole for Homer, see chapter 12 in this volume.

2. At the time that Homer painted *Dad's Coming*, his parents were in their mid-sixties, and living in Belmont, Massachusetts. For a discussion of the impact their deaths had on him, see chapter 3, as well as Henry Adams, "Mortal Themes: Winslow Homer," *Art in America* 71, no. 2 (1983): 112–26.

3. See Gordon Hendricks, *The Life and Work of Winslow Homer* (New York, 1979), 78–80. Hendricks speculates that, because of its

date and connection to the later Gloucester subjects, *Shipbuilding* may prove that Homer visited that Cape Ann town in 1871. But confirming its exact location is impossible, and all the other pictorial and documentary evidence indicates that Homer first spent substantial time and painted extensively in Gloucester in 1873.

4. For a discussion of the possible influence of Mount and Bingham on Homer's work of this period, see John Wilmerding, *Winslow Homer* (New York, 1972), 74–75, 87–92, 108–10.

5. See ibid., 27–30, 36–38, 91–92, 111–17.

6. See Hendricks, *Life and Work of Winslow Homer*, 95–100.

7. For a full survey and analysis, see Philip C. Beam, *Winslow Homer's Magazine Engravings* (New York, 1979). In 1874 Homer completed another eleven engravings, but only two in the following year, the last of his production in this medium.

8. See *Girl Reading on a Stone Porch* (1872; private collection), *Portrait of Helena de Kay* (1872; collection of Baron Thyssen Bornemisza, Lugano, Switzerland), and *Reverie* (1872; private collection), all reproduced in Hendricks, *Life and Work of Winslow Homer*, 92.

9. See William Howe Downes, *The Life and Works of Winslow Homer* (Boston and New York, 1911). Downes knew Homer personally, and published his biography a year after the artist's death. Although there is no question that we are looking at a family group, one alternative reading of the figures might be to see them as three siblings: a boy and his older sister holding the baby.

10. See, for example, *The Country School* (1871; St. Louis Art Museum) and *Breezing Up (A Fair Wind)* (1876; National Gallery of Art, Washington). These themes are discussed more fully in chapters 12 and 14.

11. Information from Lloyd Goodrich in a letter to Paul Mellon, 5 April 1973. My thanks to Beverly Carter, curator of the Mellon collection, for the fullest assistance with photographic and archival materials.

12. Hendricks, *Life and Work of Winslow Homer*, 90; and Downes, *Life and Works of Winslow Homer*, 77.

13. *Harper's Weekly* (New York, 1 November 1873), 970.

14. Similar examples include *Seven Boys in a Dory* (1873; private collection, courtesy of Coe Kerr Gallery, New York), *Three Boys in*

a Dory (1873; Nelson-Atkins Museum of Art, Kansas City, Mo.), *Boys in Dory* (1880; Addison Gallery, Andover, Mass.), and *Gloucester Harbor and Dory* (1880; Harvard University Art Museums). Related compositional elements may be found in *Boy with Anchor* (1873; Cleveland Museum of Art), *Winding Line* (1874; Plainfield Public Library, Plainfield, N.J.), *Three Boys on a Beached Dory* (1873; Museum of Fine Arts, Boston), *Waiting for a Bite* (1874; Cummer Gallery, Jacksonville, Fla.), and *Gloucester* (1880; Art Institute of Chicago).

Chapter 14

1. Irma Jaffe, *Trumbull: The Declaration of Independence* (New York, 1976).

2. Nicolai Cikovsky, Jr., "Winslow Homer's *Prisoners from the Front*," *Metropolitan Museum Journal* 12 (1977): 155–72.

3. "The Thanksgiving Dinner Was Spoiled," *Art Digest* (15 September 1957): 41; and "Better than Apple Pie," *Newsweek* (24 November 1958): 78. For an almost complete Homer bibliography, see Melinda Dempster Davis, *Winslow Homer: An Annotated Bibliography of Periodical Literature* (Metuchen, N.J., 1975).

4. Roger B. Stein, "Structure as Meaning: Towards a Cultural Interpretation of American Painting," *American Art Review* 3, no. 2 (March–April 1976): 66–78.

5. Philip C. Beam, *Winslow Homer at Prout's Neck* (Boston, 1966), 248.

6. William Howe Downes, *The Life and Works of Winslow Homer* (Boston and New York, 1911), 245; and Beam, *Winslow Homer at Prout's Neck*, 249. Beam also modifies the account of Homer's getting the birds, stating that a Boston friend, Phineas W. Sprague, had been duck hunting at the Neck in the fall of 1908 and hung a pair of ducks on the artist's studio door.

7. Downes, *Life and Works of Winslow Homer*, 244–45. Downes apparently confused his years, reporting that the occasion was in November 1909, when it seems fairly certain that Homer began this work in the previous autumn and completed it early in the new year of 1909.

8. Transcript of a letter to Charles Homer in the files of the National Gallery of Art, Washington. Historians generally agree that the picture referred to here can only be *Right and Left*, since Homer was working on no other known painting at the time ("in maturity he averaged only two or three oils a year"—Lloyd Goodrich, *Winslow Homer* [New York, 1959], 31) and since indeed the painting is "surprising" within his oeuvre. See Beam, *Winslow Homer at Prout's Neck*, 247–48, and Lloyd Goodrich, *Winslow Homer* (New York, 1944), 197–98.

9. For example, *Our Watering Places—The Empty Sleeve at Newport* in *Harper's Weekly*, 26 August 1865; *Thanksgiving Day—Hanging Up the Musket* in *Frank Leslie's Illustrated News Paper*, 23 December 1865; *St. Valentine's Day—The Old Story in All Lands* in *Harper's Weekly*, 22 February 1868; *You Are Really Picturesque, My Love* in *The Galaxy*, June 1868; *All in the Gay and Golden Weather* in *Appleton's Journal of Literature, Science, and Art*, 16 June 1869; *The Artist in the Country* in *Appleton's Journal*, 19 June 1869; *Come* in *The Galaxy*, September 1869; *Weary and Dissatisfied with Everything* in *The Galaxy*, November 1869; *A Quiet Day in the Woods* in *Appleton's Journal*, 25 June 1870. See Barbara Gelman, *The Wood Engravings of Winslow Homer* (New York, 1969); and Lloyd Goodrich, *The Graphic Art of Winslow Homer* (Washington, D.C., 1968).

10. *Swinging on a Birch Tree* in *Our Young Folks*, June 1867; *Summer in the Country* in *Appleton's Journal*, 10 July 1869; *The Playmates* in *Our Young Folks*, November 1869; *Making Hay* in *Harper's Weekly*, 28 June 1873; *The Bathers* in *Harper's Weekly*, 16 August 1873.

11. *Danger Ahead* in *Appleton's Journal*, 30 April 1870; *Trapping in the Adirondacks* in *Every Saturday*, 24 December 1870; *Deer Stalking in the Adirondacks in Winter* in *Every Saturday*, 21 January 1871; *Lumbering in Winter* in *Every Saturday*, 28 January 1871; *Camping Out in the Adirondack Mountains*, in *Harper's Weekly*, 7 November 1874.

12. For example, *The Two Guides* (1876; Sterling and Francine Clark Art Institute, Williamstown, Mass.); *The Herring Net* (1885; Art Institute of Chicago); *The Life Line* (1884; Philadelphia Museum of Art); *Undertow* (1885; Sterling and Francine Clark Art Institute, Williamstown, Mass.).

13. For example, *Winter Coast* (1890; fig. 23) and *The Gulf Stream* (1899; Metropolitan Museum of Art, New York).

14. Homer continued with expressive and simplified paired shapes in *Eight Bells* (1886; Addison Gallery, Andover, Mass.). Even bolder was his composition a decade later of *The Lookout— "All's Well"* (Museum of Fine Arts, Boston); here he virtually filled his canvas with the two large forms of the fisherman's head and the ship's bell behind. This juxtaposition is, of course, one of compared masses as well as sounds.

15. For a discussion of Homer's fish still life in the context of other late-nineteenth-century paintings of similar subjects, see William H. Gerdts and Russell Burke, *American Still-Life Painting* (New York, 1971), chapter 9, "Fish and Game Still Life," 121–32.

16. Citing Downes, Beam notes that this painting was originally titled *At the Foot of the Lighthouse*. See Beam, *Winslow Homer at Prout's Neck*, 248.

17. See Alfred Frankenstein, *The Reality of Appearance: The Trompe l'Oeil Tradition in American Painting* [exh. cat., University Art Museum] (Berkeley, Calif., 1970), 134; and Gerdts and Burke, *American Still-Life Painting*, 156.

18. See Albert Ten Eyck Gardner, *Winslow Homer, American Artist: His World and His Work* (New York, 1961), chapter 4, "Homer in Paris—1867," 89–118; John Wilmerding, *Winslow Homer* (New York, 1972), chapter 2, "Painting What is Seen and Known," 41–83, and chapter 4, "A Stern Poetry of Feeling," 131–63; John Wilmerding, "Winslow Homer's English Period," *The American Art Journal* 7, no. 2 (November 1975): 60–69; and William H. Gerdts, "Winslow Homer in Cullercoats," *Yale University Art Gallery Bulletin* 36, no. 2 (Spring 1977): 18–35. With specific regard to the Landseer parallel, see Gardner, 156. I am grateful to Peter Sutton for bringing this possible connection to my attention.

19. M. E. Chevreul, *The Laws of Contrast of Colour* (London, 1859). See David Tatham, "Winslow Homer's Library," *The American Art Journal* 9, no. 1 (May 1977): 92–98.

20. Gardner, *Winslow Homer, American Artist*, 96.

21. Beam, *Winslow Homer at Prout's Neck*, 162, 191, 205.

22. For example, the watercolor *International Tea Party* (1868; Cooper-Hewitt Museum, New York); *St. Valentine's Day* in *Harper's Weekly*, 22 February 1868; and *The Chinese in New York—Scene in a Baxter Street Club House* in *Harper's Weekly*, 7 March 1874.

23. See Gardner, *Winslow Homer, American Artist*, 206–7; Beam, *Winslow Homer at Prout's Neck*, 107–8; and Wilmerding, *Winslow Homer*, 171.

24. Beam is one of the few to comment on this specific image as a possible source. *Winslow Homer at Prout's Neck*, 248. I also wish to acknowledge with gratitude the helpful assistance of Martin Amt of the Freer Gallery of Art.

25. For example, the bird photographs are neither analyzed nor illustrated in Van Deren Coke, *The Painter and the Photograph: From Delacroix to Warhol* (Albuquerque, N.M., 1964); Kevin MacDonnell, *Eadweard Muybridge: The Man Who Invented the Moving Picture* (Boston, 1972); or *Eadweard Muybridge: The Stanford Years* [exh. cat., Stanford University Museum of Art] (Stanford, Calif., 1972). Single illustrations without discussion of the subject appear in Aaron Scharf, *Art and Photography* (Baltimore, 1969), 169; and Gordon Hendricks, *Eadweard Muybridge: The Father of the Motion Picture* (New York, 1975), 169.

26. Samuel M. Green is the one historian who has cited this specific plate from Audubon as an inspiration for Homer's painting. See his *American Art* (New York, 1966), 403. The original watercolor is now in the collection of The New-York Historical Society.

27. Quoted in Marshall B. Davidson, *The Original Water-Color Paintings by John James Audubon for "The Birds of America"* (New York, 1966), pl. 248.

28. Davidson, *Audubon*, pl. 248.

29. Beam, *Winslow Homer at Prout's Neck*, 97.

30. See Wilmerding, *Winslow Homer*, 162–163, 189.

31. Downes, *Life and Works of Winslow Homer*, 245.

32. Green, *American Art*, 403.

33. Stein, "Structure as Meaning," 75.

34. See the discussion of this by Wanda M. Corn, *The Art of Andrew Wyeth* [exh. cat., Fine Arts Museums of San Francisco] (San Francisco, 1973), especially 92–165.

35. Quoted in *Art News* (November 1977): 103

36. Davidson, *Audubon*, pl. 248.

37. For their editorial assistance I would like to thank Polly Roul-hac and Don Mathison.

Chapter 15

1. See Lloyd Goodrich, *Thomas Eakins: His Life and Work* (New York, 1933), 188–89, catalogue no. 309.

2. Ibid., 189. The only difficulty with a conclusive identification of the figure in *Taking the Count* is that the figure in question, while bald like Fort, wears no glasses and appears to have a beard as well as a moustache. A possible, but not definitive, response is that near-sightedness could explain the former, and shadow under the head the latter. Goodrich, in correspondence with the author (7 December 1977), says that David Wilson Jordan gave him this information in 1930: "Jordan had studied with Eakins at the Pennsylvania Academy and was one of Eakins' and Mrs. Eakins' closest friends. Eakins painted his [Jordan's] portrait in 1899, the year after he painted *Fort* and *Taking the Count*."

Chapter 17

1. The most extensive argument for this realist clarity as an American tradition is made by Barbara Novak, *American Painting of the Nineteenth Century: Realism, Idealism, and the American Experience* (New York, 1969). See also John Wilmerding, *The Genius of American Painting* (New York and London, 1973), 13–23.

2. To take one typical example, see the discussion of sources in George Caleb Bingham's work in E. Maurice Bloch, *George Caleb Bingham: The Evolution of an Artist*, 2 vols. (Berkeley and Los Angeles, 1967), 1:91–92, 129. See also Denis R. O'Neill, "Dutch Influences in American Painting," *Antiques* 104 (December 1973): 1076–79; and Bartlett Cowdrey and Hermann Warner Williams, Jr., *William Sidney Mount, 1807–1868: An American Painter* (New York,

1944), 4. With regard to still life specifically, see Wolfgang Born, *Still-Life Painting in America* (New York, 1947), 5–9.

3. See Ingvar Bergstrom, *Dutch Still-Life Painting in the Seventeenth Century* (London, 1956), 1–10, 154–55.

4. Additional discussion of this connection is offered in chapter 18 in this volume.

5. Theodore E. Stebbins, Jr., *The Life and Works of Martin Johnson Heade* (New Haven and London, 1975), 115.

6. Alfred Frankenstein, *After the Hunt: William Harnett and Other American Still Life Painters, 1870–1900* (rev. ed., Berkeley and Los Angeles, 1969), 31.

7. This picture is spuriously inscribed 1847 at the lower left. See Charles H. Elam, ed., *The Peale Family: Three Generations of American Artists* [exh. cat., Detroit Institute of Arts] (Detroit, 1967), 98.

8. William H. Pierson, Jr., *American Buildings and Their Architects: The Colonial and Neoclassical Styles* (Garden City, N.Y., 1970), 221.

9. Ibid., 264.

10. Ibid., 224.

11. Ibid., 314.

12. See Garry Wills, *Inventing America: Jefferson's Declaration of Independence* (Garden City, N.Y., 1978).

13. Pierson, *American Buildings: Colonial and Neoclassical Styles*, 413 and 385–86.

14. Ibid., 382, 412–13, and 376.

15. John L. O'Sullivan (1845), quoted in Arthur M. Schlesinger, Jr., *The Age of Jackson* (Boston, 1945), 427.

16. John Ruskin, *The Elements of Drawing; in Three Letters to Beginners* (London and New York, 1857), 164; "Proserpina," in *Complete Works of John Ruskin*, 39 vols., ed. E. J. Cook and Alexander Wedderburn (London, 1905), 25:249; and *Praeterita*, vol. 35 (London, 1899), 2:300. See also Ella Milbank Foshay, "Nineteenth Century American Flower Painting and the Botanical Sciences" (Ph.D. dissertation, Columbia University, 1979).

17. Henry David Thoreau, *The Journal of Henry David Thoreau*, 20 vols. (Boston, 1906), 10:325.

18. Quoted in William H. Pierson, Jr., *American Buildings and*

Their Architects: Technology and the Picturesque, The Corporate and the Early Gothic Styles (Garden City, N.Y., 1978), 350.

19. Ibid., 270.

20. Ibid., 343.

21. Henry James, Jr., *Hawthorne* (Ithaca, N.Y., 1966), 1.

22. Ibid., 112.

23. Ibid., 114.

24. Quoted in James F. O'Gorman, *H. H. Richardson and His Office: Selected Drawings* [exh. cat., Fogg Art Museum, Harvard University] (Cambridge, Mass., 1974), 8.

25. Bergstrom, *Dutch Still-Life Painting*, 3.

26. This chapter is an expansion of an earlier essay that set forth these ideas in preliminary and summary form; see John Wilmerding, "The American Object: Still-Life Paintings," in *An American Perspective: Nineteenth-Century Art from the Collection of Jo Ann and Julian Ganz, Jr.* [exh. cat., National Gallery of Art, Amon Carter Museum, Fort Worth, and Los Angeles County Museum of Art] (Washington, D.C., and Hanover, N.H., 1981), 85–111.

Chapter 18

1. Alfred Frankenstein, *After the Hunt: William Harnett and Other American Still Life Painters, 1870–1900* (rev. ed., Berkeley and Los Angeles, 1969), 107.

2. For example, see three of Gysbrechts's works from the 1670s: *Vanitas* (Ferens Art Gallery, Kingston upon Hull, England) and *Painter's Easel* (National Museum of Art, Copenhagen) (reproduced in Celestine Dars, *Images of Deception* [New York, 1979], 33, 37), and *Turned-Over Canvas* (National Museum of Art, Copenhagen) (reproduced in M. L. d'Otrange Mastai, *Illusion in Art* [New York, 1975], 163).

3. See Frankenstein, *After the Hunt*, xiii.

4. Howard Mumford Jones, *The Age of Energy: Varieties of American Experience, 1865–1915* (New York, 1971), 105; see also 358–88.

5. From an undated newspaper clipping in the Peto family al-

bums, The Studio, Island Heights, New Jersey. The article goes on to take note of Peto's painting of a plucked chicken and some of his other subjects:

> Another handsome oil painting represents a rooster hanging on an old door, the chicken has been picked and presents a very natural appearance. He has many other beautiful paintings in realistic art representing book, fruit and hunters; studies which we have no room to describe.

It should also be recorded here that one of Peto's rack pictures with a Lincoln engraving, *Old Reminiscences* (1900; Phillips Collection, Washington, D.C.), was at one point repainted so that an address on a letter would read "Mr. W. Harnett," and thus be attributed to him. In keeping with Peto's interpretation of the Lincoln mythology, another envelope nearby bears only the word "Proprietor." Yet another Lincoln rack painting, *Jack of Hearts* (1902; Des Moines Art Center), displays a hanging booklet with a partly obscured title of "HOUSE KEEP[ER]."

6. See Jones, *Age of Energy*, 100.

7. For a discussion of the different images of guns, in relationship to masculinity, animal hunting, fighting the Indians, opening the frontier, and the romantic militarism after the Civil War, see Roxanna Barry, *Plane Truths: American Trompe l'Oeil Painting* [exh. cat., The Katonah Gallery] (Katonah, N.Y., 1980), unpaginated. On the chivalric and martial cults ascendant in the later nineteenth century, see T. J. Jackson Lears, *No Place of Grace: Antimodernism and the Transformation of American Culture, 1880–1920* (New York, 1981), especially 98–102. See also Jones, *Age of Energy*, 102.

8. Stephen Crane, *The Red Badge of Courage*, in *The Portable Stephen Crane*, ed. Joseph Katz (New York, 1969), 238; see also Katz, introduction, xiv–xv.

9. Walt Whitman, *Specimen Days* (Boston, 1971), 120.

10. Ibid., 41.

11. Alfred Kazin, introduction to Whitman, *Specimen Days*, xx. I am also grateful to Jo Ann Ganz for discussion of the Lincoln rack pictures.

12. For documentation on the several treatments of the house of cards, see Pierre Rosenberg, *Chardin, 1699–1779* [exh. cat., The

Cleveland Museum of Art] (Cleveland, 1979), 218–21, 231–33, 236–37. For illustrations of eighteenth-century playing cards, especially of jacks and knaves in France and central Europe, see Detlef Hoffman et al., *Spielkarten: Ihre Kunst und Geschichte in Mitteleuropa* [exh. cat., Graphische Sammlung Albertina] (Vienna, 1974), 72.

13. On this aspect of cubism especially, see Robert Rosenblum, "Picasso and the Typography of Cubism," in *Picasso in Retrospect*, Sir Roland Penrose and John Golding, eds. (New York, 1973), 75.

14. Henry James, Jr., *Hawthorne* (Ithaca, N.Y., 1966), 1.

15. Henry James, *The American Scene* (Bloomington, Ind., and London, 1968), 83, 158.

16. Ibid., 386.

17. A useful study of Adams's intellect and ideas is J. C. Levenson, *The Mind and Art of Henry Adams* (Stanford, 1957).

18. Henry Adams, *The Education of Henry Adams* (Boston, 1961), 209.

19. Ibid., 381–82.

20. Ibid., 451.

Chapter 19

1. For a more complete analysis of this painting, see chapter 14 in this volume.

2. Eakins the portraitist is covered in detail in chapter 15 in this volume.

Index